D1589074

FRANCHA LEALE TOGE.

The

Godolphin Library.

a. d. IV NON. MAI. MCMXXVII.

FOR REFERENCE USE ONLY

GODOLPHIN AND LATYMER SCHOOL

20615

FOR REFERENCE USE ONLY

30097

PICASSO: SCULPTOR/PAINTER

TateGallery

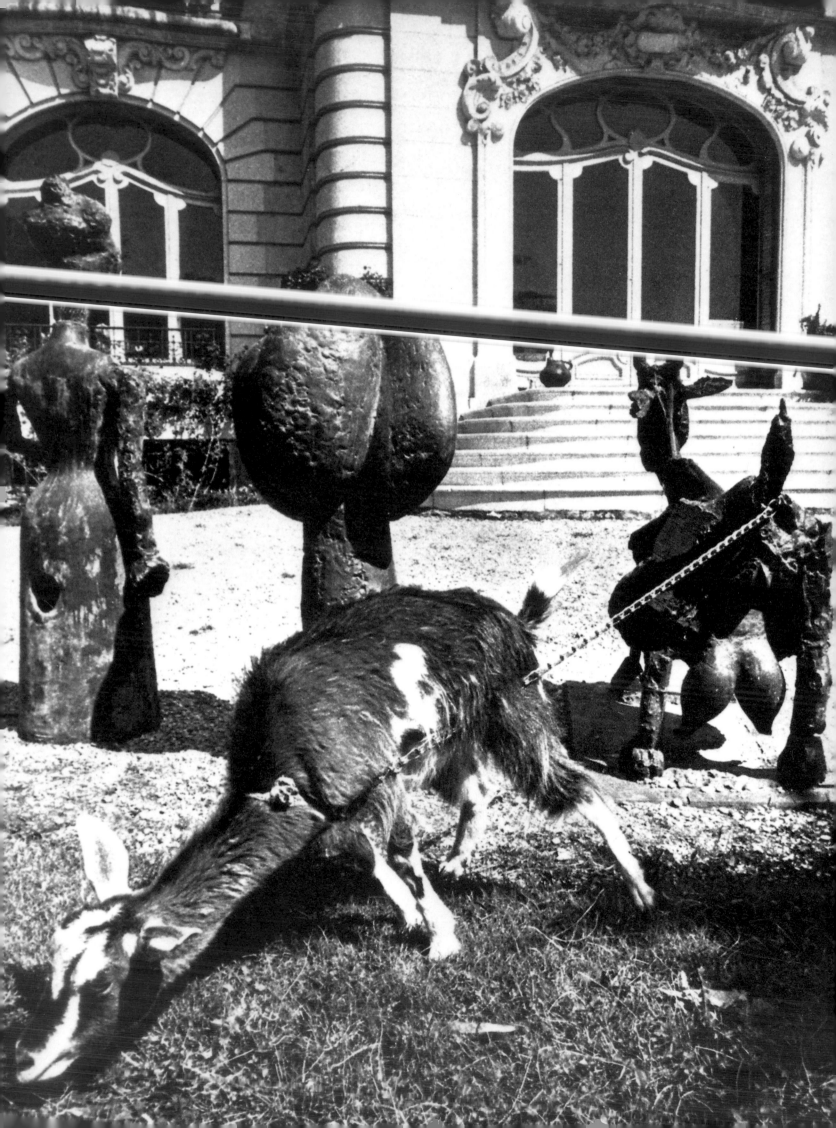

ELIZABETH COWLING

JOHN GOLDING

Picasso: Sculptor/Painter

TATE GALLERY

Exhibition sponsored by

ƎJ ERNST & YOUNG

Ernst & Young is an award winner under the Business Sponsorship Incentive Scheme for its support of the *Picasso. Sculptor / Painter* exhibition. The BSIS is a Government Scheme administered by ABSA (Association for Business Sponsorship of the Arts)

bsis

Matched

20615

~~30097~~

R
759.6
PIC

cover
Woman with Outstretched Arms 1961 (no.144)

frontispiece
La Californie, Cannes 1957
Photo: David Douglas Duncan

ISBN 1 85437 131 2

Published by order of the Trustees 1994
for the exhibition at the Tate Gallery 16 February – 8 May 1994
Published by Tate Gallery Publications, Millbank, London SW1P 4RG
Designed by Caroline Johnston
© Tate Gallery and contributors 1994 All rights reserved
Typeset in Monotype Columbus by ICON Colour, London
and Tate Gallery Publications
Printed in Great Britain on 150gsm Parilux Matt White
by Balding + Mansell, Wisbech, Cambridgeshire
All works by Pablo Picasso © DACS 1994

Contents

Foreword

There have been three major Picasso exhibitions at the Tate Gallery. The first was the legendary exhibition of 1960. Then, in 1967, Roland Penrose presented one of the first exhibitions devoted solely to Picasso's sculpture. Finally, in 1988, we mounted *Late Picasso: Paintings, Sculpture, Drawings, Prints 1953–1972*.

The idea for the present exhibition, showing the relationship between Picasso's sculpture and his painting, first developed in conversation with our artist trustees in 1990. We were delighted when both John Golding and Elizabeth Cowling accepted our invitation to work together to realise such a project. We are deeply grateful to them, not only for their total commitment from the very beginning but also for their continual enthusiasm which some inevitable setbacks did nothing to quench.

The selection is theirs and the reasoning behind it is explained in their joint preface. The catalogue material is also largely written by them with additional and illuminating essays on particular aspects of Picasso's work by Pepe Karmel, Peter Read, Marilyn McCully, and Claude Ruiz-Picasso, and finally an interview with Lionel Prejger by Elizabeth Cowling and Christine Piot. We offer our grateful thanks to all contributors. Securing the appropriate works of the highest quality was fundamental to the success of the project. However, promises of major loans as well as of advice and help were offered at a very early stage by members of the family, by the Musée Picasso and the Musée National d'Art Moderne in Paris and by the Museum of Modern Art in New York. Their exceptional generosity guaranteed the viability of the exhibition and encouraged us to pursue the project. We do so much appreciate their support.

We are indebted to all our lenders, not only public collections but also the private collectors, who have made a considerable sacrifice in parting with such superlative works for the run of the exhibition. We trust that they will feel that their generosity has been worthwhile and that the exhibition does indeed fulfil all our expectations, offering and achieving a greater understanding and appreciation of Picasso's creative spirit.

I should like to offer particular personal thanks to Claude Ruiz-Picasso, Gérard Régnier, Kirk Varnedoe, and Germain Viatte.

The exhibition could not have been realised without the sponsorship of Ernst & Young. Their involvement in the project and their considerable interest and enthusiasm are sincerely appreciated.

Nicholas Serota
Director

Sponsor's Foreword

Ernst & Young is delighted to be sponsoring the Tate Gallery's major exhibition, *Picasso: Sculptor/Painter*.

Picasso's vision and originality find many echoes in the philosophy of Ernst & Young. He gained his reputation by breaking down barriers and setting new standards for others to follow. Internationally he was a leader and a visionary. At Ernst & Young we pursue the same principles of leadership, vision and originality of thought for the benefit of our clients. Like Picasso, we aim to be always at the leading edge.

As one of the largest firms of business and financial advisers in the world, we welcome the opportunity to contribute to the cultural life of the countries in which we operate. Through its exhibitions and educational projects, the Tate Gallery makes a major contribution to cultural life in the United Kingdom and our sponsorship of Picasso is one way that we can help it maintain the very high standards that its visitors have come to expect.

We hope that you will enjoy this unique exhibition and that the catalogue will provide a reminder for the years to come.

Elwyn Eilledge
Senior Partner

Preface

Although Picasso's sculpture has often been shown in exhibitions dedicated primarily to his paintings and has been on several occasions featured in its own right – most notably at the Tate Gallery in 1967 – this is the first attempt to relate the sculpture more closely to the paintings and drawings and to demonstrate how Picasso's activity as a sculptor was not simply nourished by his work in two dimensions but also fed back into it and frequently altered and enriched it. Because Picasso's sculpture is still not as widely known and appreciated as his painting it forms the backbone of this exhibition; paintings and drawings are not in any way subsidiary to it but (taken separately) they are fewer in number and have been chosen to complement and illuminate Picasso's activity as a sculptor.

Picasso began sculpting soon after the turn of the century and produced works in three dimensions virtually throughout his life. But he first gave his attention to it wholeheartedly in 1906 and that is when the exhibition begins, although significantly enough it is the paintings executed towards the end of this year that were to change his views about the very nature of sculpture. Picasso's sculptures account for only a fraction of his vast output, the largest of any recorded artist, but even an exhibition devoted exclusively to it could not hope to be comprehensive. Here we have focused on the most intensive and historically important phases of his sculptural career. These are broadly speaking in chronological order, although subdivisions appear within them; for example the sculptures of animals produced after the Second World War are separated from the contemporary figure pieces and are given a space by themselves. Conversely the stylistically very disparate sculptures produced in the late 1920s and early 1930s are allowed to inform and flow into each other. The sequence in which the paintings are presented is much looser and more fluid. Often sculptures are anticipated by paintings that directly precede them, but new devices introduced into the paintings are sometimes picked up in sculptures executed many years later. Similarly, sculptural innovations often find an immediate response in the paintings but at other times find an echo in them only after a period of gestation. At certain focal points in the exhibition sculpture and painting are so closely related to each other that it is virtually impossible to separate the two activities.

In the interests of creating a broader and more vivid impression of the interrelationship between Picasso's sculpture and his painting we have been forced to leave out significant aspects of his sculptural activity. None of the very early sculptures which reflect his more painterly concerns at the time have been included. The exquisite miniature constructions of 1924–6, the low relief constructions assembled at Juan-les-Pins in 1930 and coated with sand, and the small whittled wooden figures produced at Boisgeloup in 1930, make no appearance here because, despite their beauty and importance, they are subsidiary clauses within the wider syntax of Picasso's sculptural activity; many of these works are also extremely fragile and it is dangerous to move them about. A few key works of sculpture are missing, for example the large-scale group of 'Bathers' of 1956, now in the Staatsgalerie, Stuttgart; these are somewhat precariously assembled out of wooden elements and transport of them is understandably forbidden. None of the vast, monumental concrete pieces executed towards the end of Picasso's life are included, partly because dislodging them from their present sites and the subsequent installation

of them within a museum context presents virtually insoluble problems, and partly because, although they were done under Picasso's indirect supervision, they never felt the touch of his hand; he saw only one of the completed projects and this was a mural relief and not a true sculpture.

As work on the project progressed we became increasingly aware of the importance and relevance of Picasso's ceramics. In a very direct way the ceramics forge a link between sculpture and painting, and many of Picasso's greatest ceramics are in fact sculptures in their own right. We have been helped in our selection of them by the artist's son, Claude Ruiz-Picasso, who also contributes an essay on the subject to the catalogue.

The selection of the drawings presented problems of a different nature. From 1906 through to 1936 there are drawings for existing sculptures and many more that look like projects for sculptures that were never realised. After 1936 the drawings tend to complement and inform the paintings more exclusively and because of this there are no drawings from subsequent years. We reluctantly eliminated drawings that do in fact relate to later sculptures but that are not in themselves particularly sculptural; for this reason the numerous drawings that preceded one of the most famous of all Picasso's sculptures, his 'The Man with a Sheep' of 1943, are not included in the exhibition. Instead we have chosen to include drawings for imaginary sculptures in the hope that these will widen and deepen our insights into Picasso's sculptural thought processes.

Elizabeth Cowling
John Golding

Acknowledgments

This exhibition and catalogue could not have been realised without the advice and help of many people and we are most grateful to them all.

We were given immense support and encouragement from an early stage and throughout the period of the planning of the show by Claude Ruiz-Picasso, by Gérard Régnier, Hélène Seckel and Brigitte Léal of the Musée Picasso, Paris, by Kirk Varnedoe and Cora Rosevear of the Museum of Modern Art, New York, and by Germain Viatte of the Musée National d'Art Moderne, Paris. The Musée Picasso and the Museum of Modern Art in New York, as too the Musée National d'Art Moderne in Paris, have all been exceptionally generous with loans. We have also benefited enormously from the generosity of Heinz Berggruen, Gilbert and Janet de Botton, Catherine Hutin-Blay, Paloma and Rafael Lopez Cambil, Marina Picasso, Christine Ruiz-Picasso and Maya Widmaier-Picasso.

So many people were ready to offer assistance, whether in tracing works, responding to very special pleas or offering vital contacts. We should particularly like to thank Brigitte Baer, Monique Barbier-Müller, Laurence Berthon, Jan Krugier, William S. Lieberman, Marilyn McCully, Christine Piot, John Richardson, Charles Stuckey, Jeanne Yvette Sudour, and Alan Wilkinson, as well as Doris Ammann, Ernst Beyeler, Olle Granath, Joséphine Matamoros, Lionel Prejger, Emily Rauh Pulitzer, Angela Rosengart, Allan Skarne, Lubomir Slaviçek, Björn Springfeldt, and Angelica Zander Rudenstine.

Many others too responded helpfully to our enquiries and pointed us in the right direction. Amongst these we would like to thank particularly: William Acquavella, Dawn Ades, Anne Baldeassari, Susan Barnes, Claire Barry, Felix Baumann, Olivier Berggruen, Marie-Laure Bernadac, Claude Bernard, Rosamund Bernier, Annie Boucher, the late Dominique Bozo, Brian Caster, Pierre Daix, Jacqueline Delubac, Maureen Duggan, John Elderfield, Patrick Elliott, Evelyne Ferlay, Kate Ganz, Danielle Giraudy, Arnold B. Glimcher, Marc Glimcher, Béatrice Hatala, Michel Hoog, Maurice Jardot, David Jones, Pepe Karmel, Myron Laskin, Hélène Lassalle, Quentin Laurens, John Leighton, Jean Leymarie, Neil MacGregor, Kynaston McShine, Matthew Marks, Stephen Mazoh, Frances Morris, Raymond Nasher, Hubert Neumann, Elisabeth Palmer, Hélène Parmelin, Joëlle Pijaudier, Noëlle Rathier, Peter Read, Michèle Richet, Elizabeth Rogers, Robert Rosenblum, William Rubin, John Russell, Etienne Sassi, Didier Schulmann, Werner Spies, Susanne Stratton, David Sylvester, Gertje Utley, Leslie Waddington, Florence Willer-Perrard.

Staff in many departments of the Tate have coped continually with the seemingly endless problems connected with the exhibition. We should especially like to thank Ruth Rattenbury and Emmanuelle Lepic, Lisa Lewis, Clarissa Little, Helen Sainsbury and Sionaigh Durrant, as well as many others of their colleagues in the Exhibitions and Registrar's Departments as, too, Iain Bain, Tim Holton and Judith Severne from the Publications Department, and the catalogue designer Caroline Johnston. Their support at all stages has been invaluable.

Explanatory Note

Abbreviations

Where relevant in the text and in catalogue entries references to the standard *catalogues raisonnés* of Picasso's work are supplied:

D Pierre Daix and Joan Rosselet, *Picasso: The Cubist Years, 1907–1916: A Catalogue Raisonné of the Paintings and Related Works*, London 1979

G Bernhard Geiser, *Picasso: Peintre-graveur,* vol.2: *Catalogue raisonné de l'oeuvre gravé et des monotypes, 1932–1934,* revised and corrected by Brigitte Baer, Berne 1992

S Werner Spies, *Picasso: Das plastische Werk,* Werkverzeichnis der Skulpturen in Zusammenarbeit mit Christine Piot, Stuttgart 1983

Z Christian Zervos, *Pablo Picasso,* 33 volumes, Paris, 1932–78

Other abbreviations and references:

Carnet Sketchbook catalogued by the Musée Picasso, Paris

Inv. inventory number (of individual works catalogued in the Succession of Picasso)

MP Musée Picasso, Paris

r recto (of a drawing)

v verso (of a drawing)

Measurements given in the colour plates are in centimetres, height before width, followed by depth

Translations
Unless credited otherwise, translations into English are by the contributors to this catalogue

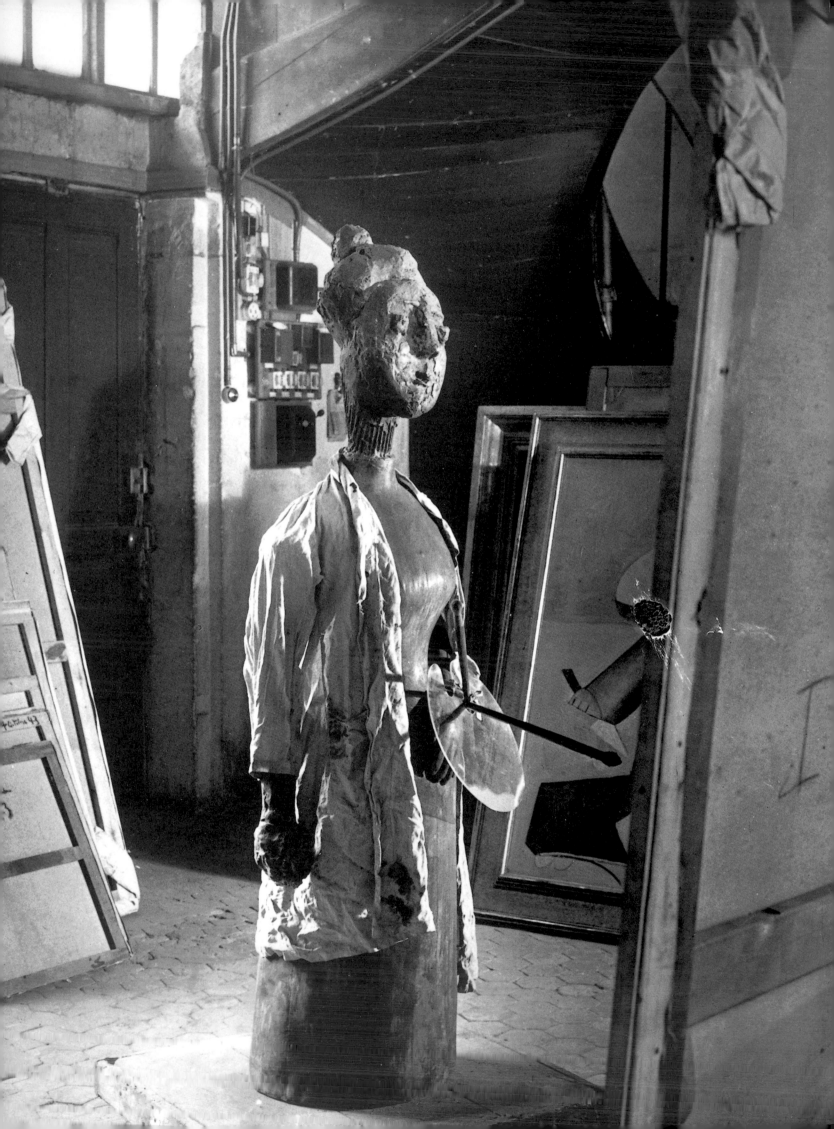

Introduction

JOHN GOLDING

fig.2 Picasso at La Californie, Cannes 1957
Photo: Edward Quinn

In old age Picasso was fond of remarking that 'Painting is stronger than I am. It can make me do whatever it wants'. He inscribed the words on the inside back cover of a late sketchbook,[1] and when he did so he was in a sense writing his own epitaph. This avowal might seem strange, coming as it did from an artist who more than any other in history had re-examined the art of the past, reinvented it and reshaped it, and who on occasion had virtually assaulted and raped it. And yet even to this most voracious and prolific of creative geniuses there were aspects of the art of painting that remained elusive and unattainable. The fundamentally abstract nature of painting, the most aristocratic of the visual arts, remained a perpetual challenge to an artist whose prime obsession was gaining possession of things in their totality. In 1935, at the beginning of his most intense period of literary activity, Picasso wrote, 'I can no longer bear this miracle that of knowing nothing of the world and to have learnt nothing but to love things and eat them alive and to listen to their farewells when the hours strike in the distance'.[2] How to achieve this total consumption and domination of things, of subject matter, on a two-dimensional surface and within a rigorously defined format? Picasso's attitude to sculpture, however, was more relaxed, and by the very nature of the medium more confrontational. Friends noticed that he felt paternalistic about his sculptures. Once finished, paintings by Picasso tended to be stacked face to the wall in studios and storerooms, although periodically they were brought out and turned around for study and consultation; sketchbooks and portfolios were similarly rifled at intervals, and their contents seemed at times to surprise even the artist himself. Picasso's sculptures on the other hand were his companions, presences in his daily life, part of an extended family. On innumerable occasions Picasso posed with them for photographers and in these records one senses instantly that his sculptures were his familiars (fig.2). When he is photographed in front of his paintings he seldom shows any direct involvement with them. After the Liberation of Paris in 1944 visitors who flocked to his studio in the rue des Grands-Augustins were received in an enormous room filled with objects of every kind; among the clutter stood some of his own bronzes and pictures by other artists, but none of his own paintings was on display. After he could afford to do so Picasso retained for himself many of his most significant canvases, although he appears to have experienced no psychological difficulties in selling his paintings. But his sculptures were very much for himself, and when latterly he very occasionally agreed to part with any of them it was always with reluctance.

After the Second World War, when Picasso was living mostly in the Midi, the larger of the L-shaped spaces in the old perfume factory in Vallauris that had been rented as studios contained not only sculpture in progress but also sculptural progeny from earlier times; once again amongst the sculptures were to be found not his own paintings but works by other artists from his personal collection. The *genius loci* of this area was the 'Pregnant Woman' of 1949 (no.106), propped up high in a corner; few people were allowed through into the secondary working space where Picasso drew and painted. At the last and most loved of all his homes, Mas Notre-Dame-de-Vie (overlooking Mougins, near Cannes), the viewing studio, in which Picasso also very occasionally painted, was for the most part devoid of any art other than a nineteenth-century African

opposite
fig.1 'Woman in a Long Dress' with a palette, rue des Grands-Augustins, Paris 1946
Photo: Brassaï © Gilberte Brassaï

[15]

Baoulé wooden sculpture. The main studio in the room beyond contained paintings in progress. But the ground floor studio immediately under it was once again crowded by a profusion of sculptural presences. Plaster casts of Michelangelo's 'Slaves', gifts from the municipality of Antibes, faced each other across the space and between them sculptures from different periods, including work not yet finished, mingled happily (fig.3).

By the time that he reached the age of forty Picasso had already produced two turning points in twentieth-century sculpture: 'Head of a Woman (Fernande)' of 1909 (no.6) and the cardboard maquette of 1912 'Guitar' (see no.19). Umberto Boccioni, Raymond Duchamp-Villon, Alexander Archipenko, Henri Laurens, Jacques Lipchitz and Naum Gabo are only a few of the sculptors who felt the impact of the former and it left an indelible imprint on their work. 'Guitar' and the constructions related to it gave to sculpture a totally new vocabulary; the force of these fragile objects, many of which were subsequently lost or destroyed, is still reverberating in much sculpture that is being produced today. Many of Picasso's earliest and closest friends were also sculptors. Among them were Pablo Gargallo, Manolo (Manuel Hugué), and most important of all in the light of subsequent developments, Julio (or Juli) González. In the final analysis Picasso's influence as a sculptor was to be as vast as his influence as a painter.

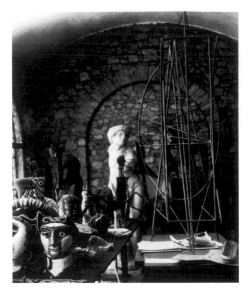

fig.3 Mas Notre-Dame-de-Vie, Mougins
Photo: Werner Spies

And yet as Picasso's fame and reputation soared during the 1920s and 1930s his sculpture received virtually no critical acclaim or even attention. The catalogue to the large and important retrospective exhibition held at the Georges Petit gallery in Paris in 1932 lists seven sculptures, and the two versions of 'Woman in a Garden' (no.83), Picasso's most ambitious sculpture to date, were amongst them. But at the time no one appears to have recognised that yet another landmark in the history of sculpture had been produced. The following year the first issue of the ambitious magazine *Minotaure* (Picasso provided a cover for it) contained an essay by André Breton, 'Picasso dans son élément', which asserted the importance of the first Cubist constructions, but virtually no one had seen them. The essay was illustrated by photographs of Picasso's newly acquired sculpture studios at Boisgeloup as well as views of individual sculptures. These were by the photographer Brassaï whom Picasso had just met. 'I learned then what my important mission was to be; to photograph the sculptures of Picasso which were still entirely unknown', Brassaï later wrote.[3] Today these photographs still evoke a sensation of excitement and discovery. But recognition of Picasso's achievement as a sculptor was still long to come.

During the Occupation of Paris Picasso had been forbidden to show his work even had he had the heart to do so. After 1944 when he began exhibiting again sculpture and ceramics sometimes went on view with the paintings, and the sculpture now began to attract a certain amount of attention although critics still regarded both the sculpture and the ceramics as entirely peripheral to Picasso's activity as a painter. The first serious text to attempt an appraisal of the importance of Picasso's sculpture did not appear until 1949. This was by Picasso's dealer and friend Daniel-Henry Kahnweiler and was written to accompany a volume of Brassaï's photographs. In his introductory essay Kahnweiler makes the point that most people who were aware of Picasso's sculpture at all regarded it as his 'violon d'Ingres'. Kahnweiler then goes on to insist that 'Throughout his evolution [his sculpture] has often gone ahead of his paintings on which it has left a profound impression'.[4] Jaime Sabartés, Picasso's secretary and companion, in a volume of memoirs that had recently been published made the same point: 'In some cases his sculpture is inspired by his paintings, but at other times it is the very opposite; he may convert a canvas into a sculpture. Or from a sculptural motif he may make an entire painting.'[5]

But it was only at the great *Hommage à Pablo Picasso* exhibition organised by the French Government under the direction of Picasso's friend Jean Leymarie to honour

Picasso's eighty-fifth birthday in 1966 that Picasso agreed to let his sculptures out en masse. These were shown together with the ceramics in the Petit Palais, across the road from the Grand Palais which housed the paintings. The sculptures came as a revelation even to many of those who thought they were familiar with Picasso's work. Through Roland Penrose's friendship with Picasso, in 1967 the Tate Gallery was able to stage a magnificent display of a large percentage of the sculptures that had been on view in the Petit Palais the previous year; the exhibition then moved on to New York's Museum of Modern Art to even greater acclaim. Some critics now asserted that Picasso's greatest achievements were in the field of sculpture. Paradoxically, Picasso had now virtually turned his back on sculpture to enter the final phase of his career as a painter. The cardboard models that he had been providing for his most recent sheet-metal sculptures made fewer physical demands on him than the vast canvases on which he was concurrently at work, so he cannot have abandoned sculpture out of fatigue; but these sculptures had involved him in working with other people and therefore with delays and interruptions. As death beckoned and his vision became increasingly obsessive and hallucinated, collaboration with others must have seemed like an intrusion into his private studio world that he could no longer bear.

Picasso belonged to a long tradition of painters who had sculpted and, more rarely, of sculptors who had painted, although the magnitude of his achievement also placed him apart from all save one. Among his most immediate antecedents the names of Edgar Degas and Paul Gauguin come at once to mind. Degas, whom Picasso came increasingly to venerate, had been described by Renoir (himself a painter/sculptor) as 'the greatest living sculptor'[6]; and contrary to popular belief he did not turn to sculpture simply because of increasingly bad eyesight but had modelled virtually throughout his entire career. Degas's technical innovations in sculpture, his unorthodox approach to the making of armatures for example, are often concealed under the works' surfaces; but Picasso must have sensed that they contributed to the extraordinary vitality of the sculptures, and Degas's total disregard for accepted ideas about finish would have gone straight to his heart. There can be no doubt that when Picasso encountered Gauguin's sculptures in 1906 they came to him as a revelation largely, one suspects, because they had about them a more truly atavistic quality than did the paintings with which Picasso was already familiar. Amongst Picasso's own contemporaries both Georges Braque and Juan Gris, colleagues in the forging of Cubism, produced sculpture and Braque's paper and cardboard relief of 1912 preceded Picasso's own Cubist constructions, but neither became significant sculptors. Henri Matisse achieved greatness as a sculptor, and if some of his 'Heads of Jeanette', executed between 1910 and 1913, suggest an awareness of Picasso's great 'Head of a Woman (Fernande)' of 1909 (no.6) they also look forward towards the monumental heads made by Picasso at Boisgeloup twenty years later (nos.77–81). Basically, however, Matisse's sculpture spelt out the problems he was trying to resolve in his paintings; and while they appear frequently in his paintings and help to furnish them, the sculptures did not alter the course of his art. From time to time Picasso's sculptures did. But if one searches for a truly valid parallel for Picasso's role as a painter and sculptor, for another artist who changed both the vocabulary and outward appearance of both art forms, one must go back much further in time and to a figure by whom Picasso was secretly obsessed: Michelangelo.

1 Crisis and Analysis

Although Picasso received no formal training in sculpture, some of the most accomplished of his student drawings were of plaster casts; and in 1902 he produced his first essay in the medium, a small 'Crouching Woman' (s 1). In 1905 he produced a memorable sculptural image in 'The Jester' (s 4). But it was in 1906 that Picasso first seriously turned his attention to sculpture. As a prelude to this, in the summer of 1905 during a holiday in Holland Picasso had produced a handful of pictures that showed an unprecedented interest in rendering his subjects in full volumetric form. 'The Beautiful Dutchwoman' (Queensland Art Gallery, Brisbane) in particular is the bulkiest nude that Picasso had yet produced. A companion piece, identical in size (Musée National d'Art Moderne in Paris) shows three sturdy Dutch girls assuming the postures of the Three Graces of antiquity. The Dutch pictures form an interlude in Picasso's dreamy, nostalgic Rose Period; and they look forward to the paintings executed at Gósol in the summer of 1906. Many of the Gósol canvases, which breathe an air of quiet physical contentment, also make use of poses drawn from Classical sculpture; John Richardson, Picasso's most recent biographer, has described these paintings as hovering 'on the brink of sculpture'.[7] Picasso's mistress and model, Fernande Olivier, whose presence informs so many of the Gósol pictures, was herself of statuesque appearance. Picasso executed two wood carvings at Gósol (s 6B, 6C) which are, in contrast to the painted figures, willowy and attenuated. Picasso's sculptor friends Manolo and Enric Casanovas had been urging him to try his hand at sculpture once more, and Casanovas, who had hoped to join Picasso in Gósol but was unable to make the journey, did however send him chisels for working the wood.[8]

Most of Picasso's sculptural output of the year was executed on his return to Paris in the autumn, although 'Head of a Woman (Fernande)' (no.1), Picasso's most impressive sculpture to date, and a work closer in appearance to the Gósol paintings than the sculptures actually carved there, may have preceded them.[9] This head of Fernande is conceived of as a solid, simplified form, although the surface is soft and melting in a way that recalls the sculpture of Medardo Rosso; one side of the head has been abraded and this may owe something to the fact that so many surviving classical heads have suffered uneven damaging. Like the sculptures that follow on from it this beautiful work is untroubling, and like them it could be described as simply post-Rodinesque. 'Woman Combing her Hair' (no.2), the most important of the 1906 sculptures, was originally executed as a ceramic in the studio of Picasso's compatriot Paco Durrio. Durrio had been a friend of Gauguin's and owned a superb collection of his art. Already in 'Woman Combing her Hair' the influence of Gauguin can be sensed. Gauguin's sculptures were virtually unknown to the general public (and even to most artists) until they were featured boldly in the great Gauguin retrospective mounted within the Salon d'Automne of 1906; twenty-seven sculptures were shown. The pose of Picasso's figure ultimately derives from the Hellenistic 'Crouching Venus',[10] although it is also reminiscent of that of one of the figures in Ingres's 'Turkish Bath' (Musée du Louvre), a picture which fascinated Picasso throughout his life, and which had been one of the centrepieces of the Ingres exhibition at the Salon d'Automne of 1905. Thus within a single work Picasso's sources, always rich and diverse, were multiplying and building up tensions within themselves.

It is, however, in the paintings executed in Paris during the last months of 1906 that the sculptural crisis in Picasso's work makes itself explicitly manifest, notably in the 'Seated Nude with Crossed Legs' (no.10) and in the monumental 'Two Nudes' (no.9). 'Seated Nude with Crossed Legs' is placed on a rectangular plinth that helps to define and confirm her girth; she resembles a pneumatic lay figure, pressed up against a pane

of glass and pumped fuller and fuller of air so that as she billows and swells she is simultaneously flattened out against the transparent wall in front of her. The 'Two Nudes' share her bulk but are more stone-like and even more truly sculptural in feeling. Their monolithic trunks are supported by abbreviated legs and the painting is misnamed, for what we are seeing is the same figure, depicted twice, and rotated as though on a sculptor's wheel through 180 degrees. These are possibly the stockiest nudes ever to have been painted.

The sensation of crisis engendered by these works clearly indicates Picasso's dissatisfaction with conventional or traditional methods of representation and it coincides with his confrontation with a new range of artistic sources. Picasso had been aware of Egyptian art for some time; and Gauguin, who had used it very overtly, had been a force in his art since the early years of the century. The great Gauguin retrospective at the Salon d'Automne of 1906 marked the culmination of his influence on advanced French art. The preface to the exhibition was by Charles Morice, and in it Morice disassociated Gauguin from a Renaissance tradition in order to stress his return to the principles of early mediaeval art and to those of Egyptian, Maori, Aztec and Assyrian art. Morice had also written a preface to an exhibition at the Serrurier gallery early in 1905 which had featured eight 'Saltimbanque' paintings by Picasso, the first public showing of works from his Rose Period. It may have been then that Morice presented Picasso with a copy of Gauguin's poetic journal *Noa Noa*; Picasso was to treasure it throughout his life. It was during the course of 1906 that Picasso became increasingly interested in Iberian art; the Louvre had recently put on view a group of archaic Iberian sculptures (dating to the sixth and fifth centuries BC). Two Iberian stone heads, stolen from the Louvre, entered Picasso's possession in March 1907 and they make their presence felt in his great masterpiece, 'Les Demoiselles d'Avignon' (Museum of Modern Art, New York). Although it was only in the latter stages of work on the painting that Picasso felt for the first time in depth the impact of tribal art, he was certainly already aware of it towards the end of the previous year. 'Primitive sculpture has never been surpassed', he once remarked to Sabartés.[11] Looking at the crisis paintings of late 1906 one gets the impression that some sort of explosion was inevitable, and that explosion was, of course, 'Les Demoiselles d'Avignon' itself. Today it still remains the most important single painting of the twentieth century, and it took Picasso himself several years to work his way through its pictorial implications. In doing so he once more reverted to a more volumetric, sculptural type of painting.

The revelation of tribal art occurred when Picasso had gone to the Musée du Trocadéro to look at plaster casts of Romanesque sculpture and had strayed into adjacent galleries. Of his discovery of tribal art he later said, 'At that moment I realised what painting was all about'.[12] The statement shows how closely the two activities of sculpture and painting were related in his mind. 'Sculpture is the best comment that a painter can make on his painting', he later said to the Italian artist Renato Guttuso.[13] Picasso was ultimately more interested in the principles embodied in tribal art than in any of its individual manifestations, and he very seldom makes reference in his art to particular tribal pieces. His original reaction to it was psychological and emotional and even in a sense anarchic in that in the 'Demoiselles' he used it to subvert six centuries of European art. Subsequently he took a cooler, more dispassionate look at tribal art. He confided to his friend the writer André Salmon that he was attracted to African art (and the expression 'art nègre' was then being used to cover all tribal art) because of its 'reasonable' qualities.[14] 'In a head by Raphael', he said, 'you can't measure exactly what distance there is between the mouth and the end of the nose. I'd like it to be measurable in my pictures.'[15]

During 1908 it was the conceptual, formally reductive properties of tribal art that

helped Picasso to do the measuring, and many of the paintings of this year, such as the large 'Seated Nude' (no.13) are in effect surrogate sculptures. Of these he remarked to Julio González that 'it would have been sufficient to cut them up – the colours after all being no more than indications of differences in perspective of planes being inclined one way or the other – and reassemble them according to the indications given by the colour in order to be confronted with a sculpture … The vanished painting would hardly be missed'.[16] Two paired oil paintings on wooden supports, 'Nude with Raised Arms' (no.11) and 'Standing Nude' (no.12) both executed in the early summer of 1908, are supreme examples of sculptural thought and intention conveyed in two dimensions. This, he claimed to González, had been possibly the happiest moment of his career. These paintings are indeed partnered by a small chiselled stone head of 1907 (s 14) and by a group of sculptures in wood, traditionally ascribed to 1907, although the largest and most significant piece, the unfinished 'Figure' (no.4), is almost certainly of the following year. The touches of colour on the wood on this work may be markings to indicate where further incisions were to be made, but they also serve to remind us that many tribal sculptures make extensive use of colour. 'Standing Man', or 'Standing Figure' as it is sometimes called (no.3), is stained yellow and appears to marry the facial conventions of New Hebrides heads to a 'reasonable' African body. The heterogeneous quality of these wooden works, the rough handling and the sense of *non finito*, make an important if simple point: carving was simply too lengthy and laborious an activity for an artist of Picasso's questing, restless spirit.

The story of Picasso's partnership with Braque in the invention of Cubism has been often told; but while examining the relationship of Picasso's painting and his sculpture it is worth reaffirming that it was Braque who brought Picasso back to a more thoughtful study of Cézanne's painting with its implications of a shifting, mobile viewpoint. Picasso's paintings of 1908 had been sculptural in appearance and intent and in some of them there are already hints or implications of the multi-viewpoint perspectives of early Cubism. This reached its first full, explicit expression in the work produced by Picasso at Horta de Ebro, a remote Catalan village, in the summer of 1909. Picasso had become interested in a sculptural approach to painting because of the physicality of his vision, because he wanted to touch and to mould and to handle his subjects. Now, with the abandonment of traditional single viewpoint perspective he was able to achieve his goal of taking possession of his subjects more completely and to give his canvases a dimension that in a sense already existed in free-standing sculpture: for clearly the essential property of sculpture in the round is that the sculptor impels the spectator to move around it and study it from all angles. With the adoption of multi-viewpoint perspective Picasso presented the viewer with a sculptural fullness or completeness on a two-dimensional support.

To this extent it could be argued that for Picasso sculpture had become temporarily redundant. Some of the drawings produced at Horta de Ebro in connection with the series of female heads he painted there do nevertheless look like projects for sculptures rather than like studies for paintings or comments on painting already in existence. And on his return to Paris Picasso felt the need to verify his latest pictorial achievements when he executed the celebrated 'Head of a Woman (Fernande)' (nos.5, 6) in Manolo's studio; it was modelled first of all in clay, then according to common practice two plaster casts were taken (a *plâtre de travail* and a *plâtre d'artiste*). Somewhat unusually Vollard purchased both of the plasters from Picasso, possibly because he was afraid that if Picasso retained one he or someone else might make an independent edition in bronze. Vollard also purchased plasters of other early sculptures and these were all cast in limited editions, so that a small group of Picasso's work did reach a wider public than did the more radical experiments still to come. Subsequently, and as the 1909

'Head of a Woman' established itself as a seminal work, Vollard appears to have had fresh casts of it made as demand arose, so that it became the most widely disseminated of all Picasso's sculptures.[17] Despite its supreme historical importance it remains an isolated peak in Picasso's achievement. And it is true that between late 1908 and the end of 1912, that is to say during the Analytic phase of Cubism, Picasso found sculpture less challenging than painting. Of 'Head of a Woman' he later said, 'It was pointless to go on with this kind of sculpture'.[18] And yet the importance of this work for the pictures that succeed it has never been sufficiently stressed. The Horta paintings had virtually abandoned the use of a single light source, arbitrarily playing off lights and darks against each other to achieve a sense of sharp, edgy sculptural relief. The faceted and deeply gouged surfaces of the sculpture convey some of the same effect, but in a more dappled, mysterious fashion. And whereas the appearance of the paintings remains constant, varying light conditions affect the appearance of the sculpture profoundly; this can be sensed particularly in the play of light on the original white plasters. Picasso told Roland Penrose that he had contemplated defining some of the planes of the sculpted head with wire so that the spectator could literally have the sensation of seeing inside it; he had, however, abandoned the idea because it was 'too intellectual, too like painting'.[19] In retrospect the sculpture seems as relevant to the deliquescent, shadowy and transparent paintings that succeeded it as it does to the more sculptural painted heads that had preceded it.

2 Construction and Synthesis

More than any other single work the famous construction 'Guitar' (no.19) ushered in Picasso's Synthetic Cubism; it was executed in cardboard in the late autumn of 1912. Picasso clearly recognised its importance and it was transposed into sheet metal soon afterwards with the addition of string and wire.[20] The cardboard sculpture could be dismounted and its component parts stored away in a box. Seen under these circumstances the individual elements would have looked meaningless and it was only by once more manipulating them into place that the 'Guitar' could be reborn or reformed. The relationship of this 'Guitar' to tribal African Grebo masks (see fig.22 on p.191) has long been recognised; Picasso owned two of these masks, and one of them may have been purchased just a couple of months before the 'Guitar' was conceived.[21] As in the 'Guitar', the components of these masks or heads – projecting wooden pegs for eyes, oblong blocks for forehead, nose and mouth – are simply assorted abstract shapes until the sculptor brings them together in meaningful combinations or juxtapositions. During the earlier phases of Cubism Picasso had begun with relatively naturalistic or at least recognisable images and had then analysed and in the process often abstracted them. Now the process was reversed and abstract pictorial or sculptural elements were being assembled into images which do not so much echo or resemble their counterparts in the natural or external world but rather confront them as independent entities in their own right. These two approaches of Picasso's, the one a desire to seize and possess and examine objects, the other a desire to recreate or confront external reality in a totally independent form, were to characterise the rest of his vast production.

Picasso always claimed that his first sculpted 'Guitar' was produced before his first *papiers collés* were begun, although it is possible that one of these, 'Musical Score and Guitar' (no.27), had preceded it or had been executed at the same time; Braque's first *papiers collés*, which Picasso had seen, were done early in September 1912, while Braque in turn stated that his own *papiers collés* had been preceded by experiments in paper

sculpture.[22] During the course of this year the subject matter in Picasso's painting, after having been fragmented and analysed virtually out of existence, had become once again more clearly legible and the shapes that describe it more self-contained and more clearly defined, although earlier effects of transparency were retained. The overlaying and overlapping of shapes in the 'Guitar' construction convey at least by implication sensations of transparency: for example we become aware of the left-hand contour of the guitar through its far rather than its near side, which is missing. Similarly, the sound-hole of the object is conveyed by a projecting cylinder containing a void within it, while the neck of the guitar is not flat and rigid but concave. 'I have said that painting shouldn't be a *trompe l'oeil* but a *trompe l'esprit*', Picasso said to Françoise Gilot, 'I'm out to fool the mind rather than the eye. And that goes for sculpture, too'.[23] The sense of physical manipulation that is so overpowering in the sculpted 'Guitar' transmits itself onto Picasso's *papiers collés* which followed on from it, and these in turn affect the appearance of his paintings which become more solid and weighty in appearance. This sensation of the very physical manipulation of visual elements is one of the prevalent characteristics of virtually all Picasso's Synthetic Cubism. A high proportion of the drawings of 1910–12 look like projects for sculptures or relief constructions, and even though some of these are small, quick jottings, they too have a tactile quality to them.[24]

Now sculpture and painting were informing each other in an unprecedented way, not only within Picasso's own development, but within the history of art, although the sculptures produced during 1912–14 do not rival his achievements in the pictorial field. Nevertheless the revolutionary quality of Picasso's relief constructions cannot be overemphasised, despite their often intimate scale and the deliberately rough, homespun technique they employ. They were to have a profound effect on a large proportion of subsequent sculpture, much of it technologically oriented and technically sophisticated. They changed the course of Tatlin's career when he saw them in Picasso's studio in 1914, and they stand directly behind the whole Constructivist ethos. They also, in the words of a distinguished contemporary sculptor, demonstrate the 'object-nature of modern sculpture'.[25] There was much talk in Cubist circles of *le tableau objet*, or in other words of the idea of paintings themselves being seen as objects rather than as traditional works of art; Picasso's fascination with oval and circular formats is part of this concept. And yet these Cubist constructions continue to acknowledge their pictorial origins in that they are mostly reliefs designed to be hung on the wall (as were many tribal objects when not in ceremonial use) and many of them make extensive use of colour; quite a few have been destroyed and are known only in old photographs, and several others were probably originally contained in frames or boxes which were subsequently discarded. The minute but incalculably significant 'Guitarist with Sheet Music' 1913 (no.20) executed in paper, the only surviving early Cubist construction depicting the human figure, owes its existence to the fact that Gertrude Stein, who acquired it from Picasso, had it placed in a box-like frame under glass. At least two surviving works were originally part of more elaborate and more pictorial ensembles[26]; these extended sculptural 'tableaux' were presumably too complex and fragile to preserve; but it is also possible that Picasso felt the need to make certain parts of them more sculptural by removing the more anecdotal or pictorial elements around them. Many of the paintings of 1913–14 in their turn are built up in such a way that the upright, interacting shapes within them seem to advance towards the spectator from their flat supports in the manner of three-dimensional reliefs. The densest of the *papiers collés*, which incorporate pasted papers, gesso, newspaper cuttings, cigarette packages and other 'found' objects are quite literally assemblages that hover midway between painting and sculpture in low relief.

Two sculptures of the prewar period occupy a particular place in Picasso's oeuvre.

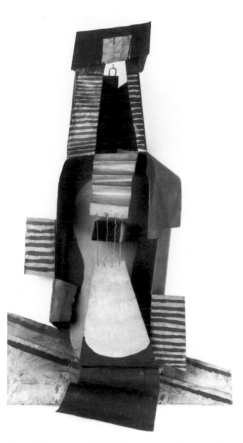

fig.4 **Guitar** 1924 Folded sheet iron, tin box and wire
Musée Picasso, Paris

'Still Life' 1914 (no.22) was shown in the *Exposition Surréaliste d'Objects* mounted in the gallery of Charles Ratton in Paris in 1936 and was subsequently given to the artist's friend, the poet Paul Eluard. It was the first construction to have left Picasso's own personal collection. It is related closely to a painting of narrow horizontal shape (no.36), and may even have originally included a bottle to the left of the glass. It is the first instance of prepared food being used in sculpture as a subject in its own right, and it helped to invent the whole idea of sculpted still life that subsequently became so ubiquitous. 'Glass of Absinthe', also of 1914 is executed totally in the round. Six casts were made from the original wax model; five of them were decorated differently by Picasso while the sixth was coated in sand (nos.23–4). Each cast is topped by a real silver sugar-spoon, so that these objects are in fact sculptures that are traditionally made but with the addition of sculptural collage and pictorial surface decoration. The effect of transparency achieved in the constructed 'Guitar' 1912 (see no.19) is conveyed here by the way in which a section of the glass has been gouged out to expose its interior and the level of the liquid within it. It has been suggested that since the consumption of absinthe ultimately proves lethal these small objects are in effect *memento mori*, although they also have about them a jaunty, carefree air that recalls a line from Guillaume Apollinaire's *Alcools*, published in 1913 with a frontispiece by Picasso himself: 'Mon verre s'est brisé comme un éclat de rire' (My glass shatters like a burst of laughter).[27]

In 1915 and then again in 1924 Picasso produced two enormous painted relief constructions in metal of musical instruments. The first depicts a violin (no.26), the second a guitar (fig.4). The reason for the exaggeration of scale is puzzling although in 1915 Picasso had produced a number of monumental figure pieces in which he exploited the architectonic possibilities suggested by some of the prewar *papiers collés*. One of these, 'Woman with a Guitar' (no.37), begun in 1915 but almost certainly reworked in subsequent years, with its superimposed, bent and folded component parts, looks like a flattened relief construction. The gigantic musical instruments are the counterparts of these paintings. During the latter stages of his prewar Cubism Picasso had become increasingly interested in the interchangeability of imagery or of the component parts of objects – for example a double curve laid down onto a canvas or piece of paper could be developed into the contours of a guitar, a human head or a woman's body. The scale of these two metal reliefs demands that we confront them as we would confront life-size depictions of the human form.

3 The Sculptor's Studio

In 1906 Picasso produced drawings directly related to his sculpture and for the next thirty years a very large proportion of his drawings give the impression of being ideas or projects for sculptures that remained unexecuted; often in the sketchbooks one can witness Picasso's sculptural thought processes evolving literally before one's eyes. During 1907–8 the drawings for and towards sculpture well outnumber the sculptures themselves. The 'Guitar' construction of 1912 (see no.19) is preceded by scores of drawings with sculptural or Constructivist implications; some of them show, in addition to familiar Cubist heads and musical instruments, whole-length figures and more unlikely objects such as cruet stands (no.53), the formal and spatial oddity of which had caught Picasso's eye. Many of the drawings of 1912 and 1913 experiment with the new sculptural principles Picasso had apprehended in his Grebo masks; these drawings, like the paintings of the time, are characterised by a sense of assembly: the component parts of objects are not only bent and folded but are now also propped and piled and

balanced against and on top of each other in way that is prophetic of sculptures yet to come. Between 1915 and 1928 Picasso produced relatively little sculpture; but he was engaged on other projects with sculptural implications. In 1917 he collaborated with Eric Satie and Jean Cocteau on Diaghilev's ballet *Parade*. The costumes for the Managers (no longer in existence although reconstructions have been attempted) were approximately twelve feet high and worked as mobile constructions, echoing closely the monumental painted figure pieces of 1916. Picasso's collaborations with Diaghilev and the theatre also inform the series of small, exquisite still lifes in architectural settings; frequently they are set on tables in front of open windows (no.60). Some of these are executed on sheets of paper with indications as to how they might be transformed into paper or constructions (no.61). And a few of them did actually find their way into three dimensions (no.39).

Many of the paintings of the neo-classic phase initiated in 1917 and dominant between 1920 and 1924 are, like the canvases of 1908, in effect surrogate sculptures (no.87). And not surprisingly they make constant reference to the sculpture of both ancient Greece and Rome, although the Cubist heritage endows the figures with a fullness of volumetric form that transforms the goddesses and matrons of antiquity into giantesses of a new age. A group of chalk drawings of 1921 gives the impression of being ideas or projects for sculpture in low relief (no.62). And Picasso's extraordinary notebooks of the summers of 1927 and 1928 (no.64), spent at the seaside resorts of Cannes and Dinard, show him once more overtly thinking in terms of sculptural and even of architectural projects. These have often been related to the commission Picasso had received to design a monument to his old friend Apollinaire soon after the latter's death in 1918.[28] Most characteristically they show full-length figures or paired figures. The Cannes figures appear to be made entirely of tumescent tissue and to this extent recall some of the 'crisis' paintings of 1906. Although the figures are almost invariably female they also exhibit overtly phallic properties and are characterised by an interchangeability of bodily parts that gives them a potent and at times bizarre sexual charge. Apollinaire had played an important role in forming both the mood and the subject matter of Picasso's Rose Period. Subsequently, with his thirst for novelty which he coupled with an uncanny recognition for what was truly original and significant in new art, Apollinaire had championed Picasso's Cubism and once again left an imprint on its iconography. These Cannes drawings relate to and reflect the more bawdy, Rabelaisian side of Apollinaire's talent. The Dinard drawings, although they too have overtly erotic implications, are by contrast flinty or rocky in appearance and recall bleached bones or large pebbles stacked and piled up against each other to produce effects that are simultaneously monumental and indestructible, like ancient dolmens. In his mind's eye Picasso had envisaged some of the figures that fill the Cannes sketchbooks as transposed into three dimensions and executed on such a scale that they would tower above the heads of strollers along the Croisette. Some of the Dinard 'bone' drawings were reproduced in the 1929 issue of *Cahiers d'Art* as 'Projects for a Monument'.

In 1933 Picasso executed a suite of forty prints on the theme of the sculptor's studio; the copper plates for the etchings were acquired by Vollard and became part of 'The Vollard Suite', Picasso's most celebrated graphics. The etchings were printed by the master craftsman Roger Lacourière before Vollard's death in 1939 but were not released until after the war – yet another reason for the delayed recognition of Picasso's profound involvement with sculpture. As a group 'The Sculptor's Studio' (no.68) works as a counterpart to the etchings of 1927 representing the painter at work in his studio (one of them, showing a realistically drawn painter rendering a realistically drawn model in abstract configurations was used as an illustration to Balzac's *Le Chef-d'oeuvre*

inconnu, published by Vollard in 1931) affirmation of the fact that Picasso now saw painting and sculpture as complementary activities. The sculptor is generally shown as naked, bearded, and frequently he is garlanded; sometimes he is at work but more often he contemplates his sculptures gravely. The young models who join him appear to be worshipping both the sculptor and his products. 'The Sculptor's Studio' represents the culmination of Picasso's neo-classic style. The suite was executed by Picasso in Paris and it celebrates the most intensive phase of Picasso's activity as a sculptor to date. In June 1930 Picasso acquired the Château de Boisgeloup, near Gisors, about forty miles north-east of Paris, and the stable wings had been converted into studios dedicated exclusively to the making of sculpture.

One of the last plates related to 'The Sculptor's Studio' group, and which stands slightly aside from the series as whole, shows a model, rendered in flowing neo-classic line, contemplating an amusing and absurd but also somewhat sinister construction that is her sculpted Surrealist counterpart; and in 1933 Picasso produced his series 'An Anatomy', amongst the most truly Surrealist of his inventions, and which consists of rows of drawn figures that read like a storehouse of sculptural inventions (no.67). These remind one of the more experimental, playful quality of so many of Picasso's smaller sculptures such as the bent and twisted wire pieces of 1931–2 (no.41), witty and inventive improvisations executed when he was relaxing from the rigours of the monumental Boisgeloup heads and bathers. Throughout the first half of the 1930s Picasso turned out endless drawings that ring fanciful changes on the sculptures he was producing at Boisgeloup, and their swollen biomorphic forms are manipulated into new and fantastic configurations. Other drawings of a more private nature are endowed with darker erotic connotations. By the end of the decade, however, Picasso's activity as a draftsman was once more commenting on his painting.

4 Classicism and Metamorphosis

Picasso's great canvas of 1925, 'The Three Dancers' (fig.5), marked a turning point in his career and in effect put a final end to the neo-classicism that had been a prevalent mode in his work during the first half of the decade. In the paintings of 1926 and early 1927 Picasso's use of line and contour became increasingly free and calligraphic, partly as a reflection of the current Surrealist interest in Neolithic cave painting and Easter Island 'hieroglyphs'. Through the latter in particular Picasso's fascination with the inter-changeability of bodily parts was strengthened: the same conventions could be used to render an arm or a leg, a hand or a foot, a pair of breasts or a pair of eyes. The deliberate confusion between facial features and genital parts in particular was to become a familiar feature of the Surrealists' visual vocabulary. The drawings produced in Cannes during the summer of 1927, when Picasso was thinking so often in sculptural terms, transform female heads and limbs into male phalluses, and their three-dimensionality further underscores the sexuality that was becoming so pervasive a theme in Picasso's art. Early in 1928 Picasso modelled his two biomorphic bathers, 'Metamorphosis I and II' (see no.73), which develop the preoccupations of the previous summer, although they lack some of the Cannes drawings' sardonic wit. These had been associated in Picasso's mind with the proposed monument to Apollinaire, and although the Apollinaire committee which had met in Picasso's studio late in 1927 had rejected the drawings that he had shown them as plans, he nevertheless continued to pursue the project.[29] 'Metamorphosis I and II' were the first completely three-dimensional sculptures that Picasso had produced since the 'Glass of Absinthe' series of 1914

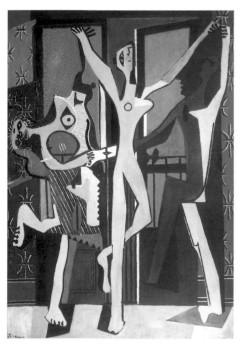

fig.5 **The Three Dancers** 1925 Oil on canvas
Tate Gallery

(nos.23–4). Like the Cannes bathers these sculptures are pulpy and tumescent in appearance, but at the same time they show a marked gravitational pull: in each one a foot appears as the largest single element in the body's component parts. Even in metal the sculptures exude a sensation of soft, spongy bulkiness, although this is relieved by the use of negative spaces contained between legs, torsos and arms. They look forward, in particular, to developments in the work of Henry Moore.

Simultaneously, in the winter of 1927–8 Picasso was at work on a large painting, 'The Studio' (no.88), which depicts a stick-like painter (or sculptor) in confrontation with a large plaster head. As in the companion piece which followed it, 'Painter and Model' (Museum of Modern Art, New York), the pictorial conventions used for rendering the bodies and facial features make indirect use of Neolithic diagrams and of a wide range of tribal masks and artefacts. The white, sculpted head in 'The Studio' is a premonition of things to come in Picasso's activity as a sculptor. The bold black linear scaffolding that organises these two pictures compositionally may owe something to the fact that while Picasso was at work on them he was also producing the illustrations commissioned from him by Vollard for Balzac's *Chef-d'oeuvre inconnu*; for some of them Picasso simply used a selection of the experimental dot and line drawings of 1924 (fig.6) which had been translated into woodcuts in 1926. These drawings, which resemble astrological charts, were much venerated by the Surrealists.

Both the large studio pictures and the earlier dot and line drawings helped to inspire Picasso's next group of sculptures which were executed in the studio of his old friend Julio González in the rue de Médéah, Paris.[30] González had been trained as an ironsmith and Picasso now sought him out to help in the construction of open-work wrought iron sculpture; it seems likely that the wire constructions of 1928 were actually forged by González, working from drawings by Picasso and under Picasso's supervision. It has been suggested Picasso may have been inspired to do them by Lipchitz's open-form sculptures in which he used strips of wax suspended between more solid forms, all of which were then cast in bronze.[31] Lipchitz used to refer to these works as 'transparent objects which can be seen from all sides at once'. We know that Picasso had visited Lipchitz's studio on New Year's Day of 1927 and had been impressed by what he saw there. Nevertheless Picasso's new adventures into sculpture, which have been described as 'space sculptures'[32] and also as 'drawings in space',[33] broke totally new ground and are works of startling originality.

As a prelude to them Picasso fashioned the very small 'Head' of October 1928 which exists in three versions (no.40). This is derived more or less directly from the head of the painter in 'Painter and Model' and has about it a strong tribal and atavistic quality. Despite its minute scale it has a commanding presence and a sense of completeness. The wire constructions that follow on from it by contrast have the feeling of being maquettes for larger works (see nos.74–5). Picasso was clearly becoming increasingly obsessed with the Apollinaire project and the openness of these sculptures may well owe something to a monument described in Apollinaire's *Le Poète assassiné* of 1916. Picasso appears in the novella as 'l'oiseau de Benin' who kills the poet and subsequently erects a memorial to him. This is described by Apollinaire as 'a deep statue in nothing, like poetry and like glory'.[34] Certainly the wire constructions introduce a totally new weightlessness and airiness into sculpture. Their openness may also owe something to the stringed African harp owned by Picasso and we are reminded, too, that the strings of the sheet-metal 'Guitar' (no.19) had been of wire. The linearity of this group of sculptures speaks for itself and they are the only sculptures by Picasso to use only straight lines and mediating circles or segments of circular forms. It is perhaps not surprising that more drawings exist for these sculptures than for any others. They are saved from rigidity by the fact that the upright metal bars are heavier and thicker than

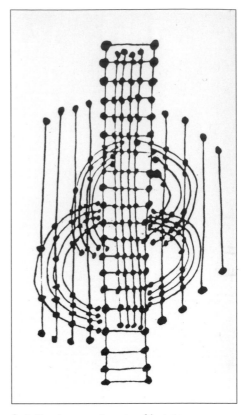

fig.6 Drawing 1924 *Succession of the Artist*

their horizontal and angled counterparts, a technical device probably proposed by González. Had they been enlarged at the time, as Picasso would have liked, they might conceivably been filled out with tilted metal planes or sheets. Picasso came to accept them as being complete for later he had one of them enlarged and then agreed to have it scaled up yet again to truly monumental proportions.

The largest of the welded metal pieces executed in González's studio is 'Woman in a Garden' of 1929–30 (see no.83), another turning point in twentieth-century sculpture: she stands in somewhat the same relationship to much later welded sculpture as 'Guitar' stands to subsequent Constructivist sculpture. The work was first executed in wrought iron and painted and was then duplicated or reproduced in bronze. The first version is technically somewhat crude, suggesting that Picasso put it together for himself, although he presumably called on González for help.[35] The linear metal armature is here indeed filled out with curved and angled pieces of metal to create an effect of astonishing fantasy. Picasso was by now making use of 'found' objects, pieces of discarded metal, many of them presumably picked up off the floor in González's studio: the figure's eyes, for example, are rendered by enormous nails. The sculpture also makes use of different techniques: some parts are welded, others are bolted; some of the 'found' elements appear to have been unaltered, others were clearly modified. The Apollinaire monument was still haunting Picasso. González wrote: 'this work is made with so much love and tenderness in memory of his dear friend, at the moment he doesn't want to be separated from it, or to think of it being at Père Lachaise in that collection of monuments where people seldom go.'[36] Apollinaire, who had written some of the most spirited and inventive pornography of his time would undoubtedly have responded to the aggressive and at times hilarious eroticism of the Cannes drawings, and we can be equally sure that he would have loved the recklessness and abandon of 'Woman in a Garden'. The second, technically more sophisticated version of the sculpture, executed by González, took up residence, appropriately enough, in the garden at Boisgeloup.

Having themselves been born out of Picasso's paintings, the metal constructions in their turn inform such paintings as 'The Studio' 1928–9 (no.90), while the inventiveness of 'Woman in a Garden' can be sensed behind the Boisgeloup canvases of 1932, the ripest and most hedonistic pictures that Picasso ever produced; like the sculpture many of the paintings juxtapose foliage with the female form. The large sculpture gave birth to two other sculptures in which the use of found objects becomes crucial, the 'Head of a Man' 1930 (no.76) and its companion piece 'Head of a Woman' of 1931 (fig.48 on p.214). 'Head of a Man', which incorporates disparate pieces of iron, brass and bronze, looks back to the painted and collaged Cubist heads of 1913 and 1914 and to the heads of the Managers in *Parade*, one of whom trumpets forth his wares. 'Head of a Woman' on the other hand looks only forwards to the sculptures (and particularly the animal sculptures) of the 1940s and 1950s. The famous colanders incorporated into her skull are not strictly speaking found objects since Picasso sent González out specifically to buy them. Picasso's visual memory was legendary and he was unable to see an object of interesting or unusual shape without mentally filing it in his visual repertoire.

The monumental heads executed at Boisgeloup in 1931 and 1932 stand in total contrast to the forged metal pieces. The latter are experimental and at times witty and debonair; the former are massive and grave and for all their originality are classical in feel, a fact recognised by Valsuani who cast so many of Picasso's sculptures in bronze.[37] Picasso had bought the Château de Boisgeloup for various reasons: he needed a depository for his work, he had enjoyed working with González in the rue de Médéah but felt the need for a larger sculpture studio of his own, and he also wanted an escape

from his increasingly unhappy marital headquarters in Paris. The stable blocks of the château made ideal studios and Picasso was not bothered by the fact that there was no electricity in them; the painting 'The Lamp' 1931 (fig.7) evokes his nocturnal working habits, and the light shed by the big kerosene lamp made him particularly sensitive to the play of shadows over the white plaster sculptures. He tended to distrust the official heaviness of bronze and declared that the Boisgeloup heads in particular were more beautiful in their original white or plaster state.[38] While the studios were being got ready Picasso executed a series of small slender standing figures whittled out of single pieces of wood (s 86–101), and the respect for material that these required may have encouraged him to concentrate on more closed, self-contained sculptural forms.

fig.7 **The Lamp** 1931 Oil on canvas *Private Collection*

Ideas about a possible monument to Apollinaire had played a cardinal part in the evolution of Picasso's metalwork sculpture. The Boisgeloup heads (nos.77–81) are monuments to Marie-Thérèse Walter. The conventional or accepted date for Picasso's meeting with her is 8 January 1927 although her profile is incised onto a musical instrument in a large still life of 1926.[39] Other early references to her are also coded and oblique: Picasso had to keep her existence secret from his wife Olga and she was in any case under age at the time of their meeting which meant that Picasso had to tread carefully. Her Grecian profile, athletic young body and calm blonde beauty were to hold Picasso in thrall for some ten years. The Boisgeloup series appears to be initiated by the most naturalistic of the heads, tilted as though in reverie, and by a profile relief, both of 1931 (nos.80–1). These are in effect portraits of Marie-Thérèse and they look back very directly to the strongly sculptural neo-classical canvases of the early 1920s (no.87). Yet Kahnweiler has stated that the Boisgeloup heads were not all made consecutively but were rather developed simultaneously.[40] As a series, however, they do appear to unfold with wonderful inevitability. 'Bust of a Woman (Marie-Thérèse)' 1931 (no.78) still has about her a strongly classical air although the nose, running straight down from the crown of the head, has taken on markedly phallic properties as in so many of the painted heads of 1929. The prominence of the nose and the way it flows down from the top of the forehead are features that are also to be found in the large and imposing Baga mask that stood in the entrance hall of the château proper. African Baga masks were used in fertility rites and this in turn reminds us that the Boisgeloup heads also find an equivalence in the lumpy, swelling, full-length Neolithic Venus of Lespugue of which Picasso owned two casts. The bisected breasts of 'Bust of a Woman' also lend her a sphinx-like air.

As the series progresses, the noses of the heads become increasingly tumescent and the heads' component parts increasingly abstracted and interchangeable. Necks, cheekbones and hair are all rendered in soft bulging shapes which are simultaneously hard and bone-like. Picasso was an avid collector of bones and often talked of his love for them; the Baga mask which welcomed visitors to the château was partnered by a hippopotamus skull. The asymmetry of the eyes noticeable in 'Bust of a Woman' becomes increasingly pronounced and in the final and most abstract of the heads a single eye has been moved to the side of the skull which together with the monstrous nose now frankly stands proxy for male genitalia (no.79). Finally the metamorphosis becomes complete and the head becomes a crowing cock, symbol from time immemorial of rampant male sexuality (no.86). And yet the Boisgeloup heads throughout their transformations continue to radiate a stately *gravitas* and a feeling of calm, Olympian fulfilment. And their classicising bias is confirmed by the fact that these heads and variants of them appear, together with their Hellenisitic counterparts, in the etchings of 'The Sculptor's Studio', the most perfect of all Picasso's essays in a classical or neo-classical mode (no.68). The Boisgeloup heads are amongst the greatest of all Picasso's sculptures, and taken in conjunction with the metal sculptures that precede them they

confirm the fact that Picasso's stature as a sculptor now equalled his greatness as painter.

The Boisgeloup heads are spelt out by smaller, full-length 'Bathers' (nos.82, 85). These are more indirect tributes to Marie-Thérèse who was an ardent swimmer. (Picasso was not, although he loved the sea). The two metamorphic sculptures of 'Bathers' (no.73) had succumbed to the pull of gravity but the Boisgeloup 'Bathers' defy it. Heavy, almost prehistoric in feel – and more than any other works by Picasso they show affinities with the Venus of Lespugue – they nevertheless are simultaneously charged with movement and a sense of almost bacchanalian abandon. The monumental sculpted heads had given birth to some of the Boisgeloup paintings of 1932; some of them show the most obviously classicising of the sculptures accompanied by still lifes, although the most prevalent are of Marie-Thérèse supine and asleep. Other paintings, like the 'Seated Nude' 1933 (no.98), comment on both the sculpted heads and the sculpted bathers in another way, by rivalling them in terms of bulk. The sculptures of bathers should be seen, metaphorically at least, against the multi-figure seashore canvases such as 'Games and Rescue on the Beach' 1932 (no.97).

The theme of rescue from drowning sounds an ominous note in what otherwise appears to be an idyllic world. The deterioration and collapse of Picasso's marriage was hastened and sealed by three external factors. The great Picasso retrospective of 1932 at the Galerie Georges Petit ended with the recent Marie-Thérèse pictures; they were the most physically sated of all Picasso's paintings and must have come to Olga as an insult. In 1933 Fernande Olivier, the muse of Picasso's early Cubist years, published her touching memoirs *Picasso et ses amis*, to the distress and fury of both Picasso and Olga. Picasso was soon to enter what he later described as the worst years of his life. In 1935 Marie-Thérèse gave birth to his illegitimate daughter Maya. During the latter part of this year he virtually gave up working in his studios and devoted himself to writing instead. A legal separation was arranged and by a supreme irony Olga in her settlement was awarded the Château de Boisgeloup and its studios where the most memorable and beautiful images of Marie-Thérèse Walter had been sculpted and painted.

5 Death and Transformation

Between 1933 and 1941 Picasso produced relatively little sculpture of true significance although 'The Orator', an eloquent work of 1933 or 1934 (no.101), acts in a sense as a herald of things to come; some drawings of 1937 show the same figure brandishing a sickle in his raised left hand, thus endowing him with political significance[41]; with the bombing of Guernica on 26 April of this same year politics were very much on Picasso's mind. During the Boisgeloup years Picasso had begun to make use of what might be described as 'found' textures, embedding and pressing textured papers, leaves, kitchen utensils and so forth into the wet clay or plaster. His awareness of found objects had been quickened by the constructions enclosed in frames or boxes made at Juan-les-Pins in the summer of 1930 and which include such unlikely objects as an abandoned glove, desiccated palm leaves, bits of rope and other seaside detritus, all covered with a unifying coating of sand (e.g. s 75). But the use of found objects goes back, of course, to the prewar Cubist days. 'The Orator' for all his vitality is a remarkably flat, two-dimensional sculpture; his draped trunk is achieved by pressing corrugated paper into wet plaster, whilst his shoulders, neck and arm show the imprint of wire mesh. Similar effects already inform an earlier work, the 'Woman Leaning on her Elbow' of 1933 (no.100); the pleated classicism of her tunic is echoed in the *contrapposto* of her pose – and although she, too, looks forward to later sculpture her classical attributes link her to

Boisgeloup. Again the corrugated surfaces of these sculptures remind one of the surfaces of the largest of the Cubist constructions, 'Violin' of 1915 and 'Guitar' of 1924 (fig.4). The surfaces of some of the later Cubist still lifes such as 'Table, Guitar and Bottle' of 1919 (no.38), for example, also bear the impress of corrugated papers.

In 1937 Picasso acquired a vast new studio in the rue des Grands-Augustins; it had recently been used as a rehearsal space by the great actor and director Jean-Louis Barrault. (The building had originally been known as the Hôtel de Savoie-Carigues and Balzac had used it as the meeting pace for the artists Frenhofer, François Pourbus and Nicholas Poussin in his *Chef-d'oeuvre inconnu*). However, it was not until 1940 that Picasso abandoned the two apartments in the rue La Boëtie, where so much of his married life had been spent, and moved into his new quarters. These soon filled up with earlier sculpture (an annex for further storage was found nearby) and their presence must have incited him once again to resume sculptural activity on an ambitious level and scale, although during the forthcoming years the shortage of fuel meant that only the bathroom could be heated so that it was there that many of the new sculptures were made. Given the threat of war, its inception and the subsequent Occupation of Paris, it is not surprising that a darker note now informed Picasso's work. Already the last major sculpture to have been produced in Boisgeloup, 'The Woman with a Vase', of the summer of 1933 (no.99) has disassociated herself from her sisters of the previous years; whereas they breathe an air of Classical repose she has moved, so to speak, back in time. A faceless Neolithic goddess, she proffers her vase or vessel not as an offering but in a gesture of sacrament or commemoration. More than any other of the sculptures of the period, including those associated with the memory of Apollinaire, she is a monument, a marker in time. Two bronze casts were taken from the original plaster and much later one of them was placed over Picasso's own grave at the base of the steps leading to the entrance of the Château de Vauvenargues, overlooked by Cézanne's beloved Mont Sainte-Victoire.

Although Picasso spent the whole of the Occupation in Paris, becoming in his own way a symbol of resistance, originally he had thought of seeking refuge elsewhere and arrived in Royan, near Bordeaux, the day before the declaration of war on 3 September 1939. The agony of the times found expression in the paintings of sheep's skulls he executed there, some of the grimmest and most disturbing pictures he ever produced. Picasso's fascination with death and his fear of it were legendary and now he sensed it all about him. In April 1942 he painted the two versions of 'Still Life with a Steer's Skull' (no.112), amongst the greatest of his still lifes, which commemorate the death of his friend and collaborator Julio González; on 27 March Picasso had attended the funeral. In the same month *La Conquête du Monde par L'Image* reproduced on its cover one of the most famous of all his sculptures, 'Bull's Head' (no.103), fashioned out of the saddle and handlebars of a bicycle. Picasso described the genesis of the work to Brassaï when the latter photographed it: 'One day in a rubbish heap, I found an old bicycle seat lying beside a rusted handlebar and my mind instantly linked them together. The idea for this *Tête de Taureau* came to me before I even realised it'.[42] Like the 'Still Life with a Steer's Skull' it is a *memento mori* and the trashed origins of its discarded parts give it an air of pathos and vulnerability despite its insolence and wit. One of the greatest of all Picasso's sculptures, 'Death's Head' (no.102) traditionally ascribed to 1943, although it may be somewhat earlier, seems quite literally to depict the skull beneath the skin — larger than life-size, it seems to embody and imprison the idea of death, not so much in its outer configurations as underneath its surfaces.

Whereas the works of Picasso's earlier bouts of activity, even the wooden sculptures of 1907–8, fall into coherent groupings, the major sculptures of 1940s and early 1950s, Picasso's most prolific sculptural decades, tend to line up behind each other indepen-

dently, sentinels in an increasingly long and unbelievably productive career. 'The Man with a Sheep' (no.105), more than any other single work, helped to establish Picasso's fame as a sculptor when his output in the medium eventually entered the public consciousness. In 1943 he had the seven foot high armature for it constructed and it was executed in a single session (or on successive afternoons – accounts vary) in the presence of the Surrealist poet Paul Eluard. At one point the sculpture had to be steadied by supporting ropes, on another occasion the sheep fell off and had to be wired back on. Picasso recognised the need to act swiftly and had the work cast in plaster before the clay was even properly dry. 'The Man with a Sheep' owes its great appeal to its timelessness. The subject goes back to classical antiquity and beyond; and yet the work has a living, breathing presence and its sacrificial implications are overlaid with a sense of deep humanity. Alan Bowness has suggested that the work may be related to Picasso's decision to join the Communist party.[43] In its plaster form it presided over the largest of the lower floor spaces of the apartment in the rue des Grands-Augustins, a symbol of optimism and hope. And Picasso's need to surround himself with the physical presence of his sculptures at this time may reflect the loneliness and isolation he experienced working entirely on his own in wartime Paris. The new sculptures were done in the face of adversity and despite shortages of materials; clay itself was hard to come by at the time. And the fact that Picasso actually had a sizeable number of works cast into bronze at a time when the Germans were destroying and melting down French national monuments can in itself be seen as a gesture of resistance and defiance.

After the war Picasso began to spend an increasing amount of time in the South of France. In 1946 he began his collaboration with the Madoura potteries at Vallauris, near Antibes, and the production of his first ceramics. Their importance, and the place they occupy in the development of his sculpture have yet to be adequately examined.[44] It was through his activities as a potter that Picasso discovered the old abandoned perfume factory in the rue du Fournas. Studios were set up, and the largest was soon filled with sculptural presences in plaster and bronze brought down from Paris, and this in turn encouraged new sculptural activity. In 1949 the birth of his daughter and second child by Françoise Gilot inspired one of the most fanciful and fetishistic of all his sculptures, 'Pregnant Woman' (no.106): to a long, upright metal rod he affixed arms and legs at top and bottom and between them, halfway down the spinal support he placed three circular protruberances, the largest signifying the belly, two smaller ones the breasts. Picasso had come to see Françoise Gilot as 'la femme-fleur' – it became the title of a beautiful painting of 1946, 'Woman-Flower' (no.115) – and he often depicted her face, flower-like, suspended over a stalk-like body. This first 'Pregnant Woman' was followed in the next year by another sculpture on the same theme (no.108), executed, Gilot tells us, as a wish fulfilment after she had refused to have a third child[45]; a variant of it was cast in 1959. The first version is less naturalistic to the extent that the feet are truncated so that the woman seems bound back into the earth; in the second she is planted firmly above it. In both versions breasts and belly are fashioned out of smooth, rounded forms, waterspouts found in a scrap heap nearby; they look burnished and somehow sanctified in relationship to the figures' heads and limbs. The quality of transformation, of objects having been taken and shaped into new configurations or given different meanings, had found explicit expression earlier in 1943 when Picasso picked up a dressmaker's dummy from the turn of the century, added to it a head of his own devising and two arms, one from the Easter Island (this had been a gift to him from the dealer Pierre Loëb), and another more primitive one, again fashioned by himself; 'The Woman in a Long Dress' was subsequently either destroyed or dismantled, but fortunately not before a bronze cast of her had been made (no.104). 'The Woman with a Key' 1954 (fig.8; no.109), also

fig.8 Picasso with 'The Woman with a Key', Le Fournas, Vallauris 1954 Photo: Edward Quinn

known as 'The Madam', is completely made up of found or redeemed objects and to this extent she is the female antithesis of 'The Man with a Sheep' (no.105) who had been traditionally modelled; she was assembled on the floor and can't ever have stood up until after her component parts had been cast and welded together; and while he radiates compassion and nobility she has about her a somewhat ruthless air and exudes a certain malevolence which is enhanced by her handbag and key.

The sculptural activity of the 1940s was preceded by paintings that are, yet again, in effect surrogate sculptures. This is true of, for example, 'Head of a Woman with Two Profiles' (no.111), painted in Paris on 1 April 1939, one of the most powerful and explicit recapitulations of Cubism's multi-viewpoint perspectives. For the next fifteen years, however, painting and sculpture inform each other without interacting as closely as they had during Picasso's earlier bouts of sculptural activity. On the other hand, 'Bust of a Woman against a Grey Ground' (no.113), for example, painted in 1943, in her gauntness looks forward to 'The Woman with a Key'. But now sculpture often leads the way. The important and little-known 'Monument to the Spanish Dead', in effect a painted sculpture of 1945–7 (no.114), breathes the same air as the great 'Death's Head' (no.102). The painting was reportedly shown in the exhibition *Art et Résistance* which opened in Paris on 15 January 1946; a manifesto painting, something rare in Picasso's art, he had hoped it would find its way into a museum. It did, but only after Picasso's death when his widow Jacqueline gave it to the Spanish nation.

6 Searching in the Animal Kingdom

Close to Picasso's studios in the rue du Fournas in Vallauris there was a field where potters threw their debris; it was there that Picasso had discovered the breasts and belly of his sculpture 'The Pregnant Woman' of 1950 (no.108). Other rubbish tips were visited on the way to the studio and were also mined assiduously. Sometimes Picasso knew what he was looking for. On other occasions a discarded or broken object would catch his eye and give birth to a new sculptural subject. Occasionally he left his discoveries just as they were, thus elevating these objects to the status of works of art and even casting them in bronze; for example in 1945 a rusted valve and burner from an old gas stove became 'The Venus of Gas' (no.44). But it was in his sculptures of animals that Picasso made most fanciful and elaborate use of both readymade objects and of the contrasting textures and surfaces with which they provided him. 'Aside from rhythm one of the things that strikes us most strongly in nature is the difference in textures and beyond that the relation of colour and volume to questions of texture', he said to Françoise Gilot.[46]

Picasso's love of animals was legendary and they invariably responded to him instantly. Even in early Paris days when he was struggling and penniless he surrounded himself with a menagerie which included various dogs, a monkey, a tame mouse that lived in a drawer of his studio and, later on, a cat. Domestic cats, however, he found too tame and preferred their feral, streetwise counterparts, which fascinated him. One imagines that his wife Olga, who was houseproud in the extreme, would have discouraged household pets, but Picasso was never without a dog and Picasso's friend John Richardson has often spoken of the way in which their varying appearances inform the depictions of mistresses of the moment. It was difficult to keep animals in wartime Paris, but pigeons and owls were to be seen in the upper studios in the rue des Grands-Augustins, and the dog Kazbek was in constant attendance. After the war in the South of France animals of all kinds became a part of family life (fig.9). Animals, and dogs in

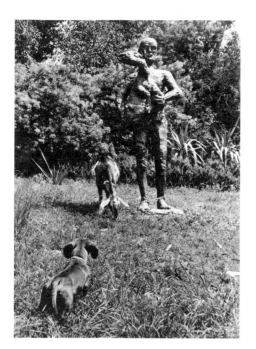

fig.9 La Californie, Cannes 1957
Photo: David Douglas Duncan

particular, figure in Picasso's paintings although not as frequently as one might expect given his attraction to them – and for the most part the painted animals appear in the company of human beings; in 1938 a solitary cock figures prominently in a series of drawings and pastels. But it is in the realm of sculpture that Picasso produced his most memorable images of animals.

Most famous of all is 'The Goat' 1950 (no.118). A goat was in residence at the time and Picasso already had the sculpture in mind when one morning he picked up an old wicker basket. 'That's just what I need for the goat's rib cage', he declared.[47] The same year he dignified the discarded object as a subject in its own right in the painting 'Cock and Wicker Basket' (no.132); in the sculpture the basket reinforces the goat's comfortable solidity, here it is crackling and animate. Pottery milk pitchers, their handles and bottoms knocked off, became the goat's teats. Part of a palm frond that Picasso had been hoarding for years was the backbone or spine. Curly vine stalks were used as horns and young tree trunks or branches as legs. An open tin can unequivocally proclaims the nature of the animal's sex. Later, a bronze cast was placed in the garden of La Californie, the villa overlooking Cannes which had been bought in 1955, and Picasso amused himself by hitching the chain of the goat's live counterpart, Esmeralda, to the sculpture's tail (see frontispiece). For 'Baboon and Young' 1951 (no.120), Picasso raided the toy box of his son Claude; two toy motorcars were clamped together to form the baboon's head. Sometimes these fantasies of Picasso lose by being cast into bronze. This is certainly true in the case of 'The Goat'; reproduced in bronze much of the work's wit and vitality as well as its textural variety and richness evaporate. In the case of 'Baboon and Young', however, the imagery of the toy cars is so obvious and blatant that the work is strengthened by being transposed into a single medium. For all his distrust of bronze Picasso was well aware of its unifying properties, and he had welcomed them when the bicycle saddle and handlebars had become more truly a 'Bull's Head' in bronze (no.103); we remain aware of the origins of the work's component parts and yet we accept their coming together into a new image more readily.

'Little Girl Skipping' 1950–?52 (no.119) is unique in Picasso's sculpture in that she is literally suspended in space – Picasso had always wanted to make a sculpture that did not touch the ground.[48] She seems to feel most at home in the animal kingdom because she is touched by the affectionate humour that characterises virtually all Picasso's depictions of animals. Once again she suffers somewhat from being cast into bronze, although in this case the losses of textural juxtapositions are to a certain extent offset in that she gains a new dignity and presence – and her feat of gravity seems even more remarkable. Picasso intended to paint the two bronzes of her that were cast but never got around to it; the basketwork so prominent in her body is anticipated in the woven, striated configurations of Picasso's brushwork in paintings of 1938, yet another example of pictorial invention preceding the discovery of a found element being used for sculptural purposes. On the other hand sculpture and painting find an exact equivalence in 'Goat's Skull and Bottle' (no.125), executed in the sculpture studio in Vallauris in 1951–3, and 'Goat's Skull, Bottle and Candle' (no.133) painted in Paris in 1952. Assembled from bicycle handlebars, nails, metal and ceramic elements, the casting of this particular sculpture gave rise to almost insuperable technical problems; each individual nail attached to the skull and to the halo of light around the candle, for example, had to be cast separately. The result, however, is one of Picasso's most haunting and memorable *memento mori*.

The metal constructions executed between 1928 and 1931 relate to Picasso's Cubist constructions in that they are assembled objects which bring together disparate parts to produce images that confront rather than echo their counterparts in the natural world. The Boisgeloup 'Heads' and 'Bathers', on the other hand, recall many of the earlier

preoccupations, of Analytic Cubism and of the paintings that led up to it. Heavily volumetric, distorted to the extent that from every angle one apprehends more of the subject than one would by looking at it from a single, stationary viewpoint, they seek once more to take possession of observed reality in its totality. Many of the figure sculptures produced in the rue des Grands-Augustins and at Vallauris, 'The Pregnant Woman' of 1950 (no.108), for example, combine and balance these two basic impulses in Picasso: his desire to dominate, possess and consume things in their entirety and his urge to produce their totally independent counterparts. The animal sculptures, so obviously built up out of disparate fragments of detritus, belong once more to the world of Picasso's confrontational constructions. What is so remarkable is that at the same time, they are for the most part much more naturalistic in appearance than their sculptural counterparts of the human figure (fig.10).

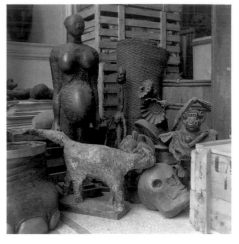

fig.10 Entrance hall among packing cases, La Californie, Cannes c.1958 Photo: Edward Quinn

7 Cutting and Folding the Figure

As early as 1933 Picasso had said to Kahnweiler, 'I should like to make sculpture in colour'.[49] Later Kahnweiler came to see Picasso's work in ceramics as 'the long sought link between sculpture and painting'.[50] In 1948 Picasso remarked to the sculptor Henri Laurens, 'You ought to go in for pottery, it's magnificent … I've done a head and whichever way you look at it from it's flat. Of course it is the painting – I painted it specially to look like that'.[51] Clearly a new dialogue between works in three and two dimensions was under way. On the same occasion, discussing one of his own *papiers collés* of 1914, he went on to say, 'What idiots or cowards we must have been to have given that up. We had marvellous means at our disposal. You see how beautiful it is – not because it is mine, of course – but we used to have that, and then I went back to oil paints and you to marble. It's crazy'.

In 1953–4 Picasso entered a new phase of sculptural activity, or to be more precise, two new phases of it. During the mid-1930s he had executed a series of playful wooden figures (no.42), and in 1953 he produced a whole family of them for his small daughter Paloma (s 481–7). The same year he produced the more ambitious 'Woman Carrying a Child' (no.135), again in painted wood. Further constructions followed. These were made up of whatever wooden material came to hand, planks picked up on walks into Cannes from La Californie, strips from packing cases, empty picture stretchers and parts of easels, even broomsticks; the later sheet-metal sculptures are also associated with La Californie, and all the sculpture he produced there radiates a sense of joy. In 1956 Picasso brought together a group of wooden figures that had been conceived of originally as independent figures to form a group of 'Bathers' (fig.11). Clearly as he moved the works about the airy spaces of La Californie they had begun to signal to each other and Picasso had recognised their wish to congregate. After having been cast in bronze they were shown around an imaginary pond in the Galerie Leiris in 1958; and at one point they actually got into the lake at Battersea Park.[52] Clearly these assembled works belong to, and are in a sense the culmination of, a Synthetic or Constructivist strain in Picasso's sculpture, although some of them are given a pictorial quality by being brightly coloured, and others, the 'Bathers' in particular, have only a single, frontal viewpoint.

Simultaneously, in 1954, Picasso produced his first bent metal heads, executed by assistants in a workshop outside Vallauris from cardboard models cut and folded by Picasso himself. The heads were then painted by Picasso who, as his later remarks to Laurens suggested, delighted in defying expectations by painting in folds where none

fig.11 **Bathers** 1956 Wood *Staatsgalerie Stuttgart*

existed and at other moments by flattening out bent forms by the use of striated lines. Picasso also sometimes modified the metal, attacking it with pliers or whatever other tools came to hand. A group of heads executed in the second half of the 1950s are raised on circular shafts or elongated angular plinths, giving the appearance almost of totem poles (nos.136–7). As the series progresses the markings on the sculptures become increasingly bold and in some cases abstract and hieroglyphic. Matisse in old age became increasingly preoccupied with the concept of signs. 'Each thing has its own sign', he said to the poet Aragon, 'the discovery of this marks the artist's progress in the knowledge and expression of the world, a saving of time, the briefest possible indication of the character of a thing'.[53] Similarly Picasso confided to Hélène Parmelin: 'What is necessary is to name things. They must be called by their name; I name the eye. I name the foot. I name my dog's head on someone's knees … To name. That's all, that's enough'.[54] The sign language employed in these painted metal heads and the pronounced enlargement of the eyes, which seem to stare the spectator down, make them prophetic of Picasso's very last paintings. In old age the friendship between Picasso and Matisse had become much closer; and when Picasso visited Matisse at Vence and at the Hotel Régina at Cimiez he had watched him at work on his late *découpages* which themselves can be seen as carvings made out of pure colour.

In November 1960 Picasso and Jacqueline Roque, whom he was to marry the following year, were shown around the factory at Vallauris where Lionel Prejger and his associates made metal tubes. Picasso, as always, seized opportunity when it struck and asked if Prejger would like to work for him. 'Next day he sent us a first paper form in the shape of a superb-looking eagle. We executed the sculpture immediately, and following that, every day, other subjects were born out of his magic scissors and his inexhaustible imagination'.[55] The following months saw Picasso's most concentrated period of activity in bent and folded metal and some one hundred and twenty sculptures were produced, most under the supervision of Prejger. As various commentators have pointed out, Picasso's wizardry with papers and scissors went back to his early childhood when he would enchant various members of his family by cutting images out of paper, often to their command; later on, eating out at restaurants he would delight friends by tearing paper napkins into fanciful images, even creating portraits. The bent metal sculptures are of varying degrees of complexity. Some are merely playful and there is a light-hearted vein that runs through the entire series. This is conveyed in part at least by the deceptive weightlessness of the thin, rolled metal. And yet some of these pieces also strike a wistful, plangent note.

As in the case of the two giant constructions of musical instruments of 1915 and 1924 (see p.23) some of the most visually complex of the new rolled metal pieces have been produced by the skilful bending and twisting of only one or two elements. Prejger recalled that on one of his visits to Picasso he saw that he had drawn an odd, tentacular shape onto a piece of wrapping paper. 'That's a chair', said Picasso, 'and, do you see, its an explanation of Cubism. If you imagine a chair that's been under a steamroller it would look like that'.[56] Needless to say, cut and folded according to Picasso's instructions the octopus sketch was transposed into a convincing piece of furniture (s 592). The totem-like heads of the 1950s (nos.136–7) – and some of them were indeed later scaled up into gigantic monuments – slice their way through space rather than filling and informing it in the way earlier sculptures had done. They effect a marriage between sculpture and painting in that they take on meaning only after the pictorial notations have been added to them, and they have the directional qualities of signposts in that we are always aware of the flatness of the elements that compose them. The folded metal figures define a shallow space and do so discreetly. At various points in Picasso's career his paintings had looked like surrogate sculptures; from time to time his images had

seemed quite literally to be trying to get off the wall. Now, while we marvel at the feats of balance performed by the late bent metal pieces, and at the inventiveness and ingenuity of the way in which the bodies and limbs of the figures are folded gently backwards and forwards, in and out of compressed depth or space, and also at the way in which they meet or rise from their anchoring bases, we nevertheless get the feeling that sculpture is now aspiring to the condition of painting.

Many of the paintings of the 1950s and early 1960s, on the other hand, continue to look astonishingly sculptural. And there is a sense in which the revolutionary years between 1906 and 1914 are revisited. The mural-sized 'Two Women on the Beach' of 1956 (no.148) looks back to the great 'wooden' canvases of 1908; once again one feels that these figures could be dismantled and reassembled in three dimensions. The swollen and distended forms of 'Seated Nude' 1959 (no.150) hark back to the 'crisis' pictures of 1906, although through Cubism the crisis had long since been resolved and the figure presents herself to us serenely and with a monolithic completeness. The sheet-metal sculptures, which themselves have their origins in the bent and folded structures of Synthetic Cubism, inform 'Composition: Two Women' 1958 (no.149), while the painting itself is prophetic of the gigantic concrete groups which Picasso subsequently agreed to have cast from models that he supplied. The relevance of sculptures like 'Woman in a Hat' 1961–3 (no.145) for paintings like the little-known 'Seated Woman' 1962 (no.151) and the magnificent 'Large Profile' 1963 (no.152) speaks for itself. 'Bust of a Woman' (no.147), a late sheet-metal piece of 1964, has in effect turned herself into a painting in 'Woman with a Coif' (no.153) executed in 1971, just two years before Picasso's death.

8 New Arcadias

At the very end of 1954 Picasso began his variations on Delacroix's 'The Women of Algiers', a painting that had long haunted him, as it did so many other artists. Picasso had always pillaged the art of the past, as he freely admitted. But the fifteen canvases based on the Delacroix masterpiece marked a change of attitude in Picasso's relationship to earlier art. The Delacroix series (fig.12), like the other variations on celebrated turning points in visual history which succeeded them, are homages to individual artists of the past venerated by Picasso; but essentially they are homages to painting itself. Just as 'The Sculptor's Studio' suite of 1933 (no.68) had been in effect about the veneration of sculpture, so these variations on earlier pictorial cornerstones are in the final analysis about the worship of painting. 'The Women of Algiers' series cemented Picasso's relationship with Jacqueline Roque, the last of Picasso's great emotional attachments; Picasso identified her particularly with the right-hand figure in the Delacroix. They also commemorate the death of Matisse, the only figure Picasso was prepared to accept as a rival. 'When Matisse died he left his odalisques to me', Picasso remarked.[57]

The 'Meninas' series executed between August and December 1957 in the studio at the top of La Californie consisted of more than forty variations on the most celebrated of all Velázquez's works and was important to Picasso at many levels (fig.13). It was a picture he had encountered in adolescence and had loved ever since. It was also the archetypal studio picture; the theme of the artist and his model and the studio world they inhabit had preoccupied Picasso since the 1920s and it came to obsess him in old age. The 'Meninas' carried Picasso back to Spain's Golden Age, and not only to its art but to its literature. And the quality of ceremony and pageantry in the 'Meninas' must have encouraged Picasso to view the world as one great theatre of kaleidoscopic visual

fig.12 **Women of Algiers, after Delacroix** 1955
Oil on canvas *Mrs Victor W. Ganz, New York*

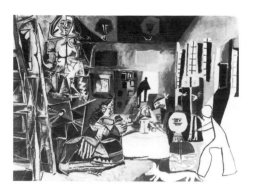

fig.13 **Las Meninas, after Velázquez** 1957
Museu Picasso, Barcelona

revelations and encounters. Clearly these were visions and sensations that could be conveyed better in painting than in sculpture. And yet it has been suggested convincingly that the first painting in the 'Meninas' series shows the influence of Picasso's sculpted wooden 'Bathers' of the previous year.[58] Within the totality of his output the two art forms still had something to say to each other although the pendulum was swinging increasingly toward painting. And painting was to occupy Picasso exclusively in his final years.

The variations on Manet's 'Le Déjeuner sur l'herbe' – over a hundred were executed between 1959 and 1962 – introduced other considerations that were to make painting seem to Picasso once again the supreme art, although the figures in his 'Déjeuner' pictures (nos.165–8) do show a debt to the bent metal sculptures that had preceded them; and of course Picasso was still at work on other sculptures at the time. The Manet series in turn engendered some models in folded cardboard that were in a sense Picasso's final farewell to sculpture (nos.156–164). In 1924 the critic André Suarez had written of Picasso's seminal canvas of 1907, 'The *Demoiselles* are Picasso's *Déjeuner sur l'herbe* and he must secretly have thought so'.[59] A few years later Picasso noted on the back of an envelope, 'When I see Manet's *Déjeuner sur l'herbe* I say to myself trouble for later on'.[60] Manet's 'Le Déjeuner sur l'herbe' itself makes overt references to masterpieces of the past, and this underlines an important difference between Picasso's painting and his sculpture. If Picasso's painting had constantly borrowed from the art of the past it had also commented upon it. His sculpture had also done so but less frequently and in a more indirect fashion, except in the case of his use of tribal art. And the encounter with tribal sculpture was the most important single pivotal factor in Picasso's career. Apart from this the most direct affiliations that his sculpture had shown were with its Neolithic and its Classical antecedents. Neolithic and tribal art had fed into the mainstream of his modernism. Classical art he had assimilated into it. But with the notable exception of the sculpture of Gauguin which had been so important to him between 1906 and 1908, the sculpture of the three hundred years that had preceded him had much less to say to him than did its painting. In old age and as he withdrew increasingly into himself, painting enabled him to communicate metaphorically with other artists in a way that sculpture could not. 'Le Déjeuner sur l'herbe' must have led Picasso simultaneously to reassess the origins of modernism as he had known it when he was first drawn to Paris in the early years of the century. Finally, the erotic implications of the subject which had so disturbed the critics of Manet's day coincided with Picasso's ultimate equation between the act of painting and the act of love. 'Painting', he declared, 'that is actual lovemaking'.[61]

Picasso's variants of 'Le Déjeuner sur l'herbe' have about them a genuinely Arcadian air and a sense of freedom and abandon that is lacking form Manet's original *tour de force*, which is essentially a studio painting and, despite the cardinal position which it occupies in the history of modern art, also in a sense a 'salon machine'. Ultimately the furore which it created lay not so much in its moral implications as in the extraordinary freshness and physicality of Manet's technique. This is echoed not only in Picasso's painted variants of the canvas but more surprisingly in their sculptural spin-offs (nos.156–64). In 1957 Picasso met the young Norwegian artist Carl Nesjar who spoke to him of a technique he had been exploring which had implications for mural work and also for monumental sculpture. This consisted in filling wooden supports, which could either hug the wall or be three-dimensional, with an aggregate of stone chippings; reinforced cement was then poured in to bind them. Subsequently high-pressure, fine-nozzled blasting hoses could be directed at the surfaces to cut through the outer casing of concrete to the aggregates below. The procedure was known as Betograve or concrete engraving.[62]

Nesjar showed Picasso experiments in the medium and as always when he was presented with a new technical challenge, Picasso responded. He allowed recent drawings to be scaled up onto the walls of a new a government building in Oslo in 1957, and having scrutinised the results in photographs, he agreed to a three-dimensional experiment which resulted in the 'Head of Woman', installed in Larvik the following year (fig.14). This was executed from a metal maquette and was ten feet high. Picasso was frankly delighted with the photographic records presented to him by Nesjar: the dreams of towering sculptural monuments envisaged in the Cannes sketchbooks of 1927 were in a sense coming true. Nesjar's collaborations were of the most scrupulous kind. Every project he executed had to be discussed with Picasso, not only in terms of an exact scale, but also as to the suitability of sites and even of the colour and consistency of the aggregates to be exposed in the blasting. Nesjar supplied Picasso not only with mock-up photographs of works in their proposed settings, but also with films of the work in progress.

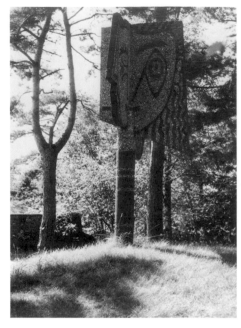

fig.14 Pablo Picasso and Carl Nesjar **Head of a Woman** 1958 Concrete *Viksjö Family, Larvik, Norway* Photo: Carl Nesjar

The only Betograve products that Picasso actually saw were the line murals blasted onto some of the outbuildings of Douglas Cooper's Château de Castille at Argilliers. These were executed *in situ* and placed behind a protective colonnade. The drawings, which were blown up onto the walls with the aid of projectors to the height of fourteen feet, were selected by Picasso and Cooper in consultation; two of them belonged to the 'Déjeuner' series. In the spring of 1964 Pontus Hulten, then Director of the Moderna Museet in Stockholm, who knew about Picasso's collaborations with Nesjar, approached the latter about persuading Picasso to create a work for the Museum's sculpture garden. Nesjar hurried down to the South of France and Picasso brought out cardboard maquettes of figures of his own variants of Manet's *dramatis personae*. Eighteen of these are in existence (see nos.156–64) and Picasso selected four of them to correspond to Manet's original cast list (see illustration on p.178). As in so many of the painted variants all the figures are nude – only one of the women in the Manet is undressed – and are hence transformed into bucolic bathers (fig.15). Their eroticism, in contrast to the disturbing sexual undertones in the Manet, is frank and relaxed. When the present exhibition was first being planned the Moderna Museet was approached about the possibility of the complex coming to London. The museum was wonderfully open-minded about the idea, but apart from problems of transport it was eventually agreed by all concerned that it would be an act of vandalism to disturb the figures. They have weathered into their surroundings, trees and vegetation have made the environment look totally rural and truly Arcadian; and the sculpted complex, like Picasso's original painted 'Déjeuners', is untouched by the note of anguish which underlies so many of the final canvases.

fig.15 Carl Nesjar and Pablo Picasso **Le Déjeuner sur l'herbe** 1962 Sandblasted concrete *Moderna Museet, Stockholm*

Notes

Elizabeth Cowling, my colleague and partner in the selecting of this exhibition, read my introduction in manuscript. She has generously shared with me much of her recent original research, made countless useful suggestions and corrected several errors of fact. I am truly grateful to her.

1 The sketchbook is dated 10–12 Feb. 1963 and is devoted to the theme of the artist and his model. It is in the Musée Picasso, Paris.
2 Picasso, *Collected Writings*, London 1989, p.9.
3 Brassaï, *Picasso and Co.*, London 1967, p.7 (first published as *Conversations avec Picasso*, Paris 1964).
4 Daniel-Henry Kahnweiler, photographs by Brassaï, *The Sculptures of Picasso*, London 1949, unpag.
5 Jaime Sabartés, *Picasso an Intimate Portrait*, London 1949, p.15.
6 A. Vollard, *Degas: An Intimate Portrait*, trans. R.T. Weaver, New York 1937, p.59.
7 John Richardson, *A Life of Picasso: Volume 1 1881–1906*, New York 1991, p.442.
8 Richardson 1991, pp.442–3.
9 Richardson dates the work to early 1906 and suggests that it was probably modelled (in clay) in Paco Durrio's studio: Richardson 1991, p.428.
10 See Ted Pillsbury, *Art News*, 1983, pp.109–10.
11 Sabartés 1949, p.213.
12 André Malraux, *La Tête d'obsidienne*, Paris 1974, pp.18–19.
13 Renato Guttuso, *Journals*, quoted in Mario di Micheli, *Scriti di Picasso*, Milan 1964, p.106.
14 André Salmon, *La Jeune Peinture française*, Paris 1912, p.59.
15 Kahnweiler 1949, unpag.
16 Julio González, 'Picasso Sculpteur', *Cahiers d'Art*, no.11, pp.89–91.
17 The casts taken by Vollard are numerous, at least sixteen, and possibly even more. In 1960, with Picasso's permission the Berggruen Gallery cast a further nine. These were taken from the plaster now in the Nasher Collection, Dallas. The plaster together with three of the new bronzes were returned to Picasso. It is possible that Vollard himself cast bronzes from both plasters.
18 William Rubin, *'Primitivism' in 20th Century Art*, exh.cat., Museum of Modern Art, New York 1984, p.340 n.182.
19 Roland Penrose, 'Picasso Sculpture, Ceramics, Graphic Art', introductory essay to an Arts Council exhibition held at the Tate Gallery 1967, p.10.
20 It is not known exactly when the transposition took place. Edward Fry in 'Picasso, Cubism and Reflexivity', *Art Journal*, vol.47, no.4, Winter 1988, pp.296–310, suggests that it may not have been until Picasso moved into a new studio in the rue Schoelcher. Picasso moved there in August 1913.
21 For a discussion of Picasso's Grebo masks see Rubin 1984, p.307.
22 None of these has survived.
23 Françoise Gilot and Carlton Lake, *Life with Picasso*, Harmondsworth 1966, p.311.
24 See Pepe Karmel's essay in this catalogue.
25 William Tucker, 'Picasso's Constructions', *Studio International*, May 1970, pp.201–5.
26 The original cardboard 'Guitar' itself and the 'Violin' of 1912–13 now in Stuttgart (s 35).
27 Brooke Adams, 'Picasso's Absinthe Glass: Six Drinks to the End of an Era', *Art Forum*, vol.18, no.8, April 1980, pp.30–1.
28 See Peter Read's essay in this catalogue.
29 See again Peter Read's essay in this catalogue to which I am indebted.
30 For an account of Picasso's relationship with González see Marilyn McCully's essay in this catalogue.
31 Josephine Withers, 'The Artistic Collaboration of Pablo Picasso and Julio Gonzalez', *Art Journal*, no.25, no.12, Winter 1975/6, p.107.
32 Penrose 1967, p.13.
33 Kahnweiler 1949, unpag.
34 Guillaume Apollinaire, *Le Poète assassiné*, 1916, *Oeuvres complètes*, ed. Michel Decaudin, Paris 1965, vol.1, p.295.
35 See Peter Read's essay in this catalogue.
36 Quoted in Withers 1975/6, p.112.
37 Gilot and Lake 1966, p.303.
38 Brassaï 1967, p.51.
39 'Musical Instruments on a Table' 1926, Museo Nacional, Centro de Arte Reina Sofia, Madrid.
40 Albert Elsen, 'Surprise, Invention, Economy in the Sculpture of Picasso', *Art Forum*, no.3, Nov. 1967, p.19.
41 Information received from Elizabeth Cowling. The drawings are in the Musée Picasso, cat. nos.1077 and 1078.
42 Brassaï 1967, p.52.
43 Alan Bowness, 'Picasso's Sculpture', in *Picasso 1881–1973*, ed. Roland Penrose and John Golding, London 1973, p.148.
44 Claude Picasso, who writes on the ceramics in this catalogue, is compiling a catalogue raisonné of them.
45 Gilot and Lake 1966, p.309.
46 Ibid., p.72.
47 Ibid., p.306.
48 Ibid., p.307.
49 Quoted in Bowness 1973, p.153.
50 Quoted in Spies 1983, p.73 (my translation).
51 Daniel-Henry Kahnweiler, 'Entretiens avec Picasso', *Quadrum* (Brussels), Nov. 1956, pp.75–6.
52 In an Arts Council sculpture exhibition organised by Alan Bowness in 1960.
53 Aragon, *Henri Matisse: Un Roman*, Paris 1971, p.153.
54 Hélène Parmelin, *Picasso's Women*, 1961, p.45.
55 Lionel Prejger, 'Picasso découpe le fer', *L'Oeil*, no.82, Oct. 1961, pp.28–32.
56 Ibid. For a more detailed explanation of Picasso's procedures see the interview with Prejger in this catalogue.
57 Roland Penrose, *Picasso: His Life and Work*, Harmondsworth 1971, p.396.
58 Spies 1983, p.221.
59 Quoted in *Les Demoiselles d'Avignon*, Musée Picasso, Paris 1988, p.587.
60 Quoted in *Le Dernier Picasso*, exh. cat., Centre Georges Pompidou, Paris 1988, p.35.
61 Picasso in conversation with Roland Penrose, who repeated it to me.
62 See Sally Fairweather, *Picasso's Concrete Sculptures*, New York 1982.

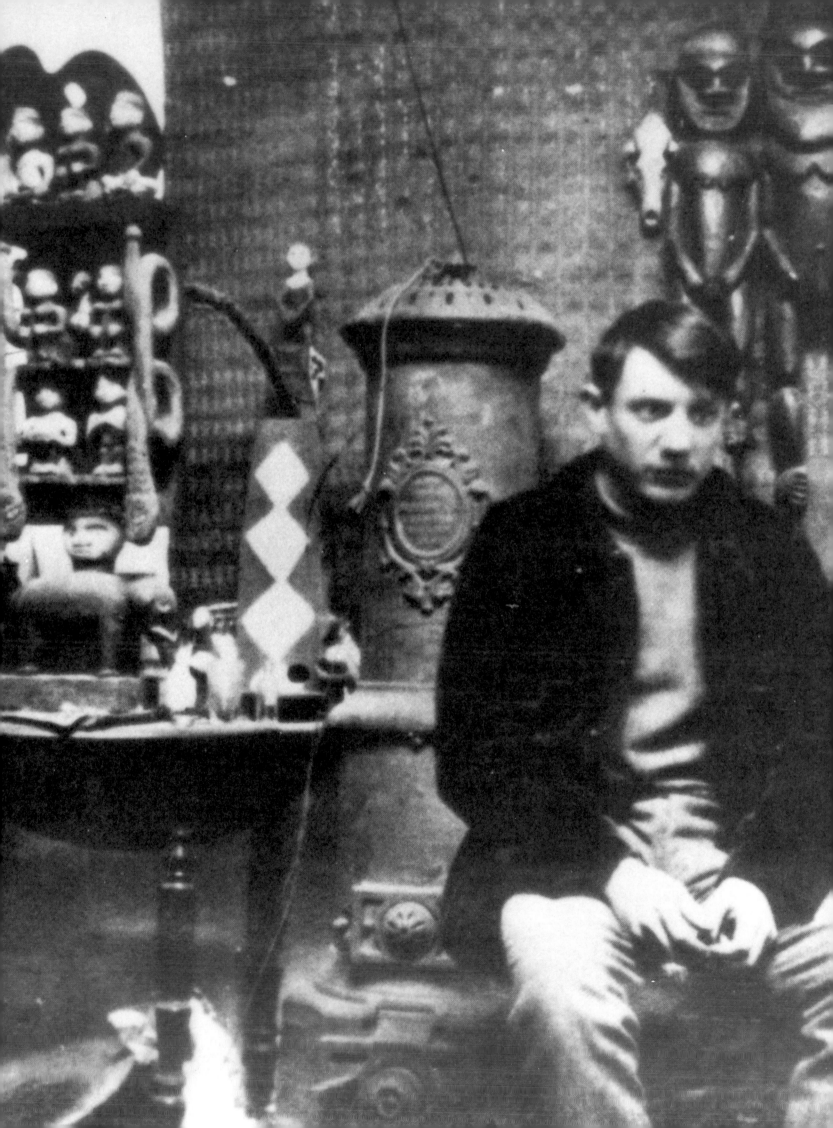

1 Crisis and Analysis

It gives me great pleasure to speak of Picasso as a sculptor. I have always considered him a 'man of form', because by nature he has the spirit of form. Form is in his early paintings and in his most recent.

In 1908, at the time of his first Cubist paintings, Picasso gave us form not as a silhouette, not as a projection of the object, but by putting planes, syntheses, and the cube of these in relief, as in a 'construction'.

With these paintings, Picasso told me, it is only necessary to cut them out – the colours are only the indications of different perspectives, of planes inclined from one side or the other – then assemble them according to the indications given by the colour, in order to find oneself in the presence of a 'Sculpture'. The vanished painting would hardly be missed. He was so convinced of it that he executed several sculptures with perfect success.

Picasso must have felt himself to be of a true sculptor's temperament, because in recalling this period of his life to me, he said: 'I have never been so content' or 'I was so happy.'

Julio González, 'Un homme de la forme', *Cahiers d'Art*, no.6–7, 1936

My greatest artistic emotions were aroused when the sublime beauty of the sculptures created by anonymous artists in Africa was suddenly revealed to me. These works of religious art, which are both impassioned and rigorously logical, are the most powerful and the most beautiful of all the products of the human imagination.

I hasten to add, however, that I detest exoticism. I have never liked the art of China, Japan or Persia.

In antique art, it is the restraint – the restraint synonymous with beauty – that I respond to, but I admit that the almost mechanical rhythm which destroys the proportions of all Greek works of art has always thoroughly repelled me.

An artist worthy of the name must give the objects he is representing the maximum plasticity. For instance, if one is representing an apple and one traces a circle, one will have given a primary indication of the object's plasticity. But the artist may wish to confer on his work a higher degree of plasticity. In this case the object, although it is in no sense being negated, may end up appearing in the form of a square or a cube.

Picasso, as reported by Guillaume Apollinaire, in a manuscript, *c.*1917 (published in *Picasso–Apollinaire: Correspondance*, ed. Pierre Caizergues and Hélène Seckel, Paris 1992)

Picasso in the Bateau Lavoir 1908
Musée Picasso Archives, Paris
Photo: Gelett Burgess

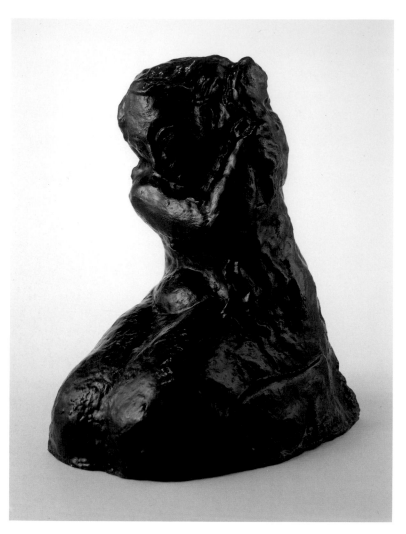

2 Woman Combing her Hair 1906
41.6 × 26 × 31.4

7 Study for 'Woman Combing
her Hair' 1906
31 × 22.5

8 Head and Figure Studies 1906
64.8 × 47.9

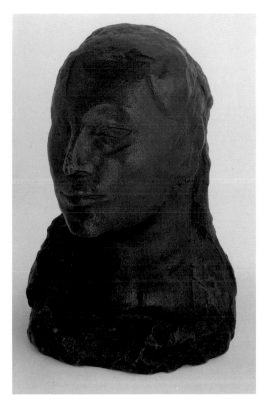

1 Head of a Woman (Fernande) 1906
36 × 24 × 23

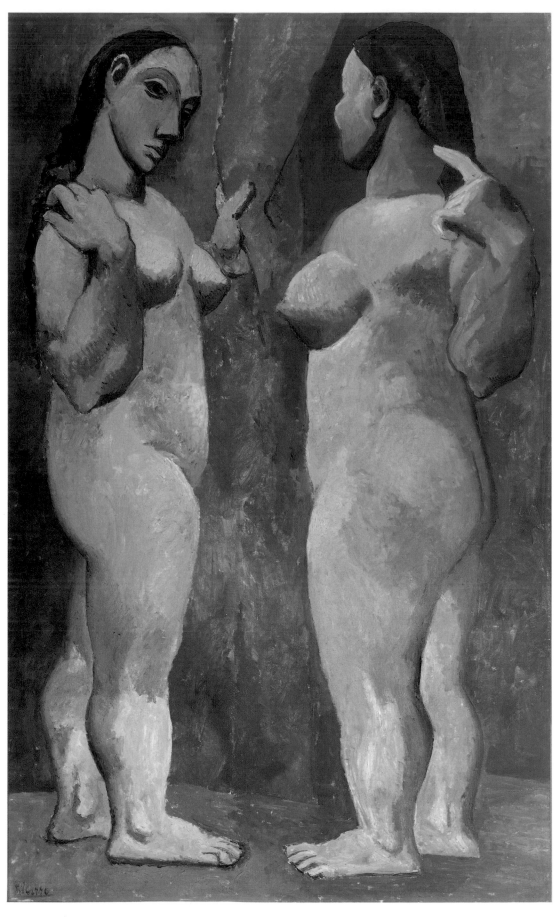

9 **Two Nudes** 1906
151.3 × 93

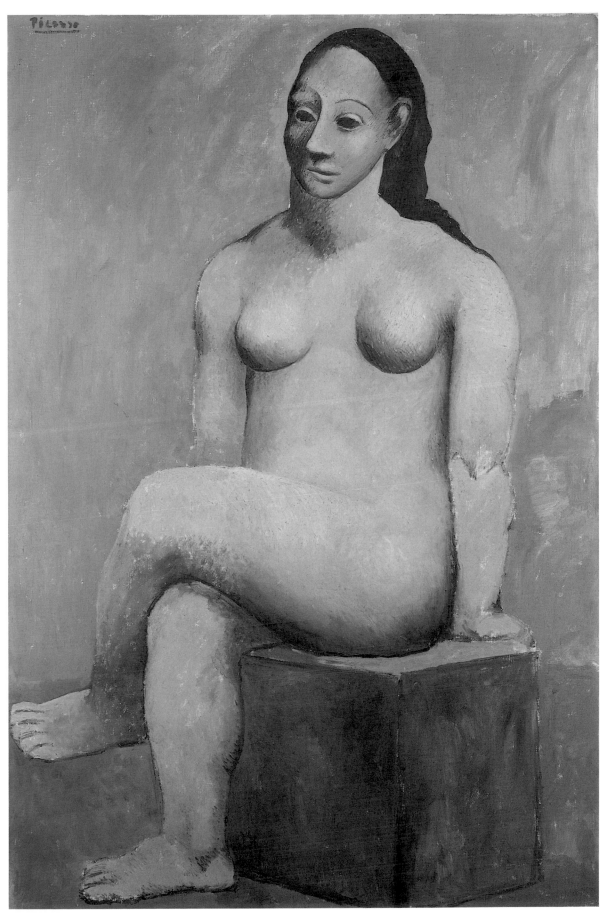

10 Seated Nude with Crossed Legs 1906
151 × 100

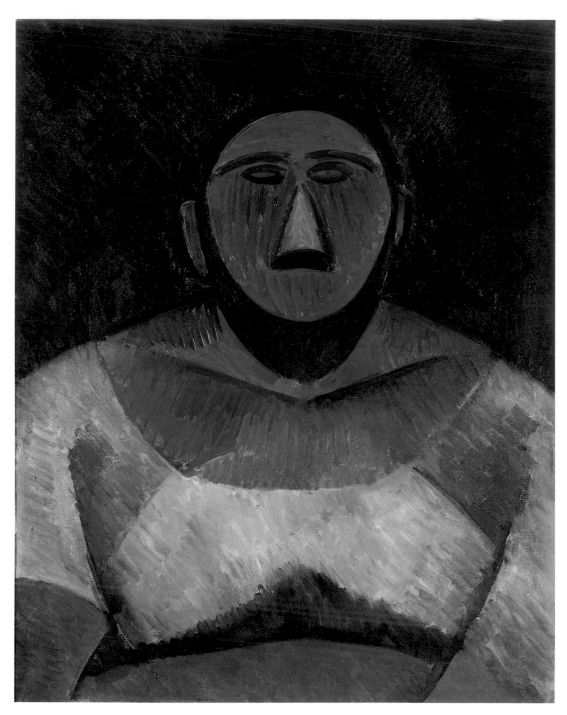

14 Head and Shoulders of the
Farmer's Wife 1908
81 × 65

3 Standing Man 1907 or 1908
37 × 6 × 6

11 Nude with Raised Arms 1908
67 × 27

12 Standing Nude 1908
67 × 27

13 **Seated Nude** 1908
150 × 100

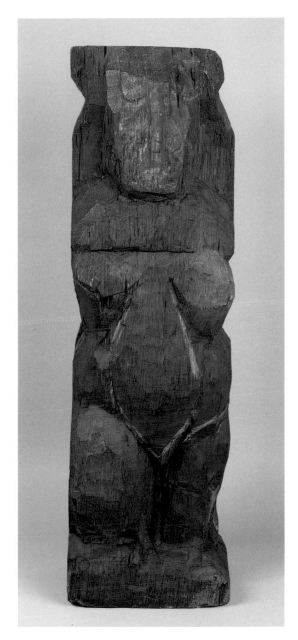

4 **Figure** ?1908
 80.5 × 24 × 20.8

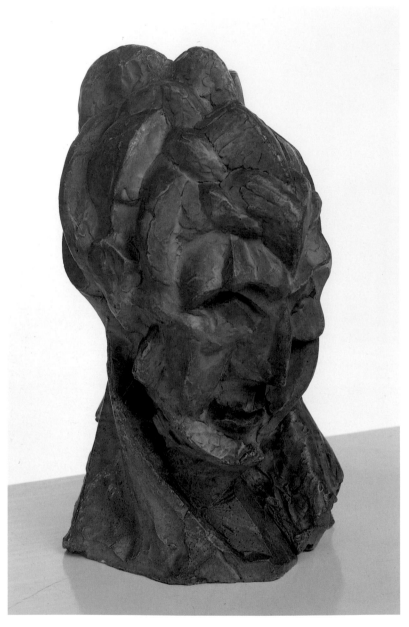

5 Head of a Woman (Fernande) 1909
 40.5 × 23 × 26

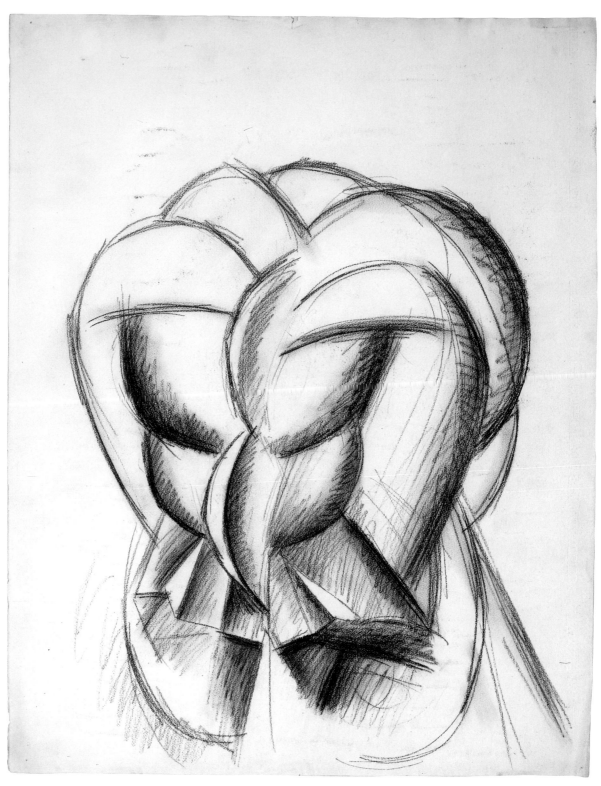

15 Study for 'Head of a Woman
 (Fernande)' 1909
 62.8 × 48

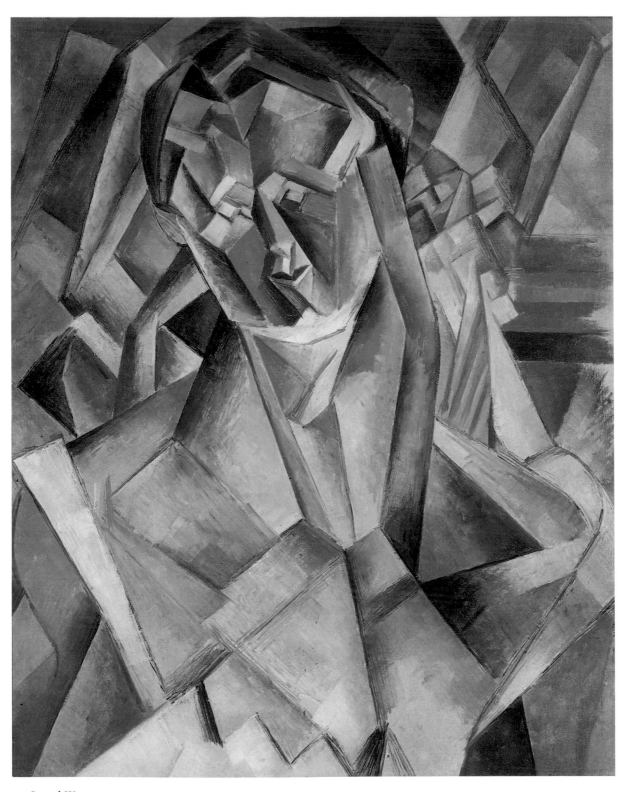

17 Seated Woman 1909
81 × 65

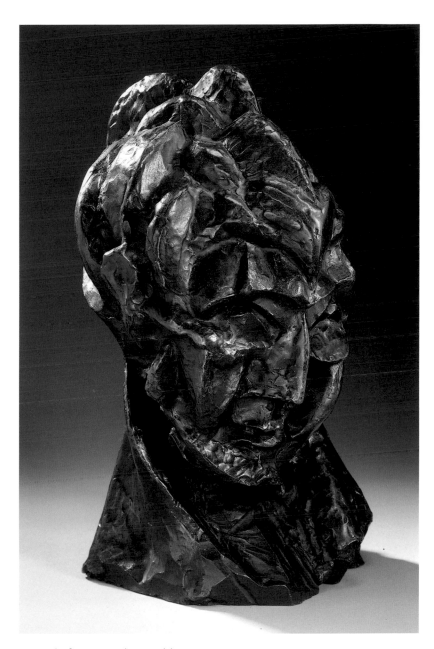

6 Head of a Woman (Fernande) 1909
 41.9 × 26.1 × 26.7

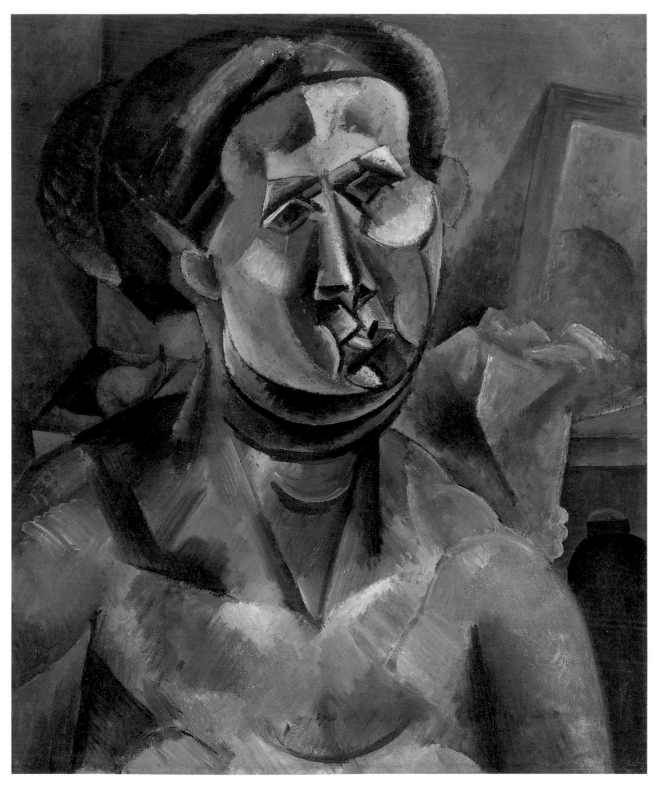

16 Head and Shoulders of a Woman
(Fernande) 1909
60.6 × 51.3

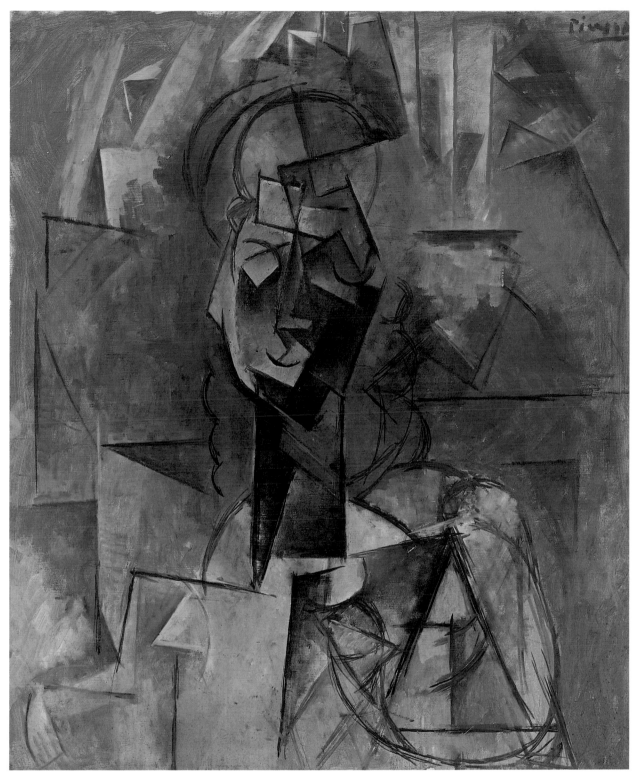

18 Bust of a Woman 1909–10
 73 × 60

2 Construction and Synthesis

Thus when we used to make our constructions, we produced 'pure truth', without pretensions, without tricks, without malice. What we did then had never been done before: we did it disinterestedly, and if it is worth anything it is because we did it without expecting to profit from it. We sought to express reality with materials we did not know how to handle and which we prized precisely because we knew that their help was not indispensable to us, that they were neither the best nor the most adequate. We put enthusiasm into the work, and this alone, even if that were all that were in it, would be enough: and much more than is usually put into an effort – for we surrendered ourselves to it completely, body and soul. We departed so far from the modes of expression then known and appreciated that we felt safe from any suspicion of mercenary aims.

Picasso, reported by Jaime Sabartés, *Picasso: An Intimate Portrait*, New York 1948

Spectators, already shocked by all those things covering the studio walls which they could not bring themselves to call pictures because they were made with oil cloth, wrapping paper and newspaper, pointed an accusing finger at the object of Picasso's intelligent attentions and asked:

'What is that? Should it have a base? Is it supposed to hang on the wall? What is it supposed to be, painting or sculpture?'

Picasso, dressed in the blue of the Parisian artisan, replied in his most beautiful Andalusian accent:

'It's nothing, it's the guitar!'

And that's it. The watertight barriers have been breached. Now we are delivered from Painting and Sculpture, themselves already liberated from the imbecile tyranny of genres. It's neither one thing nor another. It's nothing. It's the guitar! …

Art will at last be fused with life, now that we have at last ceased to try to make life fuse with art.

André Salmon, *La Jeune Sculpture française*, Paris 1919

Picasso in his studio,
rue Schoelcher, Paris *c.*1914
Musée Picasso Archive, Paris

[57]

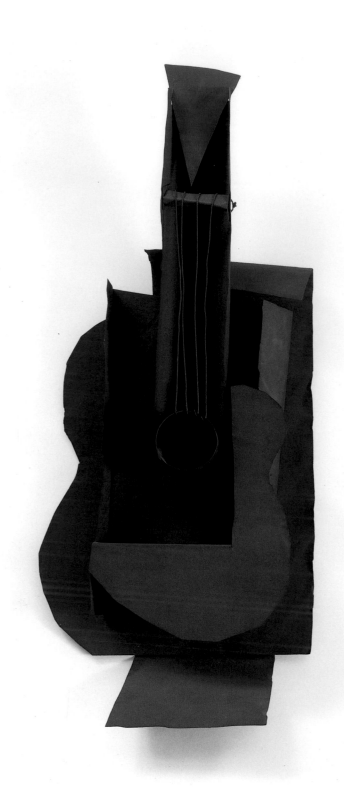

19 Guitar ?1912–13
77.5 × 35 × 19.3

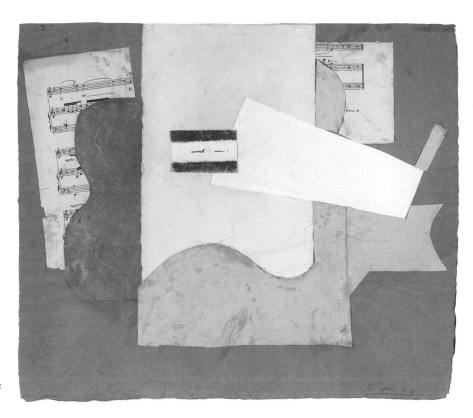

27 Musical Score and Guitar 1912
42.5 × 48

30 Head of a Girl 1913
55 × 38

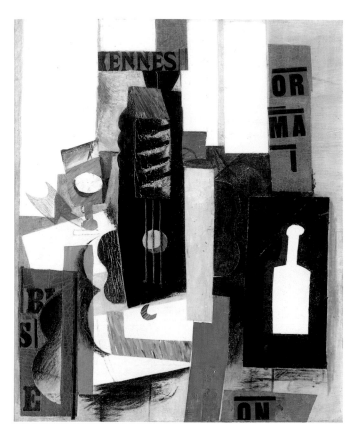

28 Glass, Guitar and Bottle 1913
65.4 × 53.6

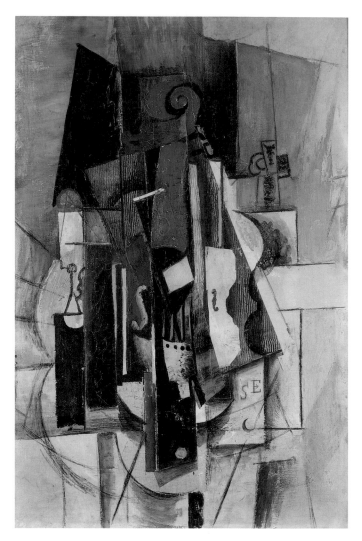

29 Violin, Glass and Bottle 1913
81 × 54

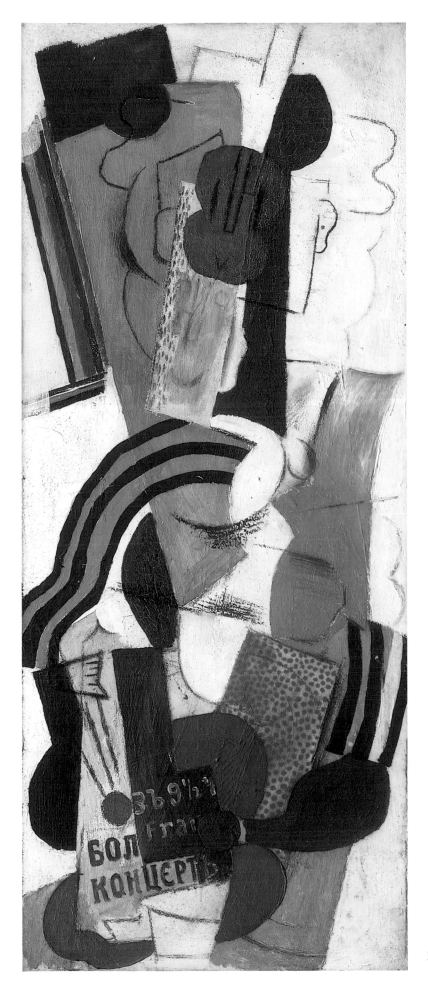

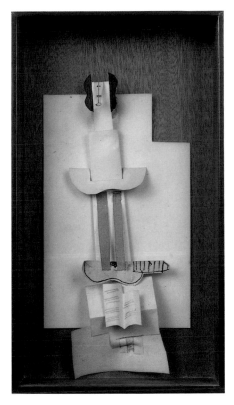

20 Guitarist with Sheet Music 1913
22 × 10.5

32 Woman with a Mandolin 1914
115.5 × 47.5

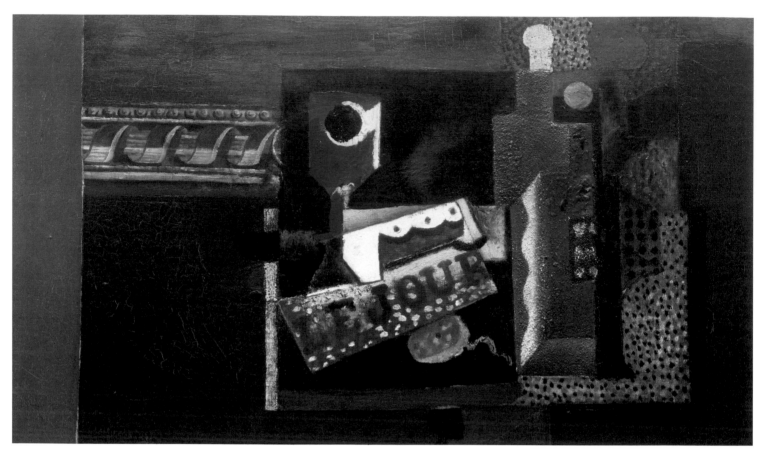

36 Glass, Newspaper and Bottle 1914
 36.2 × 61.3

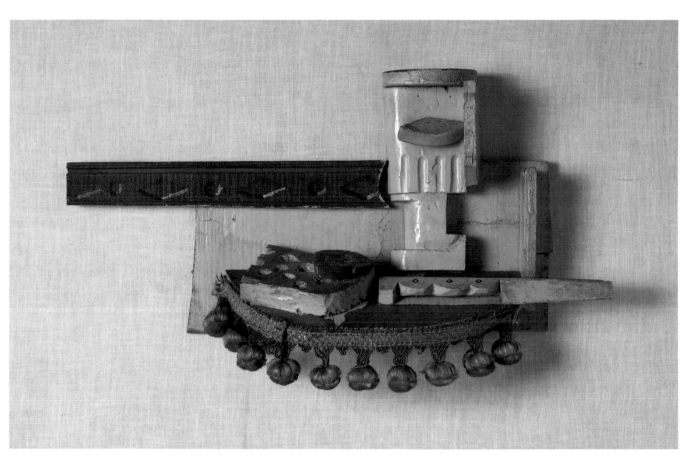

22 Still Life 1914
 25.4 × 45.7 × 9.2

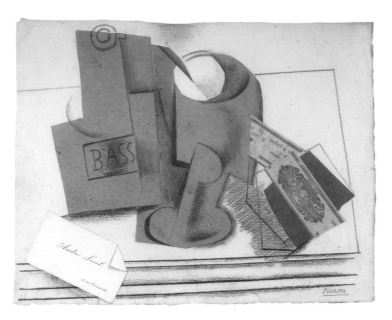

33 Bottle of Bass, Wineglass, Packet
of Tobacco, Calling Card 1914
24 × 30.5

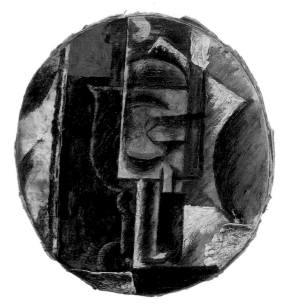

31 Wineglass with Slice
of Lemon c.1914
20.5 × 18.5

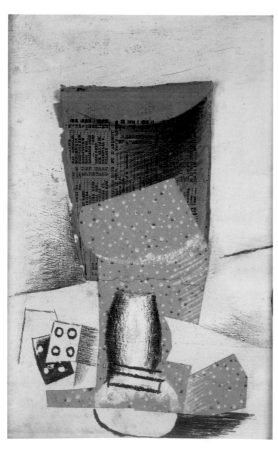

34 Wineglass and Dice 1914
23.5 × 14.5

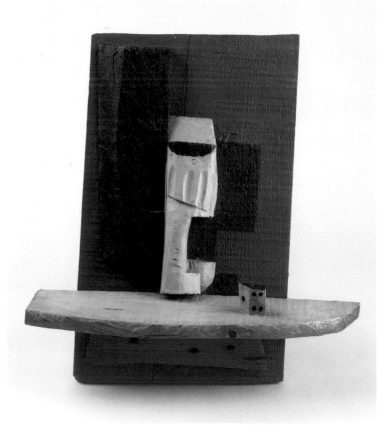

21 Glass and Dice 1914
23.5 × 21.6 × 7

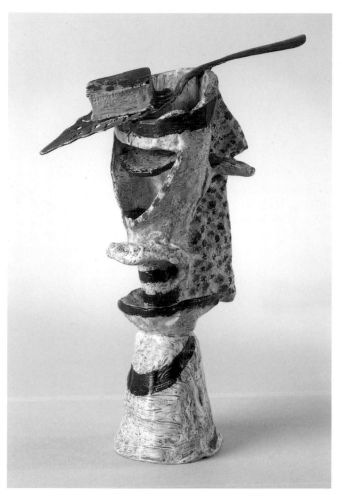

24 Glass of Absinthe 1914
 22 × 16.5 × 5

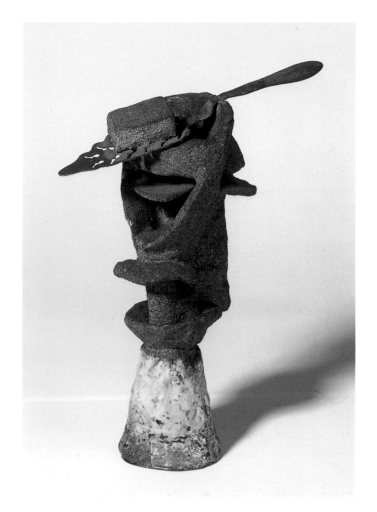

23 Glass of Absinthe 1914
 21.5 × 16.5 × 6.5

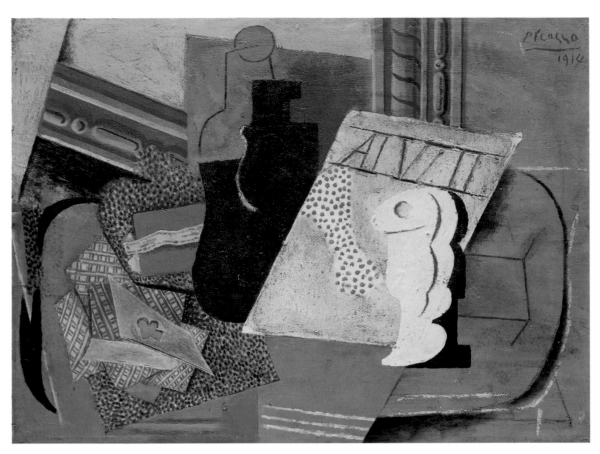

35 Playing Cards, Packet of Tobacco,
Bottle and Glass 1914
36.8 × 49.8

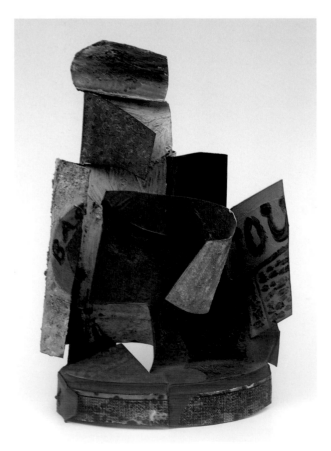

25 Bottle of Bass, Glass
and Newspaper 1914
20.7 × 14 × 8.5

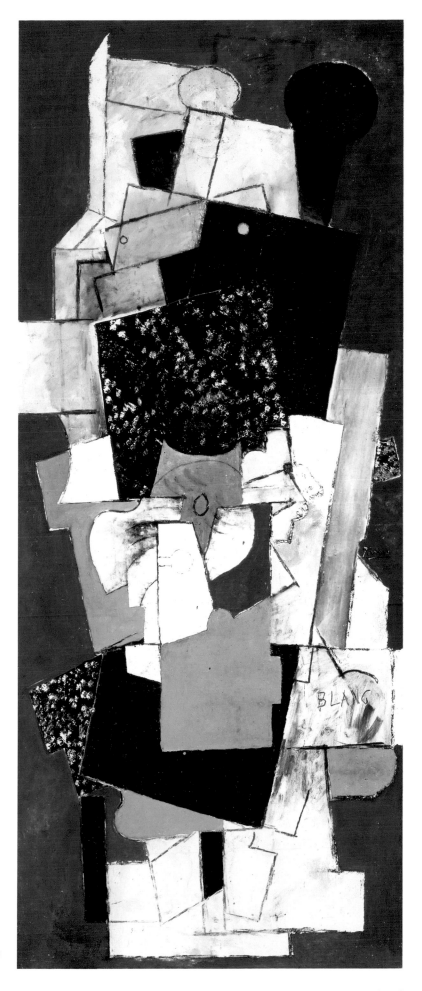

37 Woman with a Guitar 1915
186 × 75

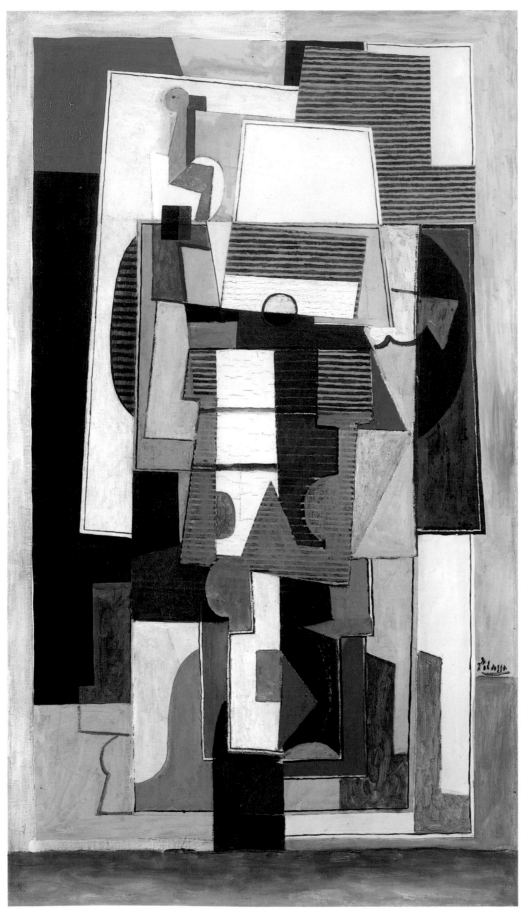

38 Table, Guitar and Bottle 1919
127 × 74.9

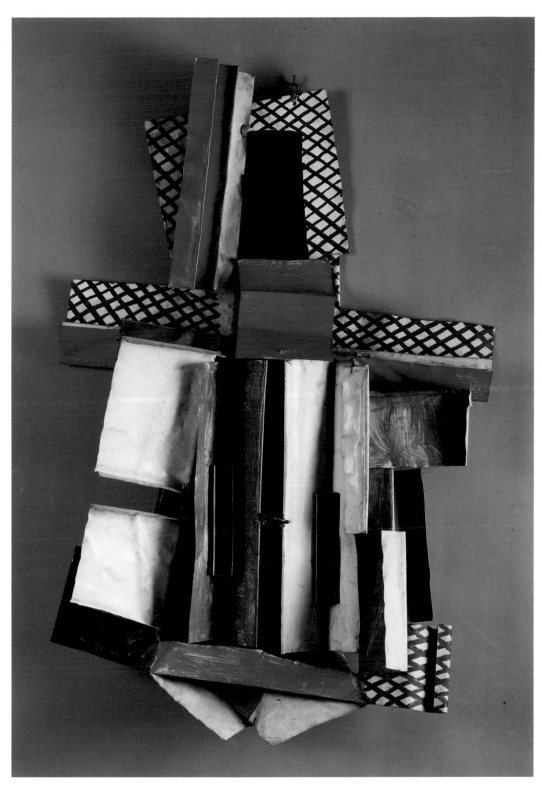

26 Violin 1915
100 × 63 × 18

3 The Sculptor's Studio

The several manners I have used in my art must not be considered as an evolution, or as steps toward an unknown ideal of painting. All I have ever made was made for the present and with the hope that it will always remain in the present. I have never taken into consideration the spirit of research. When I have found something to express, I have done it without thinking of the past or of the future. I do not believe I have used radically different elements in the different manners I have used in painting. If the subjects I have wanted to express have suggested different ways of expression I have never hesitated to adopt them. I have never made trials nor experiments. Whenever I had something to say, I have said it in the manner in which I have felt it ought to be said. Different motives inevitably require different methods of expression. This does not imply either evolution or progress, but an adaptation of the idea one wants to express and the means to express that idea.

Picasso, as reported by Marius de Zayas in 'Picasso Speaks', *The Arts*,
vol.3, May 1923

Technique? I don't have any, or rather, I have one but it wanders a great deal, according to the mood I'm in when I begin working. I apply it at will to express my idea. I think I have discovered many methods of expression, and still I believe there are many more to discover.

Picasso, as reported by Felipe Cossio del Pomar, *Con las Buscadores del Camino*,
Madrid 1932

Picasso says: 'If you know exactly what you're going to do, what's the point in doing it? Since you know, there's no interest in it ... It's better to do something else.'

Hélène Parmelin, *Picasso: Women: Cannes and Mougins: 1954–63*, London 1965

Plaster Cast of Picasso's hand 1937
Photo: Brassaï © Gilberte Brassaï

50 Standing Nudes and Study
 of a Foot 1908
 30 × 21.6

51 **Standing Nude Seen from
the Back** 1908
63 × 48

52 **Head of a Man** 1909
63 × 48

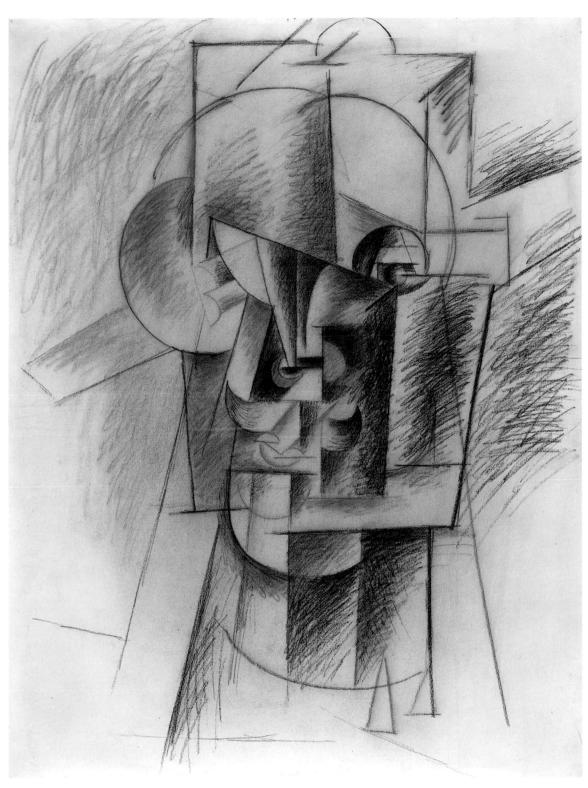

55 Head of a Man 1912
64 × 49

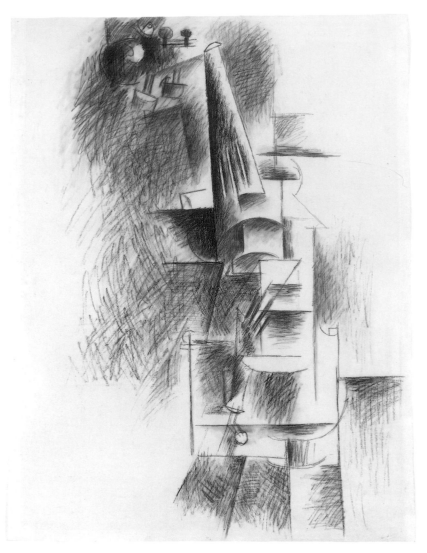

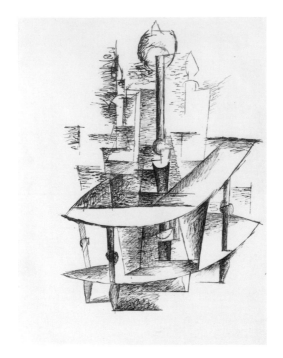

54 Violin 1912
57.8 × 45.7

53 Still Life: The Cruet Set 1911
31.4 × 24.4

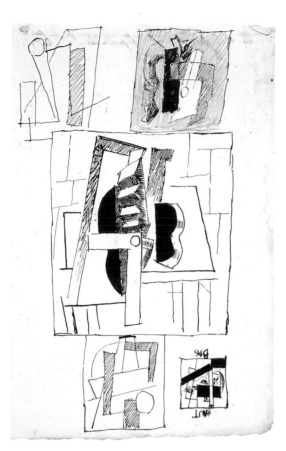

57 Various Studies: Guitars 1913
35.7 × 22.6

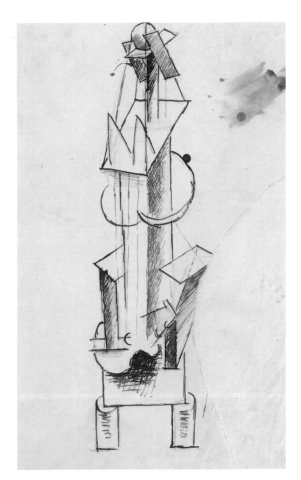

56 Woman with a Guitar 1912
31 × 20

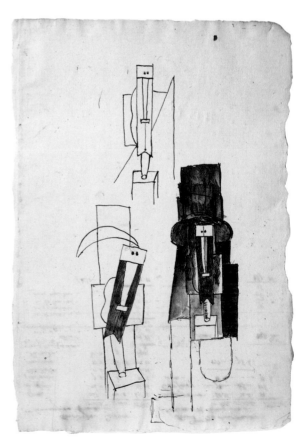

58 Three Heads 1913
35.8 × 23.3

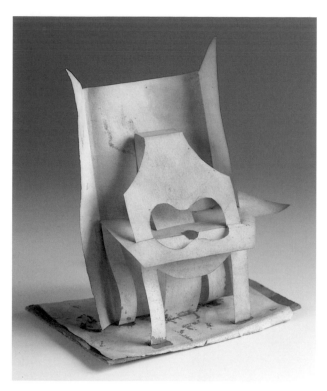

39 Guitar and Table in Front
 of a Window 1919
 16.4 × 15 × 10

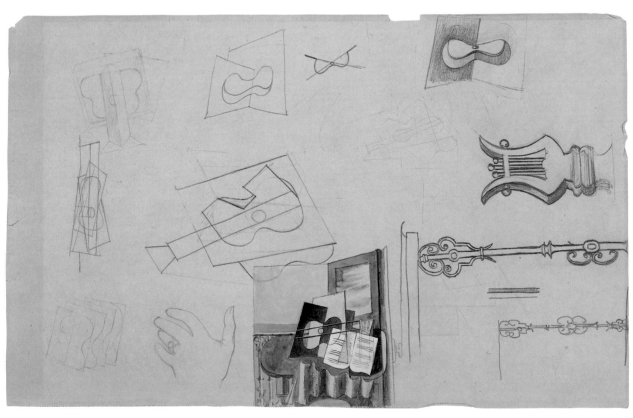

61 Still Life in Front of an Open
 Window at Saint-Raphaël 1919
 31 × 49

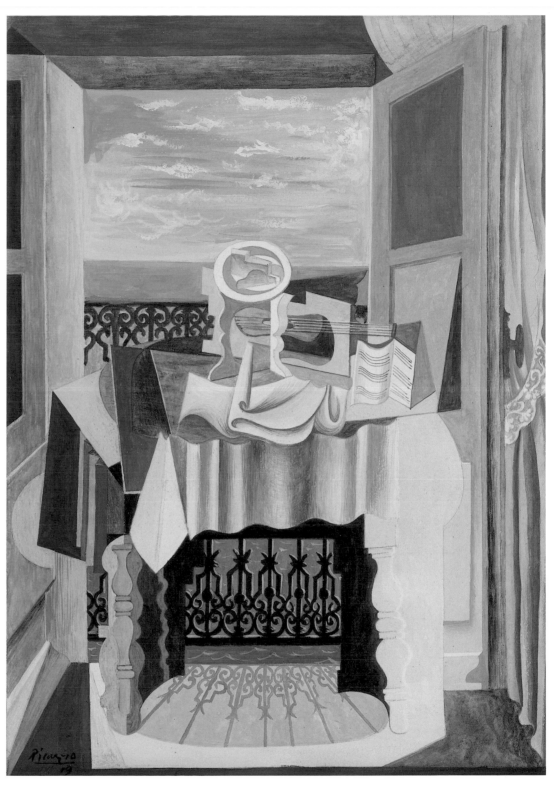

60 Still Life in Front of an Open
 Window at Saint-Raphaël 1919
 35.5 × 25

59 Woman in an Armchair
 1916 or 1917
 34.5 × 32.6

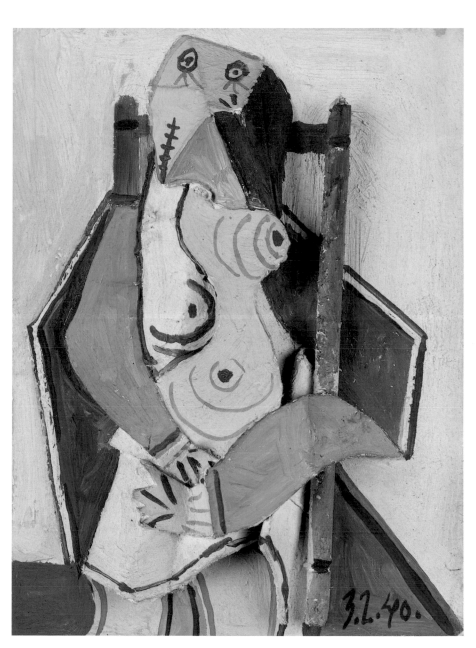

43 Woman Seated in an Armchair
1940
15.5 × 11.5

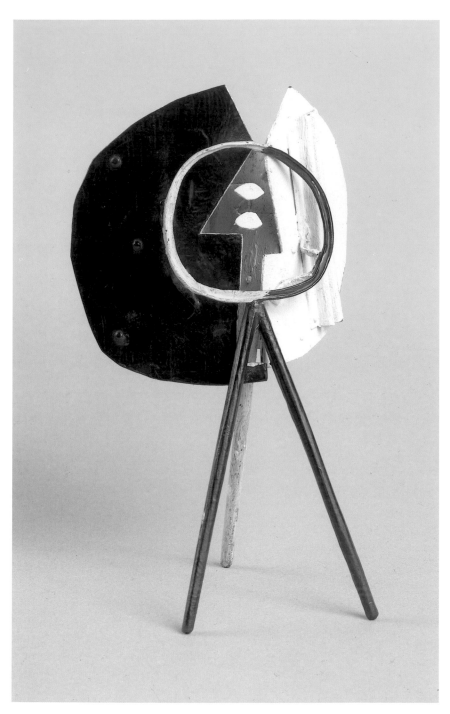

40 Head 1928
18 × 11 × 7.5

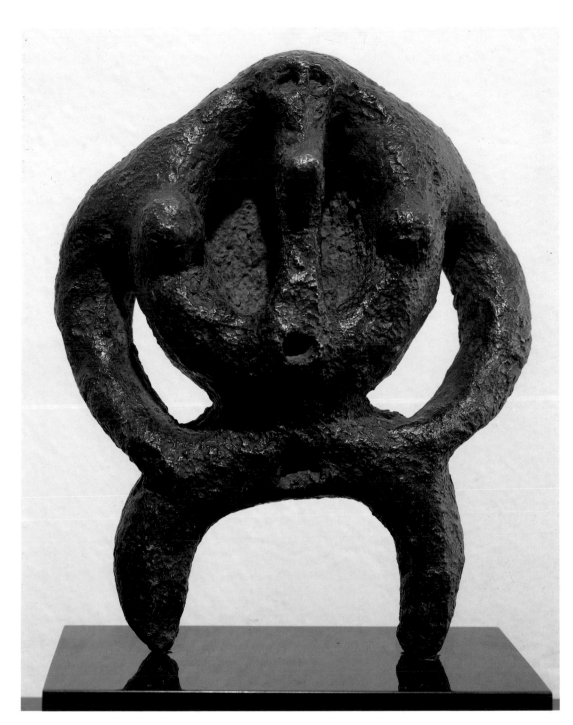

45 Woman 1948
18 × 14 × 7

64 Sketchbook 1044 1928
96.5 × 78.7
*exhibited pages

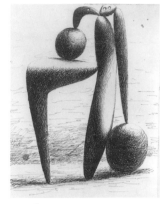

cover

page 1*

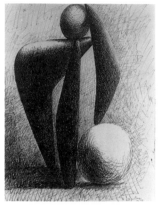

page 2

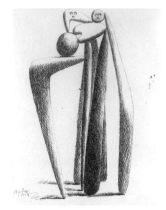

page 3

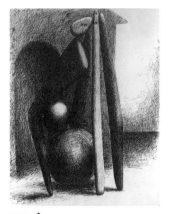

page 4*

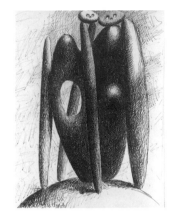

page 5

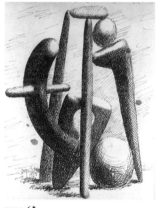

page 6*

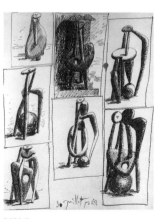

page 7

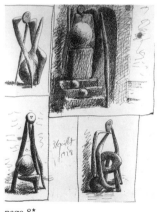

page 8*

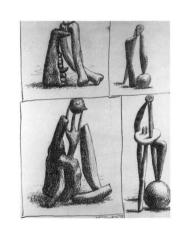

page 9

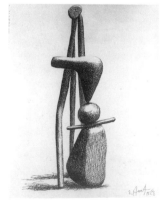

page 10*

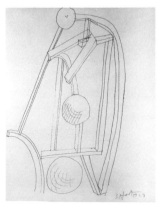

page 11

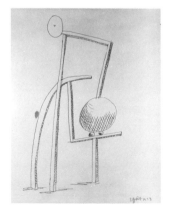

page 12

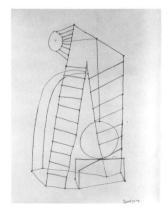

page 13

page 14

page 15

page 16

page 17

page 18*

page 19

page 20*

page 21

page 22

page 23

page 24

page 25

page 26

page 27

page 28

page 29

page 30

page 31

page 32

page 33

page 34

page 35

page 36

page 37

page 38

page 39

page 40

page 41

page 42

page 43

page 44

page 45*

page 46

page 47

page 48

page 49

page 50

page 51

page 52

page 53

page 54

page 55

page 56

page 57

page 58*

page 59

page 60*

page 61

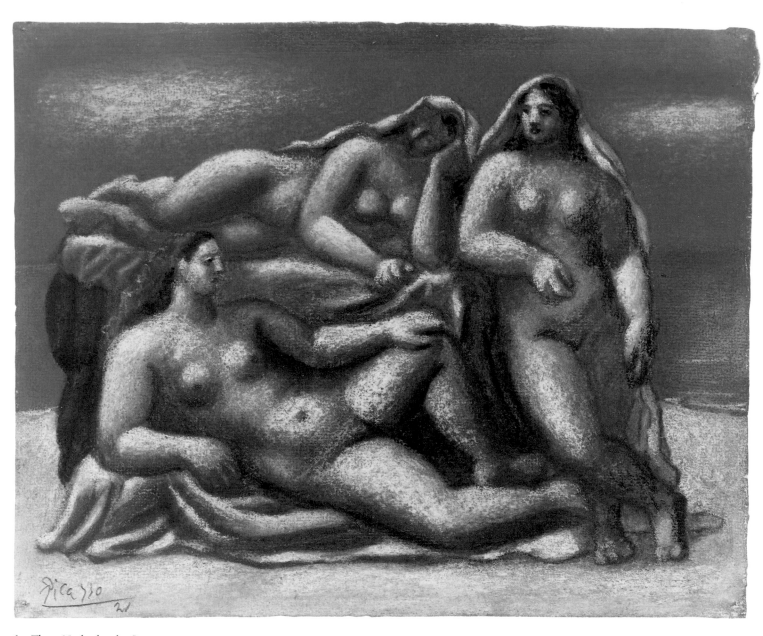

62 Three Nudes by the Sea 1921
24.2 × 30.1

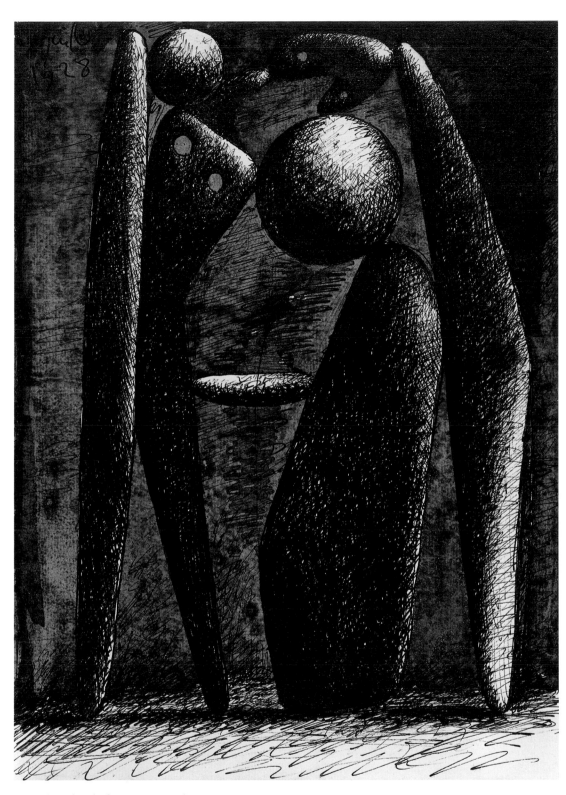

63 Bathers (Study for a Monument)
 1928
 30.2 × 22

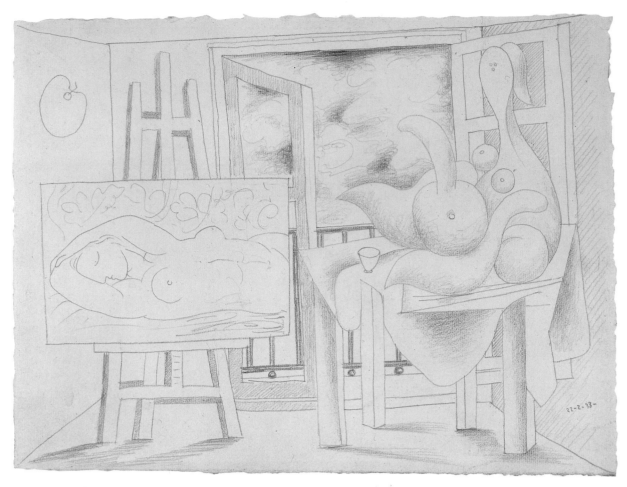

66 The Studio 1933
 26.2 × 34.3

67 An Anatomy: Seated Woman 1933
 20 × 27

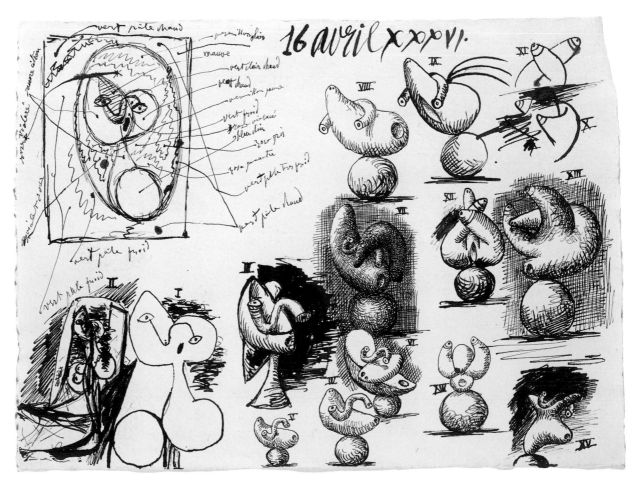

72 Various Studies: Head of
 a Woman 1936
 26 × 34

69 Two Figures 1933
 34 × 47.5

70 **Bathers** 1933
 22.9 × 28.9

65 Head of a Woman 1931
33 × 25.5

71 Composition 1933
34 × 51

49 **Palette** 1952
40 × 35.5

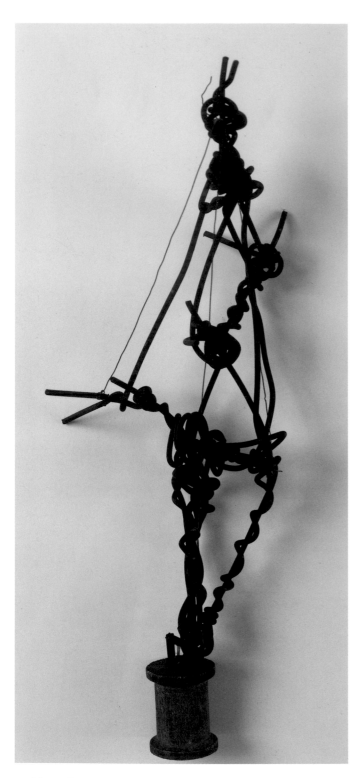

41 Figure ?1931
 32 × 9.5 × 6

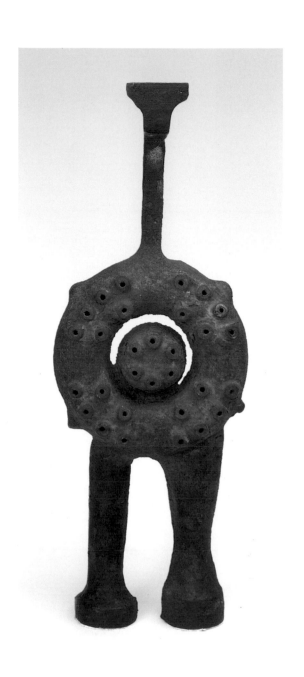

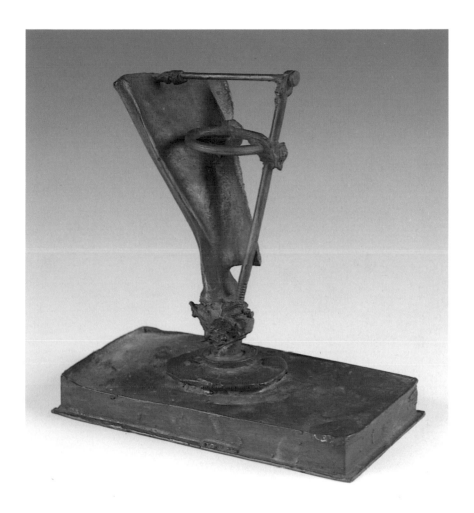

44 The Venus of Gas 1945
25 × 9 × 4

47 The Glass 1951
23 × 12 × 22

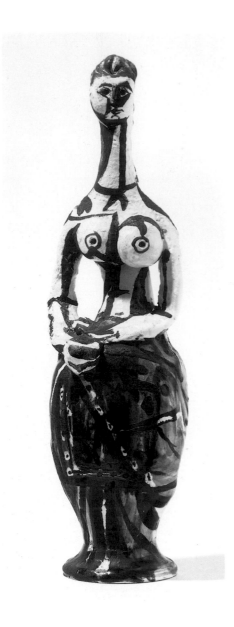

46 Woman with Clasped Hands 1950
29 × 7 × 7

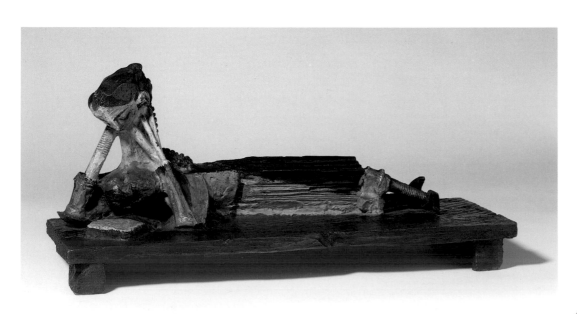

48 Woman Reading 1951–2
15.5 × 35.5 × 13

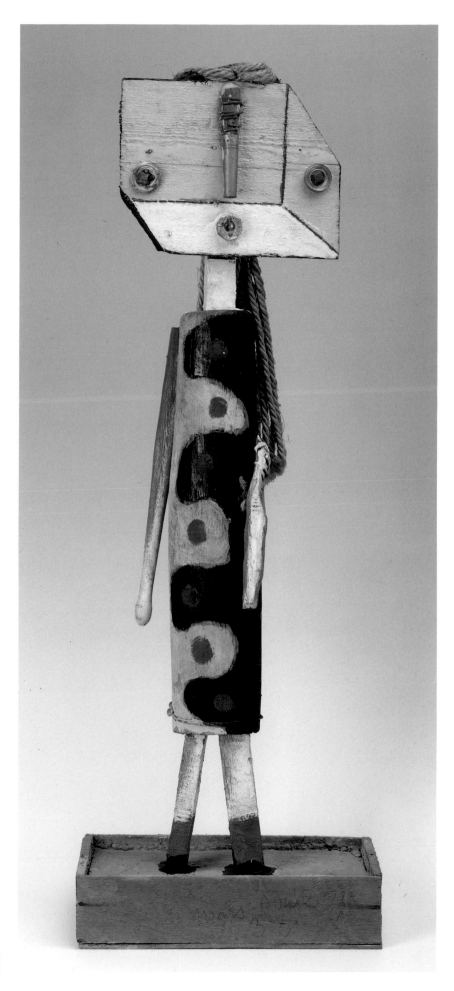

42 **Figure** 1935
58 × 20 × 11

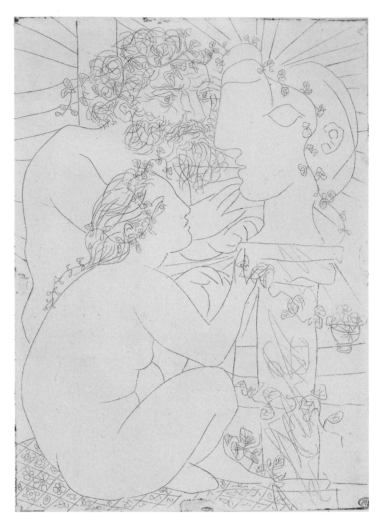

[i] **Sculptor, Seated Model and
Sculpted Head** 23 March 1933
26.9 × 19.4

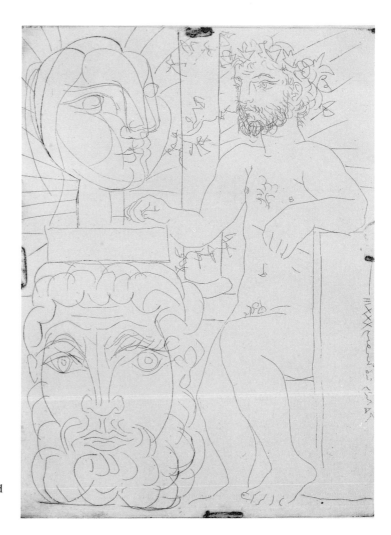

[ii] **Sculptor with Two Sculpted
 Heads** 26 March 1933
 26.7 × 19.4

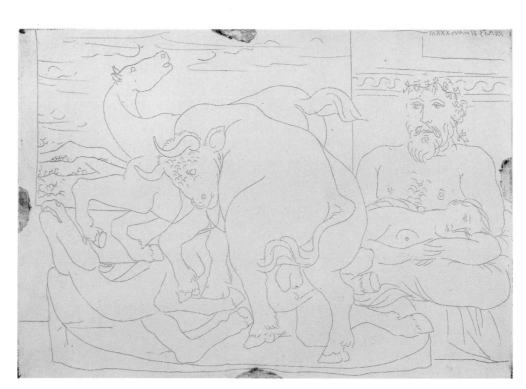

[iii] **Sculptor at Rest with a
 Sculpture of Horses and
 a Bull** 31 March 1933
 19.4 × 26.7

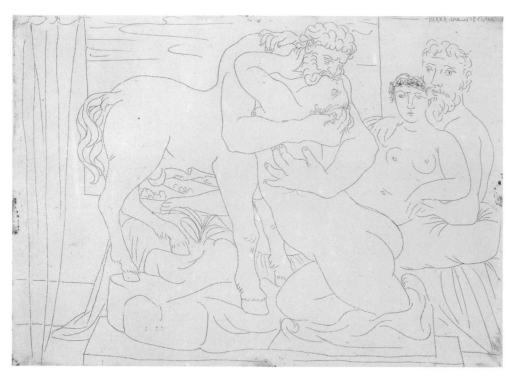

[iv] **Sculptor at Rest with a Sculpture
 of a Centaur and a Woman**
 31 March 1933
 19.4 × 26.8

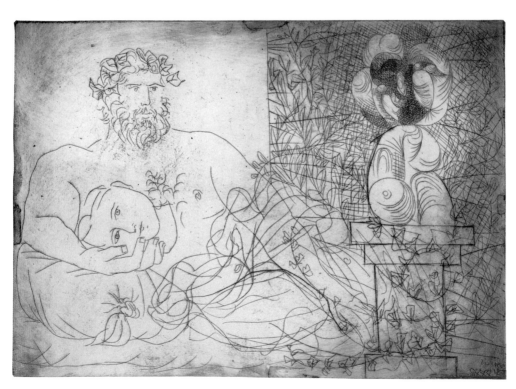

[v] **Sculptor at Rest and Surrealist
 Sculpture** 31 March 1933
 19.3 × 26.7

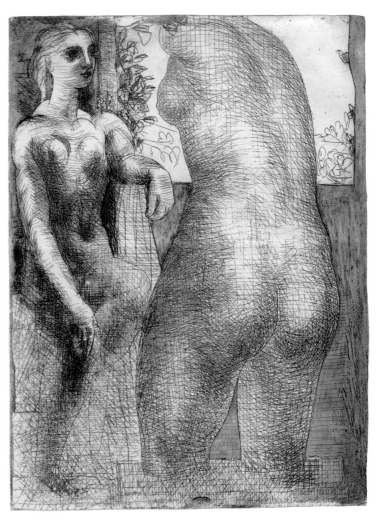

[vi] **Model and Large Sculpture Seen
from the Back** 4 May 1933
26.8 × 19.3

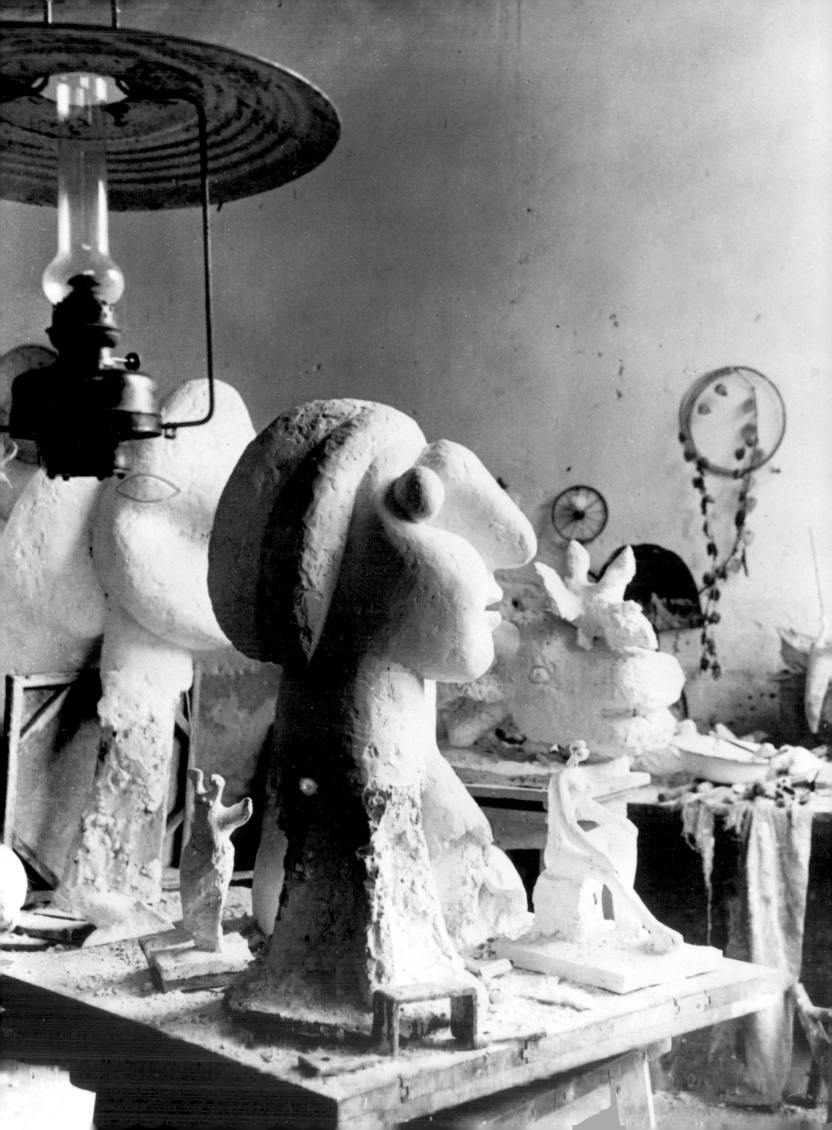

4 Classicism and Metamorphosis

The wire constructions … are *open-work sculpture*. They constitute a kind of *drawing in space*, but, at the same time, a first step towards the conquest, in sculpture, of a field which had never before been claimed by anything but architecture: the *creation of spaces*. They are, indeed, not merely line-drawings in space; they define fragments of space. These fragments of space can only be seen from without, owing to the small size of the constructions, but it ought to be known that only material considerations prevented Picasso from making practicable the constructions of that time. In 1929, he conceived of gigantic monuments, meant for erection on the Mediterranean shore as houses which at the same time would be enormous sculptures representing the female head. 'I have to paint them because nobody's ready to commission one from me', he said to me. In some of these pictures, he went so far as to add tiny human figures treated in *trompe l'oeil*, to simulate scale. He thought of the spaces which would have been enclosed by these 'monuments', which would have been at one and the same time applied – utilitarian – architecture and sculptural representations.

Daniel-Henry Kahnweiler, *The Sculptures of Picasso*, London 1949

Academic training in beauty is a sham. We have been deceived, but so well deceived that we can scarcely get back even a shadow of the truth. The beauties of the Parthenon, Venuses, nymphs, Narcissuses, are so many lies. Art is not the application of a canon of beauty but what the instinct and the brain can conceive beyond any canon. When we love a woman we don't start measuring her limbs. We love with our desires – although everything has been done to try and apply a canon even to love. The Parthenon is really only a farmyard over which someone put a roof; colonnades and sculptures were added because there were people in Athens who happened to be working, and wanted to express themselves. It's not what an artist *does* that counts, but what he *is*. Cézanne would never have interested me a bit if he had lived and thought like Jacques Emile Blanche, even if the apple he painted had been ten times as beautiful. What forces our interest is Cézanne's anxiety – that's Cézanne's lesson; the torments of Van Gogh – that is the actual drama of the man. The rest is a sham.

Picasso, as reported by Christian Zervos in 'Conversation avec Picasso', *Cahiers d'Art*, vol.10, 1935

Picasso's sculpture studio,
Château de Boisgeloup, Gisors 1932
Photo: Brassaï © Gilberte Brassaï

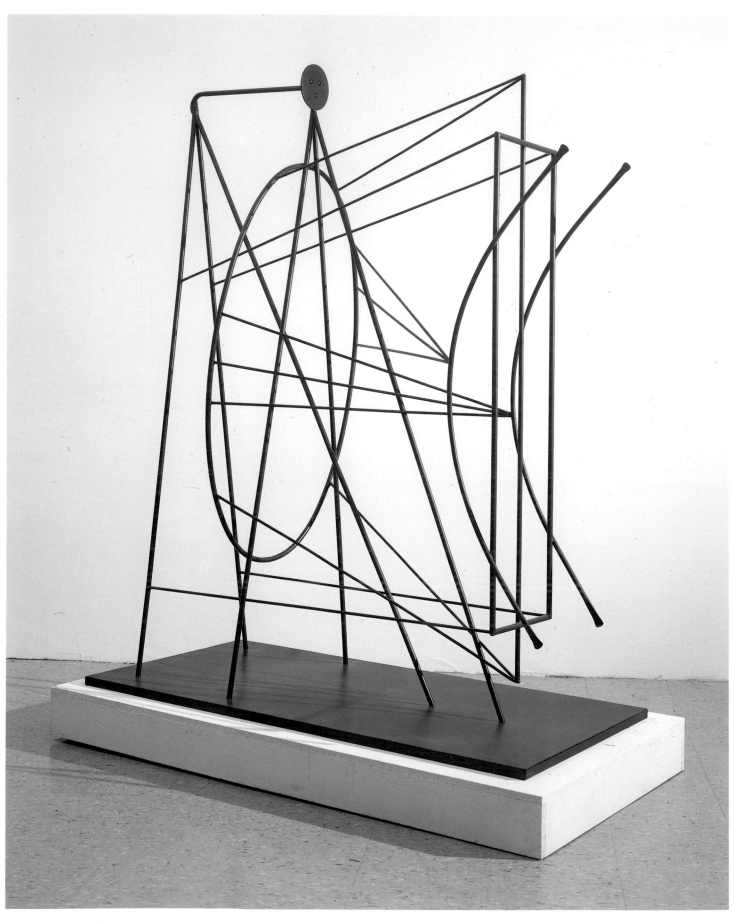

75 Figure: Project for a Monument to
 Guillaume Apollinaire 1928/c.1962
 198 × 159.4 × 72.3

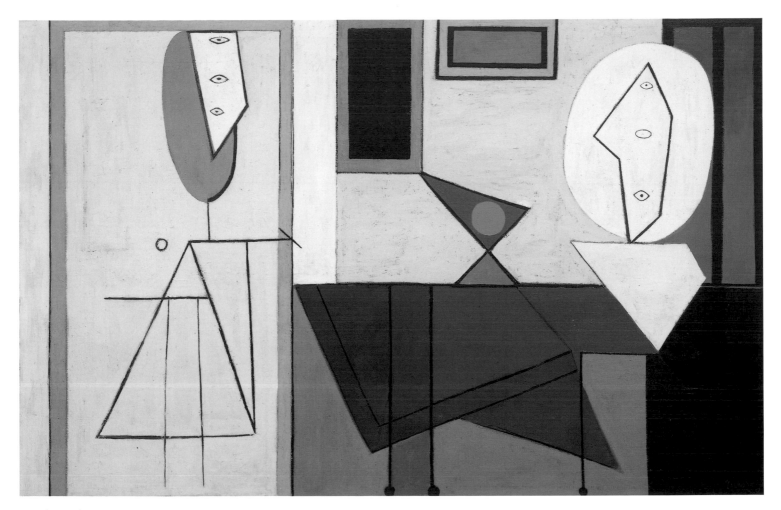

88 The Studio 1927–8
149.9 × 231.2

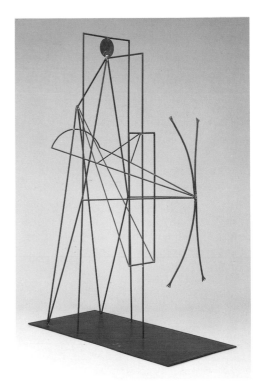

74 Figure: Project for a Monument to
Guillaume Apollinaire 1928/c.1962
95 high

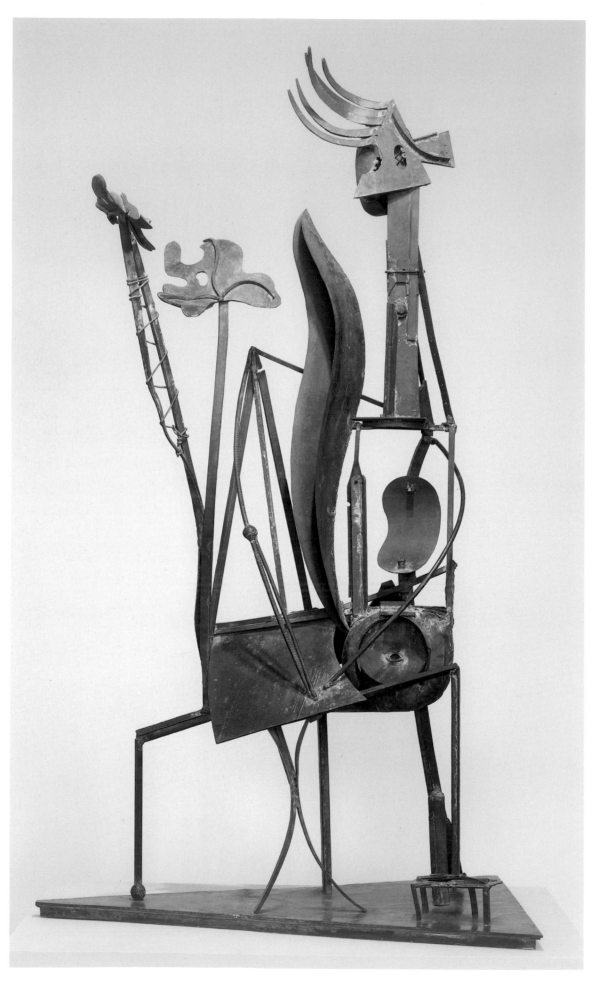

83 Woman in a Garden 1931–2
210 × 117 × 82

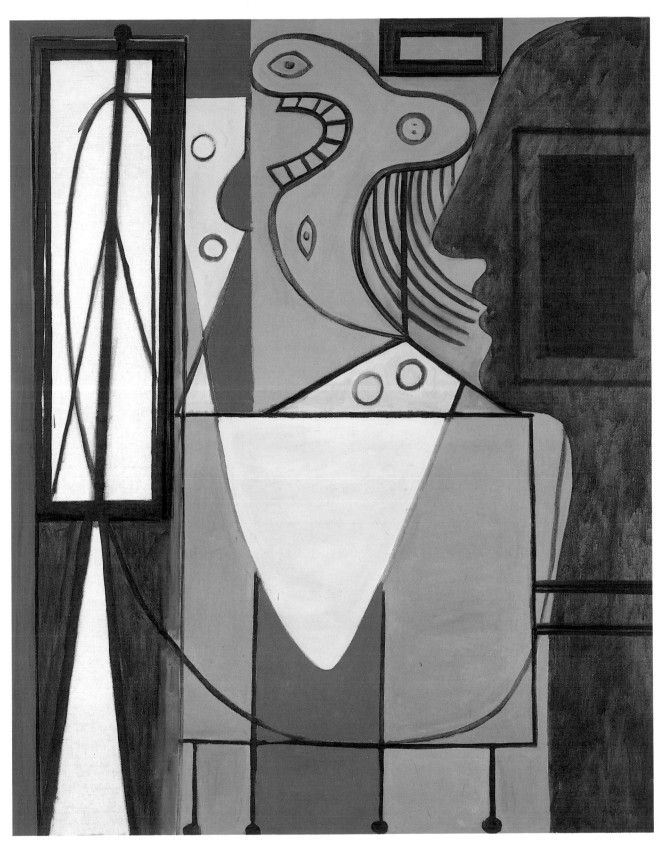

90 The Studio 1928–9
162 × 130

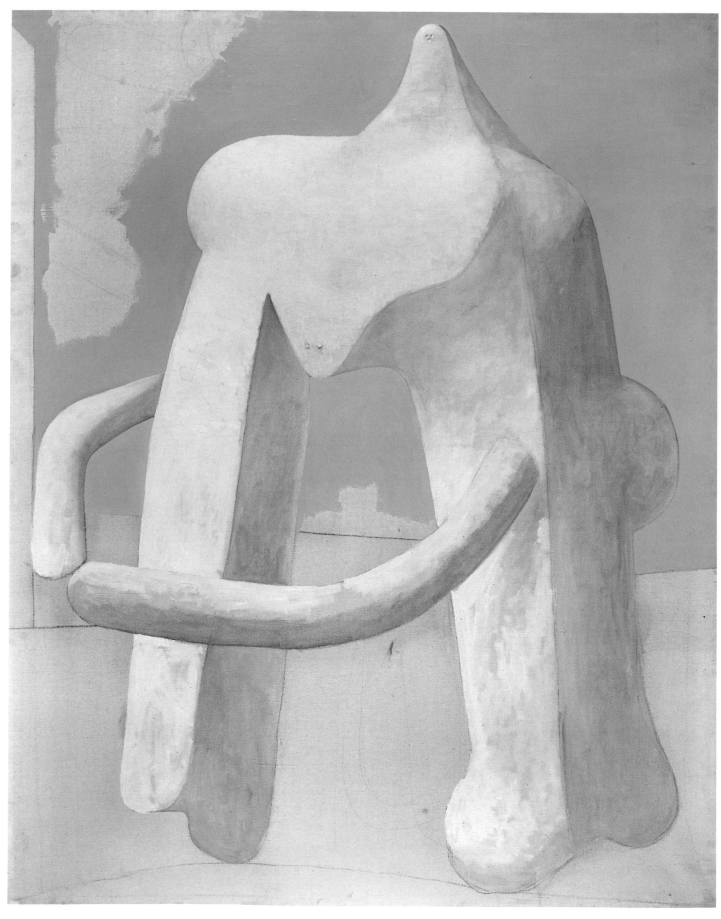

89 Standing Nude 1928
162 × 130

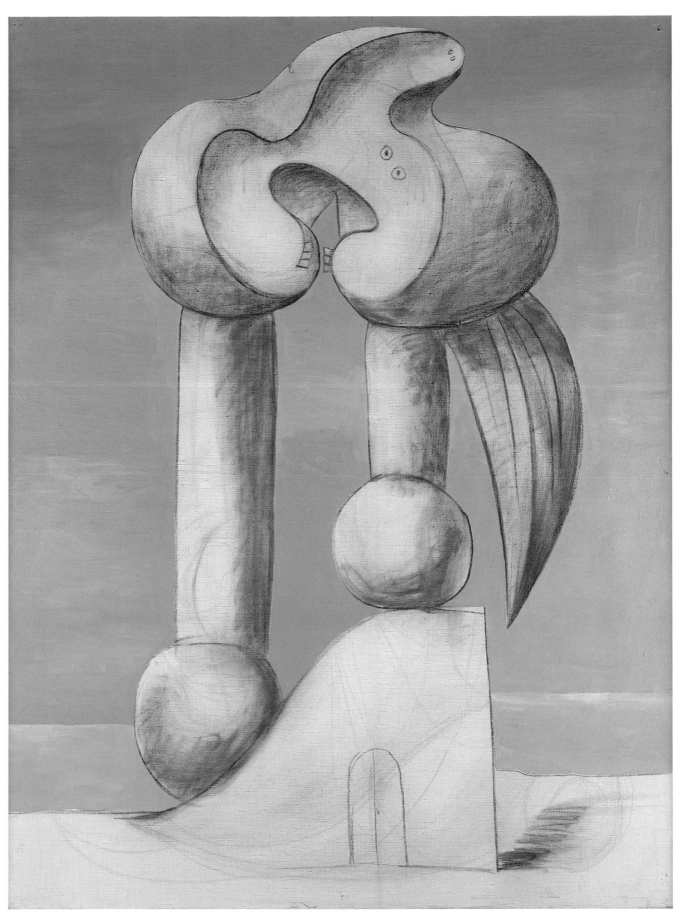

94 **Figures by the Sea** 1932
130 × 97

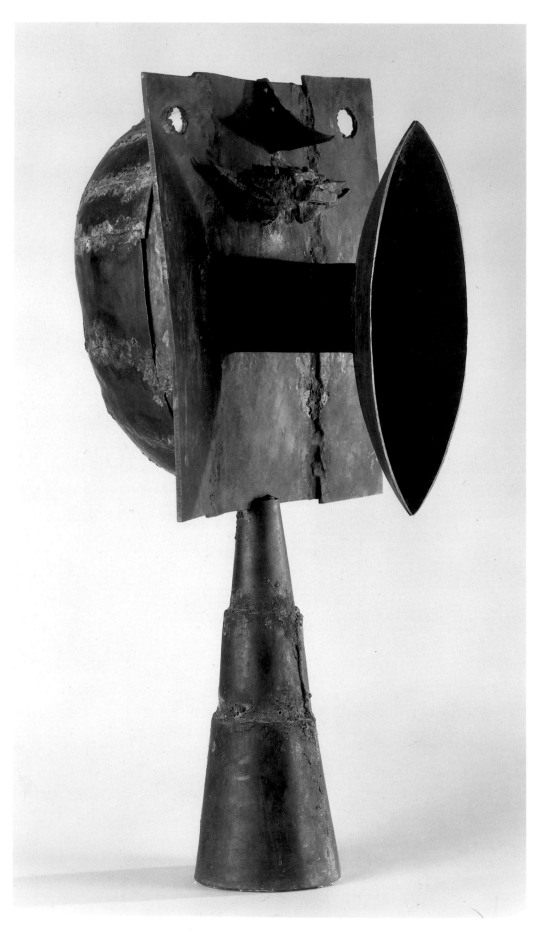

76 Head of a Man 1930
 83.5 × 40.5 × 36

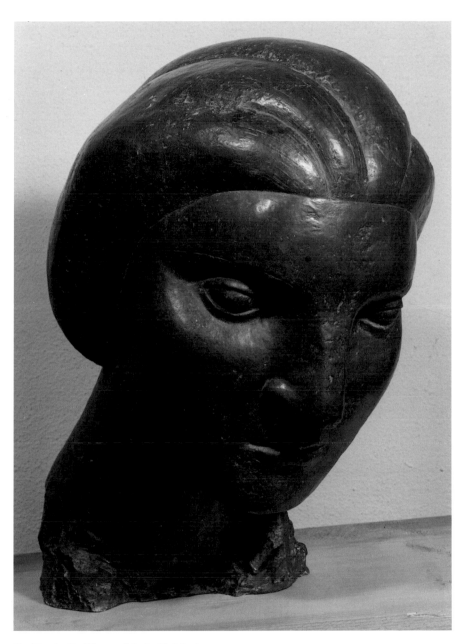

81 Head of a Woman (Marie-Thérèse)
 1931
 50 × 31 × 27

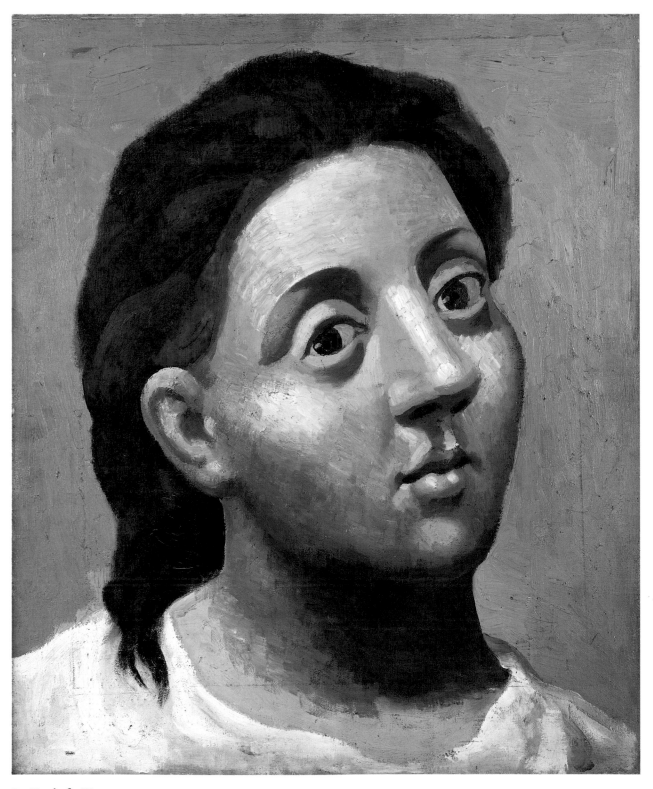

87 Head of a Woman 1921
55 × 46

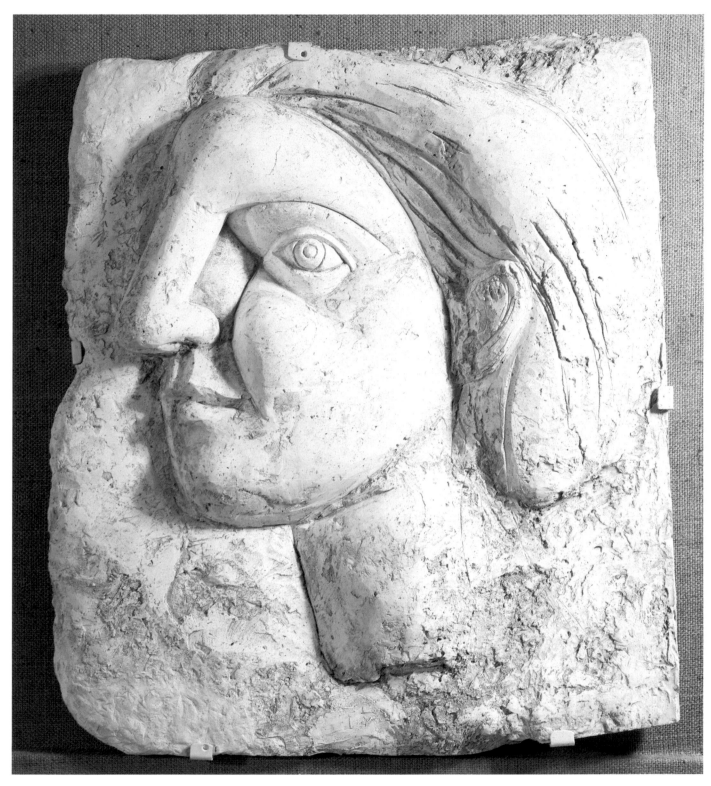

80 Head of a Woman in Profile
 (Marie-Thérèse) 1931
 69 × 60 × 10

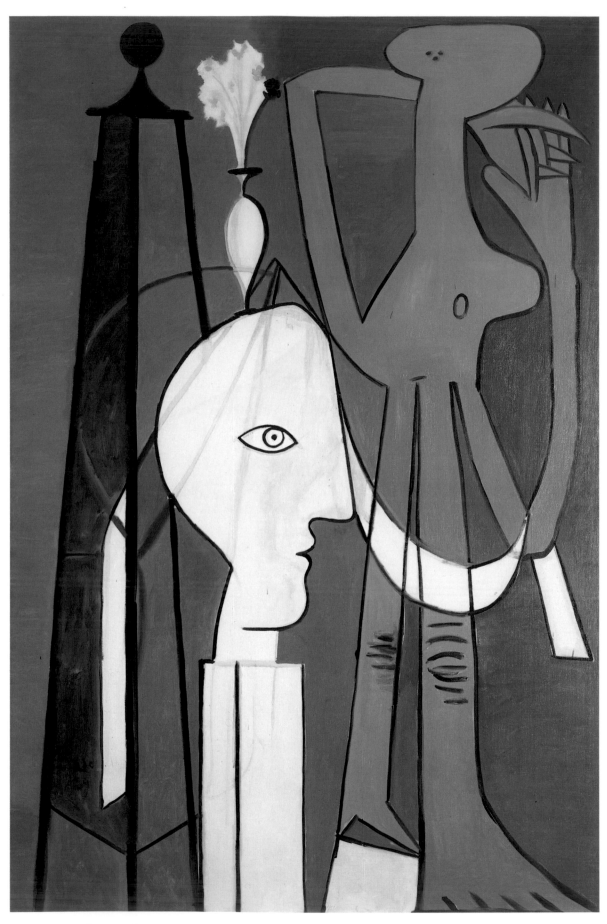

91 Woman, Sculpture and
Vase of Flowers 1929
195 × 130

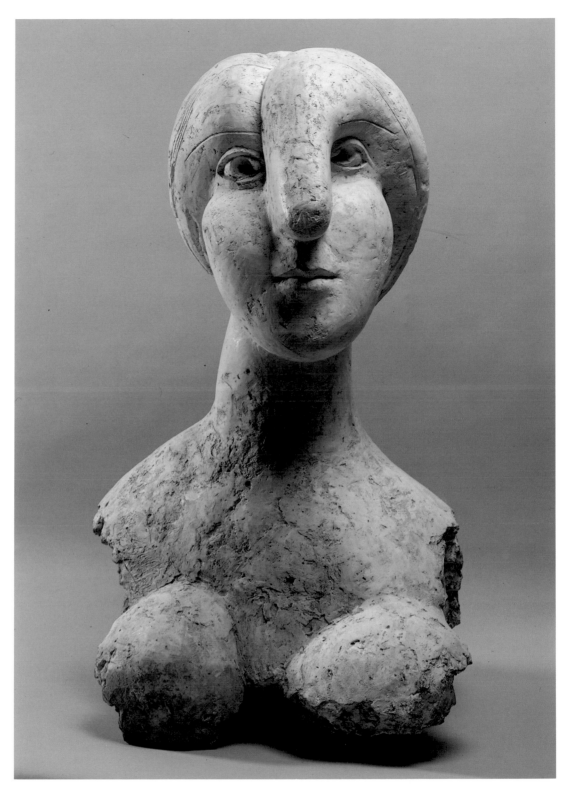

78 Bust of a Woman (Marie-Thérèse)
1931
78 × 46 × 48

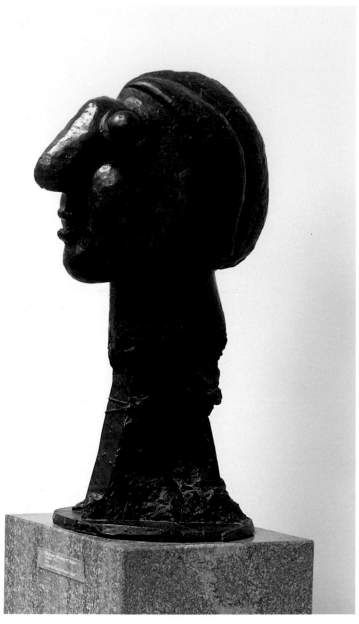

77 Head of a Woman 1931
 86 × 32 × 48.5

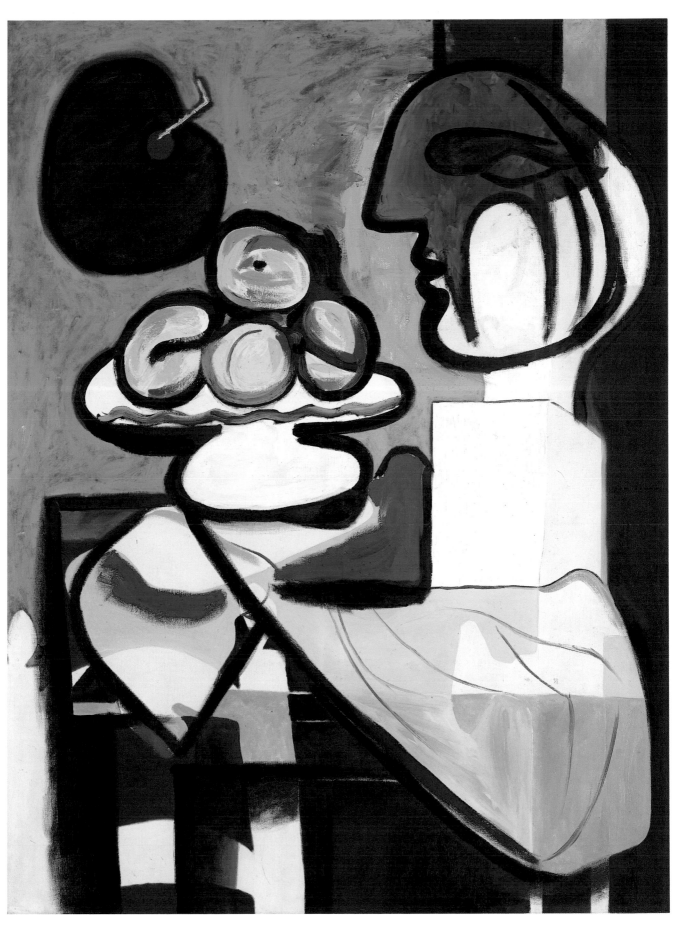

95 Still Life: Bust, Bowl
 and Palette 1932
 130.5 × 97.5

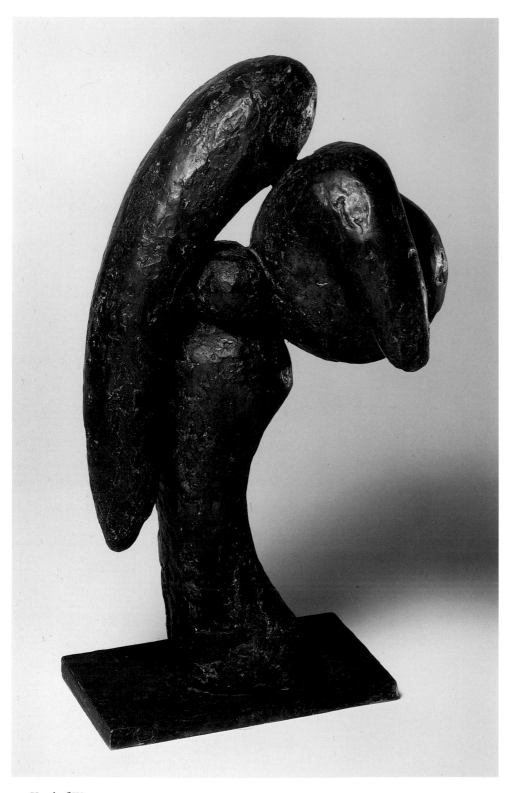

79 Head of Woman 1931
 71.5 × 41 × 33

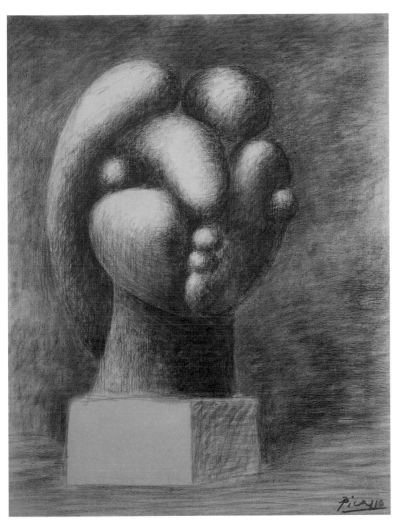

93 Study for a Sculpture 1932
 92 × 73

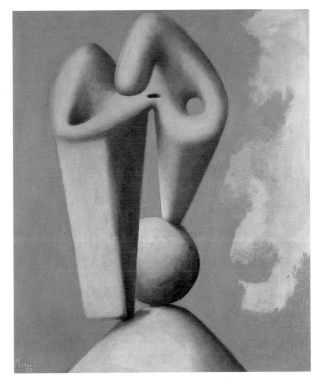

92 Head: Study for a
 Monument 1929
 73 × 59.7

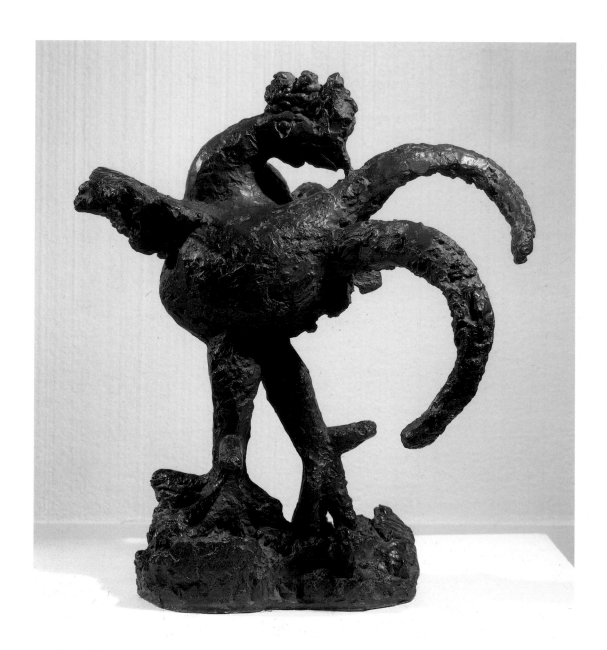

86 The Cock 1932
65.1 × 54.3 × 31.8

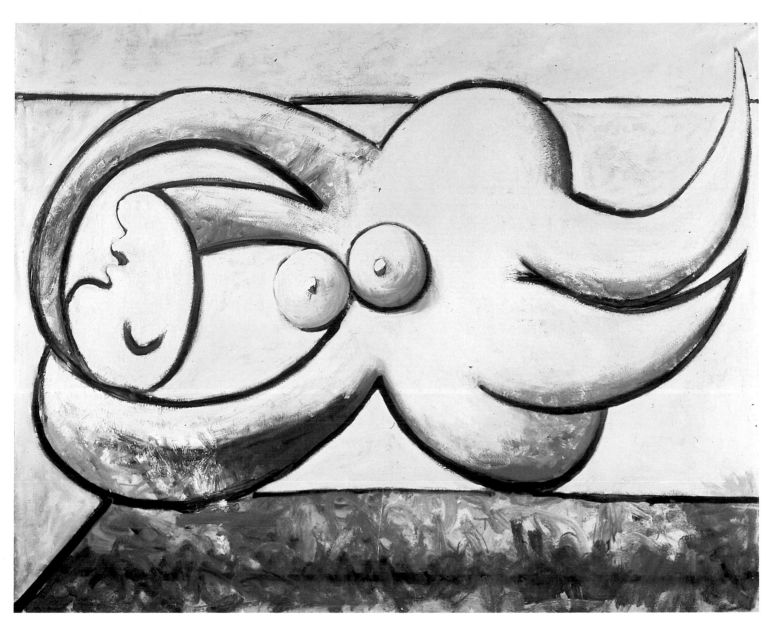

96 Reclining Nude 1932
130 × 161

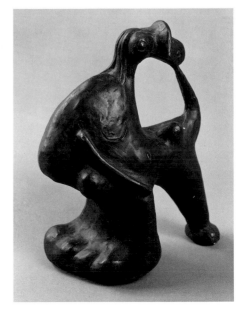

73 Metamorphosis I 1928
22.8 × 18.3 × 11

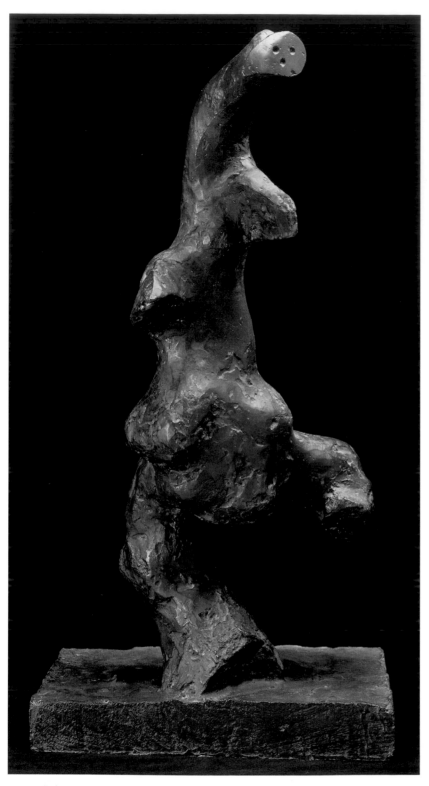

85 **Bather** 1931 or 1932
 56 × 28.5 × 20.5

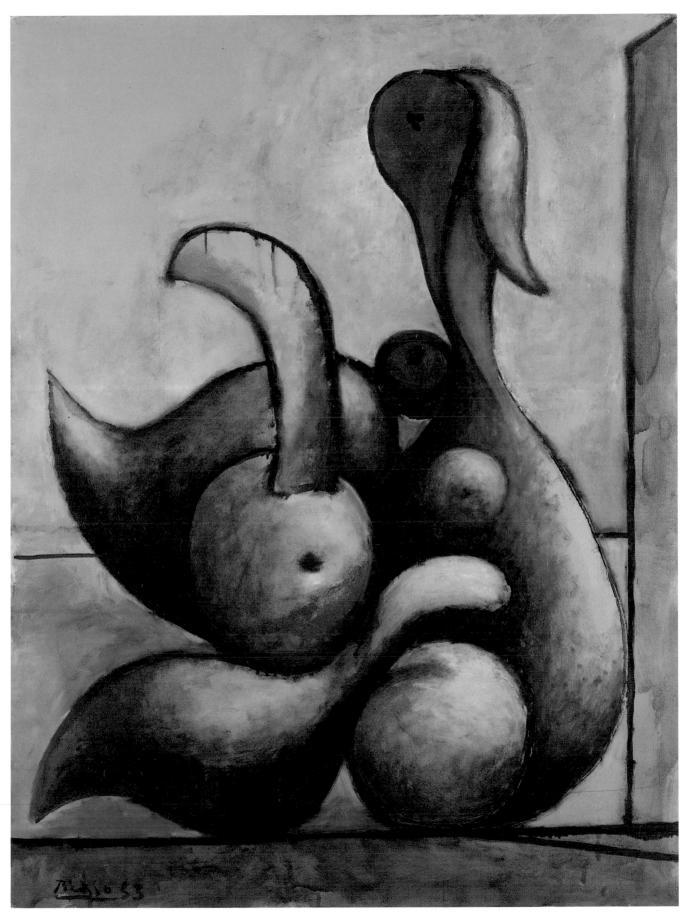

98 Seated Nude 1933
130 × 97

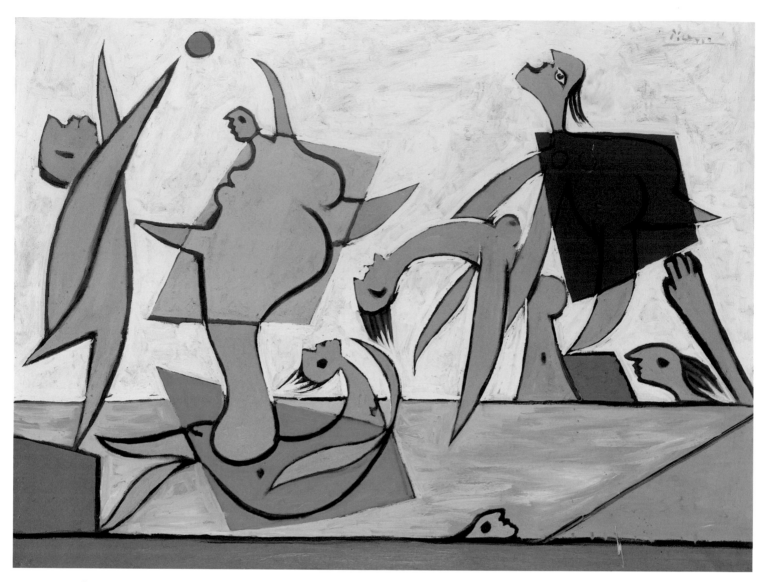

97 Games and Rescue
 on the Beach 1932
 97.5 × 130

84 Little Girl with a Ball
 1931 or 1932
 50 × 20 × 25

82 Bather 1931
 70 × 40.2 × 31.5

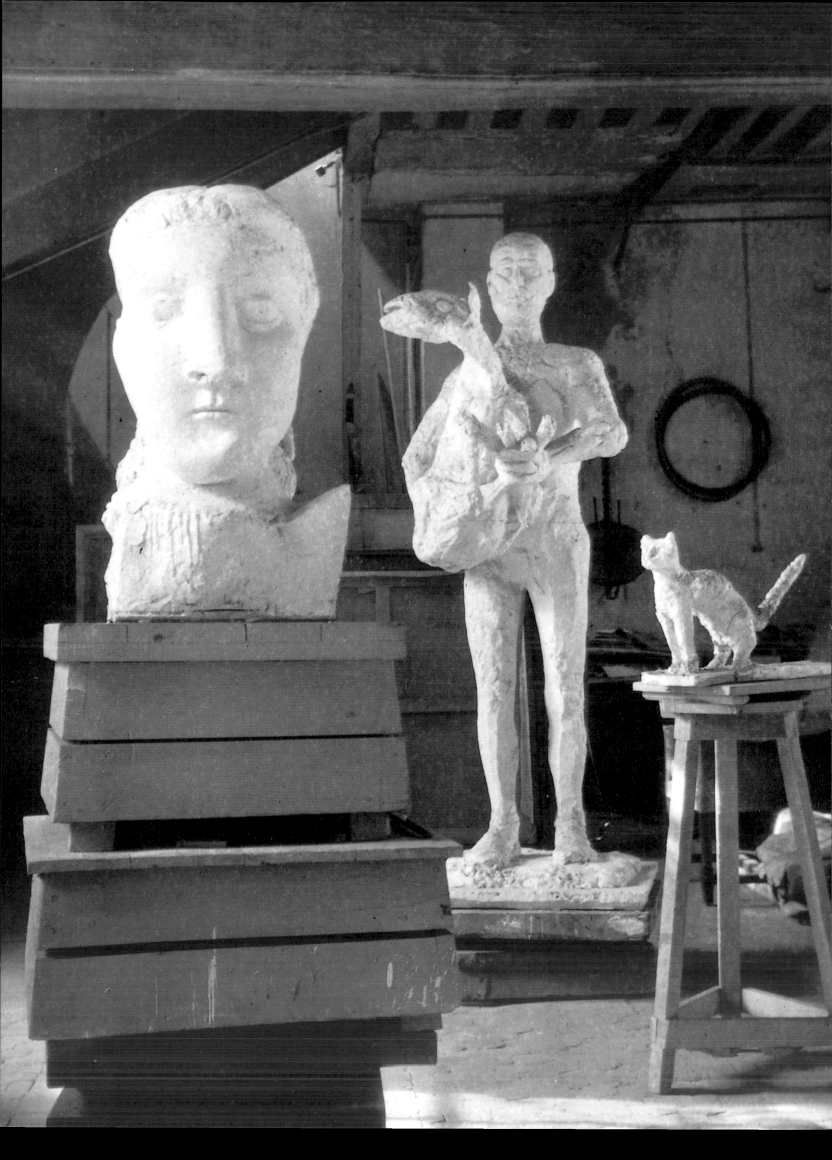

5 Death and Transformation

Rue des Grands-Augustins, September 1943. … We make a tour of his new pieces of sculpture. I am astonished at the number of them …

PICASSO: Since Boisgeloup, I hadn't done much in the way of sculpture. Then, all of a sudden, it caught me again. I've done all of this in the last three years, during the occupation. Since I couldn't leave Paris, I made my bathroom into a sculpture studio – it's the only room in this barracks that can be heated. That's where I did most of these … Guess how I made that head of a bull. One day, in a rubbish heap, I found an old bicycle seat, lying beside a rusted handlebar … and my mind instantly linked them together. The idea for this *Tête de Taureau* came to me before I had even realized it. I just soldered them together. The thing that's marvellous about bronze is that it can give the most diverse objects such unity that sometimes it's difficult to identify the elements that make up the whole. But that's also a danger: if you no longer see anything but the head of a bull, and not the bicycle seat and handlebar that formed it, the sculpture would lose its interest …

Tuesday, October 12, 1943. Picasso, the publisher of the book, and I are going to go through all of the sculptures and select the statues to be included in the album. Among them is *L'Oiseau*. A child's scooter rusted and deformed, shorn of its wheels, suggested the idea of a bird to him one day, just as the saddle and handlebar of the bicycle had suggested the head of a bull. The little plank on which the feet are placed becomes the body of a wading bird; the steering shaft its long neck, and the fork which held the front wheel its head and beak. A triangular piece, intended for securing busts on their pedestal, serves for feet. Picasso has given him a red feather for a tail. We make notes on the majority of the sculptures without incident. But when we come to the scooter-bird, the publisher whispers in my ear:

'Don't bother to photograph it. It's more an object than a piece of sculpture.'

Picasso, who hears everything, guesses everything, misses nothing, turns to him suddenly, points at *L'Oiseau*, and says sharply, 'I insist absolutely that this sculpture must be in my album!'

When the publisher left the studio an hour later, Picasso was still seething with anger.

PICASSO: An object! So my bird is just an object! Who does that man think he is? To think that he can teach me – me, Picasso – what is a sculpture and what isn't! He has a lot of cheek! I think I know more about it than he does. What is sculpture? What is painting? Everyone clings to old-fashioned ideas and outworn definitions, as if it were not precisely the role of the artist to provide new ones …

Picasso's studio,
rue des Grands-Augustins, Paris 1943
Photo: Brassaï © Gilberte Brassaï

Brassaï, *Picasso and Co.*, London 1967

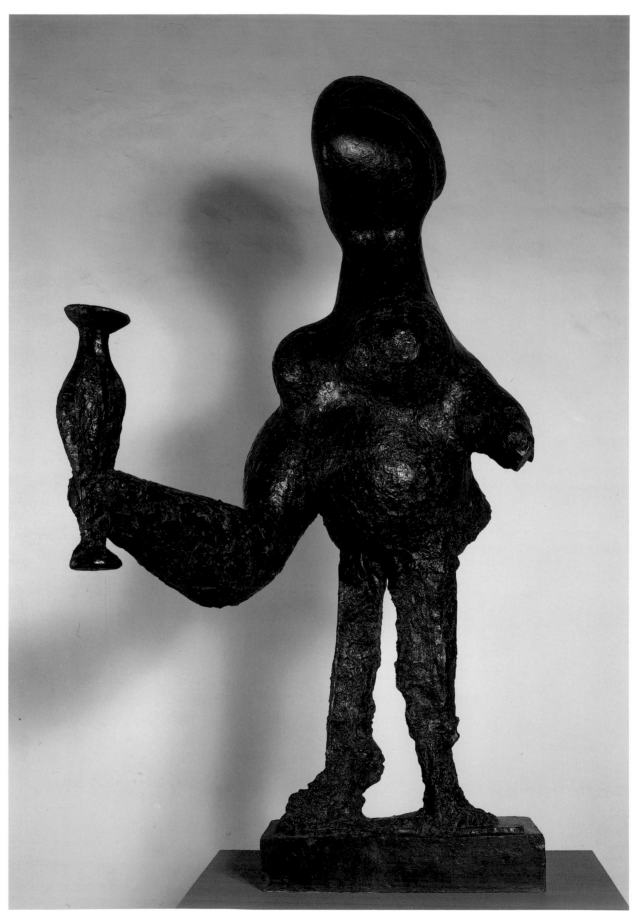

99　The Woman with a Vase　1933
219 × 122 × 110

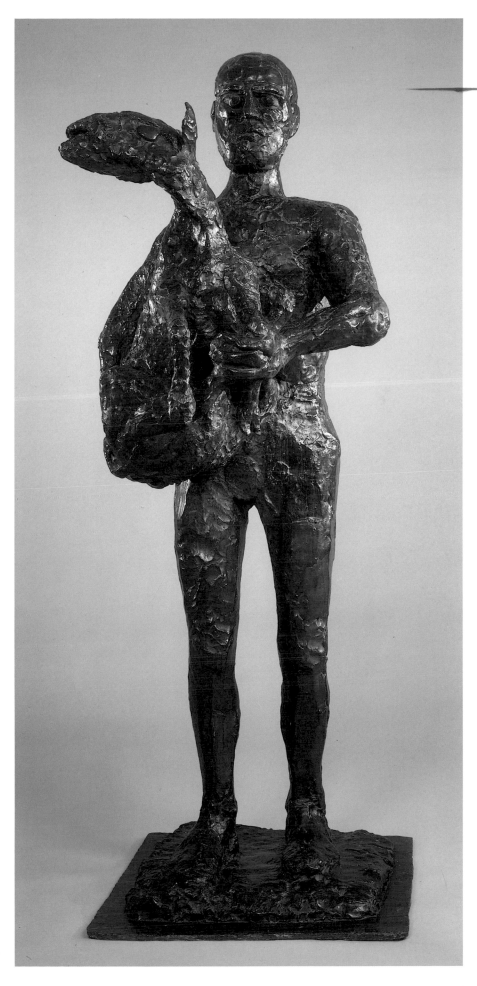

105 The Man with a Sheep 1943
222.5 × 78 × 78

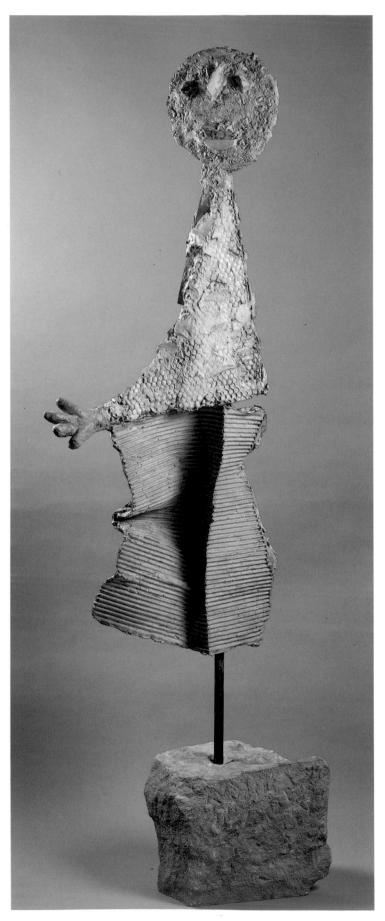

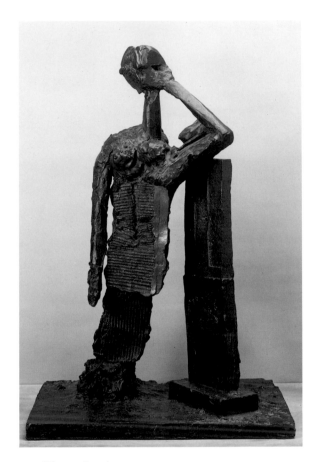

100 **Woman Leaning on
her Elbow** 1933
62.2 × 42.5 × 28.9

101 **The Orator** 1933 or 1934
183 × 66 × 27

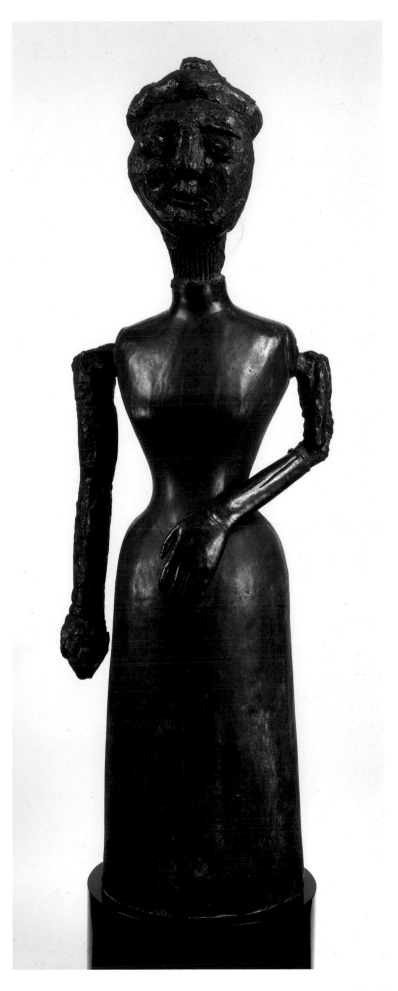

104 The Woman in a
 Long Dress 1943
 161.3 × 54.6 × 45.7

103 Bull's Head 1942
42 × 41 × 15

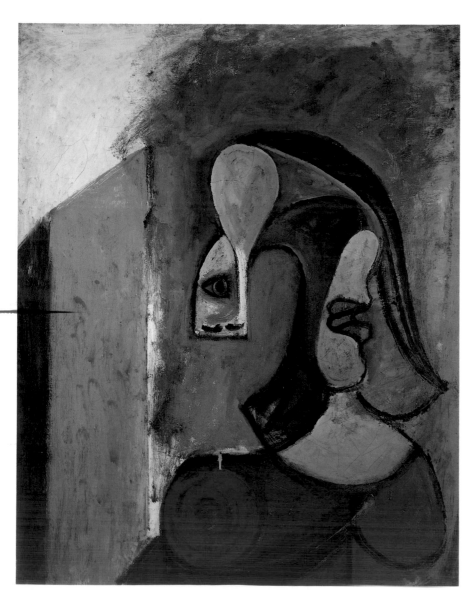

111 Head of a Woman
 with Two Profiles 1939
 92 × 73

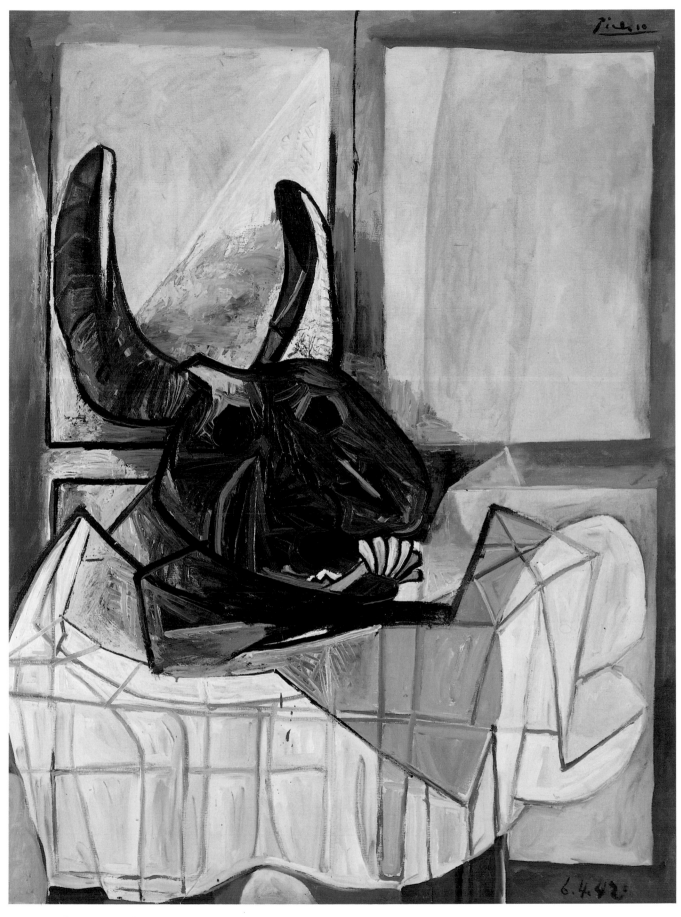

112 Still Life with a Steer's Skull 1942
117 × 89

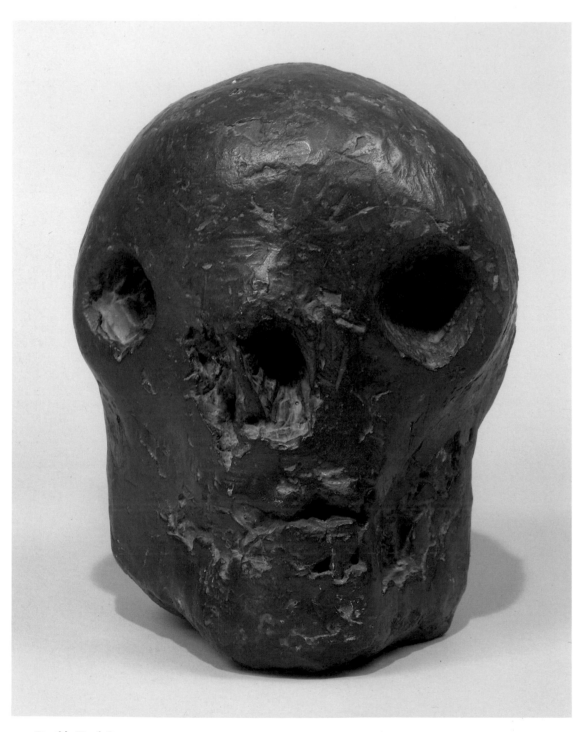

102 Death's Head ?1941
25 × 21 × 32

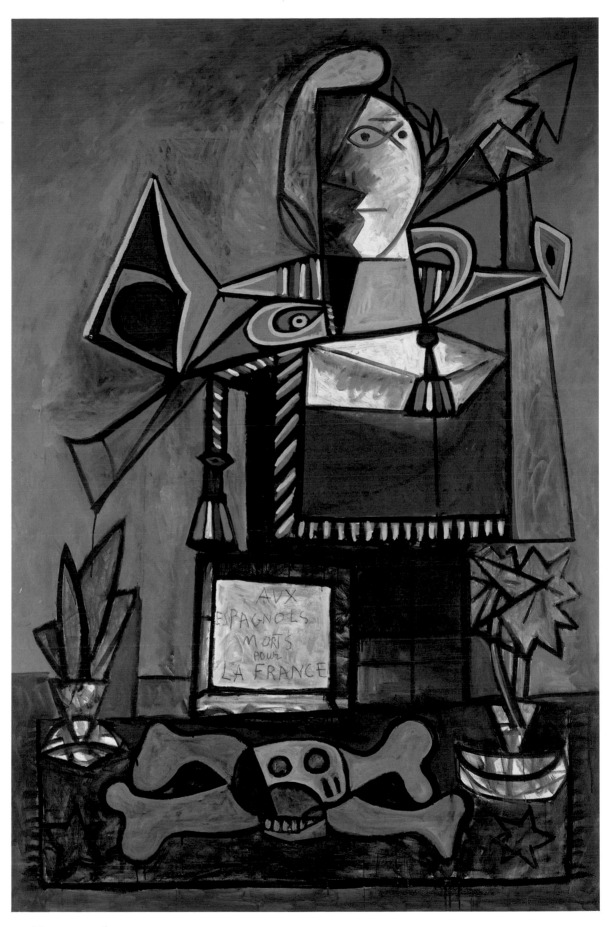

114 Monument to the
Spanish Dead 1945–7
195 × 130

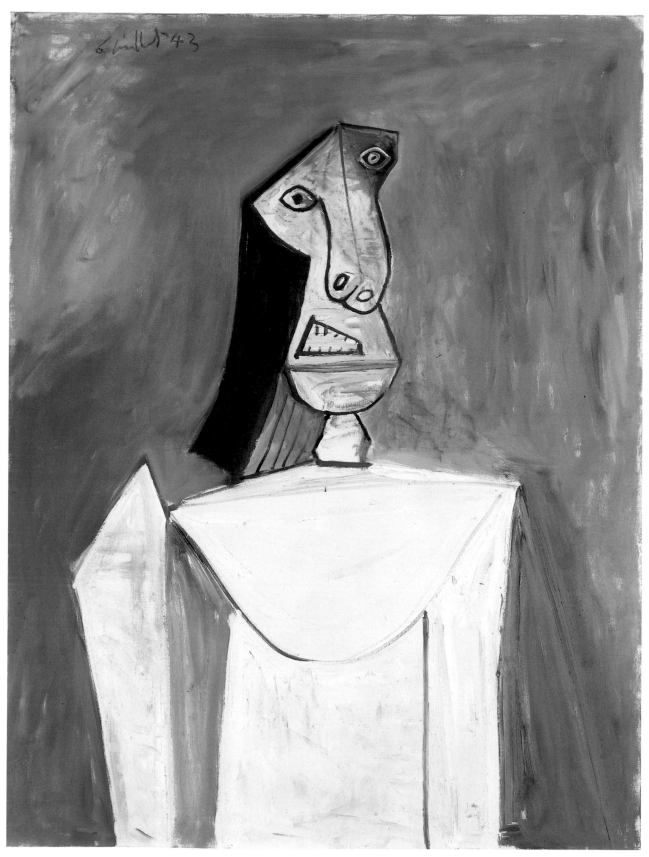

113 **Bust of a Woman against
a Grey Ground** 1943
116 × 89

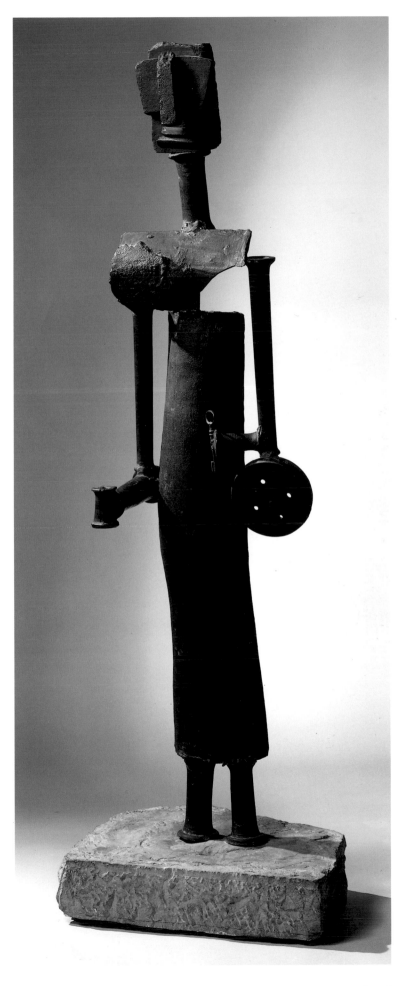

109 The Woman with a Key 1954
172 × 43 × 30

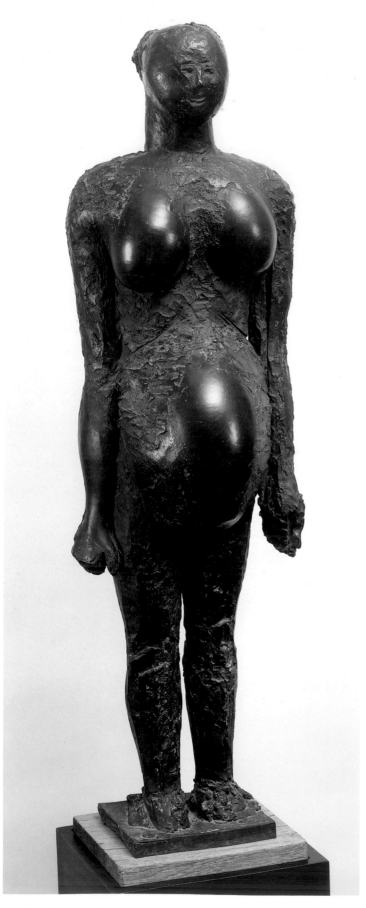

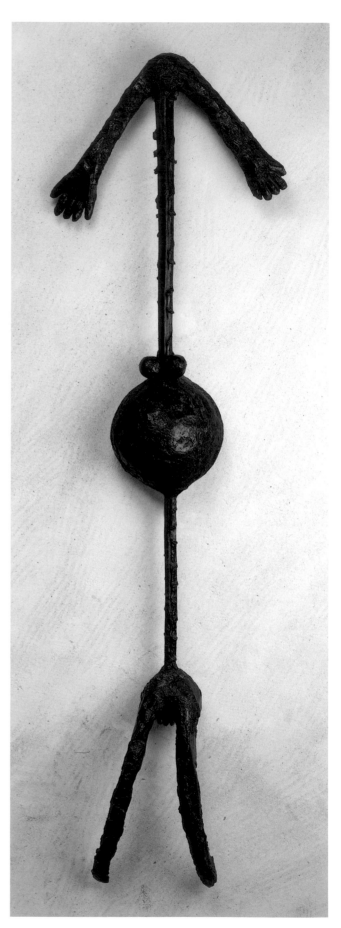

108 **The Pregnant Woman** 1950
109 × 30 × 34

106 **Pregnant Woman** 1949
130 × 37 × 11.5

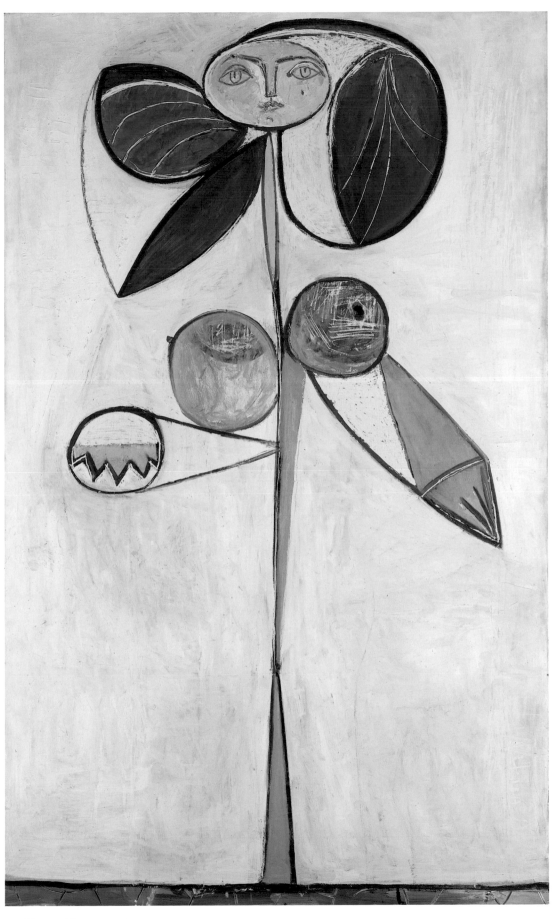

115 Woman-Flower 1946
146 × 89

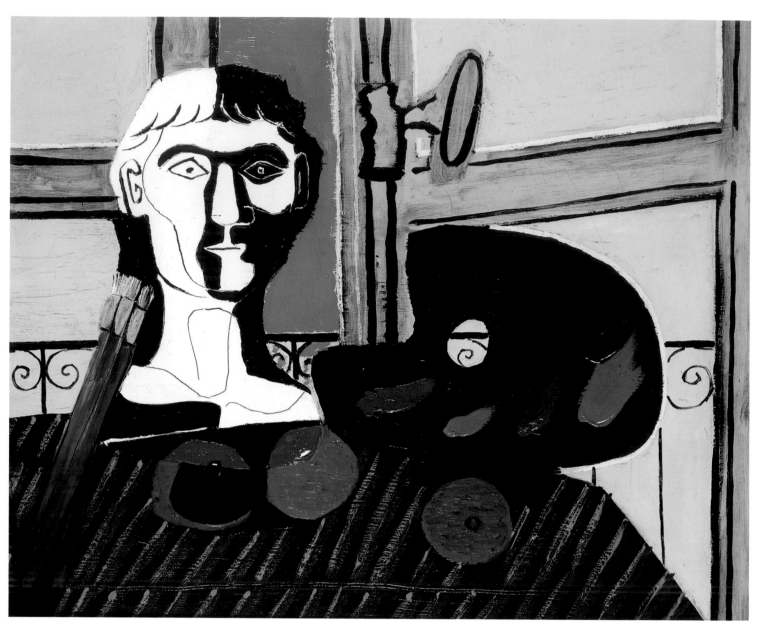

110 Bust and Palette 1925
 54 × 62.5

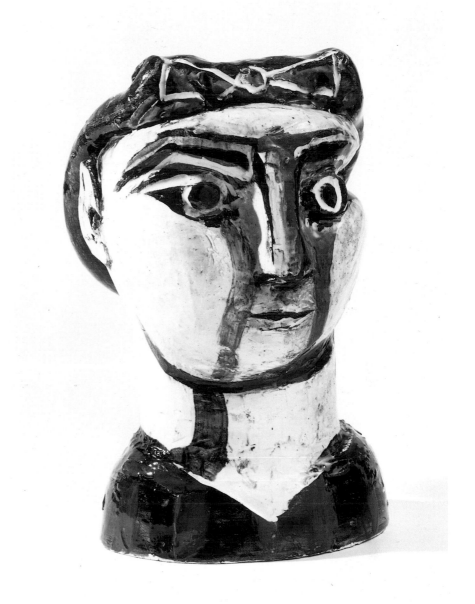

107 Head of a Woman
with a Bow *c*.1950
37 × 24 × 30

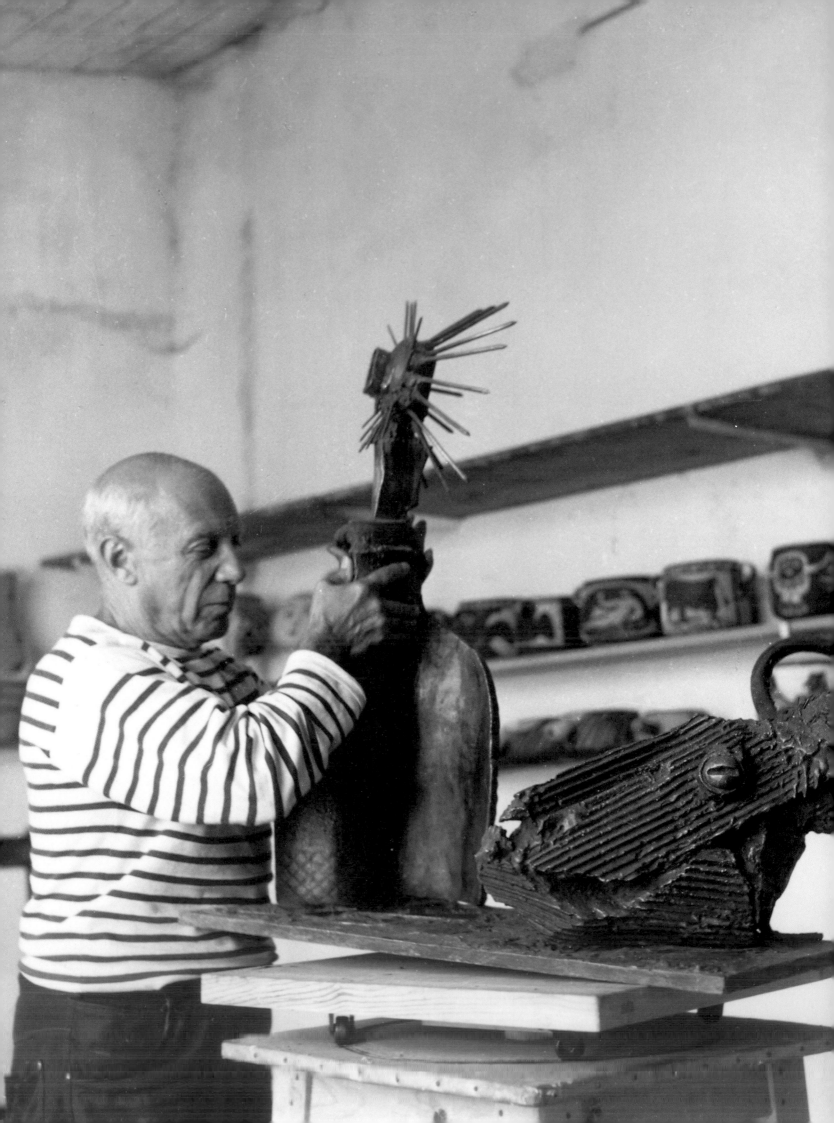

6 Searching in the Animal Kingdom

I asked Pablo one day why he gave himself so much trouble to incorporate all these bits and pieces of junk into his sculptures rather than simply starting from scratch in whatever material – plaster, for example – he wanted to use and building up his forms from that.

'There's a good reason for doing it this way,' he told me. 'The material itself, the form and texture of those pieces, often gives me the key to the whole sculpture. The shovel in which I saw the vision of the tail-feathers of the crane gave me the idea of doing a crane. Aside from that, it's not that I need that ready-made element, but I achieve reality through the use of metaphor. My sculptures are plastic metaphors. It's the same principle as in painting. I've said that a painting shouldn't be *trompe l'oeil* but *trompe l'esprit*. I'm out to fool the mind rather than the eye. And that goes for sculpture too. People have said for ages that a woman's hips are shaped like a vase. It's no longer poetic; it's become a cliché. I take a vase and with it I make a woman. I take the old metaphor, make it work in the opposite direction and give it a new lease of life … It would be very easy to do these things by traditional methods, but this way I can engage the mind of the viewer in a direction he hadn't foreseen and make him rediscover things he had forgotten.'

…

'We mustn't be afraid of inventing *anything*', he said one day when we were talking sculpture. 'Everything that is in us exists in nature. After all, we're part of nature. If it resembles nature, that's fine. If it doesn't, what of it? When a man wanted to invent something as useful as the human foot, he invented the wheel, which he used to transport himself and his burdens. The fact that a wheel doesn't have the slightest resemblance to the human foot is hardly a criticism of it.'

Françoise Gilot, in Françoise Gilot and Carlton Lake, *Life with Picasso*, Harmondsworth 1966

Picasso with still unpainted bronze cast of 'Goat's
Skull and Bottle', Le Fournas, Vallauris 1952
Photo: Robert Doisneau © Robert Doisneau/Rapho

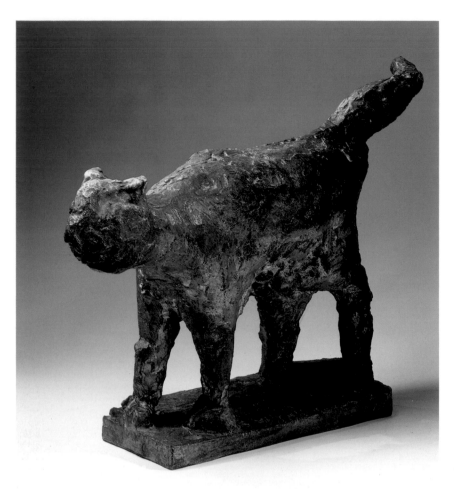

116 The Cat 1941
47 × 77 × 19

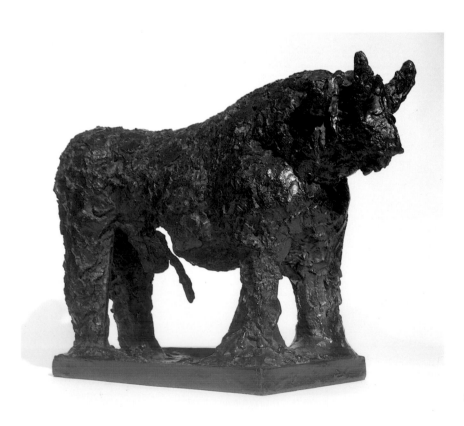

117 The Bull 1949 or 1950
40 × 66 × 21.5

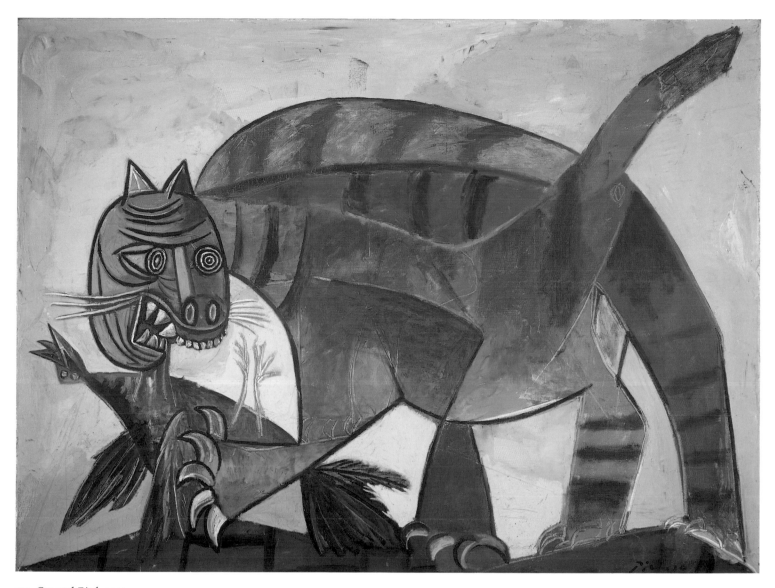

131 Cat and Bird 1939
97 × 130

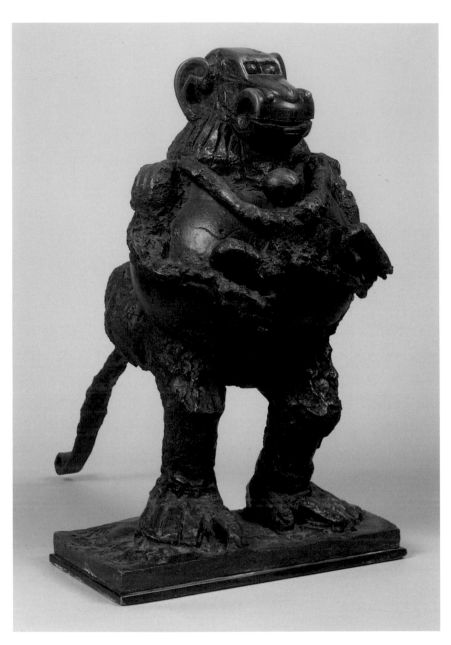

120 **Baboon and Young** 1951
 53 × 33 × 61

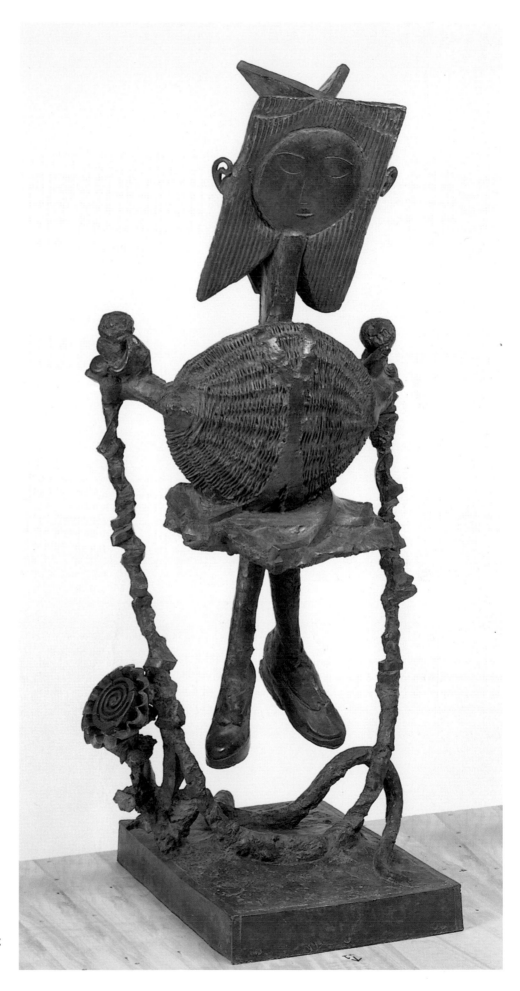

119 Little Girl Skipping
1950–?52
152 × 65 × 66

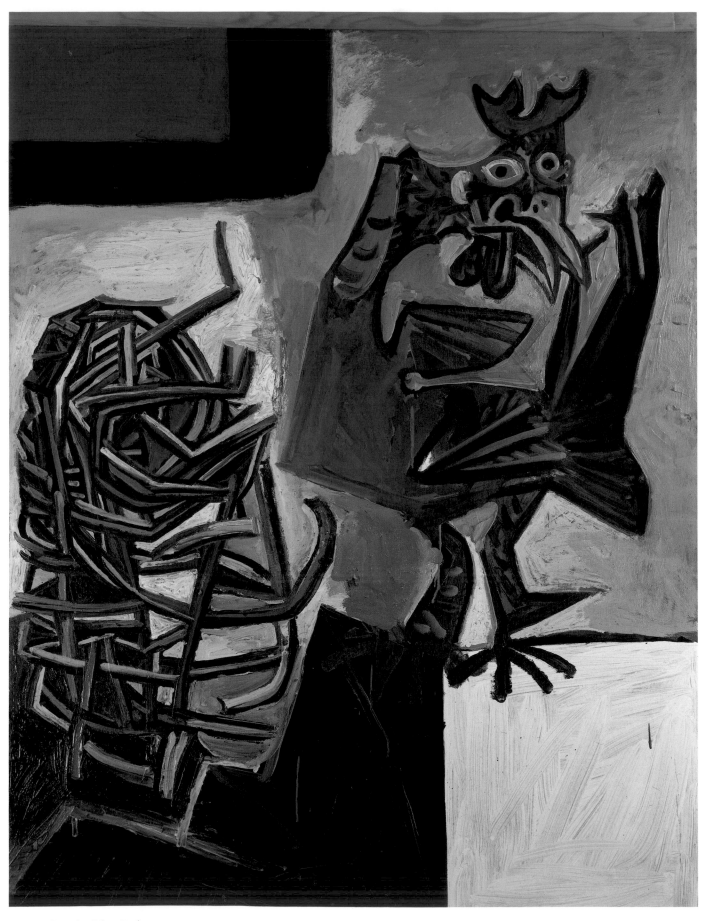

132 Cock and Wicker Basket 1950
 116 × 89

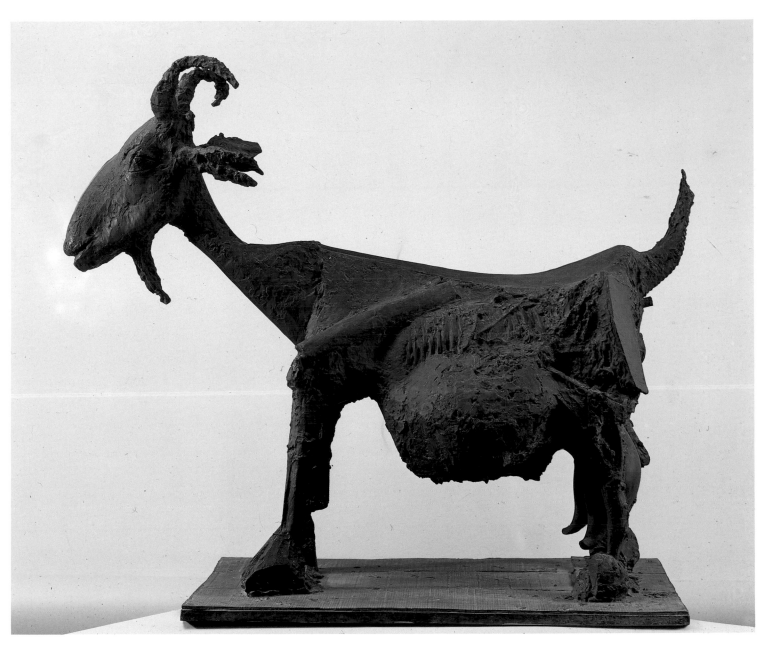

118 The Goat 1950
120.5 × 72 × 144

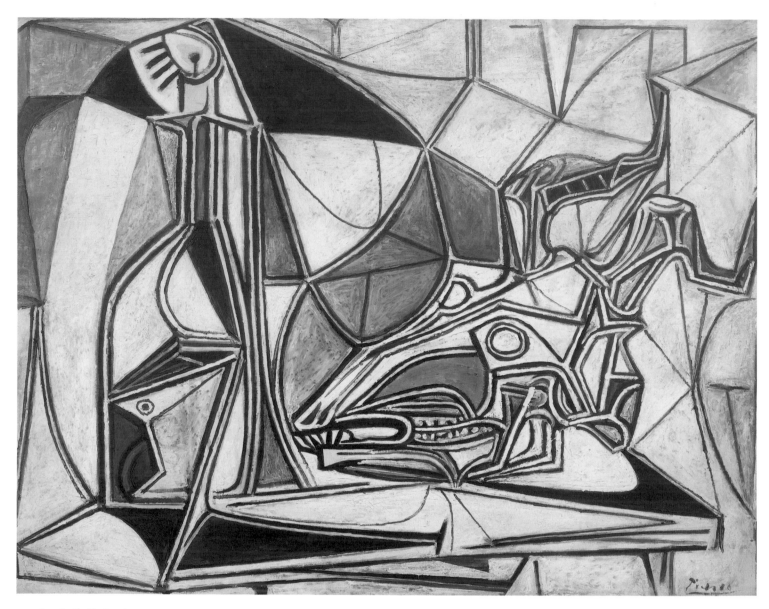

133 **Goat's Skull, Bottle
and Candle** 1952
89.2 × 116.2

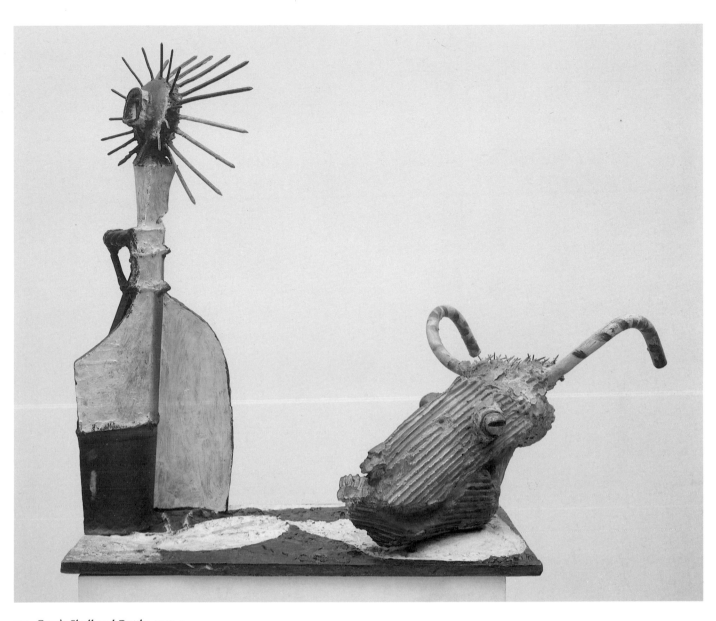

125 Goat's Skull and Bottle 1951–3
78.8 × 95.3 × 54.5

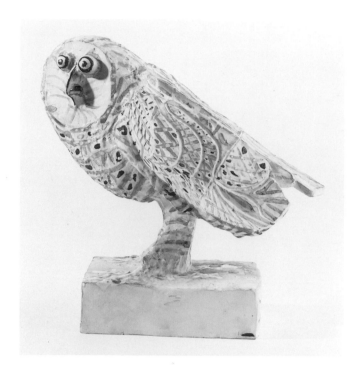

127 White Owl 1953
34 × 33 × 24

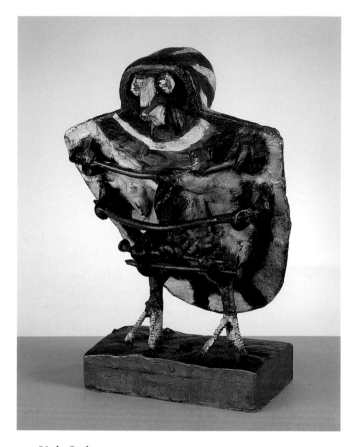

122 Little Owl 1951–2
26 × 18.7 × 14.6

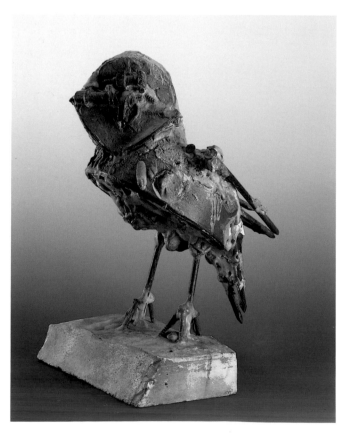

123 Little Owl 1951–2
33.5 × 22.5 × 19

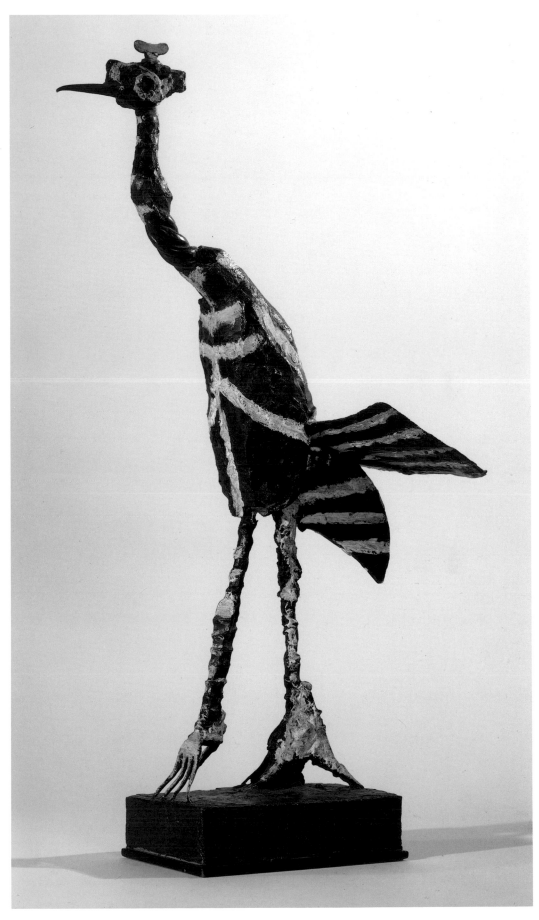

121 **The Crane** 1951–2
75 × 29 × 43

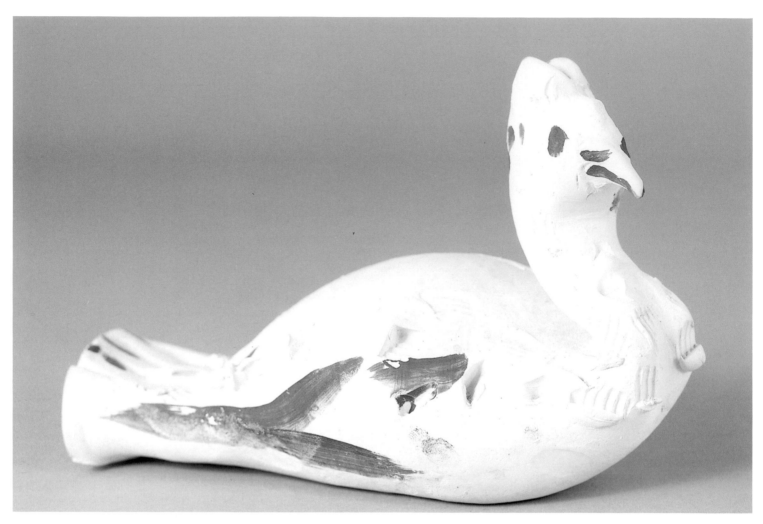

128 **Dove** 1953
15 × 21 × 13

126 Bird Breaking Out
 of an Egg c.1953
 43 × 33 × 25.5

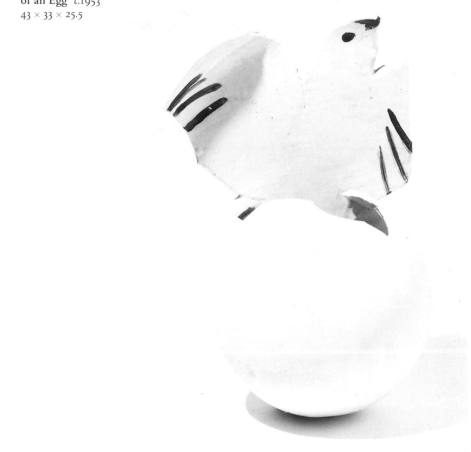

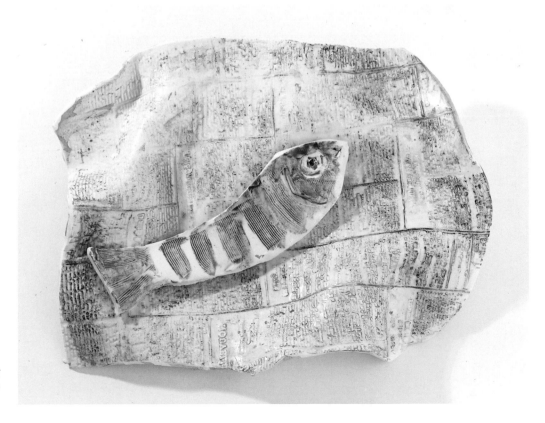

129 Fish on a Sheet of
 Newspaper c.1957
 39 × 32

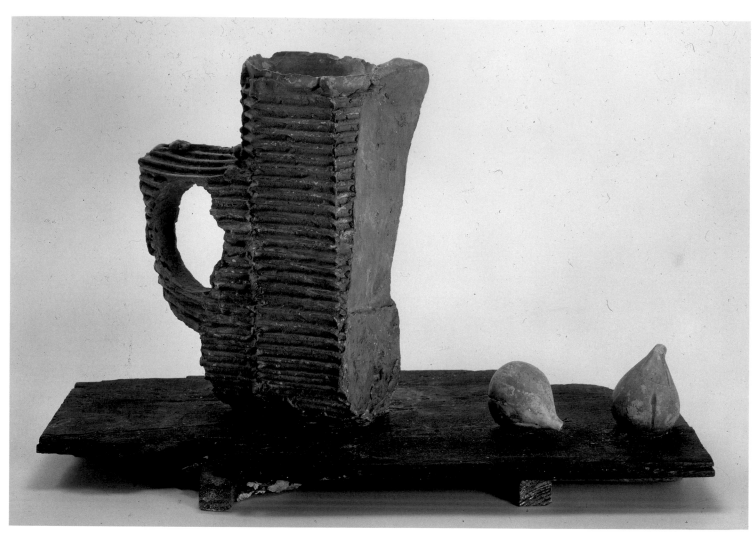

124 **Still Life: Pitcher
and Figs** 1951–2
32 × 48.5 × 21.5

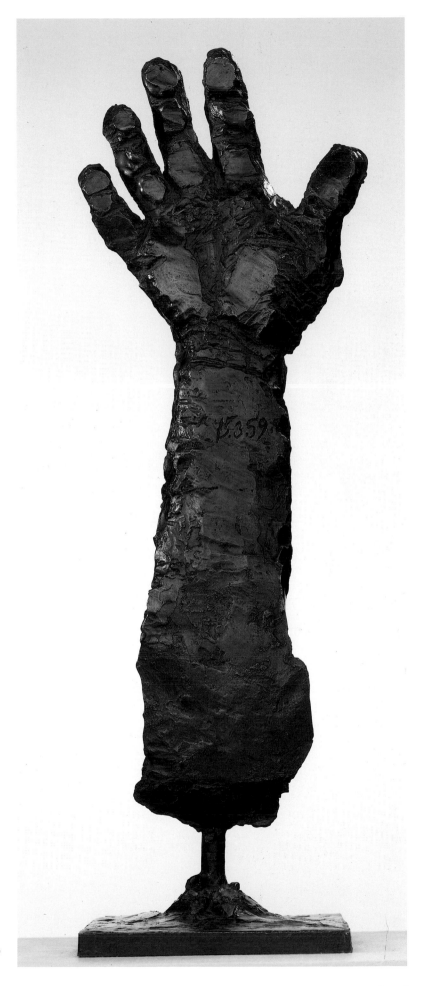

130 Arm 1959
58 high

7 Cutting and Folding the Figure

Wednesday, October 20, 1943.

PICASSO: It seems strange to me that we ever arrived at the idea of making statues from marble. I understand how you can see something in the root of a tree, a crevice in a wall, a corroded bit of stone, or a pebble … But marble? It stands there like a block, suggesting no form or image. It doesn't inspire. How could Michelangelo have seen his *David* in a block of marble? If it occurred to a man to create his own images, it's because he discovered them all around him, almost formed, already within his grasp. He saw them in a bone, in the irregular surfaces of cavern walls, in a piece of wood … One form might suggest a woman, another a bison, and still another the head of a demon …

Cannes, Wednesday, May 18, 1960. Picasso comes to the chapter in the album [Brassaï's *Graffiti*] titled 'The Language of Walls'. He is surprised by the great brushstrokes of paint, effacing the inscriptions on the wall.

PICASSO: You did well to photograph that … because it's a good demonstration of the nature and limits of abstract art. These brushstrokes are very beautiful … but it is a natural beauty. A few strokes of a brush that have no meaning will never make a picture. I do this sort of thing myself, and occasionally you might even say it was an abstract. But my brushstrokes always signify something: a bull, an arena, the sea, the mountains, the crowd … To arrive at abstraction, it is always necessary to begin with a concrete reality …

He comes to the chapter on 'The Birth of the Face', in which I have grouped faces done from two or three holes in a wall.

PICASSO: I have often done faces like this myself. The people who scratch them out like this naturally gravitate to symbols. Art is a language of symbols. When I pronounce the word 'man', I call up a picture of a man; the word has become the symbol of man. It does not represent him as photography could. Two holes – that's the symbol for the face, enough to evoke it without representing it … But isn't it strange that it can be done through such simple means? Two holes; that's abstract enough if you consider the complexity of man … Whatever is most abstract may perhaps be the summit of reality …

Brassaï, *Picasso and Co.*, London 1967

Mock-up for monumental enlargement of
'Head of a Woman', La Californie, Cannes 1957
Photo: David Douglas Duncan

139 Head 1958
50.5 × 22.2 × 20.3

138 Man 1958
117 × 76 × 25

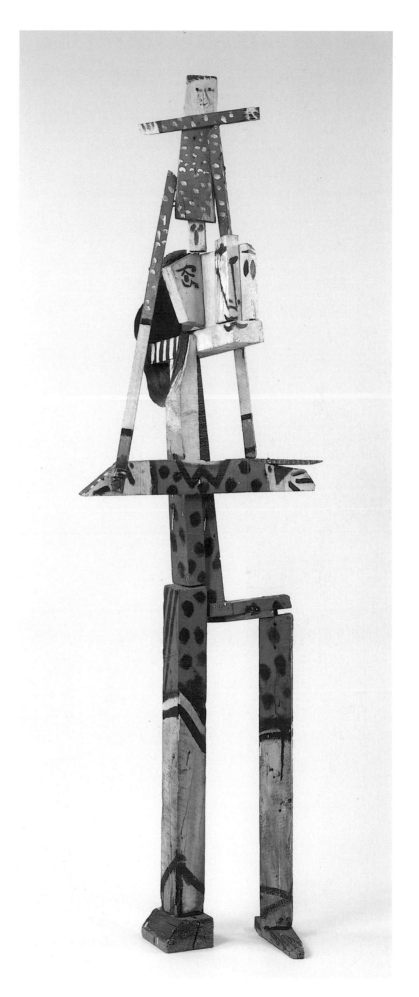

135 Woman Carrying
a Child 1953
173 × 54 × 35

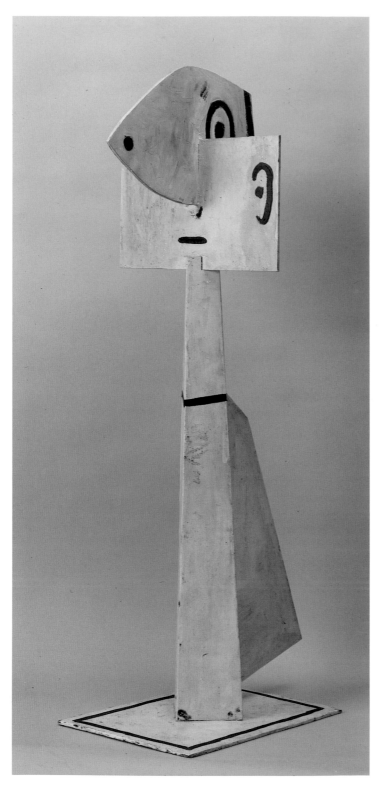

136 Head of a Woman 1957
 87 × 27.5 × 45

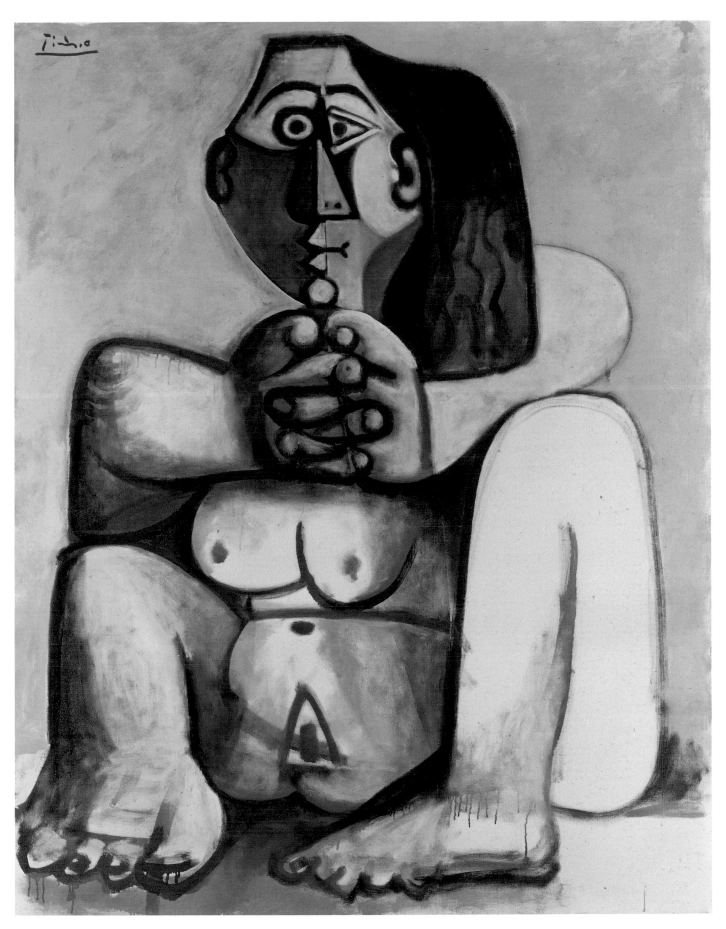

150 Seated Nude 1959
146 × 114

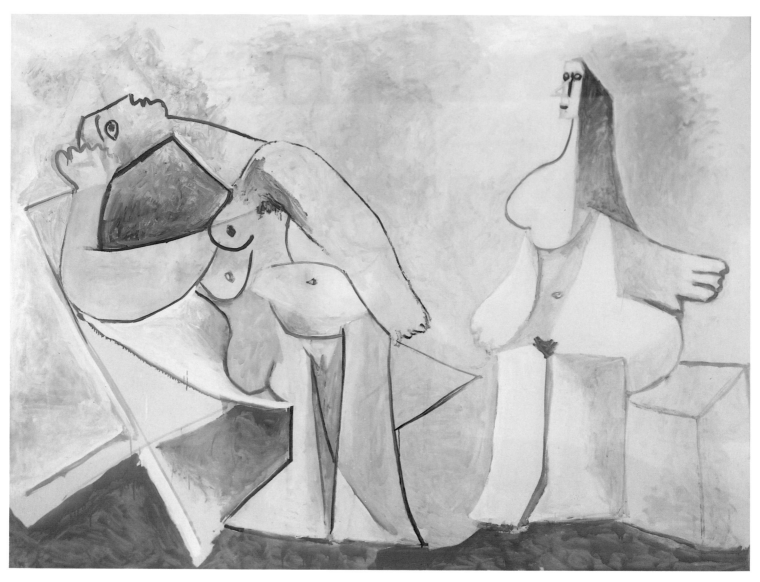

149 Composition:
Two Women 1958
194.5 × 260.5

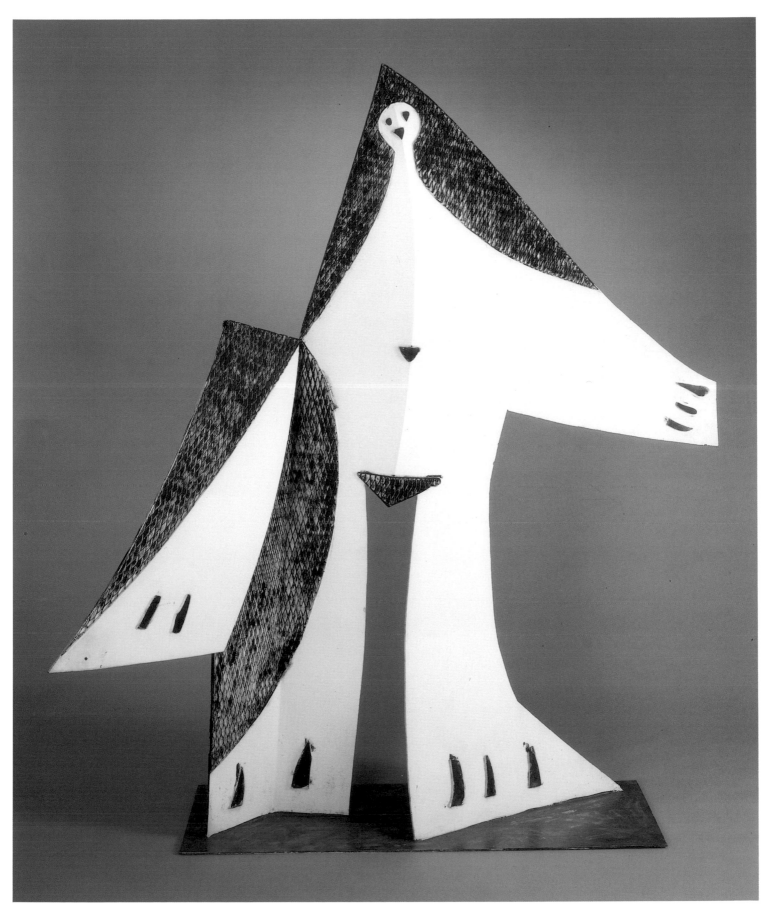

144 **Woman with
Outstretched Arms** 1961
178.8 × 156.5 × 72.7

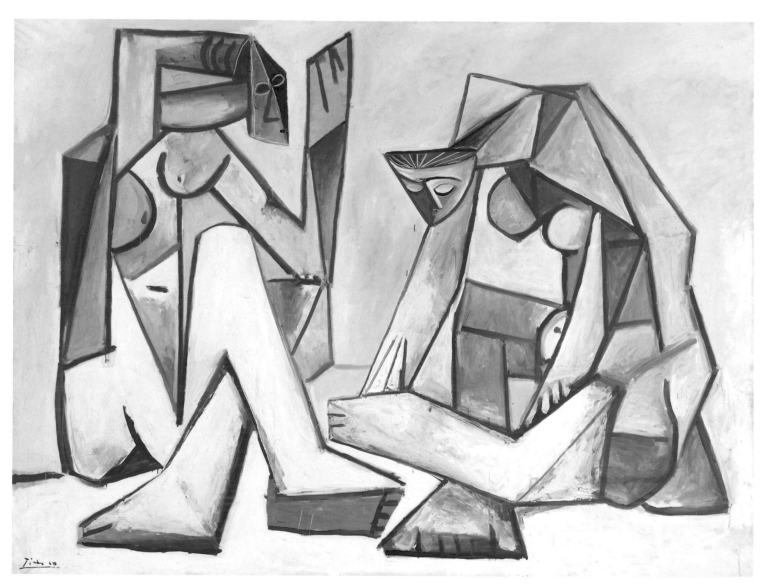

148 Two Women on
the Beach 1956
195 × 260

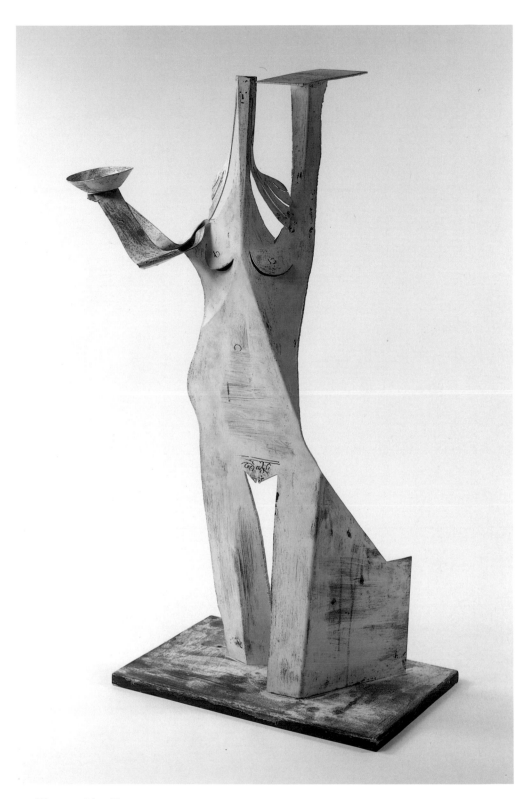

143 Woman with a Tray
and a Bowl 1961
115 × 62 × 34

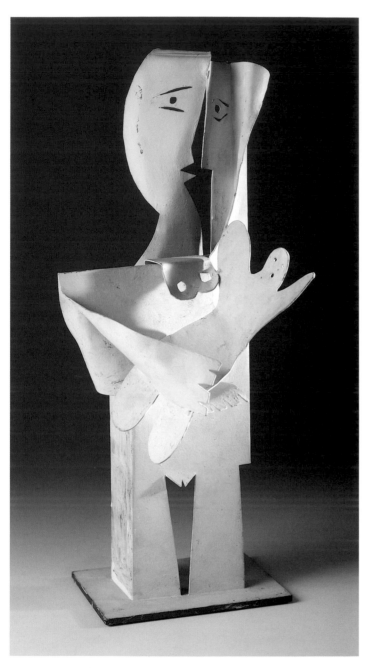

142 Woman and Child 1961
43 × 17.6 × 21

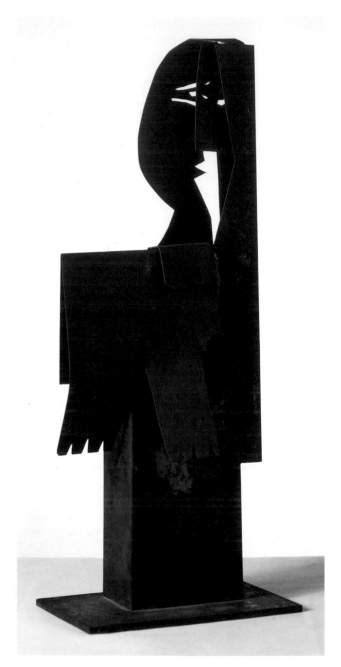

141 Standing Woman 1961
42 × 19 × 9

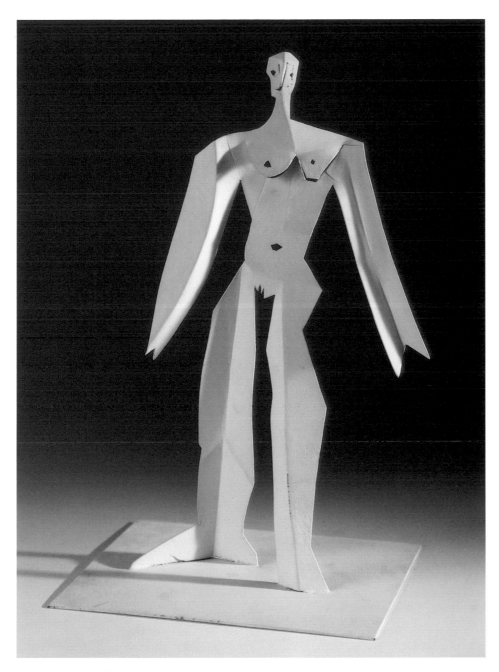

140 **Standing Nude** 1960 or 1961
 42 × 30 × 21

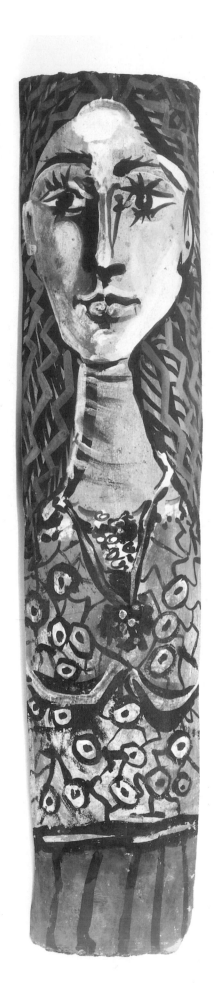

134 Françoise Gilot 1950
100 × 21 × 10

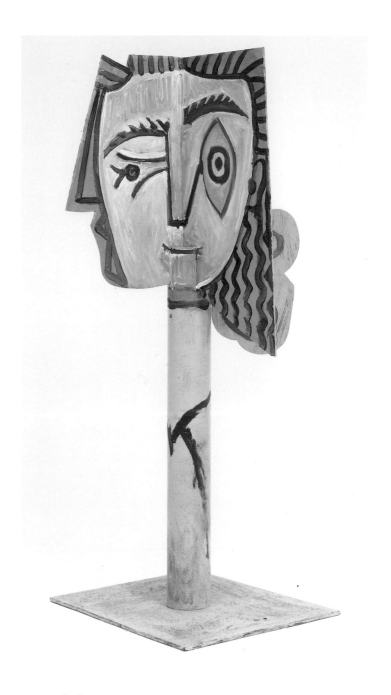

137 Head of a Woman 1957
77 × 35 × 25.7

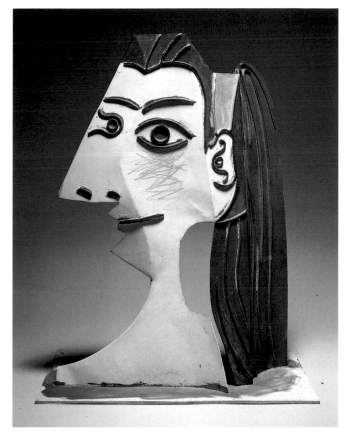

146 Jacqueline with a Green Ribbon
1962
50.7 × 39 × 28

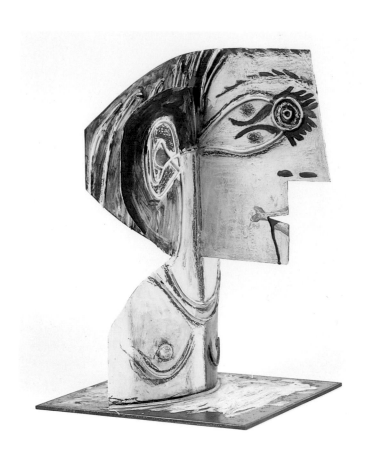

147 Bust of a Woman 1964
48 × 34 × 30

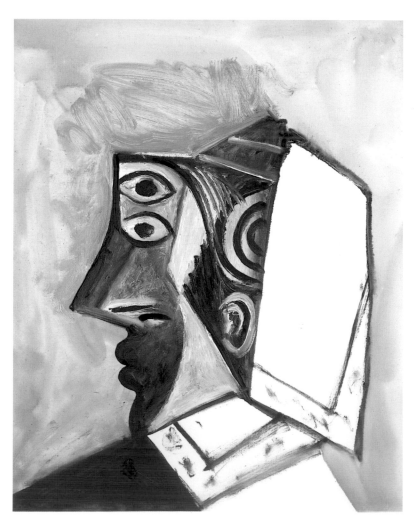

153 Woman with a Coif 1971
81 × 65

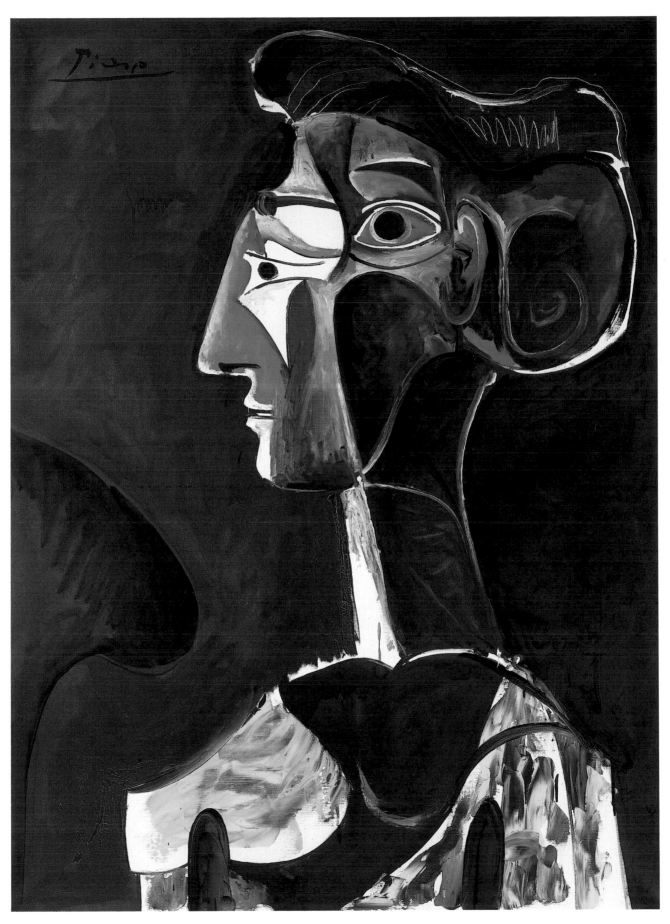

152 **Large Profile** 1963
130 × 97

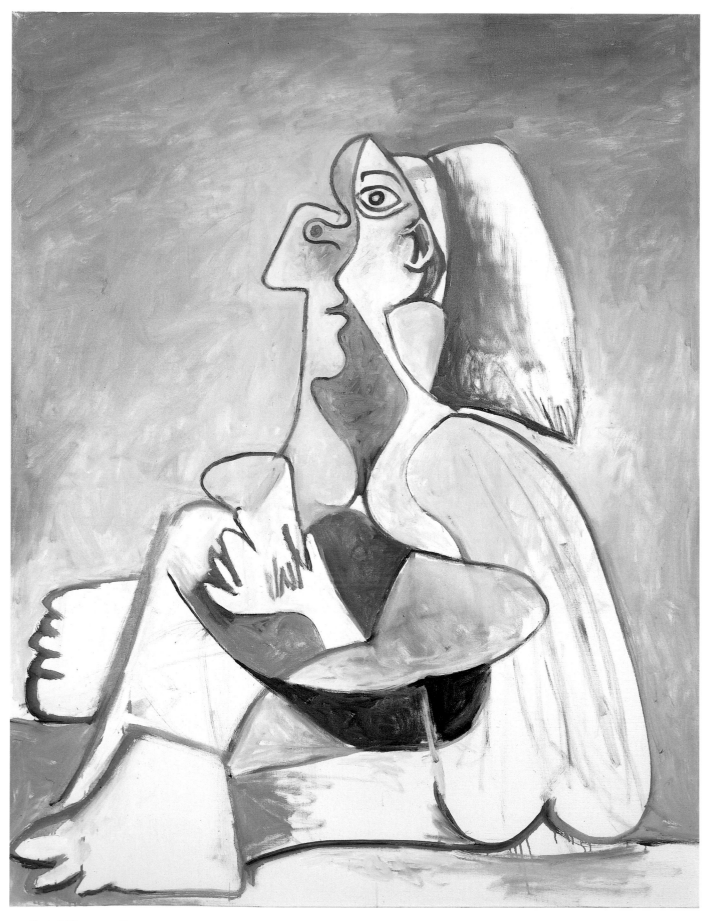

151 Seated Woman 1962
146 × 116

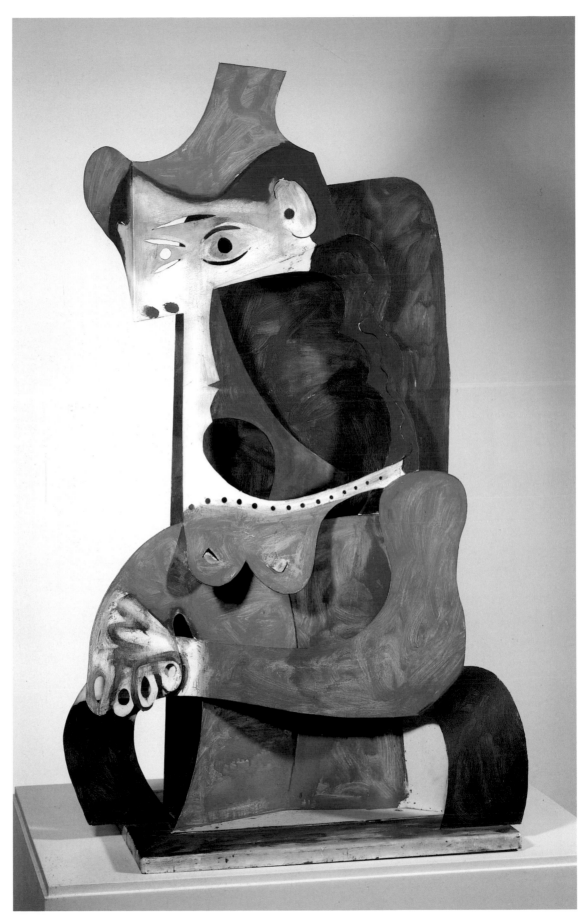

145 Woman in a Hat 1961–3
126 × 73 × 41

8 New Arcadias

We could talk of nothing else but the beautiful and magnificent *Lola de Valence*. Picasso and Pignon were in the studio. Manet was clearly the only painter in the world and they discussed all his canvases. They talked about him for an hour. They turned the pages of a book in which there were reproductions of Manets, talking delightedly all the time. Only Cézanne and Van Gogh emerged triumphant from the arena. All the rest was tripe. This was always happening, but Cézanne and Van Gogh never changed. On the other hand, the hero of the day, the starred painter who was momentarily in the ascendant was continually being replaced. He might cease to be tripe one morning only to become so again the next.

For the moment, the supreme painter was Manet.

Hélène Parmelin, *Picasso Plain*, London 1963

'Oh!, no,' exclaimed Picasso. 'Don't expect me to repeat myself. My past doesn't interest me any more. I would rather copy others than repeat myself. At least I would inject something new into them. I like discovering too much.'

Picasso, as reported by Michel Georges-Michel, in *De Renoir à Picasso*, Paris 1954

'What does it mean,' says Picasso, 'for a painter to paint in the manner of So-and-So or to actually imitate someone else? What's wrong with that? On the contrary, it's a good idea. You should constantly try to paint like somcone else. But the thing is, you can't! You would like to. You try. But it turns out to be a botch …

'And it's at the very moment you make a botch of it that you're yourself.'

Picasso, as reported by Hélène Parmelin, in *Picasso: The Artist and his Model, and Other Recent Works*, New York 1965

Sculpture is the best comment that a painter can make on painting.

Picasso, as reported by Renato Guttuso in his journals, and quoted in Mario de Micheli, *Scritti di Picasso*, Milan 1964

Picasso with a maquette for 'Le Déjeuner sur l'herbe', Mas Notre-Dame-de-Vie, Mougins 1964
Photo: Carl Nesjar

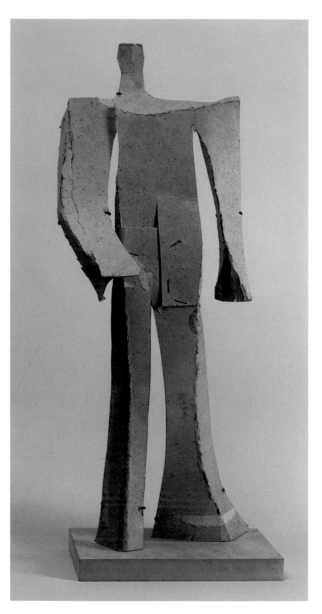

155 **Bather** 1960
50 × 19 × 15

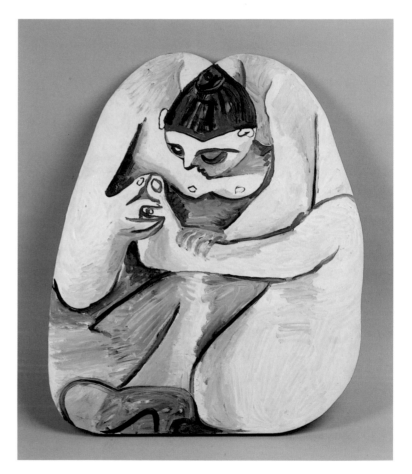

154 **Seated Bather** 1958
62 × 49.3

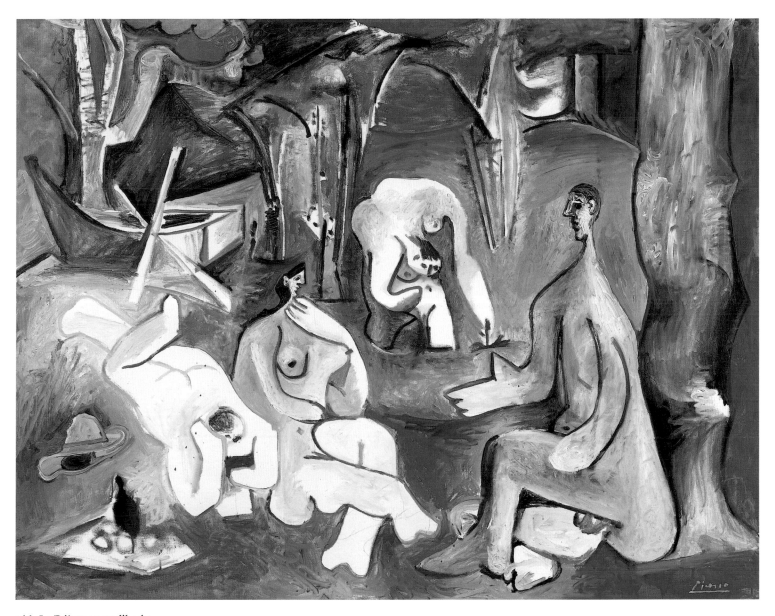

166 Le Déjeuner sur l'herbe,
 after Manet 1961
 114 × 146

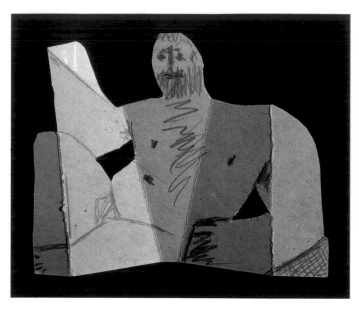

159 Le Déjeuner sur l'herbe: Seated
Man Leaning on his Elbow 1962
25 × 32

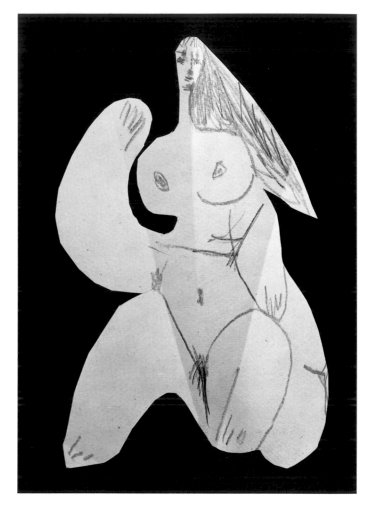

156 Le Déjeuner sur l'herbe:
Seated Woman 1962
34.5 × 25

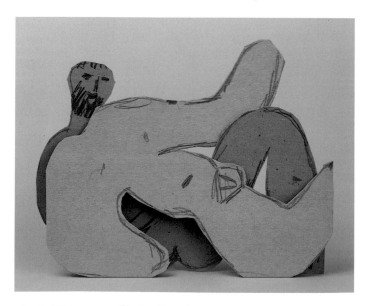

160 Le Déjeuner sur l'herbe: Seated
Man Leaning on his Elbow 1962
21.5 × 27

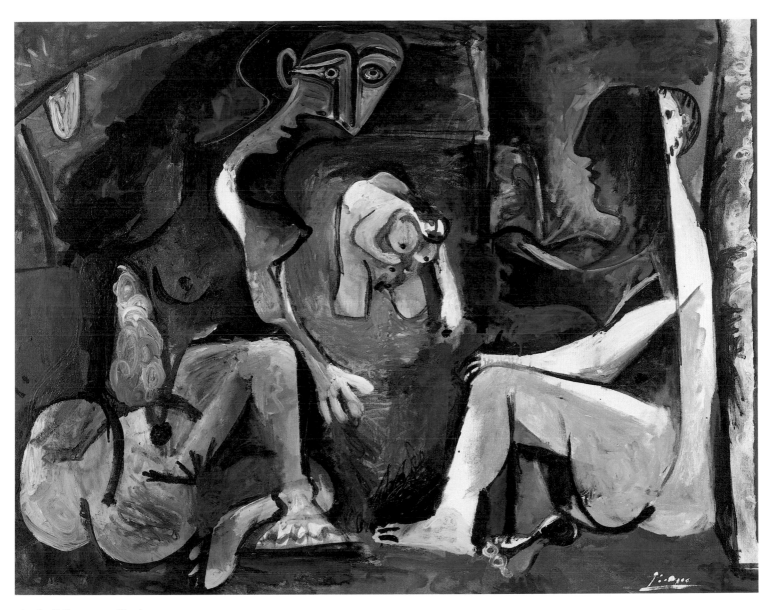

167 Le Déjeuner sur l'herbe,
after Manet 1961
89 × 116

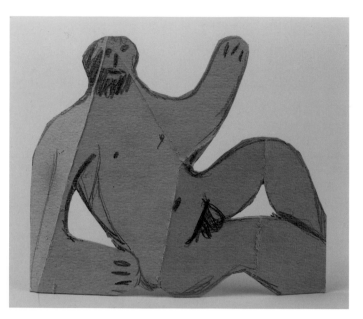

162 Le Déjeuner sur l'herbe: Seated
 Man Leaning on his Elbow 1962
 21.5 × 25.5

161 Le Déjeuner sur l'herbe: Seated
 Man Leaning on his Elbow 1962
 21.5 × 26

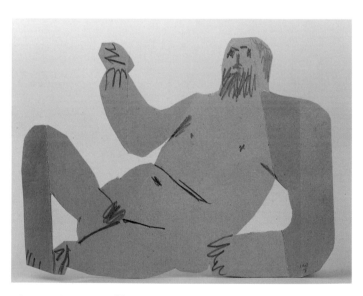

164 Le Déjeuner sur l'herbe: Seated
 Man Leaning on his Elbow 1962
 24.5 × 33

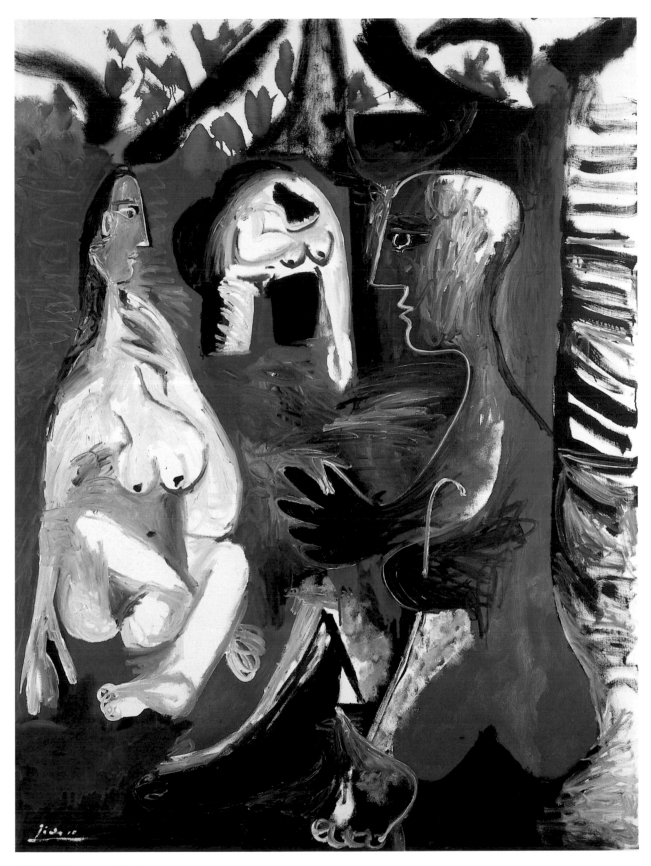

168 Le Déjeuner sur l'herbe,
 after Manet 1961
 130 × 97

163 Le Déjeuner sur l'herbe:
Standing Man 1962
36.5 × 27.5

157 Le Déjeuner sur l'herbe:
Bather 1962
29 × 21.5

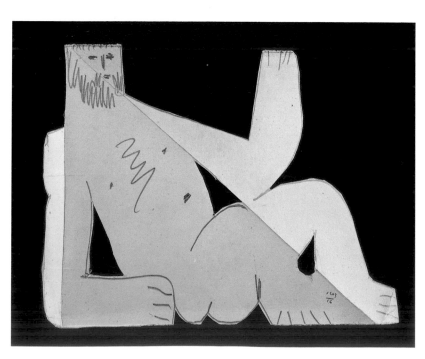

158 Le Déjeuner sur l'herbe: Seated
Man Leaning on his Elbow 1962
28 × 37.5

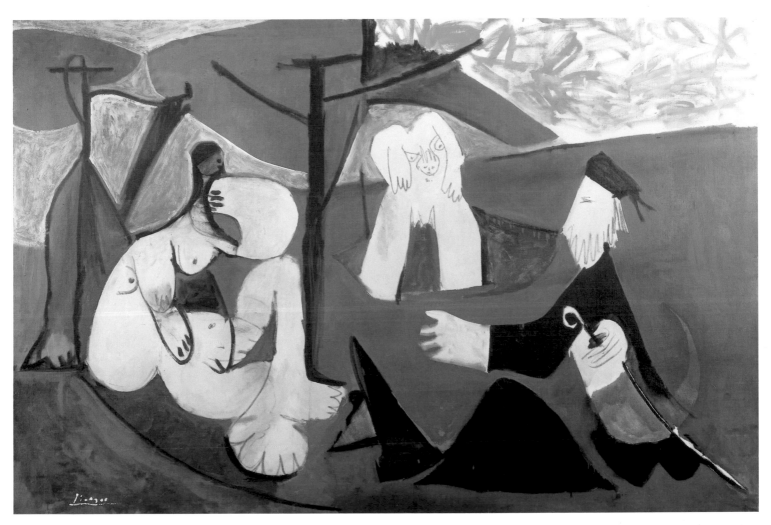

165 Le Déjeuner sur l'herbe,
 after Manet 1960
 130 × 195

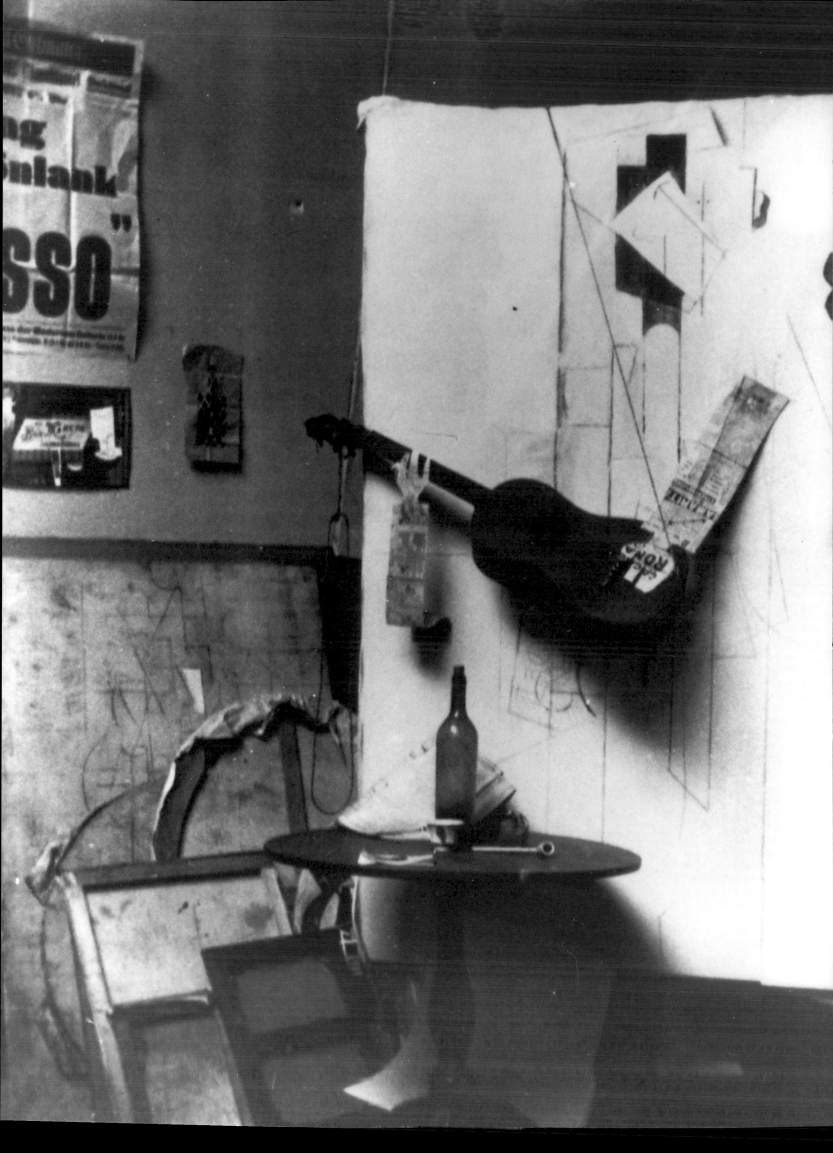

Beyond the 'Guitar': Painting, Drawing and Construction, 1912–14

PEPE KARMEL

The modest proportions and humble materials of Picasso's 1912–14 constructions belie their revolutionary importance. In them, Picasso broke with the formal assumptions which had dominated Western sculpture for millenia, assumptions to which sculptors had remained faithful even when they deviated from classical norms. If the Romanesque artisans of the eleventh century had reduced their subjects to graphic outlines, if Bernini had unbalanced his figures and enfolded them in flickering drapery, their sculptures had nonetheless continued to represent recognisable, solid figures. In discarding traditional techniques of modelling and carving, Picasso simultaneously discarded the underlying model of the body as a coherent mass with a continuous surface. His 1912–14 sculptures represent the beginning of a radically new approach to sculpture, subsequently explored by artists as diverse as Vladimir Tatlin and Henri Laurens, Julio González and David Smith, Anthony Caro and Richard Serra.

The seminal role of Picasso's constructions is all the more surprising in that many of them were destroyed not long after their creation. Even those which survived were not exhibited publicly for decades. Their influence seems to have been diffused primarily through photographs such as those reproduced in the November 1913 issue of *Les Soirées de Paris*, and through their informal display in Picasso's studio. Unfortunately, it remains unclear to what extent Picasso opened his studio to artists outside his immediate circle. We do not know whether Tatlin's spring 1914 visit – which led directly to the inception of Russian Constructivism – was typical or exceptional.

Those of Picasso's constructions which were not destroyed remained for decades sequestered within the artist's private collection, as did the numerous related studies which might have illuminated their development. Photographs of some of these lost and 'hidden' works were published in the second volume of Zervos's great catalogue, which appeared in 1942. However, the materials for a comprehensive study of Picasso's constructions did not become available until after the artist's death in 1973. Several important sculptures were discovered in his estate, and the posthumously published volumes of Zervos made available numerous sketches for constructions, executed and unexecuted. Nonetheless, the development of Cubist sculpture has received surprisingly little attention from scholars. Even today, the critical history of construction consists largely of interpretations of one work: the 'Guitar' of 1912–13 (no.19) which Picasso donated to the Museum of Modern Art, New York.

In what remains the most balanced and judicious discussion of the 'Guitar', William Rubin interprets it as a 'three-dimensional counterpart' for Picasso's Analytic Cubist canvases of 1911–12, with their combination of transparent and opaque planes, 'superimposed so as to suggest that the eye could see into and through objects.'[1] Precisely the opposite interpretation is offered by Daniel-Henry Kahnweiler, Picasso's and Braque's dealer from 1907 to 1914, who describes the superimposed planes of Cubist painting as an 'imitation' of relief sculptures, now lost, which both artists executed during this period.[2]

Kahnweiler's description (which can be verified by photographs of Picasso's and

opposite
fig.16 **Guitar Player at a Café Table** 1913
Assemblage in Picasso's studio, boulevard Raspail, Paris. No longer extant *Photo Archive, Musée Picasso, Paris*

Braque's studios) suggests that these reliefs resembled the collages and *papiers collés* by Braque and Picasso which do survive from this period, and scholars have drawn the logical conclusion that the 'Guitar' represents an extension of these techniques. This link between construction and collage seems at first glance to be confirmed by works such as 'Still Life' 1914 (no.22), whose wooden forms are supplemented by a strip of actual upholstery fringe.[3]

However, the detailed chronology of Picasso's and Braque's work which has been developed in recent years does not support the idea that construction derives from collage. It now appears that the cardboard maquette for the 'Guitar' was assembled in autumn 1912,[4] while the reliefs described by Kahnweiler date from 1913. Picasso himself said that the 'Guitar' 'had nothing to do with collage'; similarly, Braque testified that sculpture preceded *papier collé* in his work: 'I was making paper sculpture... Then I put the sculpture onto canvas. Those were my first *papiers collés*.'[5] (Braque's first constructions seem in fact to have preceded Picasso's; unfortunately, we have no idea what they looked like.[6])

If collage and *papier collé* did not provide the model for constructed sculpture, what did? Kahnweiler emphasises the influence on Braque and Picasso of the Grebo mask (fig.22) owned by the latter. It was the projecting eyes of this mask, he says, which provided the model for the projecting sound-hole of Picasso's 'Guitar'. More fundamentally, the mask demonstrated that 'the true character of painting and sculpture is that of a script'. Instead of imitating the 'real' contours of the human face, it presented a series of signs – the cylindrical eyes, the box-like mouth, the narrow wedge of the nose – arrayed on the plane of the face.[7] Similarly, Picasso's 'Guitar' breaks the actual contours of the instrument into a series of discrete 'signs'.

For Yve-Alain Bois, the 1912 'collusion' between the Grebo mask and the 'Guitar' inaugurates a new, 'semiological' form of Cubism, dramatically different from the essentially mimetic Cubism of 1910–11. Rejecting the interpretation of the 'Guitar' as 'a painting in space' – a sculptural equivalent of Analytic Cubism – Bois argues that it was this new language derived from the Grebo mask which led to the invention of 'open' construction. Since there was no risk of its being confused with a real guitar, the 'Guitar' did not require a frame or a pedestal to set it off as art; as Bois writes, 'the sculpture no longer had to fear being swallowed up by the real space of objects.'[8]

These differing interpretations of the 'Guitar' pose a number of significant questions. What is the relationship between construction and collage? Between construction and Analytic Cubism? What are the roles of the Grebo mask and of Braque's lost constructions in Picasso's development? The following discussion attempts to answer these questions by examining Picasso's sculpture projects of 1912–14.[9]

Picasso's first studies for constructions date from early 1912 (figs.18–21). They have surprisingly little in common with the 'Guitar', depicting figures rather than still-life motifs, and three-dimensional constructions rather than reliefs. There is no evidence that Picasso attempted to realise these figures as actual sculptures. However, he may have shown his sketches to André Salmon, whose art column in the 11 January 1912 *Paris-Journal* contains the tantalising comment: 'Modern sculpture – the painter Picasso, without in any way throwing away his brushes, is undoubtedly going to execute some important sculptural works.'[10]

These sculpture studies belong to a larger series of drawings associated with the spring 1912 canvas, 'Violin, Wineglasses, Pipe, and Anchor' (D 457), which (like the better-known 'Souvenir du Havre', D 458) seems to have been painted as a memento of a trip with Braque to the Normandy coast. The series begins with sketches of an accordion player. (This is probably a reference to Braque, a talented accordionist.) In subsequent drawings, the accordion player evolves into a guitarist, changing sex along

fig.17 **Mlle Léonie** 1910 Ink on paper
Marina Picasso. Courtesy Galerie Jan Krugier, Geneva

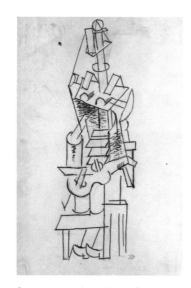

fig.18 **Guitar Player (Study for a Construction)**
1912–13 Pen, ink and pencil on paper
Musée Picasso, Paris

fig.19 **Guitar Player (Study for a Construction)**
1912 Ink on paper *Marina Picasso. Courtesy Galerie Jan Krugier, Geneva*

fig.20 **Head (Study for a Construction)** 1912
Ink on paper *Succession of the Artist*

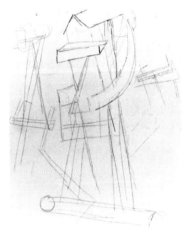

fig.21 **Head (Study for a Construction)** 1912
Pencil on paper *Succession of the Artist*

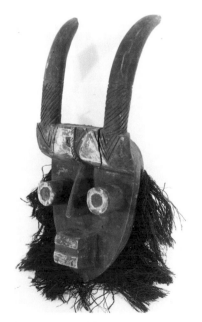

fig.22 Grebo mask (Ivory Coast)
Musée Picasso, Paris Photo: André Koti

the way. In the shaded, pictorial drawings of this series, this female guitarist is depicted in front of curtains or in a café setting; in the sculptural drawings, she is generally presented against a blank backdrop, with little or no shading.[11]

In some of the sculpture sketches (fig.18), the figure is constructed around a mast-like backbone from which the other elements of the body are cantilevered or suspended. Picasso here provides a three-dimensional equivalent for practically every aspect of the human figure. The face is reduced to a vertical plane, the mass of the head to a ball, and both of these are mounted on a horizontal plane at chin level. A round collar encircles the neck. The upper edge of the torso is depicted as a kind of shelf, with semicircular flaps (representing the figure's breasts) rising from it. The volume of the torso is encircled by curving ribs and traversed by horizontal planes. The relatively naturalistic legs and feet are visible below the rectangular seat of a chair with four square legs. In several related drawings, the figure's shoulders are indicated by a crossbar below the neck, while the elements of the head are held in place by guy-wires (fig.20). Another head study reproduces the wedge-shaped nose and the projecting brow of the Grebo mask (figs.21, 22).

Certain elements of this figuration can be traced back to the very beginnings of Analytic Cubism. If we look, for instance, at an autumn 1910 sketch (fig.17) related to the print 'Mlle Léonie', we find the shoulder on the left depicted as a large circular segment, and the shoulder on the right as a sharp angle. Both of these forms return in the spring 1912 sculpture study, the angle as a pair of bent strips atop the shelf of the torso, the circular segment as curved 'hinges' projecting at either side (fig.18).

In other versions of the spring 1912 guitarist (fig.19), the torso is reduced to a large vertical panel, mounted atop a horizontal panel, as if the figure has been identified with the seat and back of the chair in which it is seated. The arms and head seem to be attached to the back of the vertical panel, while the guitar is suspended by strings or wires from the head. If this figure resembles an old-fashioned marionette, it also looks forward to the welded-rod construction of Picasso's 1928 'Monument to Apollinaire' (no.75).

The last members of this series appear to date from summer 1912, around the time when Picasso did the drawings and paintings most closely related to the 'Guitar'.[12] However, there is little similarity between the two groups of studies. Although some of the drawings and paintings related to the 'Guitar' depict the sound-hole as a projecting, cylindrical form, in none of them is the instrument as a whole represented in sculptural terms. The three-dimensional realisation of this composition seems, in effect, to have been an afterthought, and it remained fundamentally pictorial in conception.[13]

The 'Guitar' provided the model for a number of constructed guitars and violins which Picasso created in the course of winter 1912–13. Some of them (fig.23) derived from his contemporary *papiers collés*, while others were relatively independent in conception.[14] The cardboard maquette of the 'Guitar' was incorporated at this time in a larger relief composition (fig.24) assembled in Picasso's boulevard Raspail studio. The ridged panel on the left of this relief appears to represent a wall with a chair-rail or moulding, while the guitar and the cut-diamond bottle rest on a circular table with a single abstract tassel evoking its fringed tablecloth. This relief construction seems, in turn, to have provided the model for several canvases, including 'Glass, Guitar and Bottle' (no.28).[15]

It appears likely that Kahnweiler had this particular group of works in mind when he wrote that Picasso's 1912 (or rather 1912–13) paintings were 'imitations' of his lost reliefs.[16] However, the relationship between painting and sculpture here is more complex than Kahnweiler's comment suggests. Insofar as the winter 1912–13 relief was based on paintings and drawings which Picasso had done the previous summer, its

reinterpretation on canvas was, in effect, a return to the composition's original medium. The relationship between painting and sculpture is a two-way street.

Picasso's work of spring 1913 constitutes a gigantic visual fugue composed around two familiar motifs – a man with a guitar, and a still-life arrangement of a guitar and a bottle on a table. The 1913 versions of these motifs were first stated in a large construction (fig.16) which Picasso assembled in his boulevard Raspail studio early in the year, combining a drawn Cubist figure with newspaper limbs, a real guitar, and a table-top arrangement of real objects, including a bottle and newspaper. His subsequent variations on these themes extend through a seventy-five page notebook, over two hundred drawings on loose sheets, numerous *papiers collés* and reliefs, and a comparatively small number of canvases. Many of the individual variations are unimpressive, but there is a hypnotic fascination in the constant metamorphoses leading from one work to the next. Figures are transformed into still lifes, still lifes into figures; sketches for paintings become sculpture studies, sculpture studies become sketches for paintings.[17]

In the early pages of the 1913 notebook, the guitar player is depicted as a standing figure composed of vertical strips. Several different versions of this figure were combined in a small paper construction (no.20) which Picasso gave to Gertrude Stein.[18] Other drawings reveal that Picasso was planning a considerably more elaborate version of the guitarist, to be constructed from wood and possibly other materials (figs.25–6). As in his spring 1912 sculpture studies and in the guitar player construction from the boulevard Raspail studio (figs.16, 19), the torso is reduced to a large vertical panel. The back and arms of the chair seem to extend from the reverse side of this panel, while the arms are attached to an independent framework in front of it. The spiky 'beard' below the head (in a notebook study) was presumably inspired by the raffia fringes of the Grebo mask (fig.22). Above the head, an inverted 'L' terminates in a large circle, corresponding to the top of the guitarist's stovepipe hat.

Several of Picasso's sketches indicate the details of the figure's joinery, and there is no way of knowing why he did not proceed to realise it. Picasso's skills as a carpenter may have been rudimentary, but if he could construct the wooden 'Mandolin and Clarinet' of winter 1913–14 (D 632)[19] with its cut-out curves and angled planes, he could no doubt have constructed the spring 1913 'Man with Guitar'. Perhaps he did in fact construct it, but was unable to transport it when he changed studios.

Either as a pendant to this construction or as a substitute for it, Picasso seems to have decided to convert the guitar player composition into a design for a painting. A notebook sketch (fig.27) shows how the wooden framework joining head and arms was transformed into a pattern of dark lines superimposed on a series of shaded strips. In these studies, Picasso's interest turns to problems of pattern and texture, and the large flat colour areas of the finished painting (fig.28) give no indication that the figure began as a sculptural composition.

Other notebook sketches show Picasso returning to this motif with the idea of realising it as a wall relief rather than a free-standing construction.[20] Combining several early versions of the guitar player, Picasso created a large triangular figure, with target-like concentric circles indicating the face and the sound-hole of the guitar (fig.29). The colour of each element is carefully labelled, suggesting that this sketch was done specifically as a preparatory study for a larger work. An unpublished photograph in the Musée Picasso archives reveals that Picasso in fact assembled a wall relief (fig.30) corresponding exactly to this drawing. If we gauge the size of this relief by the quarter-circle of newsprint at upper right, the relief as a whole seems to have been around 120 centimetres high and 80 centimetres wide (48 × 31 inches) – around the same size as the painted 'Man with Guitar'.[21]

The diagonal line at upper left in the drawing becomes a long strip of wooden

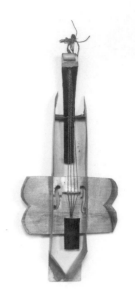

fig.23 **Violin** 1912–13 Cardboard and string *Staatsgalerie Stuttgart*

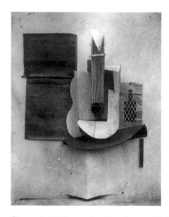

fig.24 **A Guitar and a Bottle on a Table** 1913 Assemblage in Picasso's studio, boulevard Raspail, Paris. No longer extant *Photo Archive, Musée Picasso, Paris*

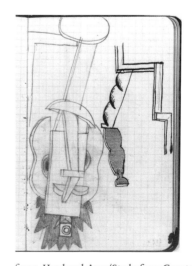

fig.25 **Head and Arm (Study for a Construction)** 1913 Ink on paper, Carnet MP 1865, f.42r *Musée Picasso, Paris*

fig.26 **Man with Guitar (Study for a Construction)**
1913 Pencil on paper *Courtesy Matthew Marks Gallery, New York*

fig.27 **Man with Guitar** 1913 Ink on paper, Carnet MP 1865, f.45r *Musée Picasso, Paris*

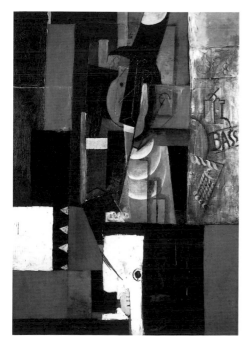

fig.28 **Man with Guitar** 1913 Oil on canvas
The Museum of Modern Art, New York. André Meyer Bequest

moulding in the actual relief, suggesting that Picasso wanted to accentuate the work's three-dimensional character. Indeed, sketches from the last pages of the spring 1913 notebook (fig.31) show that Picasso considered executing a more sculptural version, using wooden planks (*planches* and *planchettes*) for many elements. The 'target' face would have been replaced by a semicircular head similar to that of the painted 'Man with Guitar'. However, the new figure was evidently intended to be a woman, her breasts indicated by projecting dowels. (One version of the spring 1912 'panel' guitarist includes similar dowel-like breasts, probably inspired by the projecting cylindrical eyes of the Grebo mask.[22])

Picasso also executed two panel reliefs during this period; these derive from a long series of drawings which alternate, similarly, between pictorial and sculptural versions of the motif. The composition begins as a drawing of a figure playing a double bass or cello, subsequently transformed into a table-top still life with a guitar and a bottle of Bass (D 630, D 631).[23] This series is too long to reproduce here, but a pair of contemporary drawings (no.58 and fig.32) presents a similar transformation from figure to still life and from sculpture to painting. Picasso here converts a constructed head into a painted bottle by turning it upside down, deleting the eyes, inscribing a label, and adding shading. The interchangeability of pictorial and sculptural ideas thus appears as one instance of a larger tendency toward metamorphosis, in which the details of figures and objects constantly assume new meanings as they shift from one context or medium to another.

In spring 1914, Picasso created a series of relief still lifes in which the forms were 'drawn' with cut-out tin or crudely sawn planks and painted in unmodulated hues of white, grey, and brown (nos.21, 22 and s 53). He returned to sculpture in the round with a cast-bronze 'Glass of Absinthe', whose seemingly traditional technique is belied by the cutaway form of the glass, the collaged addition of a real absinthe spoon, and the fact that each of the six bronze casts is painted differently (nos.23–4; fig.33). While the motifs and forms of these works resemble those of Picasso's 1914 drawings, *papiers collés*, and paintings, they are not accompanied by long series of studies like those which preceded his 1913 reliefs. Having achieved fluency in the new medium of constructed sculpture, Picasso apparently no longer needed to rehearse his ideas as drawn sketches.

The intimate relationship between Picasso's pictorial and sculptural ideas, throughout the period 1912–14, suggests that the development of his constructed sculpture cannot be understood simply in terms of material technique. The Grebo mask may have provided an example of open-form sculpture. Braque may have pioneered the creation of paper or cardboard models. However, the particular use which Picasso made of these examples reflected the ongoing development of his own pictorial syntax.

From this point of view, Braque's most important contribution to construction may lie, not in his lost sculptures, but in the spatial model provided by his landscape and still-life paintings of 1908–9. Instead of receding into space, in the manner of conventional perspective, the forms in these paintings began at a fixed background plane and advanced toward the viewer. For this reason, Kahnweiler noted, Cubist pictures 'should not be framed in the Renaissance type of frame, which leads the eye into the picture, but in what is called "reverse section"' – that is, a series of cornices projecting forwards, with the canvas at their apex. The painting is no longer a 'window' into illusionistic space, but has become what Braque and Picasso called a *tableau-objet*, existing in the 'real space' of the viewer.[24]

However, the reverse perspective of 1908–9 would probably not, in itself, have led to the invention of constructed sculpture. Its system of advancing planes might well have been translated into a kind of geometric bas-relief, with facets forming a continuous surface – a flattened version of Picasso's 1909 'Head of a Woman (Fernande)' (no.6).

Indeed, Picasso apparently created a still life of a piano corresponding to this description.[25]

The geometrical facets adopted by Picasso and Braque in their 1908–9 work had still served to describe the *surfaces* of figures and objects. Only in 1910 did Picasso break with the fundamental Western convention of the continuous surface. Kahnweiler described Picasso's Cadaqués paintings, done that summer, as 'rigid constructions which no longer represent an imitation of solids seen in the round, but rather a kind of scaffolding'.[26] Figures and objects were now articulated by lines and planes emerging from within, so that their internal volumes appeared open instead of enclosed (fig.17). For Kahnweiler, the invention of open form was 'the decisive advance which set Cubism free from the language previously used in painting'.[27]

'Open form' was the real prerequisite for constructed sculpture as we know it. However, it was at first realised only in the mediums of drawing and painting. Not until 1912 did Picasso begin to consider the possibility of literalising his pictures as sculptures. When he did so, his sculptural vocabulary looked back to his first open-form drawings of 1910. As Alfred Barr suggested, Picasso's 1912 sculpture studies underscore 'the latent structural or architectonic character' of 1910 Cubism.[28] They thus cast serious doubt on Yve-Alain Bois's hypothesis that there is a radical discontinuity between the Analytic Cubism of 1910–11 and the semiological Cubism which emerges in summer-autumn 1912, and that this new 'sign' language was a necessary precursor to the invention of construction. Not only do Picasso's first construction studies precede Bois's hypothetical break by several months; they also derive directly from his earlier graphic work. It seems more accurate to describe both construction and the 'sign' language of summer 1912 as results of a consistent, ongoing evolution.[29]

Picasso's drawings also shed light on the question of his indebtedness to Braque and to African sculpture. His early 1912 construction studies may have been provoked by Braque's lost paper sculptures, but they were clearly quite different. We know from literary evidence that Braque's constructions were reliefs representing guitars and violins.[30] Picasso's drawings were studies for sculptures in the round, representing figures. It was only at this point – two years after the invention of 'open form' – that the Grebo mask emerged as a presence in Picasso's drawings. It thus seems to have served not as a model but as a 'witness', confirming constructive ideas Picasso had already arrived at on his own, or in conjunction with Braque.[31]

Surprisingly, Picasso's 1913 constructions and sculpture projects revert in some respects to the 'reverse perspective' model of Braque's 1908 landscapes. The boulevard Raspail guitarist (fig.16) advances toward the viewer, literalising the structure of Braque's paintings. The large Céret construction (fig.30) displays a lower degree of relief, but extends laterally across the wall. It is, quite literally, a *tableau-objet*.

The strip of wooden moulding at left in this work seems intended to underscore the absence of a frame at the other three sides of the figure. As an object existing in real space, Picasso's construction had no reason to remain within the window-frame boundaries of perspectival painting. This construction appears to have provided the model for the numerous 1914 pictures in which drawn or printed strips of picture moulding appear within the compositional field, rather than around its borders. As Gertrude Stein noted, 'pictures commenced to want to leave their frames.'[32] But bits of the frames remained behind.

From summer 1912 to spring 1914, Picasso's sculpture projects (executed and unexecuted) tend to be constructed around a large vertical plane to which the other elements are attached (figs.16, 19, 26). If this is a holdover from Braque's reverse perspective model, with its fixed back plane, it may also reflect the influence of the Grebo mask, where the face is a flat plane with the features projecting from it. In

fig.29 **Guitar Player** 1913 Ink on paper, Carnet MP 1865, f.65v *Musée Picasso, Paris*

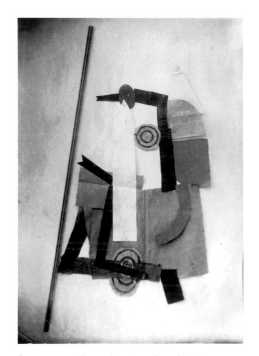

fig.30 *Papier collé* mural in Picasso's studio, Céret 1913 Presumed destroyed *Photo Archive, Musée Picasso, Paris*

fig.31 **Guitar Player (Study for a Construction)** 1913
Ink on paper, Carnet MP 1865, f74v *Musée Picasso, Paris*

fig.32 **Bottle on Table and Guitar on Table** 1913
Ink on paper *Succession of the Artist*

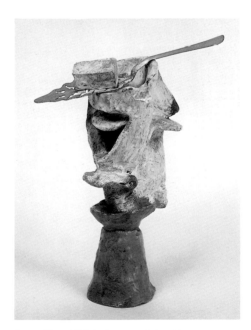

fig.33 **Glass of Absinthe** 1914 Painted bronze
Private Collection

discussing his Cubist constructions, Picasso drew special attention to this aspect of the mask;[33] furthermore, the drawing most closely linked to the mask (fig.21) reproduces its flat facial plane but *not* the projecting eyes which are usually described as its most important feature.

However, the organisation of the figure around a central rectangular plane derives most directly from Picasso's drawings and paintings of late 1911 and early 1912. This development is too complex to retrace in detail. It can be summarised by saying that, whilst the Cubist 'grid' had previously been superimposed on figures articulated according to other principles, Picasso's figures were now organised from the outset around vertical strips lying parallel to the picture plane. The representational function of the strip could be determined by the signifiers inscribed upon it: eyes for a head, a label for a bottle, a circular sound-hole for a guitar, 'f'-holes for a violin. The privileged status of the strip reflected the fact that it could function simultaneously as part of a figure (or object) and as an element in a larger grid extending throughout the composition.

Beginning in 1910, Picasso's analysis of form led him to treat different aspects of the motif as if they were literally different objects. Thus a figure's face might be represented as a rectangular plane floating in space, while a nearby circle or ball indicated the volume of the head. Similar planar and curved forms represent the face and head in Picasso's spring 1912 sculpture studies (figs.18–20). This contrast is accentuated even further in the early 1913 construction assembled in Picasso's boulevard Raspail studio (fig.16), with its diverse materials and modes of signification. The face and torso of the guitar player are represented by lines upon a canvas, while the guitar and the table-top still life are fully three-dimensional. The opposition between abstraction and naturalism thus corresponds to a contrast between planar and volumetric elements.

Except for the 'Guitar' (no.19), Picasso's Cubist constructions all include drawn or painted elements. The vertical panel probably remained an essential element in his sculptural thinking because it provided a potential site for the inscription of graphic signs.[34] There is something mystifying about this. These signs could easily have been converted into three-dimensional forms, as the angled and curved shoulders of Picasso's 1910 figures were converted in his 1912 sculpture sketches (figs.17, 18). Picasso's preference for combining two- and three-dimensional forms on (or around) a flat surface suggests that he continued, throughout these years, to view construction as a mode of painting. Not until his welded iron sculptures of 1928–31 did Picasso abandon the panel support in favour of an independent 'drawing in space'.[35]

Finally, we need to consider the significance of the constant metamorphoses evident in Picasso's sketches. In the winter of 1908–9, Picasso had developed a small figure composition, 'Carnival at the Bistro' (D 218, 219), into a monumental still life, 'Bread and Fruit Dish on a Table' (D 220). Arms became loaves of bread, a hand became an apple, a breast became a melon.[36] The transformations of his Cubist work seem at first glance to follow a similar pattern: the 1912 'Guitar' recalls the contours of a woman's body, and the cello player of spring 1913 becomes a still life of a guitar and a bottle of Bass.[37] In fact, the Cubist mode of transformation is very different from what precedes it.

The transformation of 'Carnival at the Bistro' into 'Bread and Fruit Dish' exemplifies what we might call the Arcimboldo model (after the sixteenth-century Italian painter, Giuseppe Arcimboldo). In fantastic figures of this type, what seems at first glance to be a random assortment of fruits or farmyard implements is suddenly revealed to be an image of the human body. The 'trick', so to speak, is that the outlines of the inanimate objects coincide with those of the face or limbs, naturalistically conceived.

Picasso's aim, in his Cubist drawings and sculpture studies, is the exact opposite: not

to arrange inanimate objects within the outlines of human anatomy, but to re-invent human anatomy on the model of inanimate objects. He does not make a chair look like a body (although he would do this in a later, Surrealist etching[38]). Rather, he asks: what would the human body look like if it were constructed like a chair (fig.19)?

The composition of the 'Guitar' does not derive from a figure study. On the contrary, it is the 'Guitar' which lends elements of its composition to the heads and bodies of winter 1912 and spring 1913 (figs.25–6). Even where a Cubist still life derives from a figure, the transformation does not depend on a naturalistic analysis of the human body. What makes it possible for Picasso to transform a spring 1913 head into a bottle (no.58 and fig.32) is that he has already redefined the forms of the head, reducing the face to a long narrow plane with a cylindrical chin emerging from its forked end. Inverted, this becomes a bottle. A naturalistic head, inverted, would not have the same effect.

It should be noted that the radical anti-naturalism of Picasso's constructions (actual and projected) was not an inevitable consequence of their material technique. The same technique might have been used to open up the contours of figures and objects while continuing to represent them in a fundamentally naturalist fashion, as in Naum Gabo's heads or Boccioni's 'Development of a Bottle in Space'.[39] In contrast, Picasso's anti-naturalism is already evident in his first 'open form' sketches of 1910 (fig.17), where the structure of the figure is only indirectly related to anatomy. The right side of the torso, for instance, is figured as a series of interlocking half-cones, whose open ends coincide with shoulders, chest, and waist, without in any way resembling them. Geometry sets the pattern for the reinvention of the human body.

There is no place within the dehumanised figuration of Picasso's 1912–14 constructions for the gestural vocabulary of traditional sculpture. Rather, their expressive qualities depend largely on 'abstract' associations: the tense wires and cantilevered planes of the 1912 guitarists (figs.18–20); the reassuring parallelism of the planes in the 'Guitar' (no.19); the cheerful colours and unexpected angles of the spring 1913 guitar player (figs.29–30). Substituting kinesthesia for mimesis, Picasso's constructions propose a new vocabulary for modern sculpture.

Notes

1 William Rubin, *Picasso in the Collection of the Museum of Modern Art*, New York 1972, p.74.

2 Daniel-Henry Kahnweiler, *Juan Gris: His Life and Work*, New York 1969 (originally Paris 1946), p.119. Similar comments appear in several other texts by Kahnweiler. See *Les Sculptures de Picasso*, Paris 1948, unpag. [p.4]; 'L'Art nègre et le cubisme', in *Confessions Esthétiques*, Paris 1963, p.234; and 'Cubism: The Creative Years', in *Art News Annual*, no.24, 1955, p.115. Kahnweiler specifies that Braque's reliefs were made from paper, and Picasso's from cardboard, wood, and iron.

3 In *Cubism and Twentieth-Century Art*, New York 1959, reprinted 1976, pp.294–5, Robert Rosenblum describes the 'Guitar' as a metal 'cutout' which 'paralleled the technique of pasting papers'. Similar comments about the relationship between collage and construction appear in Roland Penrose, *The Sculpture of Picasso*, exh. cat., Museum of Modern Art, New York 1967, p.20, and Alan Bowness, 'Picasso's Sculpture', in Roland Penrose and John Golding (eds.), *Picasso in Retrospect*, New York 1973, pp.130–2.

4 In Rubin 1972, p.74, the author dated the 'Guitar' to early 1912, and this dating was adopted by Pierre Daix in his 1979 *catalogue raisonné*. In his 1981 review of this catalogue, Fry argued for a dating of summer or autumn 1912, and in subsequent publications he and Rubin converged on a dating of October 1912 for the original cardboard maquette of the 'Guitar', and some months later for the more permanent, sheet-metal version (no.19). See Edward F. Fry, 'Pierre Daix and Joan Rosselet, *Picasso: The Cubist Years 1907–1916*', *Art Journal*, vol.41, no.1, spring 1981, pp.92–3, and n.21, and 'Picasso, Cubism, and Reflexivity', *Art Journal*, vol.47, no.4, winter 1988, pp.296–310; see also William Rubin, *Picasso and Braque: Pioneering Cubism*, exh. cat., Museum of Modern Art, New York 1989, pp.31–2.

5 Rubin 1972, p.108; Jean Paulhan, *Braque le patron*, Paris 1954, reprinted 1980, p.47.

6 The literary evidence that Braque was making paper constructions of some kind several months before the creation of the 'Guitar' is discussed in Rubin 1989, pp.30–41; this evidence does not suffice to establish whether these constructions were organised around pairs of parallel planes like those found in the 'Guitar', or around angled, overlapping planes like those in Braque's contemporary paintings.

7 Kahnweiler 1948, unpag. [p.4]. See Daniel-Henry Kahnweiler, *The Rise of Cubism*, New York 1949, pp.15–16, and William Rubin, 'Modernist Primitivism', in Rubin (ed.), *'Primitivism' in 20th-Century Art*, exh. cat., Museum of Modern Art, New York 1984, pp.18–20.

8 Yve-Alain Bois, 'Kahnweiler's Lesson', in *Painting as Model*, Cambridge, Mass. 1990, pp.77, 79, 91.

9 For a more detailed survey of Picasso's 1912–14 sculpture projects, see chaps.6 and 7 of my dissertation, 'Picasso's Laboratory: The Role of his Drawing in the Development of Cubism, 1910–14', New York University 1993.

10 Cited in Ron Johnson, *The Early Sculpture of Picasso 1901–1914*, New York 1976, p.115. Johnson suggests that Salmon's remark applies to the series of 'Guitar' sculptures, an interpretation based on the early 1912 dating of the metal 'Guitar' in Rubin 1972, p.207. However, as the 'Guitar' sculptures were actually done in autumn–winter 1912–13, Salmon's remark must apply to something else.

11 For reproductions of 'Violin, Wineglasses, Pipe and Anchor' and the associated drawings, see Rubin 1989, pp.220 and 242–3; for the datings of these works, see Pepe Karmel, 'Notes on the Datings of Works', in William Rubin et al., *Picasso and Braque: A Symposium*, New York 1992, pp.332–3.

12 The drawings and paintings related to the 'Guitar' were first identified by Edward Fry, in his 1981 review of Daix and Rosselet's *catalogue raisonné*; see n.4 above.

13 This is not to say that Picasso had abandoned all thoughts of construction. On the contrary, his summer 1912 notebook contains several sketches for a construction of a violin player, whose box-like head clearly derives from the Grebo mask. See the drawings reproduced in Fry 1988, p.300.

14 The 1912–13 'Violin' (S 35) is based on a *papier collé* done in Paris (Rubin 1989, p.266, upper left; not in Daix); it was subsequently incorporated in a larger relief assembled in Céret in spring 1913 (D 629A). The two guitars in D 555 and D 556 do not derive directly from Picasso's graphic work, although he later imitated their ridged necks in a drawing done at Céret (Z XXVIII.282; see Rubin 1989, p.268).

15 For the larger series of paintings deriving from D 633 (fig.24), see the series of still lifes D 564–71. It should be noted that D 629a, 630, 631, and 633 were reproduced in the Nov. 1913 issue of *Les Soirées de Paris*, and are therefore dated by Daix to autumn 1913; in fact, they seem to have been executed in early or spring 1913. The pedestal table with a fringed tablecloth is a stock property of Picasso's 1911–14 paintings and constructions (compare 'Still Life', no.22); it is also visible in photographs of Picasso's studios, such as fig.16.

16 The paper reliefs visible in an early 1913 photograph of Braque's Hôtel Roma studio (repr. Kahnweiler 1955, p.108) may, similarly, have provided the models for several of Braque's 1913 canvases.

17 Picasso's spring 1913 notebook is in the collection of the Musée Picasso (MP 1865). While it has not yet been published in its entirety, many individual pages are reproduced in vol.XXVIII of Zervos.

18 See Gertrude Stein, *Picasso*, 1938, reprinted New York 1984, p.26.

19 Repr. Rubin 1989, p.292.

20 The disposition of the relevant sketches suggests that the two projects were not pursued simultaneously. The sketches related to the free-standing wooden construction appear in a roughly coherent sequence filling ff.40–9 of the 1913 notebook. In each case, the sketch appears on the right-hand page. In contrast, the sketches related to the wall relief are scattered throughout the book, appearing on the verso of ff.16, 65, 66, 74, 75, and the recto of only one sheet, f.73. When doing the second series, Picasso seems to have flipped through the more or less completed notebook, looking for blank pages on which to draw.

21 The newspaper fragment in the relief seems to be three columns wide. As the standard column width in papers such as *Le Journal* and *Excelsior* was around seven centimetres, this makes it possible to estimate the overall dimensions of Picasso's construction. The *papiers collés* D 596 and 598 and the painting D 597 all seem to derive from Picasso's wall relief; while these are traditionally identified as 'Guitars', the link to the relief suggests that they actually represent guitar players.

22 See Z XXVIII.129.

23 See n.15 above, on the datings of these works.

24 Jacques Lassaigne, 'Entretien avec Braque' (1961), in *Les Cubistes*, exh. cat., Bordeaux 1973, p.xvi; Kahnweiler 1949, p.11; Kahnweiler 1969, pp.105, 124, 211, and n.118.

25 On the lost 'Piano' relief, see Kahnweiler 1969, p.75. On the bas-relief model of 1908 Cubism, see William Rubin's essay on 'Cézannisme and the Beginnings of Cubism', in William Rubin (ed.), *Cézanne: The Late Work*, exh. cat., Museum of Modern Art, New York 1977, pp.165, 187.

26 Kahnweiler 1948, unpag. [p.4]. On the 'continuous surface' as a characteristic of conventional European figuration, see Kahnweiler 1963, pp.232–3.

27 Kahnweiler 1949, p.10.

28 Alfred Barr, *Picasso: Fifty Years of his Art*, New York 1946, p.86.

29 I discuss the issue of Picasso's 'sign' language at greater length in the conclusion of my dissertation, cited in n.9 above.

30 See Douglas Cooper, *The Cubist Epoch*, London 1971, p.58.

31 In a 1923 interview, Picasso told Florent Fels, 'the African sculptures that hang around almost everywhere in my studio are more witnesses than models'. Cited in Rubin, 'Picasso', in Rubin 1984, p.260.

32 Stein 1938, p.12.

33 See Rubin, 'Modernist Primitivism', in Rubin 1984, p.18.

34 This is particularly evident in a spring 1912 sculpture sketch belonging to the Museum of Modern Art, New York (inventory no.80.81), reproduced along with a group of other sketches in Z 11*.296 (middle row, second from right). Here the face is represented as a flat circle, inscribed with a vertical line and two dots indicating the nose and eyes. This circular plane is connected by wires to the shaded sphere of the head. The treatment of the face directly anticipates the 1928 'Monument to Apollinaire' (no.75).

35 Many years later, Picasso told Roland Penrose that he had contemplated realising the 1909 'Head of a Woman (Fernande)' (no.6) in wire instead of bronze: see Penrose, *The Sculpture of Picasso*, exh. cat, Museum of Modern Art, New York 1967, p.19. However, the associated studies cast doubt on this idea, suggesting, on the contrary, that Picasso from the outset conceived of the sculpture as a solid, faceted mass: see Rubin 1989, p.141.

36 On the significance of this transformation, see William Rubin, 'From Narrative to "Iconic" in Picasso: The Buried Allegory in *Bread and Fruitdish on a Table* and the Role of *Les Demoiselles d'Avignon*', *Art Bulletin*, vol.65, no.4, Dec. 1983, pp.615–49.

37 On the anthropomorphic reading of the 'Guitar', see Carl Einstein, *Georges Braque*, Paris 1934, p.99; Werner Spies, 'La Guitare anthropomorphe', *Revue de l'Art*, no.12, 1971, p.89; and Alexandra Parigoris, 'Les Constructions cubistes dans "Les Soirées de Paris": Apollinaire, Picasso, et les clichés Kahnweiler', *La Revue de l'Art*, no.82, 1988, p.66, who suggests quite bluntly that the sound-holes of the 'Guitar' and of Picasso's other constructed instruments should be understood as vaginal apertures.

38 See the 1933 etching 'Woman and Surrealist Sculpture' (Geiser 346), in William Rubin (ed.), *Picasso: A Retrospective*, exh. cat., Museum of Modern Art, New York 1980, p.310.

39 See Rosalind Krauss, *Passages in Modern Sculpture*, Cambridge, Mass. 1977, pp.42–58.

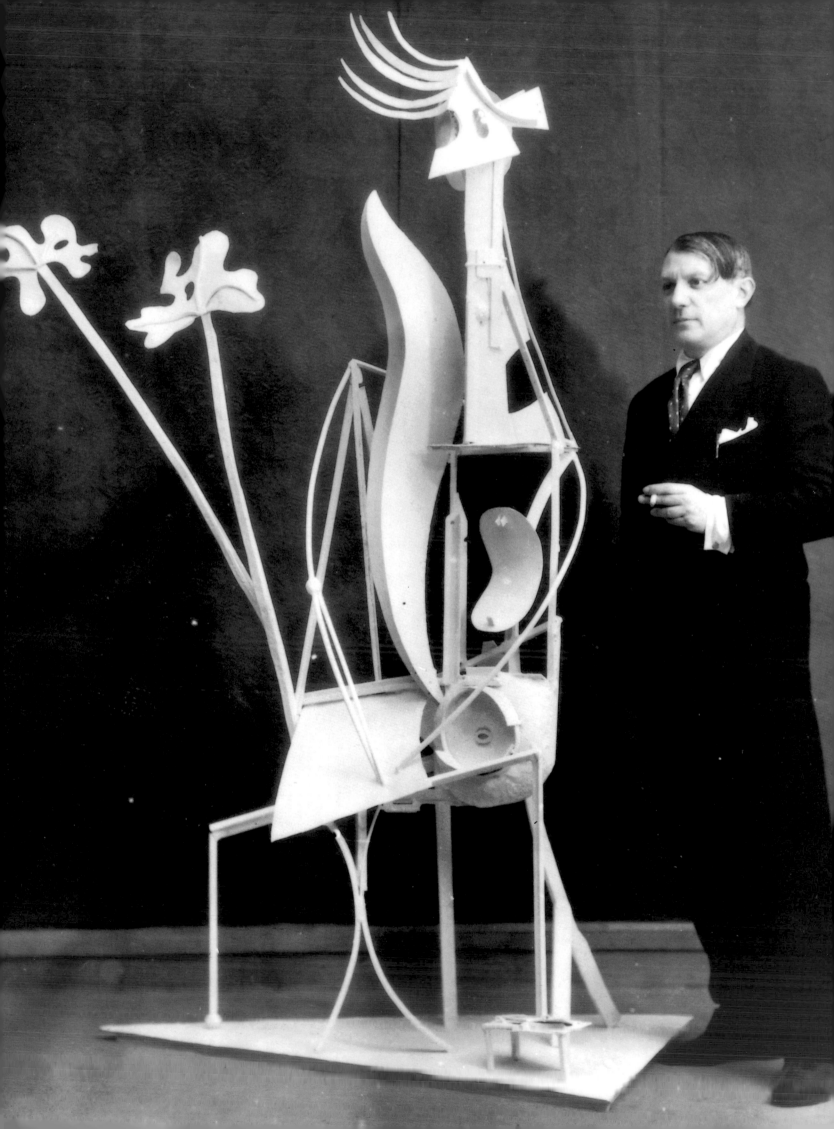

From Sketchbook to Sculpture in the Work of Picasso, 1924–32

PETER READ

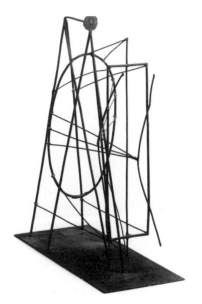

fig.35 **Wire model** 1928 *Musée Picasso, Paris*

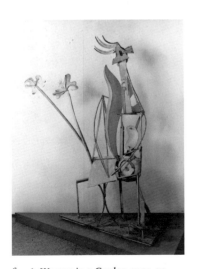

fig.36 **Woman in a Garden** 1929–30
Iron *Musée Picasso, Paris*

opposite
fig.34 Picasso with 'Woman in a Garden'
Undated photo ?1932 *Musée Picasso Archive, Paris*

Between 1928 and 1932 Picasso produced a series of sculptures infused with an extraordinary charge of vitality and creative energy. They include two versions of 'Metamorphosis' (see no.73), modelled in plaster then cast in bronze; four constructions in wire (fig.35), which Kahnweiler referred to as 'drawings in space'; three important welded metal montages, known as 'Head of a Man' (no.76), 'Head of a Woman' (fig.48 on p.214) and 'Woman in a Garden' (figs.34, 36; no.83). 'Metamorphosis I and II' and the wire constructions, made in 1928, were models, to be scaled up to an appropriate size should the opportunity arise. The last three works were, however, built as full-scale sculptures. All of them were based, to a greater or lesser extent, on preliminary drawings, and Picasso's sketchbooks carry the trace of the long period of gestation which preceded the transition from graphic conception to three-dimensional realisation. Picasso enjoyed the speed and absolute freedom which drawing allowed, but did not hurry to come to grips with the practical problems and resistant materials which the manufacture of sketchbook projects implied. Certain of his drawings and paintings are designs for large, monumental sculptures which, at the time of their conception at least, *could* only exist on paper; their eventual fabrication would have required specialist assistance, tools and materials which were not then available to him. My main concern in this essay will be to provide a brief survey of the major sculptures Picasso made between 1928 and 1932, concentrating particularly on the welded metal pieces, and to explore some aspects of the relationship between them and the artist's sketchbooks, from 1924 onwards.

The first work in this group, 'Metamorphosis I' (no.73), was born of a long series of graphic variations on the motif of the female bather on the beach, or *baigneuse*. Its outline is already prefigured by numerous drawings in a sketchbook begun in December 1926, in Paris, and finished 8 May 1927 (Carnet 061).[1] The conception of this voluptuous figure seems therefore to coincide with the beginning of Picasso's affair with Marie-Thérèse Walter, the young girl he encountered on a busy Paris street one Saturday evening, 8 January 1927.[2] Picasso spent the summer of 1927 in Cannes with his family, and with Marie-Thérèse staying nearby. The two sketchbooks from this holiday are dated 17 July – 11 September and 11–24 September 1927 (Carnet 015, MP 1874; Carnet 011, MP 1990–107). The first of these books, inspired by the activities of Marie-Thérèse on the beach, is filled with pneumatic bathers, bursting with erotic energy. The second, which contains fourteen drawings, is more varied. Six folios, opening and closing the book, continue the variations on the naked, androgynous bathers (fig.37); folio 4 represents a project for a sculpture made of metal struts and sheets, whose design marks a return to the influence of African masks (fig.42); this is followed by six folios of linear patterns that transform the solid, voluminous forms of the bathers into transparent, geometrical structures (fig.38). This sketchbook (Carnet 011) is crucially important in that it contains the plans for the three major types of sculpture which would consecutively occupy Picasso from 1928 to 1932: the naked 'Metamorphosis', modelled in plaster; the wire constructions; the welded metal montages.

Early sculptures by Picasso had been modelled in clay or carved in wood, traditional processes which had given way to work in sheet metal and tin, first with the innovatory 'Guitar' ?1912–13 (no.19), and also to constructions such as 'Mandolin and Clarinet' 1913, made from pieces of wood nailed together (s 54). In the September 1927 sketchbook, Picasso plans a return to sculpture through a series of projects which both mirrors and surpasses his earlier career in this medium. He telescopes into a few folios a repetition of the transition from modelling to metalwork and conceives of a montage sculpture built from pieces of metal.

Of relevance here is the fact that in late 1920 a campaign had been launched by the review *Action* to raise funds for the design and construction of a monumental sculpture for the tomb, in Père Lachaise cemetery, of the poet Guillaume Apollinaire. Apollinaire, one of Picasso's closest friends, had died on 9 November 1918. According to a leaflet distributed by *Action*, the text of which was reproduced by the *Mercure de France* in January 1921, Picasso had been commissioned to design the monument.[3] The necessary funds were raised in two ways: by a public subscription in 1921, and by an auction sale at the Hôtel Drouot on 21 June 1924, to which over sixty artists, including Picasso, donated paintings and other works.[4] By the summer of 1924, the money was in the Apollinaire Committee coffers; all that was needed was Picasso's design.

fig.37 Carnet 011, f.14, 1927 *Succession of the Artist*

In November or early December 1927, the committee, which included the painter Serge Férat and men of letters André Billy and André Salmon, had met in Picasso's studio where he showed them his plans. Several years later, the journalist Maurice Noël interviewed Serge Férat in order to discover why the tomb remained bare. Noël informed his readers that Picasso had originally shown the committee 'a few dozen drawings, all of which he considered to be suitable starting points for the project. Some of the drawings suggested a monument in metal wire, while others consisted of such a strange combination of volumes that anyone with a little imagination might find them obscene, like the sculptor Brancusi's *Princesse X...*, which had caused a scandal'. Serge Férat also told Noël that Picasso had shown the committee a drawing for an African-inspired sculpture constructed from metal sheets and struts and that this, like the other projects, was considered unacceptable.[5] It therefore seems likely that Picasso asked the committee to choose a monument from those he had designed in his summer 1927 sketchbooks, and in particular Carnet 011. Unabashed by their reaction, Picasso would forge ahead with the fabrication of his established programme of sculptures.

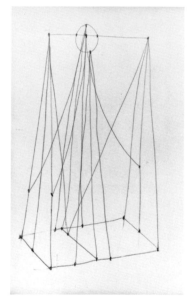

fig.38 Carnet 011, f.10, 1927 *Succession of the Artist*

'Metamorphosis I' (no.73) is a small, naked and predominantly female figure. It is a free adaptation of the *baigneuse* sketches, concentrating bulk nearer the base: weight is supported by a broad left foot, heavily out of scale with the rest of the figure, behind which leans a peg-like right leg. There is humour in this incongruity, which Picasso would again exploit in his wartime play *Le Desir attrapé par la queue* (Desire Caught by the Tail) where one of the characters is called Big Foot. The opposition between slimmer and swollen shapes characterises the whole of 'Metamorphosis', where bulbous protuberances and spheres at one end are balanced by narrowing, elongated shapes, enclosing open space, at the other. The head is pulled into a phallic column and cast back so that the open mouth becomes a vertical orifice. This position and expression combine with the swelling of tumescent tissue at the front of the figure to express the androgynous melding of male and female attributes in orgasmic abandon. Scaled up to monumental size and cast in bronze, the work would have appeared massively anthropomorphic, smooth and bulbous, exuding sensuality, one of those public sculptures which irresistibly attract a caress from the spectator's hand.

In October 1928, Picasso moved on to his plan for sculptures in wire (fig.35). 'Now I'd like to do something along these lines for the Guillaume Apollinaire monument', Picasso told Tériade in November 1928, as they examined the wire models together.[6]

fig.39 Carnet 003, f.6, 1924 *Succession of the Artist*

Picasso's fascination with these linear patterns dates back to the summer of 1924, when in Juan-les-Pins he used dots and lines to outline abstract shapes and musical instruments (fig.39), explaining later that this style of drawing was inspired by his admiration for astronomical charts.[7] He continued to play with this idea in subsequent sketchbooks, giving the constellations a human shape in October 1924 (Carnet 215, *Succession of the Artist*). In the summer of 1927, for the first time, he drew these patterns in three-dimensional perspective, so that they became projects for geometrical, transparent sculptures (Carnet 011). Drawings in Carnet 1044, made in Dinard in 1928 (no.64), are the logical continuation of the series. The resulting wire models were born of graphic experiments which poetically combined astronomy and human anatomy. They represent human figures surrounded by a geometrical frame, but sometimes reaching beyond the spatial limitations that such enclosure implies. A flat disc or a solid sphere represents the head and face. An inverted triangle of three indented dots economically produces an expression of wide-eyed astonishment, a notation devised by Picasso in 1924 when he was drawing costumes and sets for the ballet *Mercure* (Carnet MP 1990–106, f.13). Another notable aspect of these sculptures becomes apparent only as the spectator moves in a circle around them. The moving eye discovers an astonishing mobility within these works, in the fluid slide of the intersections and complex interplay of line and space.

Drawings dating from 3 and 12 August 1928, on folios 18, 20 and 26 of the Dinard sketchbook (Carnet 1044, no.64), served as blueprints, with very slight modifications, for three of the four models. The reason for this close correspondence was that Picasso entrusted manufacture of the wire sculptures to an old Catalan friend, Julio González, who used the drawings as blueprints, working under Picasso's guidance. The González family had a decorative ironwork business in Barcelona and Julio was himself a painter, designer and craftsman, with a watchmaker's skill in the manufacture of jewellery and precious metal objects. Furthermore, he had a small but fully equipped metalworker's smithy at 11 rue de Médéah, in Montparnasse. Using González as an assistant guaranteed a high quality of craftsmanship, but limited Picasso's capacity for improvisation at the moment of transition from drawing to sculpture. Correspondence indicates that Picasso was already planning to employ González as an assistant very early in 1928, but that they actually started work in October, after completion of that summer's Dinard drawings, once Picasso was satisfied that he had fully refined his ideas on paper.[8]

Following his description of the recently completed wire models in *L'Intransigeant* in November 1928, Tériade made the following remark: 'Picasso can picture these mast and aerial sculptures being built one day on a larger scale, with iron rods or some other material'. This would seem to suggest that though they were designed to be enlarged for a tomb, Picasso envisaged still grander versions of the wire models, requiring specialist help and facilities beyond the capacity of the rue de Médéah workshop. At this time Picasso also told Christian Zervos that he would like to build a grandiose series of monumental sculptures for the promenade de la Croisette in Cannes, a utopian project based on drawings made in Paris and Brittany in the summer of 1928, where the artist stripped away the nubile flesh of the bathers, transforming human figures into skeletal piles of stones, standing in precarious equilibrium.[9] Ambition of a similar scale is captured in his 1929 painting 'Monument: Head of a Woman', where a woman's face covers the facade of a large modern building (fig.40). In these two-dimensional works, Picasso was prophetically looking decades ahead, to his urban monuments in metal and concrete, to the expanded, steel-rod versions of his wire models which would be built in the late 1950s or early 1960s and in the 1970s, and to his twenty metre woman's head, the transparent sculpture which would be built in 1967 for the city of Chicago's new civic centre, with all the resources of the local steel industry.[10]

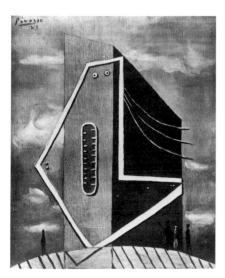

fig.40 **Monument: Head of a Woman** 1929
Oil on canvas *Whereabouts unknown*

The dot and line graphic style would reach a two-dimensional conclusion in 1948 in the large, predominantly monochromatic painting 'The Kitchen' (fig.41). The birdcages in Picasso's kitchen, described by Françoise Gilot and referred to in the painting,[11] perhaps recalled the shape of the 1928 wire models. 'The Kitchen' is dated by Christian Zervos to 9 November 1948 (z xv.106, 107) and so was painted, I would suggest, to mark the thirtieth anniversary of Apollinaire's death. Thus, over a period of many years, Picasso worked with extraordinary tenacity to exploit, in various media, the full potential of the dot and line sketchbook idea.

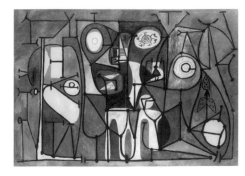

fig.41 **The Kitchen** 1948 Oil on canvas
Musée Picasso, Paris

After 'Metamorphosis' and the wire sculptures, Picasso turned, in methodical manner, to the third idea contained in the September 1927 sketchbook, the project for a sculpture made of metal rods and an oval sheet of metal, perforated by two holes, with a protuberant oval mouth (fig.42). Picasso reworked and developed this idea in his 1928 Dinard sketchbook (Carnet 1044), whose final folios were drawn in Paris and are dated 11 November 1928, marking the tenth anniversary of the Armistice and of Apollinaire's death (no.64). That day, on folio 58 of the sketchbook, Picasso made two drawings of a sculpture to be assembled from metal rods, sheets and spheres. It is seen from the front in one drawing and presented in Cubist perspective, from front and side simultaneously, in the other. The drawings represent a figure seated on a throne which has three legs and a triangular back. The figure's outstretched arms recall the wire 'drawings in space', while a modified version of its large, concave mouth, projecting like a loudspeaker, would be included in the sculpture 'Head of a Man' (no.76), built in 1930. The cone-shaped head and the oval sheet with two large holes, which in the drawing represent the body and the eyes, would be used in 'Head of a Woman' (fig.48 on p.214), built in 1931. Several elements in these drawings were borrowed from Kota reliquary sculptures, a matter to which we will return. It was a reproduction of the drawing in Cubist perspective that Serge Férat showed to Maurice Noël in 1934, stating that a plan of this sort figured among those which had been proposed by Picasso and rejected by the Apollinaire committee.

fig.42 Carnet 011, f.4, 1927 *Succession of the Artist*

González had learned oxyacetylene welding techniques in an armaments factory during the First World War and he now passed this skill on to Picasso, who was able to take an active role in the construction of the new series of sculptures, which are welded montages of disparate pieces of metal. Picasso may have tried his hand by first assembling the simple 'Figurine' made from fifteen or so metal oddments roughly welded together (s 73). This would have given him the confidence to work on the more complex metal sculptures, freely improvising around ideas previously worked out in the preparatory drawings.

'Head of a Man' (no.76) is simpler, heavier and more solid in appearance than its female counterpart, 'Head of a Woman', and has a dark, burnished surface. It is dominated by a large, lozenge-shaped mouth, placed vertically so that it advances outwards from the rectangular sheet of the face. The circular eyes were roughly scratched into the metal, then burned or drilled out. The face is also adorned with a comically pointed nose, perforated by two small holes, and an elegant, naturalistic moustache, made from shards of metal, welded in layers. The back of the head, rarely photographed, is made from a disc of bronze which has been beaten into a flattened dome. Incisions around the side of the disc were rewelded once the required shape had been achieved and finally strands of hair were lightly incised into the metal. The head has been placed on a long neck made from three rectangular sheets folded round into tubes and welded together to form a tapering cylinder.

The finest craftsmanship in this sculpture is found in the perfectly symmetrical lozenge of the mouth, made from two curved sections welded together. These two sheets, like the two rectangular pieces which attach the mouth to the face, have been cut

fig.43 Carnet 020 (MP 1990–109), f.48
Musée Picasso, Paris

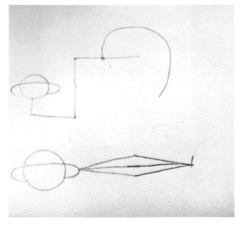

fig.44 Carnet 215, f.18, 1924 *Succession of the Artist*

and joined with such clean precision that this element must be the work of González. The other joints in the sculpture are much rougher, indicating fabrication and welding by Picasso himself.

'Head of a Man' is made of iron, brass and bronze and was built in 1930, at a time when, as we shall see, Picasso had sheets of bronze brought into the rue Médéah workshop. A photograph of 'Head of a Man' was first published in 1930, in a book by his Catalan friend Eugenio d'Ors, captioned 'Detail of a monument'.[12] This title suggests that Picasso considered the work to be the first part of an as yet incomplete monumental sculpture, and it may well be that he intended to build a body for the 'Head'. This probability, and the 1930 construction date, are largely confirmed by Carnet 020 (MP 1990–109), a sketchbook in which the head undergoes a series of metamorphoses, is given a halo of light, then an athletic pair of legs and finally, in three drawings, two of them dated 20 July 1930, is placed on the body of a mythological and lubricious beast (fig.43). The metal head as we know it was probably complete by then. In these drawings, the massive bulk of the centaur seems to strain against the narrow dimensions of the folio (which measures 11 × 17 cm): it has grown into a monumental sculpture, trying now to break out of the sketchbook.

'Head of a Woman' (fig.48 on p.214) is made of a sheet of iron, oval and concave in shape, onto which have been welded a small, pouting mouth and a pointed nose with a rectangle of metal fixed to its base. The rectangle is pierced with two holes representing the eyes. On the right-hand side of the oval sheet appear two larger holes, one above the other, behind which, on the reverse, have been fixed two metal cones, suggesting breasts. The head and the body of a woman are thus economically combined. Pointed rods and the curve of long metal springs represent the woman's hair, and the femininity of the ensemble is enhanced by the incorporation of two metal colanders, creating a sphere. Seen from one side of the sculpture, this sphere evokes the back of the woman's head. Seen from the other side, with the cones visible, the colanders evoke pregnancy. The structure stands on an elongated diamond-shaped tripod of three struts, bent outwards above their centre. The origin of this pattern is to be found in the sketchbook begun 30 March 1924, which also contains some of the earliest dot and line drawings, where the constellations were given human form for the first time. There, a similar diamond-shaped tripod supports a globe surrounded by a ring, resembling the planet Saturn (fig.44). Now the colanders replace the planet, again linking astronomy and anatomy. And Picasso has again kept an idea from a 1924 drawing in reserve until an appropriate opportunity has arisen for him to use it.

When Picasso sent González off to hunt for the two colanders,[13] he had hit on an idea rich in consequences. Early in 1912 he had incorporated a stamp into his painting 'The Letter' (z 11*.293) and in May of the same year had created the first Cubist collage, 'Still Life with Chair Caning' (D 466), where a piece of printed oilcloth represents the seat of the chair. He went on to incorporate a real sugar-spoon into his 1914 sculpture, 'Glass of Absinthe' (nos.23–4). In 'Head of a Woman', however, he takes a large step forward, as the colanders represent not themselves but the curve of a woman's stomach, or an abstract symbol of fertile femininity. This brainwave, improvised without reference to any preparatory drawing, gave Picasso access to a new sculptural vocabulary in which the original function and significance of a readymade object could be wittily subverted by its use in a work of art, a rich seam to be further exploited in later years. This discovery continues Picasso's exploration of the arbitrariness of signs, already under way in the prewar sheet-metal 'Guitar' (no.19), in which a projecting cylinder signifies the recession of the instrument's sound-hole and empty spaces designate fullness of form. These signs are recognisable because of the 'syntactic context' in which they are placed.[14] Similarly, it is their placement within the structure of 'Head of a

Woman', above the tripod stand and next to the two cones which may represent breasts, which allows the colanders to function as signifiers of pregnancy and fertility. The colanders could be granted a different meaning by a different context, or simply by a different vantage point. This semantic destabilisation makes a further contribution to the artistic statement in that it serves to counter the traditional reading of sculpture as representation. We are prompted to recognise the status of the sculpture as an autonomous, self-referential object. The perforated surface of the colanders and the empty sphere they enclose thus refer to the primary plastic quality of the work, which is the dynamic interaction of space and matter, with an open construction replacing the traditional conception of sculpture as solid mass. 'Head of a Woman' has a light and airy beauty which counters the dark solidity of the masculine 'Head of a Man', a contrast which indicates the expressive range thenceforth available to the sculptor working in metal montage.

The most complex of the welded metal sculptures of this period is 'Woman in a Garden' (figs.34, 36), a larger-than-life figure over two metres tall, made from dozens of pieces of iron, collected scraps and fragments as well as rods and shapes that were cut, beaten and bent specially for the sculpture. It represents a woman standing next to a small table whose top is tilted downwards, towards the spectator, in Cubist perspective. From the other side of the table rises the elegant curve of two long, broad-leaved branches. Christian Zervos refers to this sculpture, with its 'philodendron branches', as 'the iron monument to Guillaume Apollinaire' (z VII, p.8). Built to stand guard on a poet's tomb, this monument is a fusion of human, animal, vegetable and mechanical forms, with the main lines of force emphasising vertical energy. The head is angular and aggressive, with a shock of hair made from five curved and pointed blades, suggesting a dangerous claw or the crest of a fighting cock. The profile is sharp as an axe, two large nails serve as eyes and the mouth is vertical and lined with teeth, in the style of a mechanical animal trap, an image of sexual menace which in 1930 may be related to the dramatically deteriorating state of Picasso's marriage to Olga Koklova. The flat, triangular base of the sculpture repeats the acute angle of the face. In contrast, the rest of the figure is softened by undulatory lines and the incorporation of a convex, circular piece which suggests a maternal curve below the waist. This element has been presented as a found object, an unidentified machine-part,[15] but close inspection suggests rather that it began as a disc, with somewhat irregular edges, cut from a sheet of iron, then beaten into shape. The rear view of the sculpture recalls the back of a stage set, or an advertising billboard, held in place with supportive struts. It is no coincidence that, without exception, all published photographs of the work have been taken from the front whereas, in contrast, the 1928 wire models or the 1931 'Head of a Woman' present witty and surprising perspectives from whatever point of observation.[16] This raises questions concerning the three-dimensionality of the work. Though free-standing, 'Woman in a Garden' is in fact related to the original metal 'Guitar' (no.19), and to the larger, painted metal 'Guitar' of 1924 (fig.4 on p.23), both of which were made to hang on a wall, viewed only from the front and the sides, challenging generic classification, straddling the frontier between painting and sculpture.

To some parts of 'Woman in a Garden', Picasso added layers of small pieces of metal, picked up from the floor of González's smithy. Four irregularly shaped pieces were thus welded onto the back of the neck of the figure, others onto the front, all bound with a circle of thick iron wire. These additions serve to reinforce and strengthen the neck, while at the same time, and quite intentionally, increasing the disparate appearance of the figure. Similar additions to one foot of the sculpture are even more apparently gratuitous, with no supportive function. Zervos seems to refer to this practice when, in a 1932 article, he describes Picasso at work; 'When working on his large metal figures,

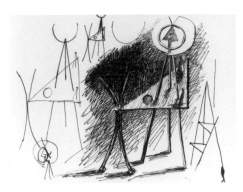

fig.45 Carnet MP 1990–108 f.47, 1928
Musée Picasso, Paris

fig.46 Carnet 018 (MP 1875), f.12, 1929–30
Musée Picasso, Paris

fig.47 Carnet 018 (MP 1875), f.17, 1929–30
Musée Picasso, Paris

instead of kicking away the scraps of old iron which litter the floor, Picasso carefully sifts through them and picks out pieces which nobody else would have bothered with, but which he can immediately use in his sculpture.'[17]

Zervos here underlines the improvisational nature of Picasso's work. González, in a text entitled 'Picasso Sculpteur et les cathédrales', dating from the early 1930s, also emphasises the sculptor's imaginative independence[18]:

Picasso can never find the time to realise any of his projects. On the rare occasions when he does decide to, he always chooses to work on the most recent one. This is because he is such an anxious man, always wanting to surpass himself, that he ends up just filling more folios in his sketchbooks. That is why, despite his thousands of sketches, he didn't take a single one on the morning he set to work at the forge. His hammer was all he needed to try and build his monument to Apollinaire. He worked at it over a period of several long months, and he completed it. Often he would say, 'I feel as happy again now as I did in 1912'.

In March 1931, André Salmon published an important article which seems to have escaped the attention of critics and historians. He writes at some length, and with first-hand knowledge, of the manufacture of 'Woman in a Garden', for he has seen Picasso at work on this sculpture, hunting through a pile of iron, by the light of the forge and the blazing gas, shaking with 'luciferian laughter'. Salmon emphasises the coexistence of care and spontaneity in this process, stating that Picasso 'has put together the most disparate bits of iron … Not haphazardly, but not being particularly choosy either … Should we call it improvisation? That would be shamelessly to ignore this great artist's rare gift of spiritual organisation. It just so happens that in his case, as with great poets, reason and impulse coincide in a single moment.'[19]

For Salmon, the work of art is born in the immediate conjunction of creative passion and lucid reflection. Preparatory drawings for 'Woman in a Garden' do exist, dated 22–6 April 1928, in sketchbook MP 1990–108 (fig.45). Others figure in Carnet 018 (MP 1875) (figs.46–7), which Picasso worked on from 25 February 1929 to 12 January 1930. Picasso draws a figure made of metal struts, standing next to a small table. In some of the sketches appear elements, such as the two cone-shaped breasts, which will contribute to 'Head of a Woman'. Some of these drawings give the figure a head which will be realised separately in October 1928 as the miniature metal sculpture 'Head', made in three versions, each painted differently (no.40). The round stomach of 'Woman in a Garden', complete with its central navel, already appears in three drawings of a seated woman on folio 17 of Carnet 018. But sketchbook drawings include neither the philodendron branches, nor the eventual shape of the sculpture's aggressively featured head: they would be improvised later, in the workshop.

The success of 'Woman in a Garden' lies in its combination of sketchbook planning and heat-of-the-moment inspiration. Whereas the drawings prepared the main structural and representational aspects of the design, actual construction, with iron and tools in hand, brought a new emphasis on the materiality of the sculpture. Picasso seems to have taken great pleasure in handling and juxtaposing the odds and ends of metal, in shaping the recalcitrant raw material to his will, fixing apparently worthless fragments of scrap onto the body of his iron creature. 'Woman in a Garden' was made amidst heat, grime and noise. Sparks flew as the metal was cut, beaten and assembled and eyewitnesses emphasise the physical presence at the heart of this process, Picasso hammering the iron into shape, hammering energy into the work. After a decade of clean fingernails and high-society luxury with Olga, this intense activity in González's smoky den came as a welcome liberation, an elation captured in the windswept, organic complexity of the sculpture. Picasso discovers in the iron sheets, struts and rods the potential for an

astonishingly broad and expressive vocabulary, including sharp angularity and taut elasticity, rigid lines, elegant curves, supple planes and cumulative accretions, all combined here into joyfully heterogeneous unity.

The uninhibited crudeness of some of the welding lends further energy to the innovatory syntax of 'Woman in a Garden'. Explicit reference to the process of construction is thus retained within the finished product, underlining the significance of this moment, as industrial techniques break into the domain of high art. The physical intimacy between the artist and his material produces a work in which the texture, density and incontrovertible presence of iron itself are emphasised. The technique and material being used thus become ends in themselves, vying for attention with the representational or symbolic aspects of the sculpture.

Salmon's 1931 article emphasises the outdoor, monumental purpose of all the metal sculptures:

> Picasso, whom fortune has allowed to acquire a château in Normandy, has no other ambition than to fill the grounds with these monumental statues. Only one of them has a special destination. It is the monument to be erected in Père Lachaise cemetery, over the tomb of our mutual friend Guillaume Apollinaire, poet and soldier whose name is engraved on the walls of the Panthéon. The triangular base is a sheet of iron which constitutes in itself, if we take into account its matching proportions, a replica of the famous Guitar. From the base rises a figure which is entirely devoted to the expression of upward movement. Some will find it full of grace, the delicate structure on which could have been built the elegant body of a woman; for others it will be no more than an incomprehensible diagram.[20]

It is clear that 'Woman in a Garden', just as much as the wire models, often referred to as 'Monuments to Apollinaire', was intended to stand over the poet's tomb. According to Salmon, once Picasso had built the human figure and the table, the branches were added in order to 'bring balance to this monumental figure, built for an outdoor setting, by connecting it with nature'. His intention was to 'integrate his work into the surrounding atmosphere (that of a landscaped environment, his own grounds or the cemetery) by bringing it as directly as possible into harmony with the natural elements'.[21] So the branches were added to balance the two sides of the sculpture and to provide a transition between the anti-naturalistic structure of the human figure and the natural surroundings in which it was to stand.

On 15 November 1930, Salmon had sent a letter to Picasso after visiting 'the strange cigar box in the rue Médéah, full of large nails'. He congratulated him on his new monument to Apollinaire ('Nothing could be more beautiful') and added that González, in Picasso's absence, had spoken to him about the sculpture: 'González spoke clearly about your work and showed me a sheet of bronze. It is attractive, but iron is so pure. You'll have to think about it!' (Picasso archive, Musée Picasso, Paris). A few weeks later, on 26 December 1930, Salmon sent Picasso his best wishes for the New Year in the form of a short poem:

<div align="center">

1931

Comme tu forges de l'ombre

Pour ta Vénus un arbrisseau

Je martelle pour toi, les tiens, des voeux sans nombre,

Avec la foi des Jours-Ravignan, PICASSO!

</div>

('Just as you are forging shade / Greenery for your Venus / So I hammer out for you and yours countless good wishes / Keeping the faith of our Ravignan days, PICASSO!')
(Picasso archive, Musée Picasso, Paris)

It seems likely that the information on the function of the naturalistic branches contained in the March 1931 article came directly from Picasso or his assistant, González. Salmon's letter implies that the main figure of the sculpture was finished by

mid-November 1930, and his poem indicates that Picasso made the two branches in late December.

In his article, Salmon also wrote that Picasso was working in the rue Médéah on 'the final stages of various monumental works, all of them planned to be in wrought iron, though the most beautiful of them will probably be recreated in bronze'.[22] In November 1930, Picasso was considering a second version of 'Woman in a Garden' in bronze, a material better suited to outdoor installation, and González could show Salmon a sample sheet of that metal. By the spring of 1931, the building of a bronze replica of 'Woman in a Garden' (no.83) was in full swing. This task was entrusted to González who, on 2 April 1931, sent Picasso the following express letter, written in Spanish and French:

Thursday 6.30 am

Pau,

Could you call round this morning or tomorrow, as I need your wise advice. Yesterday I went to the *ironmongers fair* to buy an even bigger pair of hammers because the *casserole* is turning out to be a job of Titanesque proportions. *You won't shout at me, will you?* I didn't want to go to Monthyon *but* because of the *casserole* I'm going to take three days rest. See you later.
Yours ever,
Julio

(Picasso archive, Musée Picasso, Paris)

'Casserole', meaning 'saucepan' is French slang for a subservient female partner, and is used here perhaps as a wry term of affection for 'Woman in a Garden'. The note of desperation and lassitude in this letter, albeit expressed in the friendliest of tones, is untypical of the González–Picasso correspondence and indicates what a Herculean task Picasso's amenable assistant had taken on, forcing him now to take a short break at his rural retreat in Monthyon. González had to replicate in bronze every one of the innumerable pieces which make up the iron sculpture, and then assemble them. The brilliant result is an almost exact copy, though there are differences, of varying importance, between the iron and the bronze versions. The bronze replica has suffered somewhat with the passage of time. The blades representing the woman's hair have been bent out of their original position. The exterior philodendron branch has also come away from the supporting strut which fitted lengthwise behind it, and the branch has twisted round, leaving the leaf turned ninety degrees away from its original position. Brassaï's early photograph of the bronze version, in the grounds of Bois-geloup, shows the branch undamaged, but by the time Edward Quinn photographed it in the late 1950s, placed on guard outside the front door of Picasso's villa La Californie, the branch had been damaged and roughly repaired with wire.[23] Subsequent photographs of the bronze version have shown it in this condition, without comment on the damage, as if the wire wrapped round the branch and its support were part of the original work. Furthermore, the two separate versions of the statue have often been confused, like identical twins, since Brassaï's shot of the bronze version was, in 1933, captioned 'Wrought iron statue, erected in the forest (photographed at night)'.[24]

The two versions reflect to some extent the differing characters of their makers. The iron version is uninhibitedly extrovert, dynamically expressing the excitement, violence and heat in which it was put together. González was a shy, modest man, and a careful craftsman, working as Picasso's employee. Pieces of iron which had been roughly cut and hammered, or just scooped up from the floor, had to be slowly and painstakingly copied in bronze. Photographic evidence suggests that welded joints are neater in the bronze version and that González copied only approximately the accumulation of

random fragments on the small table representing a foot. Despite the overall resemblance, in his attention to detail González seems, at least partially, to have tidied and disciplined the bronze sculpture. A more striking difference is one of colour, for 'Woman in a Garden', once complete, was painted white. 'Head of a Woman' would receive similar treatment. Surfaces in bronze and painted iron differ in texture; they age and reflect light differently. Bronze and iron also carry different cultural connotations, though this contrast was more clearly marked in 1931 than it is today: bronze was artistic, iron was industrial. Fernande Olivier recalled that 'Picasso was particularly fond of a small female mask whose face had been given a strangely gentle expression by a covering of white paint, contrasting with the wood colour of the hair.'[25] The white paint softens the expression and adds homogeneity to the two iron constructions. But whereas, paradoxically, the whiteness refers back to an African source, the use of bronze linked the replica of 'Woman in a Garden' primarily to a European tradition of monumental statuary in which this metal is a conventional sign of sobriety and nobility. While retaining the radically new formal qualities of the original, the impact of the replica is necessarily affected by the change of substance and the hand that made it. These changes were not unintentional and Picasso was, of course, aware of the consequences implied in his instructions to González. Having created the iron sculpture, it was he who ordered and controlled the replication in bronze.

It would be useful to view and compare the two sculptures together, as they were first exhibited in 1932. From 16 June to 30 July of that year, the Galeries Georges Petit in Paris presented a major Picasso retrospective. According to Etienne Bignou's preface to the exhibition catalogue, 'The works on show were chosen by the artist so as to include major pieces representing all the stages of his artistic career.' According to Jacques-Emile Blanche, Picasso also took responsibility for the design and hanging of the exhibition. Blanche found him at the gallery, before the opening, 'in the midst of hanging, unhanging, and reorganising groups of paintings that a team of villainous-looking workmen had spent a week trying to balance according to his wishes'.[26] The last seven items in the catalogue, nos.224–30, are sculptures. Four of them are early works, cast in bronze. No.228, described as 'Painted metal. – Height, 1 metre. Made in 1931' can only be 'Head of a Woman' (fig.48 on p.214). Nos.229 and 230 are the iron and bronze versions of 'Woman in a Garden', dated respectively '1930' and '1930–31–32', a chronology which is in no way contradicted by the documentary evidence we have been able to collect. André Breton recalled in his *Minotaure* article in 1933 that these tall sisters were placed face to face across a long room, the dialogue of iron and bronze.[27]

William Rubin has pointed out that Picasso's collection of African art included two, maybe three sculptures by the Kota tribes of West Africa. The diamond base of 'Head of a Woman', the oval, concave metal sheet in this work and the projecting mouth in the more masculine 'Head' were all directly influenced by Kota sculptures.[28] The Kota tribes of West Africa made their extraordinary wood and metal fetishes to protect ancestral remains by warding off evil spirits. 'Woman in a Garden' was similarly built to stand guard over a tomb; the aggressively dissuasive features of its face may, indeed, be linked with this vocation. As Eugenio d'Ors wrote, in an article published at the time of its construction, 'There is no other alternative for a statue: it must be either an idol or an ornament'.[29] 'Woman in a Garden' definitely belongs to the former of these two categories: it partakes of the spiritual force which inhabits its distant ancestors in African sculpture. But it was never to fulfil its original destiny. According to González, Picasso became so attached to the sculpture that he even dreamed of transferring Apollinaire's remains to the grounds of his mansion in Boisgeloup, on the southern border of Normandy.[30] There the bronze lady would have been able to watch over the

poet's grave, defying the traditional norms and conventions of commemorative and funerary art. Picasso finally held onto both versions of the sculpture and, in the late 1930s, Serge Férat himself designed for Père Lachaise a rough-hewn granite dolmen and an engraved stone slab which were orthodox enough to satisfy the Apollinaire Committee.[31]

In the 1930s it was a critical commonplace to suggest that Picasso's imagination moved so much faster than his productive capacities that he was unable to realise more than a fraction of his projects. To some commentators he appeared inconsistent rather than versatile and gave the impression of skipping from one idea to another, rather than working each project through to its conclusion. Even Christian Zervos reinforced that reputation when he wrote, in 1932, 'Picasso never lingers over a discovery. For him a new possibility which he has hardly begun to exploit, hardly even sketched out, has already been exhausted, and for every problem solved there appear an incredible number of other problems which haven't been.'[32] In retrospect, with the evidence of the sketchbooks at our disposal, we have a clearer perception of just how tenacious Picasso was. He liked to give the impression that his work grew as naturally as the leaves on the trees. In reality, several years of careful research preceded the realisation of his sculptures of the period 1928–32, major works whose matrix was the sketchbook.

Notes

1 Carnet 061, MP 1873, ff.4–18, 24–31, 43, 45.
2 Pierre Cabanne, 'Picasso et les joies de la paternité' (interview with Marie-Thérèse Walter), *L'Oeil*, no.226, May 1974, pp.2–11.
3 Anonyme, 'Un Monument à Guillaume Apollinaire', *Mercure de France*, 15 Jan. 1921, pp. 569–70. This text gave the false impression that Picasso had already completed a maquette for the sculpture. For a detailed study of the relationship between Picasso and Apollinaire from 1905 to 1918 and of the posthumous presence of Apollinaire in Picasso's subsequent life and work, see Peter Read, *Picasso et Apollinaire*, Paris 1994 (in press at the time of writing). Studies of Picasso's projected monuments to Apollinaire include Michael Fitzgerald, *Pablo Picasso's Monument to Guillaume Apollinaire: Surrealism and Monumental Sculpture in France 1918–1959*, Ann Arbor 1988; Christa Lichtenstern, *Pablo Picasso Denkmal für Apollinaire Entwurf zur Humanisierung des Raumes*, Frankfurt 1988.
4 *Gazette de l'Hôtel Drouot*, 24 June 1924, p.1. The subscription raised about 2,000 francs; the auction raised 30,343 francs 75 centimes.
5 Maurice Noël, 'Le Monument de Guillaume Apollinaire ... ou les dix années de gestation de M. Pablo Picasso', *Le Figaro*, 20 Oct. 1934, p.5. This article is illustrated by a project for a metal sculpture from Carnet 1044, f.58 (Z VII.424), drawn 11 Nov. 1928 (no.64). Férat showed Noël a reproduction of this drawing in a 1929 issue of *Cahiers d'Art* (Christian Zervos, 'Projets de Picasso pour un monument', *Cahiers d'Art*, vol.4, nos.8–9, 1929, pp.342–53). According to Paul Léautaud, André Billy was most struck by the plans for a sculpture based on the naked bathers, which he described as 'a bizarre, monstrous, mad and incomprehensible thing, almost an obscenity, a sort of unidentifiable lump, apparently sprouting genitals from various places' (Paul Léautaud, *Journal littéraire*, Paris 1956–63, vol.IV, p.164, entry for 14 Dec. 1927).
6 E. Tériade, 'Une visite à Picasso', *L'Intransigeant*, 27 Nov. 1928, p.6.
7 Picasso, 'Lettre sur l'art', *Formes*, no.2, Feb. 1930, pp.2–5. This is the translation of a text attributed to Picasso which first appeared in 1926 in the Russian journal *Ogoniok*.
8 See the essay by Marilyn McCully in this catalogue.
9 Zervos 1929. The article is illustrated with drawings from Carnet 021, Succession Picasso, ff.2, 36; Carnet 1044, Succession Picasso, ff.1–6, 10, 58 (no.64).
10 In the 1960s, Picasso owned three enlargements of the 1928 wire models (S 68A, 68B, 69A). They are difficult to date with accuracy, though Spies and the Museum of Modern Art, New York, give 1962 as the date of manufacture of S 68B (no.75) and a similar date has now been attributed to S 69A (no.74). There is no photographic or other evidence for the existence of these steel rod enlargements before the 1950s, though some exhibition catalogues have erroneously attributed an earlier date. In 1971, Picasso gave S 68B to the Museum of Modern Art, New York, to use as a model for the manufacture in the United States of a new, monumental version of the sculpture, which measures 407 × 149 × 319 cm (S 68C). Picasso's giant steel sculpture 'Head of a Woman' (S 653) was inaugurated in Chicago during the summer of 1967. Twenty metres tall, it successfully realises his dream, first envisaged in his 1920s sketchbooks, of an open-air, monumental and transparent sculpture made of metal sheets and rods.
11 Françoise Gilot and Carlton Lake, *Life with Picasso*, Harmondsworth 1966, p.210.
12 Eugenio d'Ors, *Pablo Picasso*, Paris 1930, plate 48.
13 Werner Spies, *Picasso Sculpture: With a Complete Catalogue*, London 1972, p.75.
14 For a recent discussion of 'Guitar' and other works in the context of representation in African sculpture and of Saussure's structural analysis of language, see Christine Poggi, *In Defiance of Painting: Cubism, Futurism and the Invention of Collage*, Newhaven and London 1992, chap.2, 'Picasso's Earliest Constructions and Collages: The Arbitrariness of Representational Signs'.
15 Margit Rowell, 'Introduction', in Jörn Merkert, *Julio González catalogue raisonné des sculptures*, Milan 1987, p.12.
16 'Fascinating as *Femme au jardin*'s spatial elaboration may be, when seen from the back it remains tightly constructed but offers no compelling views': Alexandra Parigoris, 'Düsseldorf Picasso Plastiken' (exhibition review), *Burlington Magazine*, vol.126, no.970, Jan. 1984, p.59.
17 Christian Zervos, 'Picasso', *Cahiers d'Art*, 'Exposition Picasso aux Galeries Georges Petit' (special issue), June 1932, pp.2–3.
18 Julio González, 'Picasso sculpteur et les cathédrales', in Josephine Withers, *Julio González Sculpture in Iron*, New York 1978, pp.21–38. An abridged version of this text by González was published by Margit Rowell, under the title 'Picasso sculpteur', in *Qu'est-ce que la sculpture moderne?*, Paris 1986, pp.369–72. Rowell's extract should not however be confused with a different text entitled 'Picasso sculpteur' published by González in *Cahiers d'Art*, no.6–7, 1936, p.89.
19 André Salmon, 'Vingt-cinq ans d'art vivant', pt.II, *La Revue de France*, 1 March 1931, pp.112–34 (p.123).
20 Salmon 1931, pp.124–5.
21 Salmon 1931, p.126.
22 Salmon 1931, p.122.
23 Edward Quinn, *Avec Picasso*, Bordas 1987, p.145. The bronze 'Woman in a Garden' and 'Woman with an Orange' 1943 S236 stand like sentinels on either side of the entrance to the villa.
24 André Breton, 'Picasso dans son élément, illustré par des photographies de Brassaï prises à Paris et à Boisgeloup', *Minotaure*, no.1, 1 June 1933, pp.8–29 (p.20). Daniel-Henry Kahnweiler, *Les Sculptures de Picasso*, Paris 1948, no.15 reproduces the same photograph, described as 'Fer, 1929–30 – H. 220 cm'. Werner Spies in his 1983 catalogue *Picasso: das plastische Werk*, numbers the iron and bronze versions as 72.I and 72.II respectively, but for each of these numbers prints a different photograph of the bronze version, at Boisgeloup, then repaired with wire.
25 Fernande Olivier, *Picasso et ses amis*, Paris 1933, p.170.
26 Jacques-Emile Blanche, 'Rétrospective Picasso', *L'Art Vivant*, no.162, July 1932, pp.333–4.
27 Breton 1933, p.16. Breton states that the iron version seems to have been painted very recently ('fraîchement ripolinée de blanc').
28 William Rubin, 'Picasso', in *'Primitivism' in 20th Century Art*, exh. cat., Museum of Modern Art, New York 1984, vol.I, pp.301, 321, 337 n.85, 340 n.197.
29 Eugenio d'Ors, 'Les Idées et les formes', *Formes*, no.1, Jan. 1930, pp.2–5 (p.5).
30 González 1978.
31 In November 1955, Picasso donated his 'Head of Dora Maar' (S 197), made in 1941, to stand as a monument to Apollinaire in the square Laurent Prache, Saint-Germain-des-Prés. The monument was unveiled on 5 June 1959.
32 C.Z. [Christian Zervos], 'Picasso étudié par le Dr Jung', *Cahiers d'Art*, no.8, 10, 1932, pp.352–4.

Julio González and Pablo Picasso: A Documentary Chronology of a Working Relationship

MARILYN McCULLY

The following material has been presented chronologically so that all known correspondence between Julio González and Pablo Picasso can be included. The heirs to the González estate have generously provided copies of letters and other documents in their collection and have kindly given permission for me to consult and quote previously unpublished documents in the Picasso archives in the Musée Picasso, Paris. For the most part these have been quoted in full (generally excluding salutations and other informal greetings), except where the material is repetitive or illegible in the original. In a few cases summaries or excerpts are given, and these are indicated in the text below. Building upon the research and publications of Josephine Withers, Roberta González and Margit Rowell, it is now possible with the publication of these new documents to gain a clear idea of the nature both of the friendship and of the working relationship of the two artists (dating from their youth in Barcelona to the death of González in 1942). In their work as sculptors, Picasso especially benefited from the technical advice of González beginning in 1928, while the latter was stimulated by Picasso's own sculpture and painting of the 1930s. When his compatriot died, Picasso paid tribute to their collaboration in the moving painting 'Still Life with a Steer's Skull', known also as 'Homage to González' (see no.112).

1896: Julio González, who was born in Barcelona in 1876 and who along with his brother and sisters is employed in the family metalworking concern, exhibits his funereal burnished wrought-iron 'Bouquet of Flowers' in the *Exposición de Bellas Artes y Industrias Artísticas* (Exhibition of Fine Arts and Industrial Arts of Barcelona), in the Industrial Arts section. Picasso, who had moved to Barcelona with his family the previous year, exhibits (at age fifteen) 'First Communion' in the Fine Arts section.

1897–9: Julio González and his older brother Joan frequent the café Els Quatre Gats ('The Four Cats'), where they become friendly with, among others, the sculptor Manolo (Manuel Hugué). After an absence from Barcelona of a year and a half, Picasso returns in February 1899; his first contact with the González brothers dates from this time.

1899–1900: Joan González, who is not well enough to run the family business (which he had taken over in 1896 after the death of the father), moves to Paris to become a painter; the business is sold and Julio and the rest of the family join him. They live at 22 avenue du Maine in Montparnasse, where they hold open house to Catalans who come to Paris, including Pablo Gargallo, Jaime Sabartés, Manolo, Enric Casanovas and Picasso.

1902: Julio González returns to Barcelona, possibly in the company of Picasso (in January). That spring Picasso paints a watercolour portrait of him on the hillside of Tibidabo overlooking Barcelona.

20 October 1902: *El Liberal* announces: 'The celebrated artist, Pablo Ruiz Picasso, left for Paris on yesterday's express. He was accompanied by the distinguished artists Julio González and Josep Rocarol. Picasso intends to make a long stay in Paris.'

1903: Picasso's stay, however, is short, and he returns to Barcelona in mid-January.

2 October 1903: Picasso writes to González:

Although I haven't written, do not think that I have forgotten you. I am working as much as I can. And what are you doing? 'Los patas' [the de Soto brothers: Angel a painter, Mateu a sculptor] are in Madrid. I'm longing to go to Paris but at the moment I don't have enough money. I'm waiting for better times and the day that I can stop working so as to be able to leave – God willing. Best to your family and Juanito [Joan]. Regards to Manolo.

(González estate)

1903 [Month illegible on card]:

Friend Julio, I'm annoyed that you don't want to deal with the business you were commissioned to do. Regards to your family and to Juanito from your true friend Picasso.

(González estate)

14 February 1904: Picasso writes to González from Barcelona, where he is using the sculptor Pablo Gargallo's studio on carrer Commerç:

Have you seen Gargallo? It's ages since I've heard anything from any of you. Write me and tell me what you are doing. Hugs from your friend Picasso.

[On left margin]: This year the salons will open early – [I hope] you'll tell me something about them – Adeu

[Bottom and right margins]: I've just received your postcard … the Soto brothers are in Madrid, Angel tells me to send you their regards.

(González estate)

19 March 1904: From Paris González writes to Picasso thanking him for a favour in advance:

A few days ago I saw Max Jacob and he spoke to me about you (it was the same day that he took your drawings to the publisher) and believe me if it is accomplished as soon as your proposal indicates, it will make me very happy. I'm sure you'll understand. Greetings from Max … Best to our friends – I have a [new] studio.

(Musée Picasso)

3 April 1904: González writes to Picasso (part of this letter is illegible):

I have received your [letter] and I thank you for the favour you have agreed to do for me – I'll see what Sabartés has … I hope [you'll arrive] soon and that you won't take a long time in coming. I have not taken [what you wrote] about an embrace in the wrong sense … because I know that you do not frequent those places.

(Musée Picasso)

11 and 12 April 1904: *El Liberal* announces that Picasso and Sebastià Junyer Vidal are leaving Barcelona together for Paris, where they plan to mount an exhibition (never realised). Their journey was recorded by Picasso in traditional Catalan comic-strip form as an 'alleluia'.

Over the next couple of months their movements are uncertain: Junyer went back to Barcelona, returning in June; after a few days in the house of a family friend, Picasso may have stayed with the González brothers on avenue du Maine, since Junyer's letter of 14 June is addressed to him there:

Because of the many things I must do during these last days, I won't be able to leave Barcelona until Sunday at 9:30 am, instead of Saturday as I had written. But now you can be sure I'll arrive in Paris on Monday morning – God willing – Hugs to both González brothers, the rest of our friends and to you from Sebastià Junyer.

(Musée Picasso)

During this period Joan González gives Picasso an old zinc plate (on which Joan had already begun a landscape), and helps him prepare it; Picasso utilises the plate for the etching 'The Frugal Repast'. It was probably at this time that his relationship with Joan became strained. Once Sebastià Junyer arrived back in mid-June, Picasso moved with him into the Basque sculptor Paco Durrio's old studio in the Bateau Lavoir, 13 rue Ravignan. In the summer Picasso received the following letters from Julio, which provide the first evidence of the coming break in their relationship.

23 August 1904:
Friend Picasso:

I didn't want to answer your last letter as I took it as one of your jokes, but in the end you are the one who raised the matter of honour, and if you are right in still wanting to take against my brother, after you receive this letter, in addition to being within your rights, it won't cause any damage to you. But I only wanted to tell you frankly that the matter does exist. So you have no reason to treat him as stupid, but even if he were, I must ask you to write me about it.

You say that you do not wish to see me with my brother and that for this reason you won't come to the studio, well now it is I who must say something: while this matter is being resolved for the honour of my brother and for me I have prohibited your entrance to my home as well as to the studio.

Do what you think is necessary if it is true that you wish to see me.
Your friend
Julio

(Musée Picasso)

Undated [1904]:
I am very sorry to have written you what I did – I would have told you myself yesterday if you hadn't wanted to go [with the others].

With respect to your promise, I left you what you had asked me for. But since it was not possible for you to accomplish [? the promise] I have found myself bothered and in a mess because I have had to do things which I don't like doing at all.

If I had known that you couldn't do it, I would have made an effort [? or done otherwise]. For various reasons it is useless to explain it all to you.

(Musée Picasso)

Nothing has been found to explain the cause of the rift between Picasso and the González brothers, but it is clear that there was a break in their friendship. If, as it appears, the quarrel was with Joan, his death in 1908 may have made a reconciliation between Julio and Picasso more difficult. Julio suffered a breakdown after his brother died (and the quarrel with Picasso has usually been dated to that period); he now abandoned painting and went to work with Paco Durrio, principally on the mausoleum commissioned by the Echevarrieta family in Bilbao. Durrio himself became estranged from Picasso around 1909, being unable to accept the new Cubist direction in Picasso's work.

There is a different story accounting for the break between González and Picasso around the time of Joan's death. According to the artist's daughter, certain drawings of Joan's were given to Picasso's family in Barcelona for safekeeping: 'The drawings, so the

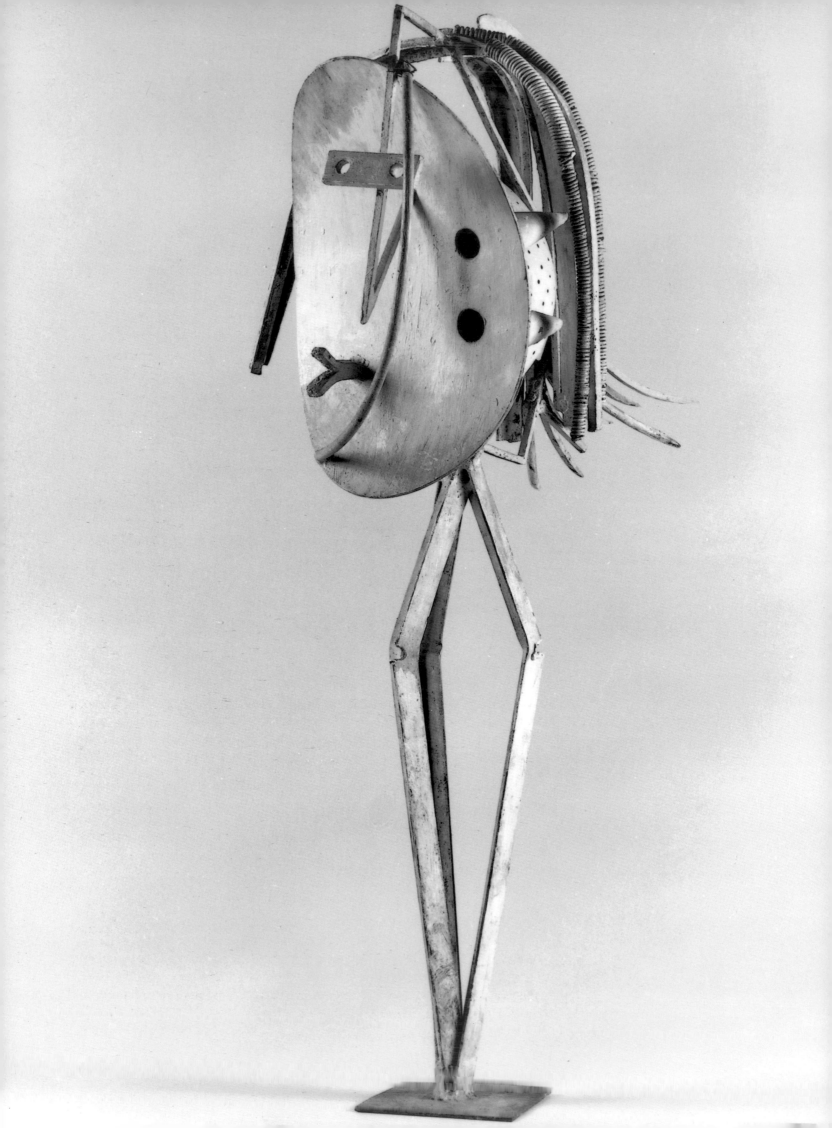

story goes, disappeared rather mysteriously, and since Picasso was known to have liked Joan's work, Julio suspected that they had found their way into Picasso's collection, and became quite upset over this' (Withers 1978, p.9). However, there seems to be a certain confusion in this account, for the group of González drawings now in the Museu Picasso, Barcelona (which were left with Picasso's family in Barcelona), have been attributed by Roberta González to her father Julio (MPB 110.977, MPB 110.977r, MPB 110.981, MPB 110.982, MPB 110.983, MPB 110.983r, MPB 110.984, MPB 110.984r, MPB 110.985, MPB 110.986, MPB 110.986r, MPB 110.989).

Between 1915 and 1920: Julio González's two sisters, Dolors and Pilar, run a shop in Paris on the boulevard Raspail. They had already established a certain reputation as dressmakers in Barcelona, and in France they sell buttons, buckles and jewellery (made by Julio) to fashion houses. (González was still receiving requests for buttons from Paris couturiers as late as 1936–40; see Rowell 1987, p.16 n.11).

1921–2: According to Roberta González, the friendship between González and Picasso resumed: 'One day my father and my aunts were walking down the Boulevard Raspail when they suddenly met Picasso, who threw open his arms and exclaimed, "Come now, we can't stay angry all our lives! Let's make up!"' (R. González 1956, p.24).

12 July 1922: Picasso arranges for Julio to meet the decorator André Groult, undoubtedly to do business either with his wife Nicole, who runs a fashion house, or his brother-in-law, the couturier Paul Poiret:

Today I went to see Groult and I told him what you said. He told me that if you would like to see him you only need to telephone beforehand and fix a day and time.
(González estate)

20 July 1922: González responds to Picasso in Paris; letter readdressed to Hotel de Terrasses/Dinard:

I have seen Groult now and I think that with a little good will we might be able to do something. Thanks for your recommendation.
(Musée Picasso)

13 May 1928: González writes to Picasso:

My dear mother died this morning. You will understand our situation. In order to help my poor sisters I beg you if as I believe you have the intention to give me work, could you be so kind as to advance me something. If you can I shall be very grateful.
(Musée Picasso)

This request for money is usually cited as the first evidence of their collaboration on welded sculpture (for, among other things, the proposed monument to Apollinaire; see Peter Read's essay in this catalogue).

14 May 1928: Picasso answers:

I have received your letter telling me of the sad news of the death of your mother. Believe me I am very sorry for you and your sisters, but for you whom I love, I am doubly sorry. I am not going to see you for fear of disturbing you. Concerning your request, I am sending you a cheque since I have [no cash] in the house at the moment.
(González estate)

14 September 1928: González writes that he has stopped by Picasso's house and the concierge tells him that the artist's wife Olga is in a clinic in Paris, and that Picasso is spending the day with her. González asks if there is anything he can do or if they should visit Olga (Musée Picasso).

fig.48 **Head of a Woman** 1931
Painted iron, sheet iron, springs and colanders. Constructed with the assistance of González *Musée Picasso, Paris*

[Late December 1928]: González writes to Picasso:

I wanted to tell you something very important concerning that matter from the other day, but I thought I would see you last week as you had said. Having heard nothing from you, if you wish you can find me every afternoon this week from 3 to 6 pm in my studio, 11 rue de Médéah. Happy new year.

(Musée Picasso)

26 February 1929: González sends a postcard showing the church at Monthyon (on the Marne) 'where the Germans put their wounded in 1914'. He says he will be back in Paris after the weekend (Musée Picasso).

1929–30: Picasso and González collaborate on an engraving, presumably in González's studio (Baer 257*bis*)

26 March 1929: Picasso writes to González:

I won't be at home either tomorrow or the next day – come on Saturday at 11 am ...

(González estate)

21 November 1930: González writes to Picasso:

Tomorrow I'll be in my studio – I'm telling you this in case you need something from me. Otherwise from Sunday to Thursday I'll be in Monthyon with Roberta.

(Musée Picasso)

An additional *pneumatique* (express letter), dated only 'Saturday afternoon', presumably also refers to the above arrangements. González says that he is leaving with Roberta for Monthyon the following day and asks if Picasso needs anything.

In addition to the actual collaboration on welded sculptures, González arranges for marble pedestals to be made for Picasso. Under the influence of Brancusi, González himself utilised rough-hewn bases both to contrast the materials of iron and stone and also to extend the conception of the sculpture to include the base. Picasso, on the other hand, seems not to have employed the pedestals for the welded-iron work he executed in González's studio, which are mentioned in the following notes:

19 December 1930:

Pablo: The first three small pedestals are promised for tomorrow at 10.

(Musée Picasso)

20 December 1930:

Pau [Catalan for Pablo]: You now have your six small pedestals in my studio.

(Musée Picasso)

30 December 1930: González writes to Picasso:

Noi [Catalan for 'my boy']: I won't be in the studio today because I think I have the flu ... if you need to come, let me know.

(Musée Picasso)

5 January 1931: Picasso writes to González:

Tomorrow morning I will come see you (today is Monday).

(González estate)

16 February 1931: González writes again concerning the pedestals he has prepared for Picasso:

The twelve marble [pedestals] are ready for you. I will be in my studio every day until Friday. Next Saturday I'll go to Monthyon for five or six days.

(Musée Picasso)

22 February 1931:
> I am in Paris – I won't be leaving until next Friday. The marble is still ready for you
> to use.
>
> (Musée Picasso)

Undated: [?1931]: Picasso writes to González from Boisgeloup:
> If you wish I will come on Thursday in the morning at 11. I too am working.
>
> (González estate)

2 April 1931: González writes to Picasso:
> Pau
>
> Could you come this morning or tomorrow – I need your wise advice. Yesterday I
> went to the ironmongers fair to buy a pair of larger hammers, because the 'casserole'
> has turned into a Titanic undertaking. Please don't shout at me! I didn't want to go
> to Monthyon, but because of the 'casserole' I'll go for three days to rest [see no.83].
>
> (Musée Picasso)

24 May 1931: González writes to Picasso that he is going to the country but that 'if it is
convenient with you, come to the rue de Médéah for sure on Thursday'.
>
> (Musée Picasso)

20 June 1931: González writes to Picasso in Boisgeloup, but also sends the same letter
the following day to rue La Boëtie:
> I cannot be in the studio on Monday, the family is arriving, but Tuesday is fine. You
> must tell me when I see you about your latest pieces, the first ones and the most
> recent. Kiss the hand of the 'Châtelaine Boisgeloup – Dupicasso' [Olga] for me –
> greetings to Paulo and to you, a hug.
>
> (Musée Picasso)

3 July 1931: Picasso writes to González:
> My friend Juli:
>
> I wasn't able to go to the studio this morning; not knowing if you'll be there I
> won't go this afternoon. I wanted to tell you that I'll be returning to Paris on
> Monday and I would like to see you – come at one o'clock (and wait for me if I'm
> not yet there) so that we can talk.
>
> (González estate)

20 October 1931: González writes to Picasso (addressing him 'Pauet', which means
'Little Pablo' in Catalan) that he will be 'at his orders' tomorrow (Musée Picasso).

During the course of 1931 González kept notes concerning Picasso for an essay he
intended to publish under the title 'Picasso sculpteur et les cathédrales'. While he was
alive only part of his manuscript was ever published, as 'Picasso sculpteur' in *Cahiers
d'Art* (see extracts under '1936' below); in 1978 Withers translated and published the full
text of the manuscript. The following are two excerpts:
> Picasso never finds the time to execute one of his projects. If, rarely, he makes up his
> mind, he settles on his most recent idea. For he is so restless, always wanting to
> improve, he only succeeds in filling new pages of his sketchbook. This is why, in
> spite of the thousands of studies, he took not a one in the morning of the day he
> went to work at the forge; his hammer alone was enough to try to bring into being
> his monument to Apollinaire. He worked on it long months at a time and he finished
> it. He would often say, 'Once again I feel as happy as I was in 1912.'
>
> (Withers 1978, p.135; in 'Picasso sculpteur', 1936,
> González gives the same quotation, but with the date 1908)

26 December 1931:

> Picasso paints as always. In looking at his latest painting – very restful – one notices that he [has] become more sensitive to color. These colors are not deliberately chosen, they are sensitive harmonies, delicate contrasts, where the color makes the ensemble vibrate. But, this abstract painting, so very flat (perhaps more so than ever) is also his most beautiful sculpture. And when astonished we ask him why, Picasso answers, 'Because in this painting, there is in its plasticity a perspective. One must create the planes of a perspective. Yes, it is the colors which do it.
>
> <div align="right">(Withers 1978, p.137)</div>

1932: The collaboration on welded sculpture ends in the spring of 1932, to judge by the following letters:

28 January 1932: González writes to Picasso:

> I won't be able to be in the studio tomorrow; I'll tell you the reason when I see you.
>
> <div align="right">(Musée Picasso)</div>

6 April 1932: González writes to Picasso informing him of his return to Paris (Musée Picasso).

[?April] 1932: Picasso writes:

> Do you want to come tomorrow morning to my house? I would like to see you and talk to you ... Picasso.
>
> <div align="right">(González estate)</div>

Picasso apparently received another letter from González dated 16 May 1932, although the contents of the envelope, in the Musée Picasso archives, are missing. No other correspondence has been located between this date and 1936.

1935: On the occasion of the planned exhibition of Picasso's works in Spain by the Barcelona-based Amics de l'art nou (Friends of New Art), González wrote in *Cahiers d'Art* (1935) about the importance of Catalonia to Picasso:

> It is more than 30 years since I met Picasso. And each time that I have seen him and spoken to him – and this is often – we have spoken of the Catalans, and I have heard him talk nostalgically about Barcelona and Perpignan. He remembers the festivals and traditions, the sardana, bonfires, and all kinds of other events in great detail. All of it interests him. It is 'ours'. He religiously keeps a handkerchief with the 'quatre barres' [the four-striped Catalan flag] in his pocket, and he speaks of the love he feels for Catalonia, the land of his youth. All of these affectionate and cherished memories and his desire to return to see us – the feeling that 'only in that place does one feel well' – does not this love and affection give a particular character to the artist's works? Isn't it this that makes his real homeland rather than all the other places which want to claim him? Cannot the characteristics of a school or of a country be traced in his work? Especially in his recent works – do they not convey a sense of tragedy – the tragedy of life – and also, why not? the tragedy of his own country and of Catalan art.

11 September 1936: González writes to Picasso:

> Yesterday I learned from Zervos that you had a automobile accident. He said that you were lucky. Good, for you must keep going! He also said you were outside Paris.
>
> <div align="right">(Musée Picasso)</div>

1936: González writes in 'Picasso sculpteur':

> It gives me great pleasure to discuss Picasso as a sculptor. I have always considered

him a 'man of form' because by nature he has the spirit of form. Form is in his early paintings and in his most recent.

In 1908, at the time of his first cubist paintings, Picasso gave us form not as a silhouette, not as a projection of the object, but by putting planes, syntheses, and the cube of these in relief, as in a 'construction.'

With these paintings, Picasso told me, it is only necessary to cut them out – the colours are the only indications of different perspectives, of planes inclined from one side or the other – then assemble them according to the indications given by the colour, in order to find oneself in the presence of a 'Sculpture.' The vanished painting would hardly be missed. He was so convinced of it that he executed several sculptures with perfect success.

Picasso must have felt himself to be of a true sculptor's temperament, because in recalling this period of his life to me, he said: 'I have never been so content' or 'I was so happy.'

...

I have observed many times that there is no form which leaves him indifferent. He looks at everything, on all sides, because all forms represent something to him; and he sees everything as sculpture.

Again, recently, having gathered some sticks of white wood in his studio, he carved the beautiful sculptures [published in the article] with his little pen-knife (retaining the planes and dimensions of each piece, each one of them suggesting a different figure to him, which will undoubtedly arouse a great deal of interest.

To my mind, the mysterious side, the nerve centre, so to speak, of the work of Picasso is his formal power. It is this power which has caused so much talk of his work, which has gained so much glory for him.

14 September 1936: Picasso is appointed Director of the Prado in Madrid, by the Republican government in Spain; his secretary Jaime Sabartés proposes in a letter to Picasso (September 21) that González be named Secretary of the Prado (González estate).

1937: Picasso and González are commissioned to produce works for the Spanish Pavilion at the World's Fair in Paris. González produces a bronze standing figure of Montserrat, a woman who is both a symbol of Catalonia and of the resistance of the Spanish Republicans. Picasso, in addition to 'Guernica', contributes five sculptures, including 'The Woman with a Vase' (no.99).

1939: Picasso moves with Dora Maar to Royan in September; González remains in Paris until January 1940, when he moves to Arcueil.

2 October 1939: González writes to Picasso:
Yesterday I received a letter from Roberta's husband asking me for a certificate or declaration of sympathy and loyalty towards France from someone like you for the police or the military. If you could do this, please send it to Hans Hartung.
(Musée Picasso)

The painter Hans Hartung had married Roberta González in 1939; he was officially considered a deserter by the Germans, and served in the French army, losing a leg.

1940: Picasso was back in Paris for some months in early 1940, when González wrote the following note to the artist:

30 January 1940:
I went to see you this morning at the rue La Boëtie but no one was there. Could I see you tomorrow quite urgently?

6 March 1940: The following letter from González to Picasso, c/o Hôtel du Tigre, boulevard Georges Clemenceau, Royan, was written in response to a request (probably verbal) from Picasso for technical information concerning the execution of gold jewellery. Dora Maar has told John Richardson that Picasso had wanted to make her earrings but in the end never realised the project.

Pau,

Well, each unit of copper weighs about 12 grams. In gold it would weigh almost double and you would be left with nothing any thicker (and that already is one or two grams); also in order to work it one must use a thicker metal than is necessary so that you can hammer it. Thus you must count on a few grams more because they won't count when the object is finished.

So, if for example each piece weighs 25 grams, four would weigh 100 plus some 40 grams extra. So you'll have to buy 140. The other day gold cost 40.251 francs a kilo. At this price (which can change daily) 140 grams would cost 5,630 francs.

This is difficult work because this metal is more inflexible, less malleable and above all it is more brittle than copper. It could cost between 2,500 and 3,000 francs for the pair (two rings, not four). Since these things are so thin even with the greatest care one can make a mistake; even when it is almost finished, when one curves it it can break. Then you have to make a new one. One could fix it by soldering but this you would not want to do.

To make another piece also means that you lose metal. Although difficult, the best course would be to try one or two in copper before making one in gold. Then you will be able to make one with more confidence. But I repeat that it is a very difficult thing to do because of the metal. It must be thin and light and at any movement it can break. Each finished piece is a miracle!

In order to accomplish all of this one must be calm and not nervous so you should eat something from time to time …

An individual cannot buy gold without authorisation from the Banque de France, but if this is not convenient for you (as I told you the other day) I shall buy it for you on my own account. Yours, J. González (from Arcueil)

(Musée Picasso)

27 March 1942: death of Julio González in Arcueil (death announcement is preserved in the Musée Picasso.)

The painter Luís Fernández (whom González had known since about 1930), later recalled that at the funeral in addition to González's wife, 'he, Picasso, Christian Zervos and his brother Marian "stood in" for the rest of the family and received condolences of the two or three friends who were able to come. Picasso, who was deeply moved by González's death, was still not immune to the incongruities of the situation: on their way to the cemetery they passed a roadworker who piously removed his hat, where-upon Picasso remarked "nous sommes en plein Courbet!"' (Withers 1978, p.16).

The large painting known as 'Still Life with a Steer's Skull' (Kunstsammlung Nordrheim-Westfalen, Düsseldorf) was painted in Paris on 5 April 1942 in response to the sculptor's death and according to Fernández, specifically to the funeral: 'the bull's skull rests on a coffin, and the brilliant colors of the background were inspired by the stained glass windows of the small Romanesque church in Arcueil where the services took place' (Withers 1978, p.16).

Roberta González, who was unable to attend her father's funeral because she and Hartung were obliged to remain in the unoccupied zone, also later wrote about Picasso's painting:

The war had scattered his friends, and only a few were present at his funeral. Picasso was among those who accompanied him to his last resting place. Stirred by his grief, he painted, as soon as he returned to his studio, the beautiful canvas representing the head [i.e. skull] of a dying bull against a background of tragic greys and violets. He entitled it 'Homage to González.'

(R. González 1956, p.24)

Bibliographic and Archival References Cited

Brigitte Baer, *Pablo Picasso: Catalogue de l'oeuvre gravé et lithographie*, vol.1, Berne 1990.

Julio González, 'Desde Paris', *Cahiers d'Art*, no.7–10, 1935, p.242.

Julio González, 'Picasso sculpteur', *Cahiers d'Art*, no.6–7, 1936, pp.189–91; trans. in *Museum of Modern Art Bulletin* (New York), vol.23, no.1–2, 1956, pp.43–4.

Roberta González, 'Julio González, My Father', *Arts Magazine* no.30, Feb. 1956, pp.20–4.

González estate: González archive, Heirs of Roberta González, Paris.

Musée Picasso: Picasso archive, Musée Picasso, Paris.

Margit, Rowell, 'Julio González: La Genèse de la sculpture en fer', in Jorn Merkert, *Julio González: Catalogue raisonné des sculptures*, Milan, 1987.

Josephine, Withers, *Sculpture in Iron*, New York, 1978.

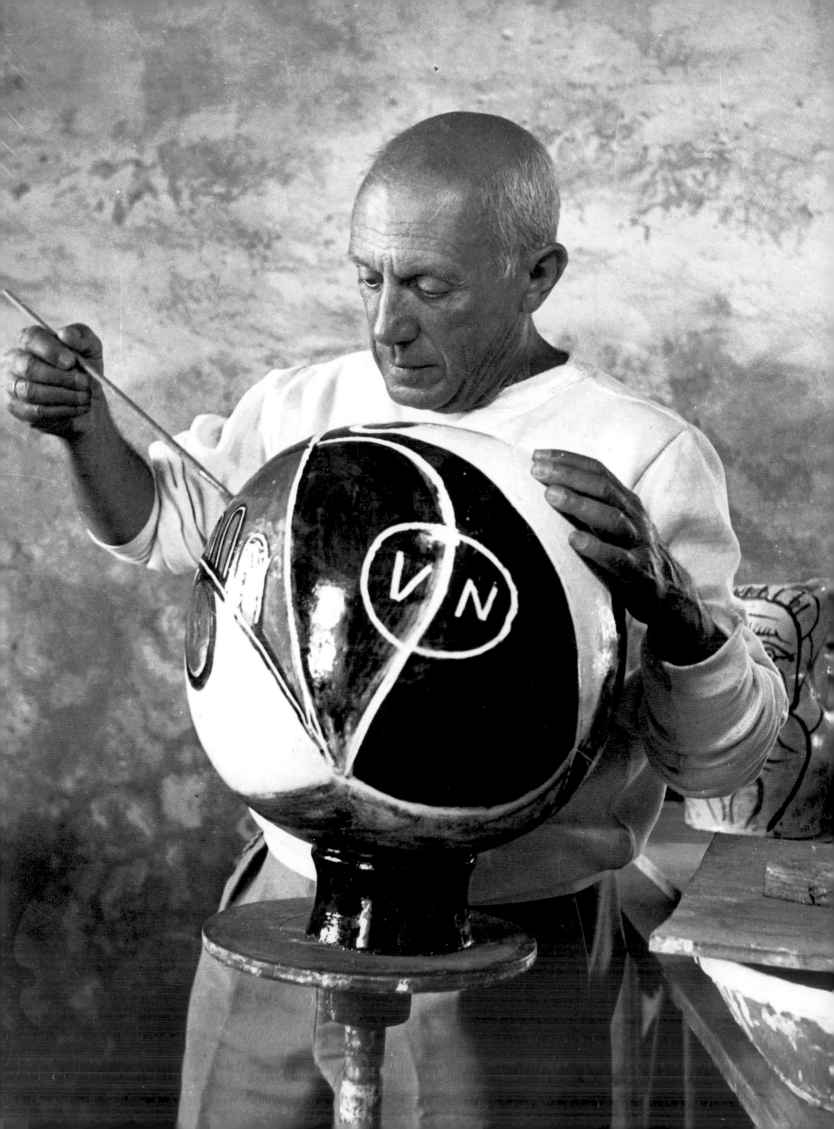

The Valley of Gold: Picasso as Potter

CLAUDE RUIZ-PICASSO

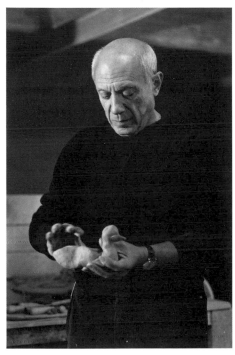

fig.50 Picasso modelling a dove, Vallauris *c*.1953
Photo: Edward Quinn

opposite
fig.49 Picasso in Madoura pottery Vallauris *c*.1948
Photo: Roger Viollet © Lipnitzki-Viollet

In Vallauris, in an abandoned orchard off the winding path between our home and my father's studio, is the flat figure of St-Claude, an ancient bishop supposedly the potter's patron saint, standing waist deep in tall grass. Its lofty, peaceful posture in the midst of persimmon trees is magical. Its flatness conceals it until we walk all around the hairpin bend. There, towering, it stands facing us. Coming back, it disappears as it stares at our backs. Its presence is very live as it plays a hide-and-seek game with our senses. I wait until the last possible moment to aim my gaze at where it should stand to surprise it. This playful relationship with a piece of painted board enthrals me.

A pompier sculpture of St-Claude holding a wreath of dried discoloured flowers presides over the workroom at Madoura. Like a frozen gargoyle this very ugly object observes every gesture from its high vantage point. I hate it even though my name is naively painted in black chipped paint on its base. It is not saintly, it is very dead. Next door in a long grey room, where it is so hot, on tiptoe I peek carefully with one eye, through the little mica heat-reddened *regard* – the window in the massive dusty steel and brick door of the kiln. I have again been allowed to glance at the secret magical transformation of the colours that my father has applied on plates, animals, pitchers or sculpted shapes. A few days ago those decorated artefacts were still so drab. Then, it was still almost impossible to tell one colour from another; they appeared just different shades of grey. In fact everything, including the potters, the floor, the air was grey. It was joy and happiness for me to watch as the ceramics came out of the kiln. Bright shiny colours sensational for a child, and for my father, the highly expert painter. No one can become blasé at experiencing the result of firing the biscuit and the enamels. Experimenting with the mixing of those non-existent colours was an interesting challenge for my father. Working with the primal elements fire and earth must have appealed to him because of the almost magical results. Simple means, terrific effects. How ravishing to see colours sing after infernal fires have given them life. The owls managed a wink now. The bulls seemed ready to bellow. The pigeons, still warm from the electric kiln, sat proudly brooding over their warm eggs. I touched them. They were alive, really. The faces smiled. You could hear the band at the bullfight.

Now Jules Agar, the potter, thumping his foot on the base of his wheel to spin it, wetting his hands at regular intervals, was finishing throwing a small vase. My father grabbed it, wrung its neck, pinched it around the belly, pressed it down on the table while bending the neck. A pigeon. The hands had worked so fast, so knowingly that I had not noticed that the head had also been shaped. A pencil was picked up and a few dashes gouged the surface to indicate the eyes, the texture of the feathers. How swift and sure the hands were. So purposeful, they went directly to their business. Another day a perfectly decently boring twelve inch tall vase was turned into a head by simply bending softly the top over the belly to form a big nose. Amazingly this looked obvious and definitely normal to me. What a grotesque nose though, next to the tiny miserly lips and the blind man's gaze under the frowning brow! The gesture had been very slow but definite, the result transcendent. If the bending of one reality could create in an instant a completely different reality, then obliterating one vision, the vase, to produce a face was magic.

Audacity and pugnacity may be necessary to attempt daily a magical feat, but courage is needed to break through basic reality. Somersaulting into the unknown it takes guts to risk one's name everyday. Maybe it only takes childlike freshness to remain open to the surprises flowing out of you. When working one must not be one's own critic, my mother told me. It is necessary to broach the subject – Reality – every day. Out of the many trials sometime blooms a master breakthrough. It is as unexpected to the onlooker as to the artist himself. 'Painting makes me do what She wants', Picasso said. The same applies to sculpture and every category of art, as all Picasso's work is fused as total life experience.

The very first terracottas at Vallauris were tiny figures – the rather full figure of my mother actually – done in 1946. A year elapsed before Picasso resumed working at the Madoura *plein feu* (full-tilt fire) owned by Georges and Suzanne Ramié. A *ramié* is a homing pigeon. This coincidence must have appealed to my father since he could have collaborated with any of the very capable and willing good craftsmen of Vallauris. One of the other potteries was Les Archanges; the owners, the Valentins, were adorable vegetarian earthly angels. At any rate the pigeons opened their coop and cooed and wooed and made sure my father stayed, and stayed well stocked with glazes and slips, fresh earth to knead and empty platters to fill with marvellous decor, simple earthenwares to be enhanced by his inquisitive mission to seek further into the mysteries of transmutation produced by the kilns. The pigeons eventually suggested producing limited editions of these efforts.

The apprentice alchemist was sent on his way and, as was his habit, he learned quickly and thereafter set out to throw the trade on its head, innovating, and bringing his knowledge of the other disciplines he had mastered. Concurrently he started a new involvement in lithography which rejuvenated that craft by his daring and unconventional attitude. In both lithography and ceramic his anarchistic approach liberated him from the accepted tricks of the trade and their customs and traditions. In ceramic he experimented with the reserve technique, blocking some areas with paraffin as you would with varnish in etching. Intaglio was also brought into play. Plaster matrixes or shapes were prepared by employees of the pottery, which Picasso engraved and proofs were pulled in clay. Once dry these were enlivened with slips and glazes of metal oxides.

It is commonly assumed that when a new person entered Picasso's life his expression changed. Granted it is absolutely true that my mother Françoise Gilot is a very distinct person (quite different to Marie-Thérèse Walter, Dora Maar, Jacqueline Roque as I remember them). She is a very straightforward, very ethically erect woman. My mother has the profound certainty of the patrician tanagras that unmistakably my father sculpted to represent her (no.46). As much as she has her feet in the ground her eyes are firmly locked into the infinite reaches of truth, well described in a painting like 'Woman-Flower' (no.115). She was then young and fearless. She is a good painter and a great debater, intelligent and generous.

So Picasso met Françoise Gilot, but was it not about time? Surely he was not seeking but he found. The instant was ripe. They were ready.

The very bitter dark times of constant threats for one's life from the nazi scourge that France, and Picasso in Paris, had just lived through suggest some other reflections about his renewed interest in Greece and its myths, the Mediterranean and ceramics. It is intriguing to note that Picasso, who in the 1920s and 1930s had been inspired by Greek mythology and had illustrated different books by ancient Greek authors, now in 1946 decided to return to those themes. This time, however, the more ecstatic, bacchic, happy themes are explored. Bacchanalias or ritual orgies are the chaotic rites of rejuvenation, of the desire for change. It is as though, consciously or not, Picasso reappropriates the

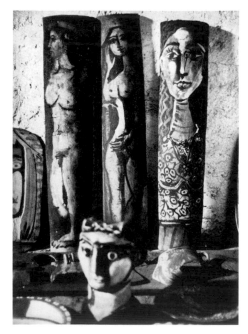

fig.51 Painted ceramic tiles and 'Head of a Woman with a Bow', Le Fournas, Vallauris 1957 Photo: David Douglas Duncan

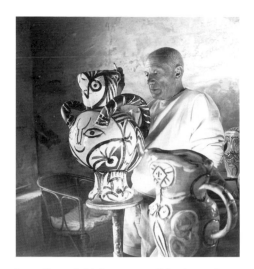

fig.52 Picasso in Madoura pottery Vallauris c.1948
Photo: Roger Viollet © Lipnitzki-Viollet

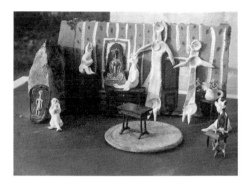

fig.53 (4 photographs) Installations created by Picasso for an uncompleted film he directed with Frédéric Rossif, Le Fournas, Vallauris 1950 Photos: Robert Picault © RMN

fig.53B

myths and culture of the Mediterranean. Ceramic and terracotta are undeniably the source of much of our knowledge of Classical times. They were also the means of dissemination of those ancient cultures. It is thus significant (and amusing) that Picasso becomes involved with ceramic after working in the Château Grimaldi in Antibes situated on the acropolis of old Antipolis. The château is a municipal museum which the director Dor de la Souchère, a professor of Greek and Latin at the Lycée in Cannes, has invited Picasso to use as a studio. The museum is fairly empty except for a few undistinguished paintings and a smattering of bacchic cult pieces and shards of Greek and Roman antiquity. The multiplication of these anecdotal coincidences seems to push Picasso to show us what he, opposed to the sinister, cynical, just recently defeated ideas of nazism, which had wrongly subverted Greek Classic antiquity to mask its totalitarian philosophy, can do with a proper reading of its humanistic ideals. It is stirring to imagine that Pablo Picasso, earthed strongly in Mediterranean culture, known for his previous associations with Greek mythology, confirms his deep feelings by this time working in clay and on clay. Clay, the most widespread, functional medium of Classic times. I am certain he was aware of the influence ceramics did have, and that through such objects we can trace the breadth and wealth of Classic civilisation. He was as keen on the durability of these objects and his own creations as he was impressed by the fastness of their colours. He must have noticed, in Naples in 1917 and at the Louvre, the almost shockingly garish colours of Apullian ceramics.

I feel he must have been tickled by producing his ceramics in Vallauris, an old Classic production centre: *vallis aurea*, the valley of gold. Clay, the humble material which could be turned into gold. Midas seizes centaurs, nymphs, flute players, goats to decorate the Château Grimaldi with his 'Joie de Vivre', modelling them in his hands at the pottery. Also Minerva's owls and regal bulls, to effectuate his real return to the Mediterranean in the three-dimensional form after having locked himself down in Paris at the mercy of those nazis and fascists who misused, misunderstood, mistreated, perverted and vilified the Classic ideal by selecting its militaristic Spartan aspect, exemplified in the official taut muscle art of Arno Brecker. Picasso the creator, with agile small hands wants to show us how plastically the same ideals can be simply beautiful, beautifully human, filled with grace and humour.

Of course Picasso celebrates the end of the war, the renewal, the rebirth of life, a new wife, even a new life: my forthcoming. He also rejoices in reuniting with the shores and in the benign pleasures of basking in the light, the only original real light of art. Let us leave Paris where we were trapped prisoners of the German invaders, barbarians to whom we had to demonstrate our will not to flee and to prove that all is not luxury, calm and voluptuousness. Let us start to live again. Let us catch up with the flow of life, of our lives. Let us eradicate those soils, those profanities to our culture. Let us remind everyone what we are, and ourselves who we are. Let us touch the earth, knead it, shape it. Let us give it our name. Let me put my hand's imprint on the earth. Let me stamp my seal on life. A life returned to our shores and to our midst. In these ovens let us give life to shapes and colours. Let us bring back to life those who were torn from us. Let us grab this pregnant wet earth to give birth exactly where others have smothered our friends, our ideals, our hopes.

Picasso during the war did not create many sculptures, however he did make some important skulls in terracotta and a large one in plaster (no.102). Apart from his most famous 'Bull's Head' (no.103) and 'The Reaper' (s 234), the most striking is 'The Man with a Sheep' (no.105). This work, larger than life-size, has the heroic stance of a Classic masterpiece. Its theme is the pastoral goodness of a man tending his helpless flock, a classic bucolic scene. Thus in the context of the times this sculpture and the others are very apt. They are critical, descriptive of the gloom, and with 'The Man with

a Sheep' show a longing for balmier times. The shepherd as always the enlightened leader, is a Christ-like figure bringing the sheep, a golden fleece, which is pure knowledge, hope.

As the war is now over, Picasso returns to the South of France and settles down at La Galloise and Le Fournas, his studio, where he embarks on a rich period of sculpture. Many of the works will come from the rubbish tip which he passes on his way from home to Le Fournas, others will be recuperated from my inquisitive, exploratory enterprises at deconstructing toys. Many great pieces such as 'Vase-Woman' (s 332) are well known as bronzes; it is seldom realised that they were originally ceramics. Many sculptures incorporated pieces of ceramic and one instance, 'The Woman with a Key' (no.109), was made entirely of elements used in the kiln. This seemed an amusing challenge to succeed in. My father's use of shards or heterogeneous elements was first a shorthand to reach quickly the hoped-for result. It satisfied his impatience. Working with clay was fast – as he had known ever since, in the early part of the century in Barcelona and Paris, he had made his first sculptures at the urging of Paco Durrio, a Basque friend who worked in that medium. Most of the sculptures Picasso made then were clay or terracotta. Clay is very malleable and allows for an infinite number of alterations, unlike woodcarving, which he also tried. There exists the added attraction of decorating, reworking in paint, the sculpture once it is fired. This second challenge is for Picasso the chance to push himself into the fourth dimension. In fact, as can be grasped from a tanagra such as 'Woman with Clasped Hands' (no.46), painting not only decorates and enhances the sculpture but resculpts it, as Picasso does in his painting. It is, as in painting, tackling the tri-dimensionallity of a body or a face on the flat plane, but here in the round. He even attempted painting still lifes on spheres. His long-time friend and dealer Daniel-Henry Kahnweiler published in 1956 in *Quadrum* a conversation between Henri Laurens, the sculptor, and my father which took place at the Galerie Leiris on rue d'Astorg on 8 July 1948. Picasso said to Laurens: 'You ought to go in for pottery, it's magnificent! I've done a head, and whichever angle you look at it from, it's flat. Of course, it's the painting – I painted it specially to make it look like that. In a picture you look for depth and as much space as possible, but with a sculpture you try to make it look flat from every direction. I did something else too: I painted on curved surfaces, balls for instance. It's amazing, you paint a bottle and it runs away from you, it slips round the ball.'

It is interesting to remember that Picasso had in the past tried to further his own vision by painting over a ceramic cast of a sculpture by his friend Henri Laurens, bought from the Galerie Leiris, about the size of a Classical tanagra and actually representing a draped nude. Picasso then successfully reworked in china ink most of the planes of Laurens's work to make it completely his own and obliterate Laurens. In this premonitory fashion he prepared himself for many experiments in his own ceramic work painting various owls or zoomorphic shapes of his own design or pitchers. He dared himself to redefine these shapes, endlessly seeking a new dimension to the same pictorial problem. His sense of humour allowed him to take free leaps and depart to the unexpected. This is something that had obsessed him since 'Glass of Absinthe' and its six different versions (nos.23–4). This breakneck challenge he took up again, painting the same shapes over and over on white rectangular canvas. Pulling all his acquired strengths and past experience into the sculpted ceramic work he channelled his curiosity for this medium. He stuck on slabs of clay imprinted with fishbones. He cast newspaper matrixes and moulded them (no.129). He made his own French fries and blood sausage, fried eggs or sardines *à la* Bernard Palissy even though he never cooked himself. Now he would be the first Pop artist, much before Claes Oldenburg, because he liked Bernard Palissy's determination and his excellence in presenting true-life

fig.53C

fig.53D

fig.54 Picasso in Madoura pottery Vallauris 1947
Photo: Keystone/Sygma

objects. His great sense of humour catapulted him to redefine, brush in hand, the volumes of his own sculptural designs. For a while he made sketches of shapes which he asked the potter to form on his turntable with a project in mind that he would duly execute. However, the same shape by his wit could one minute be a bird as planned, the next a knight in full armour astride his large palfrey. A bird held by two hands, an aquarium. A large tripod vase with spheres at its base became arms upon which my mother's face rested, which became in turn a torso of her, the spheres breasts obviously. A few gestures and the shape would take on a different meaning. In the atelier at Le Fournas he concurrently pursued the same preoccupations, painting over bronzes which had been cast from sculpture made of debris. Thus 'Woman Reading', 'The Crane', 'Still Life: Pitcher and Figs', 'Woman Carrying a Child' (nos.48, 121, 124, 135), the two 'Standing Women' of 1953 (s 479–80) and later bent sheet-metal 'Heads of Sylvette' (s 488–91) and 'Heads of Jacqueline' (e.g. no.146) were all part of the same search.

Sometimes he used shapes he found in the atelier Madoura that Madame Ramié had designed or which were traditional models. In applying his imagination at decorating these set prefabricated pieces he stretched his own painterly curiosity. If we examine the large number of simple pitchers he worked on, pitchers 'decorated' with a pitcher and glass full of water, we can see the philosopher at work. His philosophical curiosity and acumen is such that the job becomes either a surrealistic pun or a discussion about content and container or maybe an existentialist question about which is most important: on, in, inside, inherent. The same serious query is facing us when we examine the pitchers 'decorated' as flower vases. The belly part is painted as a pretty vase, the opening neck is covered with the ubiquitous tulip or plain field marigold, asking us what is container, content, contained. But the same pitcher can be the twin studios of the sculptor and the painter, separated by the handle which is the flue of the cast iron stove, inseparable from the starving Parisian artist image. Picasso's humour pervades most of the terracottas and maybe especially when he depicts Classical scenes on shards of cooking ware: the typical *pignates* (casserole dishes) made here since Roman days, turning them into archaeological finds. The same *pignate* you could buy in Montmartre to cook in at the Bateau Lavoir and that Picasso decorated in gouache for his friend Apollinaire, a reclining nude of Fernande on one side and on the other a bouquet.

Yet the most dumbfounding experience, as my mother explained and I can remember but had no idea it could be otherwise, was to see my father grab a slab of clay and instantly turn it into the tangible form of some recognisable part of nature or myth or most often the commonplace shapes of our daily lives, hence its universality. The universality of the Classic.

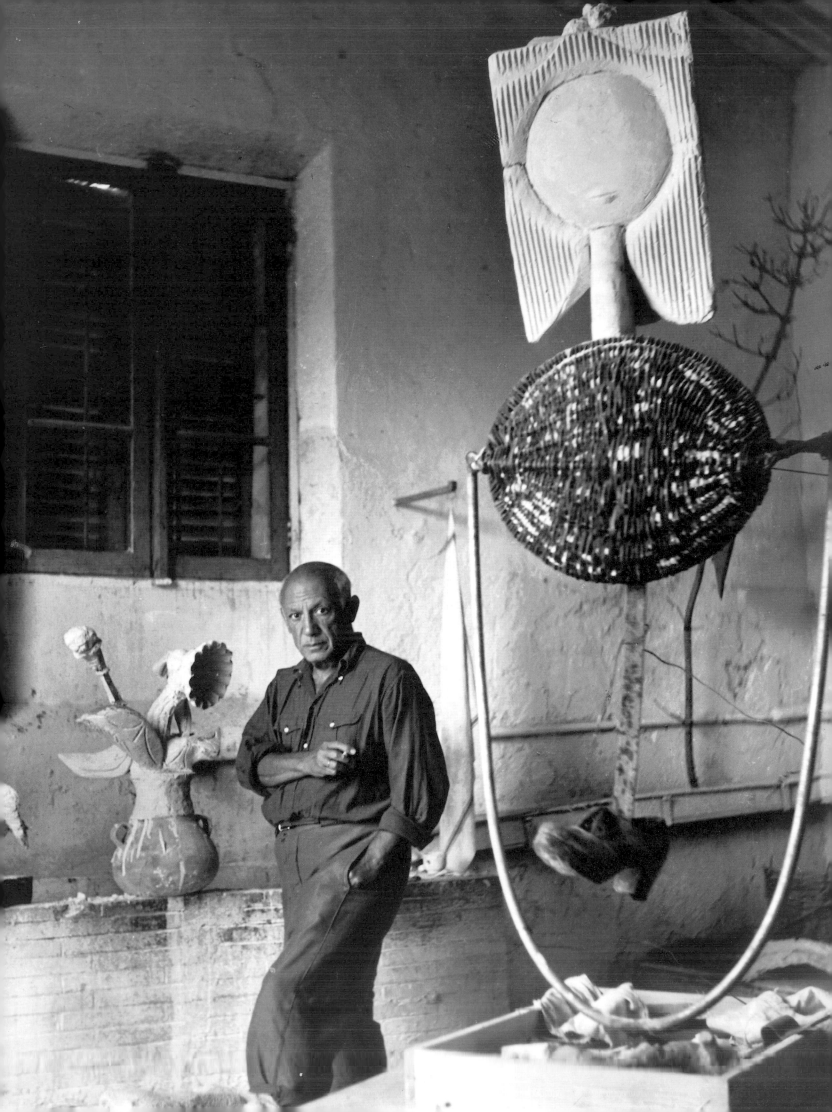

Objects into Sculpture

ELIZABETH COWLING

It is my misfortune – and probably my delight – to use things as my passions tell me
… I put all the things I like into my pictures. The things – so much the worse for
them; they just have to put up with it.

Picasso made these remarks to Christian Zervos during the course of a long
conversation held in 1935.[1] He speaks of his 'pictures', but 'things' played an even more
crucial role in his sculpture: without them, Picasso's sculpture as we know it could
barely have existed. For objects provided the inspiration for many of his sculptures and
also, literally, their substance. More than this, objects became the instruments of
extraordinary transformations, and thus the principal means by which Picasso was able
to invest his sculpture with the magical potency of 'primitive' art, and to engage directly
with the themes that preoccupied him at the deepest level – the theme of mortality in
particular.

Picasso was a great accumulator of objects. The word collector is inappropriate
because it implies more discrimination than he ever exercised. Certainly, he acquired
some fine paintings and drawings by artists he admired or knew personally – Renoir,
Degas, Cézanne, the Douanier Rousseau, Derain and Matisse among them. And over
the years he assembled a large number of tribal masks and statues. But, overall, the
quality of these collections is patchy.[2] In any case, the works of art were far outnum-
bered by the quantities of pebbles, bones, skulls and skeletons he happened upon
during rambles by the seashore, the industrial scrap he filched from dumps and
backstreets, and all the bric-a-brac acquired by chance or choice or gift. His appetite for
things curious and vulgar was voracious. Conventional beauty bored him. He was
exasperated by the concept of 'good taste'. Aesthetic considerations were always
secondary to the desire to be surrounded by things with which he felt an irresistible
affinity. The primitive artefacts and the skulls and skeletons were of special relevance to
his sculptural work.

The chaos and clutter in which Picasso lived are legendary. In later life he tended to
buy another house when he ran out of space. His friend and biographer, Roland
Penrose, was one of many to be bemused and fascinated by the spectacle. He vividly
evokes the 'jungle' in La Californie, the ornate and rambling turn-of-the-century villa
above Cannes Picasso moved into in 1955[3]:

> His house had always been his workshop and a place to store his belongings rather
> than something to be admired for its elegance and comfort … With haphazard
> finality objects took their places around the rooms. In spite of the attentions of
> Jacqueline Roque, the disorder grew. Incongruous objects, crowded together, became
> more deeply hedged in by a forest of new arrivals.

Picasso himself revelled in his reputation as 'the king of the ragpickers',[4] and a
mixture of superstition and opportunism had bred an absolute aversion to tidying up
and clearing out: one day might he not need that very bit of 'rubbish', and if he threw it
out, might he not be throwing out something imprinted with his essential self? So,
piles of empty cigarette boxes grew into precarious skyscrapers on mantelpieces; used
tubes of paint gathered in congealing mounds on the floor; pigeons' droppings were a

opposite
fig.55 Pablo Picasso in his studio with
'Little Girl Skipping' in progress, Le Fournas,
Vallauris 1950 Photo: Michel Mako © Rapho

welcome patina on his paintings; bills, receipts, cheque stubs, travel tickets, advertisements, suppliers' catalogues, newspaper clippings – all dating back decades – were stored like precious relics.[5] It is well known that Picasso's art was autobiographical to an unusual degree: it should not surprise us that this obsessive hoarding was echoed in his work, or that it was more often than not the crassly ordinary that he chose to celebrate. 'If anyone could go broke for things that don't cost any money, I'd have been broke years ago', he once remarked.[6]

fig.56 **The Blind Man's Meal** 1903 Oil on canvas
The Metropolitan Museum of Art, New York. Gift of Mr and Mrs Ira Haupt

Still life was a favourite subject for Picasso, and the most straightforward way in which he expressed his love of things in his work.[7] It was in the Cubist period that he made his first sculptures on still-life themes, but well before that the evidence suggests that objects stimulated both his tendency to think in sculptural terms and his urge to sculpt. In the Blue Period masterpiece 'The Blind Man's Meal', painted in 1903 (fig.56), the gaunt figure seated at the table leans over to feel a full-bodied pottery jug with one hand while grasping a dry loaf of bread in the other. Between these two objects lies an empty dish, turned towards us so that we can scan its interior cavity and its softly gleaming sides. The painting could be interpreted as a meditation on hunger and thirst and the pathos of a disabled underclass. But it is also about the sense of touch – about volume and shape and density, surface and texture, about the spaces between things and how those spaces can be measured through touch as well as sight. Picasso had already taken up modelling by this date: there is a small contemporary head of a 'Blind Singer' (s 2) which is closely related to the picture. Although he had not yet modelled any still-life objects, 'The Blind Man's Meal' suggests that he was just as conscious of the sculptural properties and potential of objects as of the human body.

It could be objected that there is nothing at all unusual in this correlation between objects and a sense of mass and volume. As a Spaniard, Picasso was heir to a still-life tradition of extraordinary realism: 'The Blind Man's Meal' is a very Spanish picture, reminiscent of the early genre scenes of Velázquez. Moreover, artists who received an academic training were expected to develop their command of form and structure through studying geometric solids and simple objects before they tried to tackle the human figure. Work from the live model was preceded by and mediated through the study of casts of antique sculptures – frequently casts of fragments, such as a head, torso, or foot, which effectively objectified and dehumanised the body. Picasso was conventionally trained, and plenty of tonal drawings from casts survive as proof of his youthful efforts to master three-dimensional form. Nevertheless, the development of his work after the Blue Period suggests that we are dealing with a profound impulse rather than an acquired method or an inherited tradition.

In 1906, when Picasso was staying in Gósol in the Pyrenees, sculpture was very much on his mind. Before leaving he had sculpted the portrait head of his mistress, Fernande (no.1), and now for the first time he tried his hand at woodcarving (s 6A–C). His many paintings of young male and female nudes executed in Gósol, with their classical poses and warm terracotta hues, reveal just how intently he had been studying the Louvre's collection of Greek and Roman antiquities and the archaic Iberian stone carvings he had seen in a special exhibition there that spring. But despite this preoccupation with the human figure, Picasso's commitment to objects was deepening, for it was also in Gósol that he painted his first series of pure still lifes. He seems, in fact, to have turned instinctively to objects whenever he wished to put across an idea of three-dimensional form. Thus he often juxtaposed the nudes with pottery vessels and bowls, or had them sit on plain cubic blocks, in order to enhance the sense of volume and tactility, and it is noticeable that the objects tend to look more weighty and substantial than the figures (fig.57). It is almost as if Picasso found it easier to express sculptural form in terms of objects than the human body.

fig.57 **Girl with a Pitcher** 1906 Oil on canvas
Whereabouts unknown

fig.58 **Three Still-Life Studies** 1914 Ink on paper
Musée Picasso, Paris

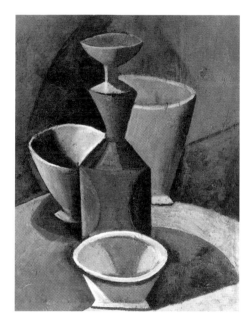

fig.59 **Carafe and Three Bowls** 1908 Oil on canvas
The State Hermitage Museum, St Petersburg

In still-life drawings from this and the Cubist period the objects Picasso chose tend to be of a commonplace kind and a relatively simple form. In his mind's eye he feels round them, showing them from different angles and experiencing their volume. There are also many quick sketches of hands holding something. Picasso may show the fingers encircling the rounded base of, say, a jug, and passing through the handle. The sheer number of drawings of objects and still-life compositions is in itself remarkable, but so is the intensity of his concentration on their weight and mass (fig.58). A painted still life like 'Carafe and Three Bowls' of 1908 (fig.59) is almost oppressive in its physicality. Each of the four objects is invested with such awesome monumentality that one cannot help but conclude that the painting is as much a substitute for sculpture as is the contemporary 'Seated Nude' (no.13), which looks as if it is hewn out of a wooden block. In a number of drawings, the presence of a human hand lying alongside a group of still-life objects signals not only the desire to communicate on a two-dimensional surface the physical experience of something three-dimensional, but also Picasso's longing to work directly with his hands, literally his longing to make something (no.61).

These observations confirm that we are dealing with a quality of vision fundamental to Picasso. He was sensitive in an unusual degree to what one might call the 'presence' of objects. Objects, unlike living models, are, of course, silent and motionless, and thus inherently monumental. We may invest them with emotion, but they do not have emotions. Unlike people, they do not themselves create narrative situations or encourage anecdotalism. These qualities lend them the gravity, aloofness and immutability of icons, and from time immemorial objects have been dignified as symbols. All of which makes them potentially an ideal subject for sculpture. As Picasso himself said many years later: 'An object and a sculpture can be one and the same thing. More or less, at any rate.'[8]

It is, then, no accident that Picasso's growing concern with still life as a subject in its own right in 1906–9 should be paralleled exactly by his increased activity as a sculptor. Objects were putting him under pressure to make works as physically real and as implacable as themselves. The Cubist *tableau-objet* (typically a round or oval canvas, sometimes of diminutive size, and occasionally bordered by a special frame which was conceived of as part of the composition) represented an effort to throw a bridge between painting and sculpture (no.31). The choice of name for this new category of art was in itself an anti-establishment gesture: Picasso and Braque did not make 'works of art' to be admired from afar; they made 'objects' to be handled. And the principal subject of these *objets* was still life.[9] When, many years later, Picasso worked with the potters of Vallauris pressing and folding the newly thrown pots, pitchers and vases into figures of women or birds, he must have derived intense satisfaction from this ultimate fusion of everyday object and sculpture (nos.46, 128).

Initially Picasso had been content to follow convention and fulfil his urge to sculpt by modelling or carving only heads or figures. The conceptual breakthrough came when, probably in the autumn of 1909, he made the faceted, hand-size 'Apple' (s 26).[10] He chiselled the plaster as if it were wood or stone, using the stepped ridges to draw the spectator's eye around, over and deep into the object. It is also likely that the small contemporary sculpture known as 'Head' (s 25) is not a representation of a head at all, but of the same cup or teabowl which turns up in several paintings and drawings of autumn 1909.[11] Picasso may have conceived these two experimental sculptures as pendants, and even planned a complete still-life composition as a sculptor's homage to Cézanne. At any rate, modest though they are, they were the forerunners of the many much bolder still-life sculptures which he went on to make in 1912–15.

Although innumerable sculptors before Picasso had given objects a supporting role as accessories to their figures, no independent genre of still-life sculpture existed. This

was because still life was considered a 'low' subject, sculpture a 'high' art with the noblest functions. So Picasso had to invent the genre. The true precedents for this quiet revolution appear to lie in the tradition of the decorative or applied arts: as on so many other occasions Picasso took his cue from art of lower status and from the products of artisans. There was, in particular, a long-established tradition of decorative carving and plasterwork on still-life themes which may have had some influence on such Cubist relief constructions as 'Guitar' and 'Violin' (nos.19, 26): musical instruments carved or modelled in relief were, for instance, quite a common form of wall decoration for the music rooms of grand houses during the seventeenth and eighteenth centuries. And elaborate and illusionistic still-life compositions in bronze, ormulu, silver-gilt and porcelain were fashionable decorations for the dining tables and sideboards of the wealthy. Picasso's Cubist still-life sculptures, whether wall reliefs or table-top pieces like 'Bottle of Bass, Glass and Newspaper' (no.25), were much more democratic in every sense – a working man's alternative, fashioned crudely out of coarse and ephemeral materials like cardboard and tin. After the Second World War when Picasso turned ceramist he gave the table decoration a further lease of life: typically his sculpted plates of food evoke the most plebeian meals, and one of his wittiest essays in this mode is a rumpled sheet of newspaper with a fresh fish lying on it (no.129).

Whether or not Picasso was consciously adapting an existing craft tradition, the fact is that he made still life into a legitimate subject for sculptors, and under his influence the genre quickly became established. From 1912 to 1915, when objects actually replaced the figure as the subject of his sculpture – or sculpture that went beyond the planning stage – still life remained a serious option for him, even though numerically there were far more figure and animal subjects in his total oeuvre. Some of these sculptures were reliefs and sometimes they were framed like pictures in a parody of the old tradition of *trompe l'oeil* still-life painting. But others, like the original apple, were free-standing – the series of six 'Glasses of Absinthe' (nos.23–4), 'Goat's Skull and Bottle' (no.125), and 'Pitcher and Figs' (no.124), among them. 'The Chair' (fig.70 on p.243), one of the most spectacular of the late sheet-metal pieces, was Picasso's farewell as a sculptor to the genre, and his final tribute to furniture as a form of sculpture.[12]

There was another way in which objects played a vital role in the evolution of Picasso's sculpture – as a driving force behind his first constructions. In October 1912, inspired by Braque's experiments with paper sculpture, Picasso made the cardboard maquette for the sheet-metal 'Guitar' (no.19).[13] Various sources for its radical planar structure and the construction technique have been identified, in particular Picasso's own Analytical Cubist drawings and paintings of 1910–12 and the African Grebo masks he had recently acquired (fig.22 on p.191).[14] But it is more than likely that the kinds of objects Picasso had around him in his studio were just as essential a stimulus. Like Braque, he owned various stringed musical instruments and hung them on the studio walls alongside his Negro masks. They are, of course, hollow constructions, made from separate cut out, flat and curved planes of wood, which have been fixed together, and equipped with strings, pegs, etc. Picasso's 'Guitar' is a bit like a blueprint or a demon-stration-piece for an apprentice instrument-maker – from a craftsmanly point of view very ineptly made, which adds to its wry humour. The squeeze-box of the concertina Braque used to play might well have been the model for the stepped folds of card that describe the necks of two other roughly made guitars now in the Musée Picasso (s 29–30).

There would have been lots of constructed objects of a more mundane kind lying around the studio. For instance, lidded cardboard boxes: these seem to be remembered in the delicate 'Violin' (fig.23 on p.191) and actually used in at least one of the cardboard guitars (s 30). Or tin cans, like the one recycled in 'Bottle of Bass, Glass and Newspaper'

fig.60 **Pottery Basket** 1909 Oil on canvas
Bayer. Staatsgemäldesammlungen. Staatsgalerie Moderner
Kunst, Munich

(no.25). Years later a rough wooden crate would serve as the skull for 'Head' 1958 (no.139). It was not just a question of flouting convention out of a spirit of anarchistic revolt: Picasso genuinely appreciated the technical dexterity of these despised utilitarian things. Brassaï records a conversation with him on 27 April 1944. Picasso showed him some little wooden boxes, and said: 'I saved them from a dustbin tonight, on the way home. That boxes could be so ingeniously and yet so simply made is quite marvellous! Look how clever they are! The lid opens and closes with just two little nails in the place of hinges. Real works of art!'[15] Perhaps the key role of the Grebo masks was that they showed Picasso how such humble, immemorial methods of construction could be adapted to sculpture, and to sculpture of striking power.

Picasso was equally fascinated by commonplace objects of intricate open structure. Probably around the time he sculpted the Cubist 'Head of a Woman' (nos.5–6) he painted a still life in which a nineteenth-century pottery basket has pride of place (fig.60). These baskets are an exact imitation of wickerwork, and Picasso recorded the structure with minute accuracy, down to the individual struts, crossover ties and woven base.[16] Many years later he employed a crude variant of the 'weaving' technique in a group of playful sculptures made of twisted wire (e.g. no.41), as well as in the latter-day Cubist 'Glass' of 1951 (no.47). And real baskets were incorporated into at least two major sculptures – 'The Goat' (no.118) and 'Little Girl Skipping' (no.119).

Another object of elaborate structure which inspired him in the Cubist period was a cruet set of the kind still found in French cafés, with cantilevered metal platforms, a carrying handle and spaces for the condiments. It was the subject of a drawing (no.53) and a painting dated January 1911 (D 370). The way Picasso presents the cruet set, particularly in the drawing, as a series of flat planes raised on vertical rounded struts projecting towards the spectator from the background is prophetic of wooden relief constructions like 'Mandolin and Clarinet' 1913 (s 54). His sketchbooks in 1912–13 are full of projects for elaborate free-standing, cantilevered and stringed constructions, usually representing musicians (no.56, and figs.18–21 on pp.190–91). Some of them resemble model sailing ships; others remind one faintly of skeletons; others of scaffolding; others of mechanical contraptions. They never got beyond the planning stage either because they would have required the kind of meticulous and myopic labour of which Picasso was constitutionally incapable, or because he realised they would be merely curious rather than magically suggestive. The wire constructions made with Julio González in 1928 (nos.74–5) are a cogent rationalisation of these earlier sculptural daydreams.

The construction technique, once discovered, released Picasso's innate versatility and he interpreted it with the greatest freedom. He could use more or less anything that came to hand. He could work extremely quickly, whereas conventional modelling and carving were relatively laborious procedures, requiring special materials and tools. A limitless variety of textures and substances could be employed in the same work, and rich and intricate effects achieved without great feats of skill. What is more, Picasso's magpie instincts at last found a legitimate creative outlet: the things he could not bring himself to discard could become the matrix of his sculptures; object and sculpture had become 'one and the same thing, more or less'. The construction technique suited him so perfectly that it brought him joy. González, reminiscing about their collaboration on the welded constructions in 1928–32, wrote that Picasso told him: 'Once again I feel as happy as I was in 1912.'[17] Making the found-object sculptures in Vallauris in the early 1950s also seems to have given him profound pleasure.[18]

From using materials like paper, card, string and stray pieces of wood, to incorporating complete objects was a small and inevitable step. A studio photograph taken early in 1913 (fig.16 on p.188) shows an outlandish assemblage including a real guitar slung over

the front of a large unfinished painting of a musician. In front of the canvas is a real table with an arrangement of real objects on it. Needless to say the assemblage did not survive, and quite probably it was a joke. However, objects soon began to find their way unaltered into Cubist constructions that were preserved – the readymade picture frame in one of the tin constructions (s 51) and the shaver's soap dish in 'Bottle of Anis del Mono and Fruit Bowl with a Bunch of Grapes' (s 58). In the case of the first, the found object stands for itself. But in the case of the second, the wooden soap dish mounted on a bit of dowel becomes a *compotier*. The transformation required no great imaginative leap, but it was prophetic of things to come.

By 1928, when Picasso embarked on his next sustained bout of activity as a sculptor, he was closely associated with the Surrealists. Transformation and metamorphosis were now the name of the game, and the Surrealist cult of the object can only have urged him to take further risks. Profiting from the metal-working skills and equipment of González, Picasso could now make much more ambitious constructions in more permanent materials. Bought kitchen colanders, coiled springs and nails were used in a most assertive fashion in 'Head of a Woman', his most daring found-object sculpture to date (fig.48 on p.214). On the other hand, the wonderful series of relief-pictures made in Juan-les-Pins in August 1930 involved only glue and fastenings, and were created with disparate objects Picasso had picked up on the beach, including seaweed, toy boats and a rubber glove, which were then covered with a unifying layer of sand (s 75–8, and s 117–19).

In 1930 Picasso purchased the Château de Boisgeloup, about sixty kilometres north-west of Paris, and installed sculpture studios in the stables. He did not have welding equipment, and any sculptures made of scrap iron and wire would have had to be fixed together in a rough and ready manner using only his hands and simple tools like pliers. So, apart from occasionally whittling in wood, he generally used plaster. This was partly because plaster enabled him to achieve the classical effect he was now seeking, and partly because he could continue to work additively, embedding into it while it was still wet all kinds of foreign materials, and cutting into it with a knife to delineate facial details and so forth. Clay would not have allowed him to work in this ad hoc way. At first the objects, such as bits of wood, which are visible in the original plasters of the 'Heads' of Marie-Thérèse Walter seem to have had a supporting function: they are like parts of the interior armature which have broken through the surface skin (s 133). But in 1933 Picasso began exploiting the unique properties of plaster in a most imaginative way, using objects (like leaves and cardboard boxes) and materials (like chicken wire and corrugated paper) as moulds from which he could take casts or which he could press directly into the wet plaster to give it surface texture (nos.100–1).[19] Although the materials he used were utterly banal, a poignant sense of remote antiquity prevails, as if one were encountering beings that have been fossilised in lava – an effect which is diminished in the bronze casts made subsequently.

Not that Picasso altogether stopped using found objects in their unaltered state during the 1930s. There is, for instance, an extraordinary scarecrow-man assembled from a metal ladle, two iron claws and several pieces of wood, held together by an anarchic cat's cradle of string (fig.61). It was made in 1935, although whether in Boisgeloup or Paris is not certain. But it was during the Second World War, when the bathroom of Picasso's apartment on the rue des Grands-Augustins in Paris became his sculpture studio, that found objects began to reassume their rights, even though his most important sculptures, 'Death's Head' (no.102) and 'The Man with a Sheep' (no.105) are modelled rather than assembled. The most famous of the wartime found-object sculptures is 'Bull's Head' of 1942 (no.103). Picasso was fond of describing how he came by chance upon the bicycle seat and handlebars, and how he saw them immediately as a

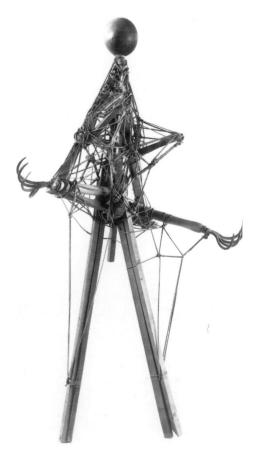

fig.61 **Figure** 1935 Ladle, claws, wood, string and nails *Musée Picasso, Paris*

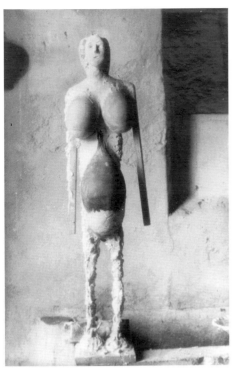

fig.62 'The Pregnant Woman' in progress in the studio, Le Fournas, Vallauris 1950 *Photo Archive, Musée Picasso, Paris* Photo: Claire Batigne

bull's head. His accounts vary slightly: sometimes he implied that both parts were lying together dumped on the pavement or in a bin, sometimes that he found them separately; sometimes he said he was with a friend; sometimes he implied he was alone. On the other hand, according to Picasso's daughter Maya, it was not Picasso himself who found the bicycle parts, but Gustave Sassier, the husband of Marie-Thérèse Walter's daily help.[20] A photograph taken in 1940 in the villa in Royan which Picasso rented for several months after the outbreak of the war, gives a further twist to the story, however: hanging on the wall above a group of recent paintings is a bicycle saddle of exactly the same type.[21] Without the handlebars it does not resemble a bull's head, but it is displayed like a huntsman's trophy or a tribal mask and has a distinctly animalistic appearance. The finding of the saddle and handlebars must have clinched an idea that had been latent for two years: no wonder Picasso pounced on them with such eagerness.

The most spectacular transformations of all took place in the sculpture studios Picasso installed in 1949 in the rue du Fournas in Vallauris. Vallauris was the pottery town of the Midi and its dumps, Lionel Prejger's scrapyard,[22] and the fields nearby provided an inexhaustible supply of the kind of things Picasso liked. The studio was soon littered with them: after the austerity of the Occupation Vallauris must have seemed like an Aladdin's cave. Françoise Gilot describes the daily foraging[23]:

> Often, on his way to work, Pablo would stop by the dump to see what might have been added since his last inspection. He was generally in a cheerful mood, full of high expectations. It was very hard for Claude, who was only three or four at the time, to understand why his father should be so happy about finding an old fork or a broken shovel or a cracked pot or something equally unprepossessing, but a find like that was often the beginning of a creative adventure for Pablo … I walked along with him, pushing an old baby carriage into which he threw whatever likely looking pieces of junk he found on the way. Or if it was something too big to fit into the carriage, he would send the car around for it afterward.

In some of the sculptures the found objects are so thoroughly integrated into the plaster that they are not easily identified. This is the case with the second 'Pregnant Woman' (no.108). A series of photographs taken by Claire Batigne in May 1950 charts the gradual development from Giacometti-like[24] beginnings to the full-breasted, full-bellied conclusion (fig.62). The breasts, belly and right forearm were made with the help of discarded pottery water jars, a conjunction that Picasso found peculiarly satisfying because of the symbolic overtones (the pregnant woman as a vessel). But the appropriations are exposed in works like 'The Goat' (no.118), 'Little Girl Skipping' (no.119), 'Baboon and Young' (no.120), 'The Crane' (no.121), 'Woman Reading' (no.48) and 'Goat's Skull and Bottle' (no.125). For the spectator the result is the classic doubletake. Scrap iron, tools, piping, screws and nails – not to mention the toy cars stolen from Claude to make the baboon's head – were wedded to wood, baskets, cardboard and pottery fragments to achieve astonishing effects of likeness. From youth onwards Picasso had been a brilliant caricaturist, and he now found the means to express in sculpture his eye for the characteristic gestures, stance and facial set of this menagerie of people and animals. He was frankly delighted by his own powers of alchemy – the word was often used by admiring friends who visited the studio – and he encouraged photographers to record the progress of each piece from scaffolding of found objects to realised likeness (fig.63). Although bronze casting unified the surface, and bold, stylised markings applied later to some of the works drew attention to the artist's creativity, the found objects still retained their own identity.

So far I have been concerned with the practical ways in which objects affected

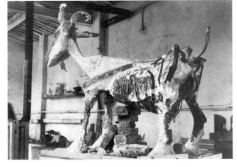

fig.63 'The Goat' in progress in the studio, Le Fournas, Vallauris 1950 Photo: Chevojon

Picasso's sculpture – their role as catalyst, as subject, and finally as substance. But his deeper motivations, and the role objects played in serving those need to be explored. Because we remain conscious of the metamorphosis of, say, corrugated paper into the drapery of 'The Orator' (no.101), of forks into the legs of 'The Crane', or of nails and screws into the arms and shoes of 'Woman Reading', Picasso's sculptures have some connection with Surrealism. The surfaces of the sculptures made in Boisgeloup and Vallauris look richly encrusted, as if deposits had accumulated over time, and in this sense recall the frottages and grattages of Max Ernst, which date from the mid-1920s and which Picasso would certainly have seen. Picasso's conception of Surrealism was, however, highly unorthodox because it did not encompass the fantastic or dreamlike, but was rooted in what he had seen. As he said in 1945[25]:

> I always try to observe nature … I insist on likeness, a more profound likeness, more real than the real, achieving the surreal. This is the way I understood surrealism but the word has been used quite differently.

And of 'The Goat' he remarked: 'She's more like a goat than a goat, don't you agree?'[26] Unlike Ernst, Picasso did not employ found objects in order to create phantasmagoric creatures and to escape reality, but to give his menagerie a reality as tangible and grounded as the reality of things we handle everyday. He explained to Françoise Gilot[27]:

> I achieve reality through the use of metaphor. My sculptures are plastic metaphors … People have said for ages that a woman's hips are shaped like a vase. It's no longer poetic; it's become a cliché. I take a vase and with it I make a woman. I take the old metaphor, make it work in the opposite direction and give it a new lease of life … I move … from the metaphor back to reality. I make you see reality because I used the metaphor.

His eye for physical detail was razor-sharp. In 'Woman Leaning on her Elbow' (no.100), for instance, the corrugated paper pressed into the plaster not only creates a lifelike impression of the folds and creases of drapery, but also of the soft tucks of slack flesh around the woman's navel. Picasso's concept of 'likeness' was, of course, in total opposition to the kind of meticulous descriptive realism that has proved so enduringly popular in the Western tradition (in particular for animal sculpture). By embedding alien objects into his sculptures he was sure to 'deceive the mind' (*tromper l'esprit*) but never the eye of the spectator, and it is noticeable that the parts he himself modelled are rough and sketchy. So although Picasso's 'Goat' is indeed very goat-like, we are never in the least doubt that she is pure fabrication.[28] And because she is fabricated from objects that have nothing whatever to do with goats, our minds are actively engaged as we struggle to fathom the conundrum with which Picasso presents us.

Picasso's sculpture involved a two-way process: if objects had the capacity to become figures or parts of figures, people and animals could turn into objects. The Cubist 'Guitar' (no.19) is undeniably feminine – an idea which becomes explicit in the tiny paper construction of a musician (no.20) where the shape of the breasts and guitar is identical. 'Violin' (no.26), with its two vertical sound-holes and its bold colour and pattern, is inescapably like a huge face-mask. And as many writers have pointed out, 'Glass of Absinthe' (nos.23–4) is also the head of a woman in a hat. Picasso never ceased to think analogically: the bottle with its blazing candle in the great still life with a goat's skull made in Vallauris (no.125) is like a young girl, a symbol of life, who confronts the stark emblem of death. Even the sheet-metal 'Chair' (fig.70 on p.243) has the commanding presence of a figure posing for the artist, and seems to share family traits with 'Woman in a Hat' (no.145). Furniture as a surrogate for the figure received its most memorable statement in 'Man' 1958 (no.138). Here chunky planks, batons and

fig.64 **Studies for 'The Woman with a Key'** 1954
Ink on paper *Succession of the Artist*

fig.65 **Studies for 'The Woman with a Key'** 1954
Ink on paper *Succession of the Artist*

fig.66 Dinoceras mirabile in the Galerie de
Paléontologie, Jardin des Plantes, Paris, *c*.1910
Photo: Bibliothèque Centrale du Muséum National
d'Histoire Naturelle

blocks of wood, a couple of turned furniture feet, and a hastily banged together frame stand as signs for a stocky man, but also for a massive easel.[29] The conclusion that this man/object-sculpture/painter's easel is a secret self-portrait is almost irresistible.

Ultimately, indeed, it may be irrelevant to classify the subjects of certain sculptures in terms of this species or that. 'Head' of 1958 (no.139) is also a wooden crate mounted on an upturned dish. Arguably, to read 'Glass of Absinthe' as a woman in a hat is just as valid as to read it as a glass with an absinthe spoon and lump of sugar. As Picasso was fond of remarking, a desperate cyclist might help himself to the seat and handlebars of 'Bull's Head' (no.103). Picasso's sculpture is not hierarchical and seems instead to gather into one genus everything under the sun. Objects, because they were the carriers of metaphor and the source of transmutations, were essential to this escape from the tyranny of definitions and categories.

Much of Picasso's sculpture, like his painting, was directly inspired by individuals. For instance, his affair with Marie-Thérèse Walter inspired one of his most intense periods of sculptural activity, and the pregnancies of Françoise Gilot prompted a series of sculptures of pregnant women and pregnant animals. Objects became a primary means for Picasso to achieve some distance from the individual that inspired him, and to attain universality. Take the case of Sylvette David, the young girl who posed for Picasso in 1954. Unlike Marie-Thérèse, she was not a 'classical' type, but slim and very pretty, with the blonde ponytail of the young Brigitte Bardot. Picasso was entranced and made some winsome portrait drawings. A series of painted sheet-metal sculptures followed, based on his folded paper maquettes (s 488–91). They are much more abstracted, but still too cute to be dignified. One great sculpture did result from this encounter, however: 'The Woman with Key' (no.109). At first sight there is no connection, and without the dated sketches which plot the transformation from the gracile figure of the standing girl to this grimly funny virago (e.g. figs.64–5), we would probably never have realised there was one.[30] The sculpture itself was assembled on the floor of the studio in Vallauris from fireclay tiles, bricks and drying stilts used in potters' kilns (fig.8 on p.31). Once cast, it was mounted on a stone plinth. The sculpture is no longer a portrait of an individual but an archetype. Through the process of objectification Sylvette has become a slightly sinister totem, like a gatekeeper of the underworld or, perhaps, the vengeful goddess of the potters' oven.

Even sculptures that do not actually incorporate found objects have a tendency to become like objects. In 'Head of a Woman' of 1931 (no.79) Picasso finally achieved his long-term aim of making an upright modelled sculpture out of separate parts balanced on top of one another. His sketchbooks (no.64) demonstrate that the inspiration for this extraordinary work came not just from chance groupings of boulders and pebbles, but from skeletons in the Muséum National d'Histoire Naturelle in Paris. This museum, in addition to the vast gallery devoted to the 'comparative anatomy' of extant species, had a famous collection of reconstructed dinosaur skeletons, and the massive, pitted forms of 'Head of a Woman' look remarkably like sections from them (fig.66).[31] Although we know that the 'woman' concerned was Marie-Thérèse Walter, and can recognise her prominent nose, swathe of hair and even her drowsy languor, her identity becomes merged with that of the ancient relics. It is significant that one of Picasso's greatest sculptures, 'Death's Head' (no.102), is both human head and object too. Larger than life – so, conceivably, a survival from an extinct race of giants – it is both a head and a skull, for mummified flesh still adheres to the bone. When he first made it, Picasso did not exhibit it as a sculpture, but, with gallows humour, placed it on the threshold between the living room and the studio in the rue des Grands-Augustins apartment, where it had to be carefully negotiated. In the gloom it was first encountered as a dangerous obstacle. Only on second glance did one register the thing as a head.[32]

Picasso's preoccupation with the bony armature of the body, evident in these two sculptures and in dozens of drawings and paintings of the late 1920s and 1930s, reflects his obsession with mortality. From the turn of the century the *memento mori* had made a regular appearance in his work, and became commonplace during the Second World War and in the aftermath. But his personal concept of sculpture was also involved. When talking of skeletons and bones Picasso would often draw attention to their sculptural character. Louis Parrot reports a fascinating monologue. Picasso began by showing him a series of skulls, and then continued[33]:

> The entire skeleton has been not sculpted but modeled. There is not one bone where one cannot find the trace of a thumb and which has not been completely modeled. The same thing goes for all the bones except the orbit of the eye. The edges of the orbit in the part touching the sinus have not been polished; they have been 'broken' … If the edges of the orbit had been smoothed and polished like the rest of the cranial case, the eye could not remain there. All the life in the work depends on this fusion of sculpture and modeling. It is at the precise moment when the creator, who holds the mud between thumb and index finger, is about to choose between the smooth perfection of the skeleton and the torn wrinkledness of the orbit, that the future life of what he has created is decided. Life is perhaps this hesitation, this point of equilibrium. Sculpture is the art of the intelligence.

The skulls and skeletons he surrounded himself with were both reminders of mortality and lessons in the art of sculpture. 'Death's Head' is the ultimate statement of this conviction of the unity of bone and sculpture.

The bone beneath the flesh is sensed in a considerable number of the figure sculptures which are not explicitly skeletal – the wire constructions (nos.74–5), 'Woman in a Garden' (no.83), 'Bather' (no.85), 'Woman Leaning on her Elbow' (no.100), the earlier 'Pregnant Woman' (no.106), among them. The decision to paint many of the late sheet-metal sculptures white probably has some connection with this abiding interest in bleached bones and with the traditional association of white with death – ashes, shroud, ghost. (Certainly, the drawings for the sheet-metal 'Head of a Woman' of 1957 (no.136) prove beyond doubt that Picasso's original idea was for a skull-head.) In some of the animal sculptures, including 'The Goat' (no.118), 'Little Owl' (no.122) and 'The Crane' (no.121), the skeleton shows through here and there or is evoked in the grisaille colours and harshly drawn markings painted on the surface of the bronzes. The subjects of the Cubist sculptures are anatomised in a similar way, when Picasso delves into the interior of 'Glass of Absinthe' (nos.23–4), or breaks the musical instruments into separate parts (nos.19, 26). In forcing the viewer to see the constructed foundations of the body, Picasso intended to heighten appreciation of its sculptural nature, and, secretly, he tried to exorcise his fear of death by confronting it head on.

Normally the found objects Picasso used were part of an amalgam. 'The Venus of Gas' (no.44) was, exceptionally, a true 'readymade' although not in the Duchampian sense. The object was a burner from a prewar gas stove, and Picasso simply stood it upright and christened it *La Vénus du gaz*. He was delighted with his discovery, which united the modern with the atavistic[34]:

> In three or four thousand years they'll say, perhaps, that at our period, people worshipped Venus in that form, just the way we so confidently catalogue old Egyptian things and say, 'Oh, it was a cult object, a ritual objects used for libations to the gods'.

On one occasion 'The Venus of Gas' was used as a demonstration piece. Picasso was discussing the relationship between art and sign with André Warnod. 'Raphael's image

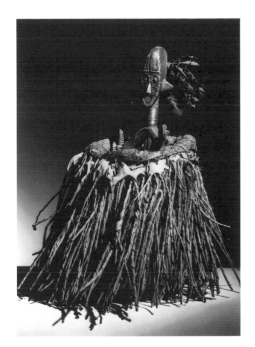

fig.67 Reliquary figure, Oudombo, Gabon
Musée de l'Homme, Paris

of a woman is only a sign', he said. 'A woman by Raphael is not a woman, it's a sign that in his spirit and ours represents a woman.' To explain what he meant he fetched his 'readymade'. At first Warnod took it to be an archaic or tribal statuette, and then admitted he had been fooled. 'Why fooled?' replied Picasso. 'This object could very well be the sign for a woman, and the lines and volumes are harmonious. It sufficed to discover them.'[35] Here was the final proof that objects could be sculptures, and, moreover, sculptures which had preserved their original votive function, which had the power of idols. In 'Carafe and Three Bowls' 1908 (fig.59) one senses that the carafe is a stand-in for the archetypal Mother: the humble gas burner was the most succinct and pure expression of that idea.

Found objects, then, could become signs for men, women, animals, birds, plants – indeed, anything in the external world, including light (as with the rays of light signified by the nails in 'Goat's Skull and Bottle', no.125). This was perhaps the most important role that objects played in Picasso's sculpture. Paradoxically, despite their utter banality and their modernity, they enabled him to create sculptures which had more in common with 'primitive' art, which has a sacred function, than with 'civilised' traditions of descriptive naturalism. Thus his 'Baboon' (no.120) is no ordinary baboon, but the equal of a fertility totem, not just because it is pregnant and clasps a new-born baby, but because it registers extraordinary transmutations within its very fabric. It is Picasso's half-humorous, half-earnest tribute to those Ancient Egyptian ritualistic sculptures of baboons which he must have seen in the Louvre's Egyptian galleries. It was through using objects as signs that he achieved a 'profound' reality, 'more real than the real'. And he was certainly aware of the relationship to those tribal 'fetishes' which were considered especially potent precisely because they incorporated rare and alien materials, like mirror glass and iron nails, acquired through contact with the White man (fig.67).

Picasso often drew directly on European art from the Renaissance period onwards, and his conversation was littered with references to the 'great masters'. But he told Jaime Sabartés that he admired the 'simplicity' of 'primitive' art most: 'Primitive sculpture has never been surpassed.' I have alluded already to his collection of tribal art. He also owned Iberian votive bronzes. He had a violin-shaped Cycladic fertility idol and two casts of the prehistoric Venus of Lespugue. It was never just the formal purity of primitive art that he appreciated, but, as he went on to explain to Sabartés, 'the faculty of understanding that which (man) had within the reach of his vision'.[36] In conversation with André Malraux he insisted that from his first encounter with tribal art in 1907, he had never responded to it primarily as 'good sculpture', but as a potent 'weapon'. It was for him an art of 'exorcism' or 'intercession'. This was why he didn't mind if the Negro carvings he owned were of indifferent quality: it was enough if they had power to intercede with the 'hostile spirits'. And he recognised at once a profound affinity with the tribal sculptors, because 'I too am against everything'.[37]

Picasso's own sculpture is also about 'understanding', rather than beauty of form. It was intended to challenge the viewer's complacent response to the most familiar things – men and women, animals and everyday objects. It was also, one suspects, intended to force a confrontation with the mysterious and threatening forces of life. For time and again Picasso engages with the fundamental themes and motivations of primitive art – sexuality, fertility but, supremely, death. Sculpture was in this sense the nearest he came to making sacred art. And it is probably for these kinds of reasons that he hardly ever willingly sold his sculptures, and why he always lived amongst them. Objects were essential to the potency of Picasso's sculpture. In his hands, they became instruments. They were his necessary accomplices in the creation of an art of intercession.

Notes

I am extremely grateful to the staff of the Library and Archive of the Musée Picasso in Paris, in particular Laurence Berthon and Jeanne Yvette Sudour, for their unstinting helpfulness. Thanks also to Jean Leymarie, Hélène Parmelin, Christine Piot, Claude Ruiz-Picasso and Maya Widmaier-Picasso for sparing the time to discuss Picasso's sculpture with me, and to John Golding for reading this essay in draft and for all his insights.

1 Christian Zervos, 'Conversation avec Picasso', *Cahiers d'Art*, no.10, 1935, pp.173–8. Quoted from Dore Ashton, *Picasso on Art: A Selection of Views*, London 1972, p.7.

2 See the section devoted to 'Picasso's Personal Collection' in *The Musée Picasso, Paris: Paintings, Papiers Collés, Picture Reliefs, Sculptures, Ceramics*, London 1986, pp.229–56. A number of the works are of dubious authenticity.

3 Roland Penrose, *Picasso: His Life and Work*, Harmondsworth 1971, pp.412–13. Jacqueline Roque became the second Madame Picasso in 1961.

4 The phrase was originally Jean Cocteau's. See Brassaï, *Conversations avec Picasso*, Paris 1964, p.178, for an occasion when Picasso quoted it with pride.

5 The Archives of the Musée Picasso in Paris hold hundreds of boxes of this ephemeral material, which has yet to be systematically catalogued.

6 Françoise Gilot and Carlton Lake, *Life with Picasso*, Harmondsworth 1966, p.152. This book provides a marvellously evocative account of Picasso at home.

7 See Jean Sutherland Boggs, *Picasso and Things*, with essays by Marie-Laure Bernadac and Brigitte Léal, exh. cat., Cleveland Museum of Art 1992, for a valuable survey of still life in Picasso's art.

8 André Malraux, *La Tête d'obsidienne*, Paris, 1974, p.172.

9 The first oval canvases by Braque and Picasso date from the spring of 1910. However, Picasso only began to use the format regularly twelve months later. A surviving invoice from his current supplier of artists' materials (E. Morin, 5 rue Lepic, Paris), which is dated 4 April 1911, records his purchase of fourteen standard-size oval canvases, each one of different dimensions and ranging from a *1-figure* to a *40-paysage*. (MP Archive. Box: 'Fournisseurs'). The sudden bout of painting on oval formats in the spring of 1911 must relate to this block purchase.

10 'Apple' was never cast in bronze and is datable only on internal evidence. It is generally ascribed to the autumn of 1909 because of its stylistic relationship to watercolours of apples made then, and it also looks as if it were a development from the Horta landscapes of the summer. However, Pepe Karmel, in a letter to me of 17 June 1993, has argued for a dating of 1911–12, on the grounds of the work's relationship to drawings of that period.

11 I am grateful to John Golding for pointing out to me that the so-called 'Head' is almost certainly a cup.

12 There is a surprising number of drawings of chairs scattered throughout Picasso's sketchbooks. Seen head on but tipped towards us or at an angle to the picture plane, they instantly provide an illusion of depth and the sensation of forms occupying space.

13 It now seems certain that it was Braque, not Picasso, who made the first Cubist constructions some time in late 1911 or early 1912. Unfortunately, we do not know what the earliest ones looked like, although it is safe to assume that they were of still-life subjects. See William Rubin, *Picasso and Braque: Pioneering Cubism*, exh. cat., Museum of Modern Art, New York 1989.

14 See, for instance, the essay by Pepe Karmel in this catalogue.

15 Brassaï 1964, p.178.

16 There may be a connection with the aborted plan to make the curved planes of the sculpted 'Head of a Woman' in wire. See John Golding's essay in this catalogue, p.21, for a description of this project.

17 Julio González, 'Picasso sculpteur et les cathédrales'. The full manuscript was first published in Josephine Withers, *Julio González: Sculpture in Iron*, New York 1978: see p.135 for the quotation. On the collaboration between Picasso and González, see the essays by Marilyn McCully and Peter Read in this catalogue.

18 Hélène Parmelin, who, with her husband Edouard Pignon, spent a lot of time with Picasso in Vallauris in the early 1950s and wrote several books of memoirs, told me that while Picasso tended to agonise over his painting, he enjoyed making the sculptures. Interview with Madame Parmelin, Paris, Nov. 1992.

19 Kahnweiler wrote this note on 2 Oct. 1933: 'Picasso tells me that, to avoid casting at Boisgeloup he did sculpture in hollowed sand into which he then poured plaster. Result: relief sculpture in plaster.' Daniel-Henry Kahnweiler, 'Huit entretiens avec Picasso', *Le Point*, vol.7, no.42, Oct. 1952. Quoted from Ashton 1972, p.115.

20 Interview with Maya Widmaier-Picasso, Paris, Nov. 1992. She and her mother had moved to an apartment on the boulevard Henri-IV, Paris, in the spring of 1941, where Picasso visited them regularly.

21 The photograph is preserved in the MP Archive. Inv. DP 52 (88 Cn 129).

22 See the interview with Lionel Prejger in this catalogue.

23 Gilot and Lake 1966, p.306. She goes on to describe the creation of several of the most important sculptures of the early 1950s, pp.306–12.

24 Picasso and Giacometti saw a lot of each other after the war. According to Gilot, Picasso admired Giacometti's work very much and enjoyed discussing sculpture with him 'because Giacometti's preoccupations were never exclusively aesthetic' (Gilot and Lake 1966, p.204). It is possible that the earlier version of 'Pregnant Woman' (no.106) was influenced by Giacometti's post-war work. The Claire Batigne photographs are in the MP Archive.

25 André Warnod, 'En peinture tout n'est que signe, nous dit Picasso', *Arts*, no.22, 29 June 1945. Quoted from Ashton 1972, p.18.

26 Reported by the potter Robert Picault, who made an amateur film of Picasso and his sculpture in Vallauris in 1951 (MP Archive. Fonds Picault, Album 2, Picault MS, p.38).

27 Gilot and Lake 1966, p.311.

28 Picasso paid a second visit to Italy in 1949. A photograph of him in the Mercato Nuovo in Florence shows him looking at Pietro Tacca's bronze replica of a life-size Hellenistic sculpture of a boar: see Antonello Trombadori, '1949: Il secondo viaggio italiano di Picasso', in *Picasso in Italia*, exh. cat., Galleria d'Arte Moderna et Contemporanea, Verona 1990, p.174. If he visited the Bargello Museum in Florence he would also have seen, among other works, Giambologna's extraordinarily lifelike 'Peacock', 'Eagle', and 'Turkey'. It is tempting to speculate that the animal sculptures Picasso made over the next few years were a response to these famous precedents – but a response which involved rejection of their perfect descriptive technique.

29 An earlier oil called 'The Easel' 1954, formerly in the collection of Jacqueline Picasso, is, as it were, the alter-ego of 'Man'.

30 Sylvette began posing for Picasso on 21 April 1954.

See the catalogue entry on 'The Woman with a Key' (no.109) for details of the drawings.

31 Picasso had frequented the museum, which is in the Jardin des Plantes, ever since his days in the Bateau Lavoir. See Fernande Olivier, *Picasso and his Friends*, London 1964, p.76. Some of the earlier drawings (e.g. Carnet 1044, f.9; no.64) actually show identifiable bones, and an equivalent to the iron armatures used to support the skeletons.

32 See Françoise Gilot's account of her first visit to the rue des Grands-Augustins, in Gilot and Lake 1966, p.15.

33 Louis Parrot, 'Picasso at Work', *Masses and Mainstream*, March 1948: quoted from Ashton 1972, p.114–15. On at least two occasions Picasso carved and engraved bones – just like prehistoric man (s 176, s 191).

34 Gilot and Lake 1966, pp.311–12.

35 Warnod 1945, quoted in Ashton 1972, p.66.

36 Jaime Sabartés, *Picasso: An Intimate Portrait*, New York 1948, p.213.

37 Malraux 1974, pp.17–19.

Picasso's Sheet-Metal Sculptures:
The Story of a Collaboration

LIONEL PREJGER INTERVIEWED BY
ELIZABETH COWLING AND CHRISTINE PIOT

CHRISTINE PIOT: Monsieur Prejger, would you begin by telling us about your first meeting with Picasso?

LIONEL PREJGER: It was in 1946, on the eve of Picasso's departure for Paris, and it didn't happen by chance. A painter-friend of mine had telephoned me in Nice to tell me that Picasso was dining in Golfe-Juan that evening, and that we might get the chance to meet him at the Hôtel de la Mer, 'Chez Marcel'. I was twenty-eight at the time.

There were only four of us in the restaurant. Picasso was at one table with Françoise Gilot, my friend and I at another some way off. During the whole meal I was staring, fascinated, at this smiling, black-eyed man whom I had never seen before. Eventually we got into a friendly conversation.

Picasso had just finished painting the panels in the Château Grimaldi, which was soon to become the Musée Picasso d'Antibes.[1] He told me that he had to go back to Paris the following day and that he was in a quandary. I asked him what was bothering him. He then explained that while he was working in the attic of the Château Grimaldi an owl had fallen from the rafters and broken its leg. Picasso had looked after it and made a splint with a bit of wood. But now that he was leaving he didn't know what to do with the bird. Point-blank, I said I would look after it for him, but only if he signed a written authorisation. Here's the note: 'I authorise Monsieur Lionel Prejger to look after my owl (Ubu), until further notice. Picasso, Golfe-Juan, 14 November 1946.'

ELIZABETH COWLING: What happened next?

L.P: Nearly two years passed without my seeing Picasso. Feeding the owl wasn't easy – dead birds, meat that was more or less rotten, and so forth. My neighbours didn't suffer too much from the smell, however, because I had a balcony on the top floor of the building. But I had to keep the owl in a cage because I couldn't let it go free in my flat. One day when I was going to Paris by car I decided to return the bird to Picasso, who was living at the rue des Grands-Augustins. I introduced myself to the housekeeper, the cage in my hand. Picasso was out and I asked her to give it to him when he returned. Her name was Inès Sassier and she looked after all Picasso's domestic affairs. She was like a confidante to him, and she and I later became friends. Sometime later in 1948, travelling by car on the coastal road from Cannes to Nice, I passed through Golfe-Juan, and there, on the terrace of the Hôtel de la Mer, I saw a big table with about ten people lunching in the sunshine. Picasso was there. Overawed, I hardly dared approach him, but decided to none the less. I asked him: 'How is Ubu?' That was the name he'd given to the owl. He turned, surprised, and I reminded him that I'd looked after the bird for nearly two years before bringing it back to Paris. Then he remembered and asked me to sit down so that we could chat. I asked him whether he'd had any trouble finding food for it in Paris. 'Not at all,' he replied, 'he feasts on the mice I kill for him.' Picasso then told me he had bought a small property at Vallauris called La Galloise, and invited

me to visit him there. 'Come whenever you like', he said. A few days later I went. That was the beginning of my wonderful and unforgettable adventure.

EC: It was a lot later, I believe, that you began your collaboration with Picasso on the sheet-metal sculptures. When was it exactly, and what work were you doing at the time?

LP: At that time, around 1960, I was very busy. I had a scrap-metal yard at Cannes La Bocca, where Picasso used to come now and then, because by then he was living in his villa, La Californie, which was just nearby. I also had a demolition business, and I had just bought a third business at Vallauris called the Société Tritub. There we manufactured conical metal tubing, which was used to make television tables, chairs, things that were fashionable at that time. As I was seeing Picasso very regularly, one day I showed him the kinds of tubes we made. And suddenly he said: 'Listen, perhaps we could work together.' 'With great pleasure.' 'We'll begin by making a toy for my grandson, Bernard', he said. And so we made a toy horse for Bernard, who was very young at the time.[2] It had wheels, and Bernard used to ride around on it [fig.68].

EC: When did Picasso first go to the factory?

fig.68 Bernard Ruiz-Picasso mounted on the toy horse made for him by Picasso, Boisgeloup 1960

LP: Picasso only came to the factory once, because when we began working for him on the sheet-metal sculptures it was I who went to see him every day. And I mean every day. Sometimes it wasn't just once, but twice a day, because he was so eager to see the results of our work. Of course, for me these visits were a great pleasure. But I was interested in art long before our collaboration started. I loved books. I always took a keen interest in Picasso's latest work. I already had some of his drawings in my office. Whenever I got something of his, a drawing or a book, I'd rush over to show it to him.

CP: So, the first object made in your factory was Bernard's toy horse?

LP: In my workshops, it was the toy horse. But earlier, in the 1950s, Picasso had made sheet-metal sculptures – heads mounted on column-like necks, and so on [s 488, s 489, s 494, and nos.136–7]. Those weren't made by me, or with me, but they were made in the same workshops that I later bought.

CP: Was it Tiola who made those sculptures of women's heads?

LP: Yes, I'm sure it was Monsieur Tiola. Picasso was still living in Vallauris at that time, and La Galloise was right by the workshop. Tiola later became my foreman. He was an extremely skilful man who was very good with his hands, and he loved doing that kind of thing. He was an excellent technician. I knew him even before he worked in the factory – and in fact it was from him that I, with a partner, bought the workshops. But Tiola wasn't an art lover and he hardly knew Picasso. He probably only met him once or twice.

EC: Was Bernard's toy horse the only object in which you made use of the conical tubing?

LP: Yes, I think so, because all the other sculptures were copied from paper or cardboard maquettes which Picasso had cut out and folded, and which he had given to me for transfer into sheet metal. Monsieur Tiola and a couple of workmen would make the sculpture in metal and the next day I'd take it to Picasso and return his maquette to him. The first piece that one can really call a sculpture that we made for Picasso is 'The Eagle' [fig.69]. It's a lovely thing.

EC: You must have made 'The Eagle' in November 1960 because there is a series of drawings for it in one of Picasso's notebooks, and they're all dated 23 November 1960.[3]

fig.69 The Eagle 1960 Sheet metal *Private Collection*

Was there a long delay between making the horse for Bernard and making 'The Eagle'?

LP: No, because it all happened suddenly, like an explosion. The process was extremely rapid. We made over a hundred metal sculptures for him in my workshops, and they must all have been made between 1960 and September 1961. In that short time. I'm certain about the date of September 1961 because that October I moved to Paris.

CP: All the sheet-metal sculptures were produced at a regular rhythm then, and without interruption? And when you went to see him you always had something to show him?

LP: Certainly. There was always something ready. We worked really fast. Picasso used to give me just one maquette at a time, never more. And every time we made a sculpture for him, I'd bring it to him, and he'd check it over very carefully. If there was something wrong we'd have to begin all over again. I used to urge Monsieur Tiola and the men to keep working because I wanted to be able to go to Picasso the next day with something new. I was doing all that in addition to my normal work at the factory, which I had to keep going. One day Jacqueline[4] said to me 'Prejger, if you continue to work for Picasso like this you'll go broke'.

EC: And you came to see him every day?

fig.70 **The Chair** 1961 Sheet metal *Musée Picasso, Paris*

LP: All the time. Some of the sculptures presented greater technical problems – 'The Chair', for instance [fig.70], or the large coloured piece, 'Woman in a Hat' [no.145]. We made four versions of that one, using heavy-gauge sheets of metal eight or ten millimetres thick. The work on those pieces was very tricky, because the thicker metal is very difficult to manipulate. I remember that the first time I brought the finished sculpture of 'Woman in a Hat' to Picasso, it was really extraordinary to see the result.

EC: Were sculptures like 'The Chair' already painted white when you brought them back to Picasso?

LP: Yes. All the sculptures that are white were painted by workmen in my factory, not by Picasso himself. He used to say: 'Give it a coat of white paint.' Later, he would work on some of the pieces himself, like the coloured version of 'Woman in a Hat'.

CP: Either they were left unpainted, or they were painted white by you?

LP: Exactly. Often they were left unpainted.

EC: But when there is any colour, or any drawing on them, that was done by Picasso himself?

LP: Absolutely.

EC: Were all the versions of 'Woman in a Hat' made at the same time?

LP: Yes. In a rush, and using the same model. They are absolutely identical. But there were versions that were rejected – not particularly of that work, but of other sculptures.

CP: If a sculpture was rejected, what was the reason?

LP: Because it wasn't perfect. For instance, when I brought Picasso a folded metal sculpture, if the angle wasn't absolutely right he would reject it. He had a real eye, of course! But that happened relatively rarely, because we worked very seriously and painstakingly.

CP: The faults couldn't be rectified?

LP: No. Either they were finished or they were thrown out. He would say: 'That's not right. There's something wrong there.' And I'd say: 'Okay, we'll see what we can do.'

But when I saw Tiola he would say: 'Look, although the work is slow and difficult, it's actually easier to start from scratch than to try to improve it.'

CP: May we turn now to the maquettes? Did Picasso give you a maquette, which he had folded himself out of a sheet of paper?

LP: Yes. In the case of 'The Chair', for instance, which has the back right-hand leg folded like a staircase, when I got the model it was large sheet of brown wrapping paper. Picasso had already cut and folded the leg, and he said: 'This is what you must do.' And we made it exactly as he told us to.

EC: Do you remember why you made four versions of 'Woman in a Hat'?

LP: Because Picasso asked us to. On the other hand, 'The Chair' is a one-off.

CP: Did he never want to make a second 'Chair'?

LP: He never asked me to. We would have, if he had. 'The Chair' is really beautiful, really magnificent. The curator at the Musée Picasso in Paris asked me one day whether they could recoat their collection of sheet-metal sculptures with white, because rust was showing through. I said: 'Do what you like. It was not Picasso who painted them. They were painted in my workshops.' Personally, I think they should be left as they are: the rust doesn't matter.

EC: Was it always you who chose the thickness of the metal, or was it Picasso?

LP: We always used the same sheets of steel, of a heavier or lighter gauge, depending on the size of the sculpture. The choice of thickness was made with Monsieur Tiola. We'd speak about it and Picasso would say to me: 'You must use a gauge that is heavy enough, given the height and the size of the piece.' But he didn't really take much interest in those kinds of technicalities. As far as he was concerned all that mattered was that the sculpture was made well and was right. And I must say that we did make them well!

EC: When it came to the solder points, was that something you decided?

LP: It was Tiola who decided that sort of thing. The eyebrows, the strands of hair and so on that stand out in relief on the large heads were drawn with solder – following Picasso's instructions, of course. On the maquettes which he had made he would draw all those details, and we would then copy them absolutely faithfully.

CP: Did the paper models consist of detached pieces, when you got them, or had they already been fixed and mounted?

LP: Depending on the nature of the sculpture, they were in separate pieces. Take 'The Pierrot' [s 604], for instance: that was made in various stages, one piece at a time.

EC: I found a photograph showing 'The Pierrot' in the course of execution, with the body in metal, but the arms still in paper [fig.71].

LP: Yes, and that was the paper that later served as the maquette for the arms.

EC: So, 'The Pierrot' was made in various stages, bit by bit?

LP: Yes. Things happened like that – they evolved gradually. By the way, the Pierrot's hat is actually an artist's beret. Now, in fact, for that sculpture we did use a bit of conical tubing to support the piece behind.

CP: How did you know how to assemble it correctly?

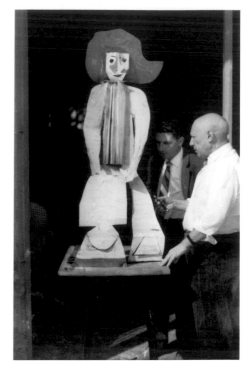

fig.71 Picasso and Lionel Prejger with 'The Pierrot', 1961

LP: We assembled it exactly as Picasso told us to. For instance, he might give me the maquette of an arm, showing me exactly how it ought to look. Then I would take the maquette straight to the factory and we'd copy it then and there. Then a few hours later I'd take it back to Picasso. With the big sculptures, we would work at them stage by stage.

CP: So, you followed the models faithfully, and if, for instance, a model consisted of four pieces, there would be four pieces of metal?

LP: Yes, we copied the models exactly. In the case of the 'Woman in a Hat' there were several different pieces because there are several superimposed planes. We would make the sculpture in sheet metal, copying the various pieces of the model exactly, mounting them as he had instructed us to, and then soldering wherever it was necessary so that it would hold. In the case of the mask-heads [s 584–5] we made several examples. The sequence began with a flat mask-head. Picasso said: 'Make me several.' I can't remember how many we made. Then he took pieces of paper and folded a nose, cut out an eye mask, or a hat [s 583], and in that way the various bits and pieces got added to the sculptures. 'The Pierrot' was, as far as I remember, made using one of those mask-heads.

EC: Did you often reuse the same maquette?

LP: Yes. As I said, we made several of the mask-heads at the same time. I took them to Picasso and then he worked on them. For instance, he coloured the one he gave me with crayons and that's all [s 584.2a].

CP: In the case of the dog, modelled on Picasso's dog Kazbek, which then doubles as a monkey [s 578.2a–c], was it Picasso who actually bent the metal?

LP: No. He gave me a maquette in paper or card that he had folded. Usually we would lay it out flat in order to copy the shape in metal. Then in the workshop we would replicate the original folds precisely. That kind of work is extremely intricate. But I was there to supervise it the whole time – I hardly had time for anything else.

CP: Picasso never folded the metal himself?

LP: He may have bent the metal here and there when it was a case of a very light gauge steel. He was physically a very strong man. Perhaps he thought he could do it better than we could. But usually we didn't use very thin sheets and so it was really impossible to manipulate by hand. If you try to bend it yourself, you'll find you can't. The only time he ever worked with metal himself was during the Cubist period, when he made the guitars or the still lifes. But then he was using old tin cans, and so on, and he could cut and fold them easily, using ordinary scissors and his bare hands [no.25].

EC: Were the maquettes always exactly the same size as the finished sculptures?

LP: Exactly the same size.

EC: Even in the case of the large version of 'Woman with Outstretched Arms' [no.144]? Was the paper maquette really that size?

LP: In the case of 'Woman with Outstretched Arms' we began by making a small version in metal [s 594.2a]. Then Picasso decided to make large versions. I think those were enlargements to his specifications. But normally the metal was exactly the same size as the paper maquette.

EC: The decision about size was always Picasso's?

LP: Yes. Incidentally, for the black areas on the large versions of 'Woman with Out-stretched Arms' we used pieces of metal grille.

EC: Which you manufactured in your factory?

LP: No, bits of grille that we had and that we brought him. He loved all that kind of thing. When Picasso came to my scrap-metal yard, he'd look at all the bits of junk. He wasn't the only one. César came, and Arman. They'd help themselves to bits and pieces of iron that took their fancy.

EC: When Picasso painted a sculpture, did he do it immediately after you had finished making it?

LP: No, not immediately. The object would remain in his studio for a time and then all of a sudden he would decide to paint it. I never saw him painting them. In fact I very rarely saw him paint. I remember one occasion. I had gone to La Californie and there was no one about. I pushed open the doors and entered the salon, where there was a large easel, and on it a big painting with a bull's head. (It's the painting in the Musée Picasso [MP 213].) And I watched him working on that. Not for long, because he wouldn't have liked it. I had brought him a self-portrait by Max Jacob dating from, I think, 1903 – Max Jacob with a beard. It was a birthday present for him and a memento. That's the only time I saw him painting. On the other hand, I often saw him draw and I also saw him making linocuts. When he used his gouge to make them, the floor was covered with slithers of lino that looked like snakes. And he showed me the palm of his hand, which was hardened by the wooden handle of the gouge.

EC: Did you ever see him cutting out the maquettes for the sculptures?

LP: Never. I did, however, see him working on the surface of 'Man with a Stick' [s 622]. To make the parts in relief he soaked newspaper in a basin of water, and then applied it to the surface. The paper dried and as it dried it stuck. He modelled the papier mâché exactly as if it were clay. Maybe he added a bit of plaster to make it hold.

CP: In the case of all the animals, all the little figures in sheet metal – would you agree that these constitute a kind of family, or a coherent series or group?

LP: I really don't think so. He would make something, and then put it in a corner. It would take its place along with the rest. I don't think that he had the idea of creating, say, a zoo. He would just make something, like that, suddenly.

CP: Would you say, then, that they are all isolated subjects?

LP: I would. There's a cock which is superb [s 576]; there's a pigeon [s 572.a], and a bird on a stick. He made six of those [s 577], and gave most of them away, including one to me. But although I don't believe he was consciously creating groups or series, I do think there was a progression. By that I mean that at first Picasso made small-scale things, and then later he suddenly decided to work on a much larger scale. He wanted to make sure that we would do the work properly, and that's why we made small things first.

EC: Were there ever any subjects that you were unable to execute?

LP: We executed everything he gave us. There were no setbacks. When he wanted to make sculptures on a much larger scale he went to Carl Nesjar.[5] For example, it was Nesjar who made the mural decorations in engraved concrete in Barcelona [s 566], and the murals for Douglas Cooper in the Château de Castille. (Nesjar made those from small sketches which he enlarged to scale [s 641].) But whereas Picasso never saw the

decorations in Barcelona, because he refused to return to Spain while Franco remained in power, he did visit Douglas Cooper's property at Remoulins on the way to bullfights at Nîmes and Arles. So he saw those decorations with his own eyes. But he never saw the huge concrete and pebble version of 'Woman with Outstretched Arms' Nesjar made for Kahnweiler at his country place at Saint-Hilaire [s 639], because he never came to Paris. He only came to Paris once in 1965, to have an operation in the American Hospital at Neuilly, but he didn't stay on in Paris afterwards.

CP: Did Picasso ever talk to you about the collaboration with Nesjar?

LP: I met Nesjar a few times at Picasso's, when he was negotiating over the concrete enlargements. But Picasso never spoke in any detail about them to me.

CP: Do you think he was satisfied with them?

LP: I think so. He only knew them from photographs – except those at Douglas Cooper's. He must have been satisfied, otherwise he wouldn't have agreed to let Nesjar go on making them.

EC: Could the ensemble in concrete of 'Le Déjeuner sur l'herbe', which was commissioned for the Moderna Museet in Stockholm [s 652], have been made in sheet metal?

LP: Maquettes in paper exist [nos.156–64], and the figures could have been realised in metal on a less monumental scale. But it wasn't done that way. Even so, although they are on a much smaller scale, there are some extremely complicated sculptures in sheet metal – 'Woman in a Hat', for instance, and 'The Pierrot', with his hat, ruffles, costume and so on. Even with some of the small sculptures, there are cut out spaces which were very complicated to execute, and are very difficult to read [e.g. s 591]. Of course, for Picasso it was all very easy, but for people not used to this kind of sculpture it could be difficult to understand what the forms and spaces represented.

CP: Picasso never wanted to make something, say, five metres high in sheet metal?

LP: We couldn't have done it in my workshops if he had. One would have needed steel thirty millimetres thick, at least, and, anyway, we didn't have the space.

EC: Do you think he was entirely satisfied with the sheet-metal pieces – that his aims were fulfilled?

LP: Definitely. I can assure you that when we had finished 'The Eagle', the first true sculpture – Bernard's horse doesn't count, because it was just a toy – he was absolutely thrilled. And I can understand him, because it is superb, even though it isn't on a grand scale.

EC: Why did he never sell the sheet-metal sculptures – apart from the painted version 'Woman in a Hat'? Why did he keep most of them?

LP: Picasso never liked selling anything. I often wanted to buy some trifle from him but he never let me. His instinct was to keep, to collect, not to sell. I believe he loved what he did and that there was nothing commercial about it.

CP: Did he ever discuss Cubism in connection with your sheet-metal sculptures?

LP: No. He showed me the Cubist guitars in the studio [no.19] because obviously there is a connection with the sculptures he made with me. But we never really talked in depth about sculpture. Never.

EC: He didn't usually like speaking about his art with anyone. Jean Leymarie, who

knew Picasso for almost thirty years, told me that he had never had a profound discussion with him about his work.

CP: I'd like to ask you now about the series of sheet-metal sculptures in which there are small variations from version to version. For instance, there are two sculptures, both called 'Woman and Child' [s 600; no.142]. There are very slight differences between the two women, but the form and position of the child are quite different in each work.

LP: Quite often Picasso would take the same element and place it at a different angle or in a different position. He had decided to represent a maternity. But originally there was no child. It was simply a 'Standing Woman' [s 580], and then he added the child. With him, it was often like that: the ideas came when things were in hand.

CP: And when the same subject was recreated several times, but with slight differences in the folds, would you agree that these were variations on the same theme?

LP: Yes. In the case of a series like the 'Standing Woman' [s 580; no.141], one can't be sure which version came first, whether it was the one where the lower half of the body is like a column, or where Picasso has cut out the legs. In any case they aren't numbered.

CP: There was no progression, no evolution, as such? Each member of a series was equivalent to the others?

LP: I would say so.

EC: You said earlier that you always gave him back the maquette when the metal sculpture was finished. He could therefore rework the maquettes if he wanted to?

LP: Yes, he could have reworked them. I always gave them back to him. Except one, which I have here. It is an owl which we made in a very thick sheet of metal [not in Spies]. It was flat, and it was made for Georges Tabaraud, the editor of *Le Patriote*, the Communist newspaper of the Côte d'Azur, and he placed it on the ridge of his house in the mountains above Nice. Otherwise, I never kept the maquettes. Jacqueline took them and put them in a box.

EC: Did he use the same maquette for the bodies of 'Woman with a Tray and a Bowl' [no.143] and 'Woman with a Child' [s 599]?

LP: Absolutely. 'Woman with a Tray' came first. Then he removed the tray and turned the sculpture into a maternity by adding the child. Possibly he may have bent the woman's arm in this case, but I really don't remember.

EC: In 'Woman with a Child' the navel is treated differently and looks like a corkscrew.

LP: All the details that you see are exactly as Picasso wanted them – for the pubic hair, for everything. We followed his designs faithfully.

EC: In the Musée Picasso I've seen maquettes made of, say, two separate pieces which he had pinned together. Do you remember getting maquettes like that?

LP: I couldn't tell you exactly which, but I do remember that. And even in the Cubist period there were *papiers collés* with pins. He had to do something to fix them together. He used dressmaker's pins, and although he used glue in some of the *papiers collés*, I don't remember maquettes that had been glued together. Pinned, yes; glued, no.

EC: Picasso made cut-outs throughout his whole life, from childhood onwards. For example, in the 1940s and 1950s there are quite a lot – depicting hens with their

chickens, and so forth — which were never executed in metal. Did he always give you new models, or did he sometimes give you models he had had by him for some time?

LP: I think I can be quite categorical: all the maquettes he gave me were new maquettes. He never reused things from the past, because for him the past was past. The old cut-outs you are talking about were probably made to amuse his children. He made a lot for them. It was marvellous to watch him cutting them — because I did see him make those toys sometimes. He was so deft and quick. I remember one time at the rue du Fournas in Vallauris, when he cut out a huge dove in paper which he had folded. That was done for an amateur film. It was brilliant. It looked just as if it was flying!

CP: What did Picasso consider was the sculpture — the model which he gave you, or the replica in metal, or both?

LP: The cut-outs in paper which he gave me were regarded as patterns. For him, what counted, I think, was the realisation in sheet metal. That was the sculpture. And if he had been able to make them in metal himself, he would never have asked me — that is certain. But it would have been really impossible for him working alone. It's very time-consuming work, and it demands great strength.

CP: What were the models made of?

LP: Sometimes he used white paper, sometimes cardboard. Picasso used anything he could lay his hands on. It would have been much easier for us if 'The Chair' had been made in cardboard instead of wrapping paper. You can tell that he sometimes used a cheap pad of paper, and simply ripped a sheet out.

CP: Did he give you the paper maquette of a work like 'Standing Woman' [no.141], with the base already in place?

LP: No. We would make the sculpture in metal, and then he would tell us to place it on a base. It would have been too much bother for him to stick on a paper base himself. As far as he was concerned, the thing was both realisable and realised when he had made the maquette of the figure.

EC: You talked to me the other day about the importance of light for Picasso. You told me you thought that the play of light on the sheet-metal sculptures was the priority for him.

LP: Definitely. He knew that if one bent or overlapped the metal in a particular manner, that would produce a play of light which would enhance the sense of volume and relief. He understood all that perfectly.

CP: Do you think that light was more important for him than colour?

LP: I think that perhaps — and of course I can't be sure — he used colour on the metal sculptures to give them greater charm. But it's true that there are sculptures which I brought to him painted white, such as a head of Jacqueline in a mantilla [s 571], which he then painted in black and grey, that are superb when painted. In those cases, there was no desire to produce something more attractive, but something more powerful.

CP: But the play of light was very important for him?

LP: Certainly. Light plays a crucial role. That's what sculpture is about, fundamentally. It receives light as it strikes the surfaces, and the light can be lively or harsh. It is the play of light which, in the end, gives life and beauty to sculpture. That, at any rate, is my opinion, but Picasso never spoke to me about it.

EC: Did Picasso go on making sheet-metal sculptures after you moved to Paris in October 1961?

LP: Tiola made a few more for him, above all portraits of Jacqueline [nos.146–7].

CP: Who acted as the go-between for Picasso and Tiola, after you left?

LP: It was either Jeannot, Picasso's chauffeur, or Jacques Baron, who had been one of my workmen. He was a marvellous chap, who later became Picasso's chauffeur. He stayed with Picasso for a long time. It was with my workmen and my lorries that the removal was done from Vauvenargues to Mougins.[6] I moved to Paris in October 1961 to run the Galerie Knoedler, and I went to Picasso first to talk to him about it. He knew the proprietor of the Galerie Knoedler very well – a man called Roland Balaÿ, who is well over ninety now and still lives in New York. I told Picasso that Roland Balaÿ had asked me to run the gallery in Paris, but that I was completely inexperienced. Picasso told me I'd be mad not to accept. And so, in three weeks flat, I sold my scrap-iron works, my demolition business and the Société Tritub in Vallauris, and I came to Paris.

EC: We were discussing the monumental sculptures in concrete made by Nesjar a moment ago. Did you ever speak to Picasso about the Chicago monument [s 653]?[7]

LP: No, never.

CP: Did he ever speak to you about the commission for the monument to Apollinaire?[8]

LP: No, he didn't. On the other hand, I often heard him speak about Apollinaire. One evening, I was dining in the kitchen – as often happened – with him and Jacqueline and Jean Cocteau. The conversation that night was extraordinary. All the memories that came flooding back, and all the anecdotes about Apollinaire that Picasso and Cocteau told!

CP: Perhaps we could now talk about the earlier sculptures – those that preceded your collaboration on the sheet-metal pieces? For instance, did you ever see Picasso making his ceramics?

LP: Yes, because I often saw him at Vallauris, at the Madoura factory run by Madame Ramié. I saw him messing around with clay – if I may put it like that. They even made a short film of him at the Madoura pottery.[9] Later he gave that up, and then it was Madame Ramié who came to show him pieces, and he would agree, or refuse, to let her bring them out in an edition.

CP: Do you think that folding or bending the maquettes and folding or modelling the clay originated in the same impulse?

LP: Yes, I think so. When Picasso was interested in anything, he entered into it completely. When he made the series of doves or pigeons in ceramic [no.128], or the standing figures [no.46], he was, I'm sure, totally absorbed in the work. Those are true sculptures. And one finds the same gestures of twisting and folding. In the ceramics, there are often thumbprints in the clay, the trace of his fingers.

EC: Do you think that sculpture was as important as painting for Picasso?

LP: I think so. For Picasso, to my mind, everything had equal importance. If he was drawing he went deep into whatever he was doing, and if he was sculpting it was just the same. For example, I've got a bit of broken pot on which he has painted a bullfight scene. I'd often seen it in his home on a chest of drawers, and I'd always coveted it. One day I said to him: 'Do, please, sell me that through Monsieur Kahnweiler.' I had very little money at the time and I didn't think it would cost much. But he wouldn't sell it to

me. And then the day, in 1959, when he made the move from La Californie to the Château de Vauvenargues, he dedicated it to me and gave it to me. That kind of trifle interested him as much as making a sculpture or a drawing. The great painted tiles in the Musée Picasso in Paris [MP 3700–2] are real masterpieces. I think everything was important to him. I don't think Picasso ever did anything by halves.

CP: Would you agree that some of the ceramics qualify as sculptures?

LP: Definitely.

CP: For Picasso too?

LP: I think so. I'm speaking about the modelled pieces, which, I think, are real sculptures. On the ordinary products of the factory, it's a more a matter of decoration, of drawing or painting on a readymade dish or jug or whatever. Originally they only made kitchen crockery in Vallauris, and Picasso decorated some of their standard products.

EC: Did Picasso sometimes talk to you about other sculptors – about González, for instance, with whom he had such a fruitful collaboration?[10]

LP: No, and I never asked him any questions. You see I was very shy. When I used to visit Picasso and when I rang the doorbell, I was always very moved. I felt it was such a privileged relationship and I dreaded being presumptuous.

EC: Matisse says somewhere that his sculpture is the sculpture of a painter, not a sculptor, and that it was done simply to complement his painting.[11] Picasso would never have said that, would he?

LP: No, I don't think he would have said that.

CP: Did you see him at work on the sculptures of the early 1950s, such as 'The Goat' [no.118] or 'The Pregnant Woman' [no.108]?

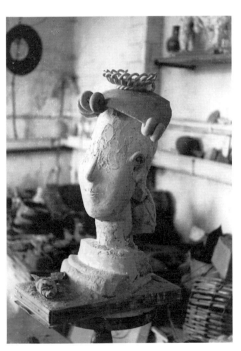

fig.72 'Head of a Woman' in progress, Le Fournas, Vallauris 1951

LP: Yes. I saw 'The Goat' both nearly finished and then finished. It hadn't yet been cast in bronze. I saw 'The Pregnant Woman' and other sculptures where he used pottery fragments to make the forms of the body, and so on. In fact, I remember watching Picasso incising the eyes of the 'Head of a Woman' [s 412], and at one point she had a hat made from a piece of broken pot [fig.72]. I saw all those things in the studios in the rue du Fournas in Vallauris. One could get in easily, and look around, as I often did. There was nothing secret about it. But I wouldn't have gone in while he was actually at work on the sculptures.

EC: Picasso used all kinds of found objects to make sculptures like 'The Goat'. Was he the person who always made the finds, or did he ask his friends to bring him things they had found?

LP: No, he never asked people to bring him things. But when he went out walking he would pick up bits of this and that he found lying around. He took things from dumps, and so forth. Everything he found that attracted him joined the piles accumulating in his studio, and thus he was able to compose the 'Little Girl Skipping' [fig.55 on p.228; no.119], 'Woman with a Pram' [s 407], 'The Goat', and 'The Pregnant Woman'. He made all those sculptures with things he'd picked up. For the 'Baboon and Young' [no.120], he used the toy cars of his son, Claude, to make the head.

EC: Do you think that in cases like these it was the find that came first, and acted as the catalyst, or did he first have the idea of what figure he wanted to make, and then set about looking for the objects which would enable him to do it?

LP: When he had found, let's say, some fragments of pottery, that would give him the idea to compose a sculpture. He didn't use things he had at home, but things he found outside. The pram, in 'Woman with Pram', has four different wheels. It's always a matter of composition, of fabrication.

EC: Did friends like you bring him amusing things?

LP: I did bring him things which he used. When I demolished a building, I might get some beautiful stones, and some of them became the bases for Picasso's sculptures – for 'The Orator' in particular [no.101]. The hard stone he used as the base for 'The Orator' came from a building I demolished. I brought him some huge stones, millstones, and so on, which he used as plinths. Sometimes when a house was being demolished there would be a tree which got in the way. We'd chop it down, and then I'd take him the best pieces of wood. He'd use the trunks of trees as bases for the sculptures which were in the garden at La Californie. But I never brought him anything like a pram. I'd never have dreamt of doing so.

CP: Did Picasso joke a lot with you?

LP: Yes. He had a great sense of humour. We had a lot of fun together. The humour comes out in the sculptures, of course. I've seen drawings which are extremely funny, like caricatures. He was a very charming man, and also a very kind and generous one. I don't say that because he gave me a lot of things. We used to exchange things too. But every time I went to see him with a book, he would say at once: 'Show me that.' And then he'd make a dedication with a drawing. At the time, in the 1960s, there were black lacquer lighters called Flaminaires. They were the first gas lighters on the market. Picasso smoked a lot, and he smoked Gauloises bleues. One day I was lighting his cigarette for him with one of these new lighters, and he said: 'What's that? Is it new?' He was always fascinated by novelties. Anyway, he took it from me and using the tip of a knife, he engraved it with the head of a bearded man, and put my initials on the other side. Frélaut made some prints from it at La Californie. Picasso said to him: 'Let's print some impressions from the lighter.' Four impressions were printed on Chinese paper – numbered and signed. I gave one to Jacqueline, one to Frélaut, and kept the others.[12]

EC: It's a bit like the engravings he made on pebbles from the beach just after the war [s 284–302].

LP: Funnily enough, the lighters were known as pebbles. Picasso engraved others later – one for my son, another for my brother, and one for the bullfighter, Dominguin. But mine was the first. He loved doing things like that.

CP: Anything could inspire him.

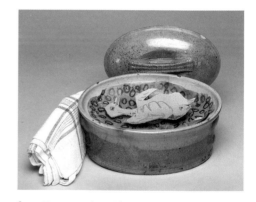

fig.73 Pottery terrine with cut-out paper pigeon and green peas 1961 Assemblage by Picasso
Lionel Prejger

LP: Yes, everything was a pretext for creativity. For example, Tiola was an excellent cook. One day he said to me: 'I've just made a pigeon pâté. Would you mind giving it to Picasso on my behalf?' And he gave me a terrine wrapped in a drying-up cloth. I gave it to Picasso, and two or three days later he returned the dish to me. I took off the lid and there was a little pigeon inside which Picasso had cut out of cardboard – it was like a maquette for one of the metal sculptures. He had laid it on a layer of peas, which he had drawn himself on green paper. He said to me: 'There weren't enough, so I made you a second layer.' I put back the lid, and asked him whether he still had the cloth, because Tiola would want it. He replied: 'You should have looked under the peas.' And there was the cloth, neatly folded at the bottom of the dish! I was able to buy this terrine from Tiola later, because he wasn't really bothered about it [fig.73]. The date is inscribed on it – 8 March 1961. That was right at the time that I was working with

Picasso every day. He often did things like that that were totally spontaneous.

CP: You say that he liked novelties. But he never seems to have wanted to make sculptures out of, say plastic, as Pevsner did.

LP: As far as I know Picasso wasn't interested in those kinds of modern materials. He did make engravings on celluloid, however. Certainly he could have bent and moulded plastic by warming it first, but he never chose to do so.

EC: It's true that when he uses found objects in his sculptures, they are, generally speaking, made from traditional, commonplace, natural materials – wicker, pottery – they are artisanal objects. Miró used a celluloid doll in his assemblages, but I don't think Picasso was much attracted to materials like that, was he?

LP: I don't think so. When he made dolls for children, he used wood [no.42]. He preferred traditional craft materials.

CP: After about 1964 Picasso stopped making sculpture. There are the late enlargements in concrete by Nesjar, but he never worked directly on them. Do you know why he stopped?

LP: I can't answer that because in the last years of his life I stopped seeing him. Things had become rather difficult with Jacqueline. It is my great regret.

Notes

This text is an edited version of an interview tape-recorded in Lionel Prejger's home in Paris on 11 November 1992. Translation by Elizabeth Cowling.

1 Picasso set up a studio in the Château Grimaldi in September 1946, and during October and November produced some twenty works there on Mediterranean and mythological subjects. The paintings remained there and became the nucleus of the Musée Picasso d'Antibes.
2 Bernard, the son of Paulo and Christine Picasso, was born on 3 September 1959. See Lionel Prejger, 'Picasso découpe le fer', L'Oeil, no.82, Oct. 1961, pp.28–32, for a briefer account of his collaboration with Picasso. (Extracts trans. in Marilyn McCully, A Picasso Anthology: Documents, Criticism, Reminiscences, London 1981, pp.259–61.)
3 The drawings are numbered I–IX (Carnet 405, 22–6; private collection). The drawing numbered I shows the eagle on a perch, and strongly suggests that Picasso initially intended to have it constructed from sections of the conical tubing made in Lionel Prejger's factory, somewhat in the manner of the toy horse. The paper maquette for 'The Eagle' also survives (private collection).
4 Jacqueline Roque, Picasso's future wife.
5 On Nesjar's collaboration with Picasso see Sally Fairweather, Picasso's Concrete Sculptures, New York 1982.

6 Picasso moved to the Mas Notre-Dame de Vie overlooking Mougins, near Cannes, in June 1961. He had bought the Château de Vauvenargues in 1958 and moved into it in 1959.
7 The metal maquette for the Chicago 'Head of a Woman' was prepared by Tiola in 1964. The twenty metre high monument, in CorTen steel, was erected at the Chicago Civic Center in 1966–7.
8 On the monument to Apollinaire, see the essay by Peter Read in this catalogue.
9 Picasso first visited the Madoura pottery works in 1946, and began working there intensively the following summer. On his ceramic sculptures, see the essay by Claude Picasso in this catalogue.
10 On Picasso's collaboration with González, see the essay by Marilyn McCully in this catalogue.
11 See Georges Charbonnier, 'Entretien avec Henri Matisse', Le Monologue du peintre, vol.II, Paris 1960, pp.7–16. The interview was tape-recorded in August 1950 (trans. in Jack Flam, Matisse on Art, Oxford 1978, pp.138–41).
12 Brigitte Baer, Picasso Peintre-Graveur: Catalogue raisonné de l'oeuvre gravé et des monotypes 1959–1965, vol.V, Berne 1989, p.543, no.1363. Baer dates the impressions June 1961. Jacques Frélaut, an employee of the master printer, Roger Lacourière, had worked with Picasso since the mid-1940s. A printing press was installed at La Californie.

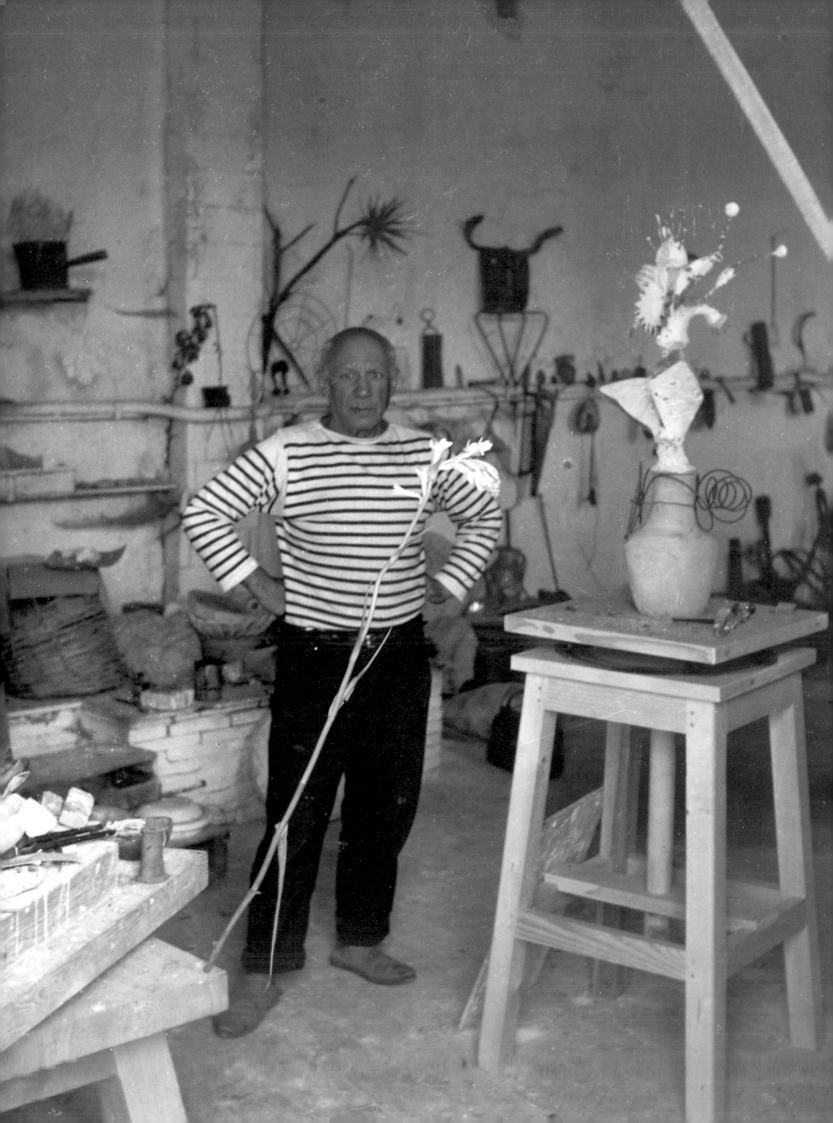

Catalogue

Catalogue entries nos.9–14, 16–18, 27–38, 87–91, 110, written by John Golding; nos.46, 49, 107, 126–9, 134, written by Claude Ruiz-Picasso. All other entries by Elizabeth Cowling.

Measurements are given in centimetres, followed by inches in brackets, height before width before depth. For abbreviations used, see p.13.

Acknowledgments

Any student of Picasso's sculpture owes a special debt to Werner Spies's *Picasso: Das plastische Werk*, Stuttgart 1983, which includes a complete catalogue of the sculpture written in collaboration with Christine Piot. I have relied heavily upon their research in preparing the following entries on Picasso's sculptures, but in a number of cases have suggested different datings. I am very grateful to Brigitte Baer and Claude Ruiz-Picasso for supplying a great deal of information about Picasso's sculpture, and to Patrick Elliott for reading my draft entries on the sculptures and making many useful suggestions. Above all, I am deeply indebted to the staff of the Musée Picasso in Paris, especially to Laurence Berthon, Brigitte Léal, Hélène Seckel and Jeanne Yvette Sudour, for answering innumerable questions and giving me access to the files on the collection and to unpublished material in the Archive. Their help was truly invaluable.

E.C.

opposite
Picasso in his studio, Le Fournas, Vallauris 1952 Photo: Robert Doisneau
© Robert Doisneau/Rapho

1 Crisis and Analysis

SCULPTURES

1 Head of a Woman (Fernande) 1906
Tête de femme (Fernande)
Bronze 36 × 24 × 23 (14⅛ × 9½ × 9)
Musée d'Art Moderne de la Ville de Paris
S 6.II; Z I.323
Illustrated on p.43

The subject is Fernande Olivier, Picasso's lover from 1904 to 1911. The original sculpture was modelled in clay, probably in the spring of 1906, in the Paris studio of the Spanish sculptor and ceramist, Paco Durrio. In about 1910 Picasso sold it and various other early sculptures to Ambroise Vollard who, over the years, issued an unnumbered edition of bronze casts. The present bronze is from this first edition. Following Vollard's death in 1939, the unbaked clay original passed into the collection of Jacques Ullmann, who eventually sold it to Heinz Berggruen. In 1959 Berggruen obtained Picasso's permission to edit a further edition of nine numbered casts. The clay is now in a private collection in California.

2 Woman Combing her Hair 1906
Femme se coiffant
Bronze 41.6 × 26 × 31.4
(16⅜ × 10¼ × 12⅜)
The Baltimore Museum of Art. The Cone Collection, formed by Dr Claribel Cone and Miss Etta Cone of Baltimore, Maryland 1950
S 7.II; Z I.329
Illustrated on p.42

The original, in terracotta, was fired in Paco Durrio's studio in Paris after Picasso's return from Gósol in August 1906. Conceived as a very high relief projecting towards the spectator, rather than a sculpture in the round, it is 'incomplete' at the back. There are many related drawings and paintings, and although the subject of a woman with an abundant head of hair, either dressing it herself or having it dressed, seems to be intimately connected with Fernande Olivier, Picasso always renders it in a generalised

manner, with a backward glance at classical works of art on the same theme. Picasso sold the original ceramic to Ambroise Vollard in about 1910, and over the years Vollard issued an unnumbered edition of bronze casts. The present bronze is a Vollard cast, and was bought from the Buchholz Gallery in New York in December 1940 by Etta Cone, who, with her sister Claribel and their friend Gertrude Stein, was one of the most important American patrons of Picasso's work. In 1968 Picasso authorised Georges Pellequier, who had acquired the original, to make a second edition of ten bronze casts.

3 Standing Man 1907 or 1908
Homme debout
Painted wood 37 × 6 × 6
(14⅝ × 2⅜ × 2⅜)
Private Collection
S 20; Z II**.656–7
Illustrated on p.47

This is traditionally dated 1907 along with Picasso's other primitivist carvings. It is among his most flagrantly 'tribal' pieces, and therefore may have been done quite soon after his famous visit to the Musée d'Ethnographie du Trocadéro in Paris in June–July 1907. On the other hand it is closely related to paintings done over the winter of 1907–8, such as 'Friendship' (The State Hermitage Museum, St Petersburg; D 104). It is probably, at any rate, earlier than 'Figure' (no.4).

4 Figure ?1908
Oak with painted highlights
80.5 × 24 × 20.8 (31¾ × 9½ × 8¼)
Musée Picasso, Paris
S 19; Z II**.607
Illustrated on p.49

This, the most monumental of Picasso's early wood carvings, has hitherto always been dated 1907. However, it is very closely related to a brightly coloured gouache and pastel drawing (MP 546), which can probably be dated spring 1908 from its similarity to sketches in a notebook used at that period (Carnet 106, ff.21–6; MP 1863). It seems likely that the gouache was a study for the

sculpture, although it could have been done afterwards to clarify and strengthen passages apparently left unresolved in the carving. The red and white highlights on the oak may have been intended to reinforce the salient features, in the manner of African and Oceanic carvings. Alternatively, they may indicate areas where Picasso originally planned to cut more deeply into the surface: according to Spies, he regarded the work as unfinished (Werner Spies, *Picasso Sculpture: With a Complete Catalogue*, London 1972, p.23).

5 Head of a Woman (Fernande) 1909
Tête de femme (Fernande)
Plaster 40.5 × 23 × 26 (16½ × 10 × 11)
From the Envoy and Latner Family Collection
S 24.I
Illustrated on p.50

The subject is Fernande Olivier, Picasso's lover. Picasso modelled the head in clay in the Paris studio of his friend the Catalan sculptor Manolo (Manuel Hugué) in the autumn of 1909. Two plaster casts were made, and Picasso apparently sold both of them to Ambroise Vollard in about 1910. Over the years, and possibly using both plasters, Vollard made a large edition of bronze casts, so that this work became the best known of all Picasso's sculptures. Following Vollard's death in 1939 both plasters passed first into the hands of the dealer Edouard Jonas and thence into the collection of Jacques Ullmann. Ullmann sold one plaster to Heinz Berggruen, who obtained Picasso's permission to make a second edition of bronze casts from it, on the condition that he return the plaster to Picasso and also give him three of the nine new casts. That plaster is now in a private collection in Dallas. Ullmann sold the other plaster – the one shown here – to Ernst Beyeler, who sold it to the present owner.

In about 1955 Picasso told Douglas Cooper and John Richardson that he had sharpened the planes of the *plâtre de travail* (the working plaster used in the foundry) with a knife in order to 'make it look more carved than modelled'. (Information from John Richardson.) The crispness of the surface of the present plaster would tend to confirm that Picasso did indeed rework it after it had been cast.

6 Head of a Woman (Fernande) 1909
Tête de femme (Fernande)
Bronze 41.9 × 26.1 × 26.7
(16½ × 10¼ × 10½)
Art Gallery of Ontario, Toronto. Purchase 1949
S 24.II; Z II**.573
Illustrated on p.53

This is one of the unnumbered bronze casts edited by Ambroise Vollard, following his purchase of the two plasters from Picasso in about 1910 (see no.5). According to Olivier Berggruen, who has extensively researched the bronze editions of this sculpture, Vollard made at least sixteen casts. One or two, at least, were certainly cast before the First World War, but since Vollard appears to have made casts as and when he had a purchaser it is probable that casting continued sporadically over a period of many years. Picasso authorised Heinz Berggruen to edit a further nine bronze casts, from the plaster he had purchased, in 1959–60. (Information from Olivier Berggruen.)

PAINTINGS AND DRAWINGS

7 Study for 'Woman Combing her Hair' 1906
Etude pour 'Femme se coiffant'
Pencil on laid paper 31 × 22.5 (12¼ × 8⅞)
Klaus Hegewisch, Hamburg
S VI.751
Illustrated on p.42

The inclusion of a back as well as a front view of the model indicates that this is a study for the sculpture 'Woman Combing her Hair' (no.2), rather than for the well-known painting on the same theme (z 1.336). The drawing dates from the weeks following Picasso's return to Paris from Gósol in August 1906. It was at one time in the collection of Gertrude Stein.

8 Head and Figure Studies 1906
Etude de nus
Conté crayon on paper 64.8 × 47.9
(25½ × 18⅞)
Museum of Fine Arts, Boston. Arthur Tracy Cabot Fund 1963
Z XXII.467
Illustrated on p.43

Although this is a study for the right-hand figure in the painting 'Two Nudes' (no.9), it is equivalent to the preliminary drawings of a sculptor seeking to define both the silhouette

and the mass his statue will have when seen from a principal view. It was executed towards the end of 1906.

9 Two Nudes 1906
Deux femmes nues
Oil on canvas 151.3 × 93 (59⅝ × 36⅝)
The Museum of Modern Art, New York. Gift of G. David Thompson in honour of Alfred H. Barr, Jr 1959
Z 1.366
Illustrated on p.44

This monumental canvas was painted in Paris in the autumn or early winter of 1906. Picasso's paintings executed at Gósol during the summer months had strong sculptural implications but had been relaxed in mood. This painting, on the other hand, is in effect a surrogate sculpture and is filled with tensions. Although it has always gone by its present name it in fact shows one nude, represented twice and rotated through 180 degrees. The trunks of the two views of the figure are abnormally distended and seem to exist on the spectator's side of the canvas; the legs are treated as mere appendages and are flattened out as they reach the lower edge of the canvas. The mask-like heads reflect Picasso's interest in Iberian sculpture; a display of the Peninsula's early art was on view in a basement gallery of the Louvre. Early in 1907 three Iberian heads were stolen from the Louvre and two of them entered Picasso's possession.

10 Seated Nude with Crossed Legs 1906
Femme nue assise les jambes croisées
Oil on canvas 151 × 100 (59½ × 39⅜)
Národní Galerie, Prague
Z 1.373
Illustrated on p.45

There is some doubt as to whether this picture was painted just before or just after 'Two Nudes' (no.9). On stylistic grounds it seems likely that it succeeded it. The tensions sensed in 'Two Nudes' have here become more overt. One senses that the figure's girth has been distended almost to bursting point; and in a sense Picasso is trying to convey in a single figure the multiplicity of sculptural or volumetric information shown in the two figure piece. Again the lower arms and legs, the slenderest elements of the body, have been flattened to allow Picasso to concentrate on the bulkiest parts of the body. There are premonitions of a Cubist multi-viewpoint

perspective in the way in which the head appears to combine a profile and a three-quarter view; as so often when painters are preoccupied primarily with the rendition of volumetric forms colour has been reduced to a minimum.

11 **Nude with Raised Arms** 1908
Nu aux bras levés de profil
Oil on wood 67 × 27 (26⅜ × 10⅝)
Private Collection
D 166; Z II**.693
Illustrated on p.47

12 **Standing Nude** 1908
Nu debout de face
Oil on wood 67 × 27 (26⅜ × 10⅝)
Private Collection
D 167; Z II**.694
Illustrated on p.47

These two panels painted on a pair of cupboard doors can be precisely dated. Picasso said that while he was at work on the right-hand side of what is in effect a diptych, he saw that the German painter Wiegels had hanged himself at the window of his studio, which faced Picasso's own. The suicide took place on 1 June 1908. Again the panels are an instance of a painter thinking in sculptural terms: the nude seen from the side turns her torso to reveal both breasts while the raised arms enfold and reinforce the bulk of the head. The same figure seen frontally lowers her arms which become sculptural appendages to the figure's trunk.

13 **Seated Nude** 1908
Femme nue assise
Oil on canvas 150 × 100 (59 × 39⅜)
The State Hermitage Museum, St Petersburg
D 169; Z II*.68
Illustrated on p.48

This is possibly the most sculptural of all Picasso's figure pieces of 1908. The figure looks as if she has been hacked out of wood, an impression heightened by the earthy, brownish palette. Here head, trunk, arms and legs are locked into each other to form a single sculptural entity. The painting shows, too, how Picasso has fully assimilated the lessons learnt from a study of the more geometric, volumetrically reductive kinds of tribal art, which Picasso himself referred to as 'reasonable'. As he acknowledged, one feels that the painting could have been cut into pieces and reassembled as a sculpture.

14 **Head and Shoulders of the Farmer's Wife** 1908
Buste de la fermière
Oil on canvas 81 × 65 (31⅞ × 25⅝)
The State Hermitage Museum, St Petersburg
D 194; Z II*.92
Illustrated on p.46

Executed at La Rue-des-Bois, north of Paris, in August 1908 this is the companion piece to 'The Farmer's Wife', also in the State Hermitage Museum, and was probably executed immediately after it; the two pictures are of identical dimensions. Sculptors often isolate and cast individual elements taken from a larger whole, and in a sense that is what Picasso has done here. This is one of the instances in which Picasso relies very directly on tribal prototypes and the head has been compared in particular with Bambara masks from Mali.

15 **Study for 'Head of a Woman (Fernande)'** 1909
Etude pour 'Tête de femme (Fernande)'
Charcoal with chalk highlights on paper 62.8 × 48 (24¾ × 18⅞)
Musée Picasso, Paris
Z XXVI.417
Illustrated on p.51

While they were in the remote Catalan village of Horta de Ebro in the summer of 1909 Picasso often painted and drew his lover, Fernande Olivier. Concentrating on her face, neck and shoulders, and viewing her from slightly different angles, he structured the great mound of hair rising above her temples into a sequence of bulging, interconnecting arcs, and her face into a rugged landscape of peaks and depressions. These drawings and paintings were the source for the great sculpted head of Fernande he made in the autumn on their return to Paris (no.6). The present drawing of the crown of her head belongs to this series. With its strong modelling, clear-cut contours and emphatic separation of parts it shares the formal extremism of the sculpture itself.

16 **Head and Shoulders of a Woman (Fernande)** 1909
Buste de femme (Fernande)
Oil on canvas 60.6 × 51.3 (23⅞ × 20¼)
Art Institute of Chicago. The Joseph Winterbotham Collection 1940
D 287; Z II*.167
Illustrated on p.54

This head, one of the first of the series, is also one of the most beautiful and lucid. Space is deliberately restricted and the sitter appears to be placed just in front of the mantel-shelf; the mirror which rests on it reflects what is probably the back of the head which on the left-hand side of the picture is in any case twisted around onto the picture plane. The necks of the Horta heads taxed Picasso's imagination: a relatively slender form, the neck had now to connect convincingly the abnormally bulky, sculptural heads to the equally heavy and distended bodies below. Here the solution is simple; the jawline is repeated twice, bringing the head down to shoulder level.

17 **Seated Woman** 1909
Femme assise
Oil on canvas 81 × 65 (31⅞ × 25⅝)
Private Collection
D 292; Z VI.1071
Illustrated on p.52

One of the last of the Horta heads and one of the most sculptural and arresting of all, it seems to be wrenching itself off the canvas and turning itself into a sculpture in front of our very eyes. The treatment of the neck is particularly daring and its sides and back have been folded out and forwards. With the rejection of traditional perspective Picasso had also abandoned the use of a single, naturalistic light source and lights and darks are played off against each other to achieve effects of strong sculptural relief.

18 **Bust of a Woman** 1909–10
Buste de femme
Oil on canvas 73 × 60 (28¾ × 23⅝)
Musée National d'Art Moderne, Centre Georges Pompidou, Paris. Donation Louise et Michel Leiris 1984
D 335; Z II*.218
Illustrated on p.55

When Picasso returned to Paris from Horta de Ebro in the autumn of 1909 he felt the need to verify the sculptural implications of the painted Horta heads in three dimensions

and produced the celebrated bronze that was to become the most widely disseminated of his sculptures (no.6). Although it changed or influenced the careers of a large number of other sculptors, Picasso came to feel that for himself it had been something of a dead-end. He had, however, at one point considered rendering some of the outermost planes of the sculpture in wire; this would have produced an effect of transparency and given the spectator the sensation of seeing into the head's interior structure. This painting gives some indication of what the sculpture might have been like had he done so. The picture looks forward to the dappled, shadowy canvases of 1910 and 1911. But the fact that Picasso is still thinking in sculptural terms is underlined by the way in which the figure's arms and breasts are abbreviated in size and dealt with in a summary fashion in order to allow Picasso to concentrate on the sculptural bulk of the head itself.

2 Construction and Synthesis

SCULPTURES

19 Guitar ?1912–13
Guitare
Sheet metal and wire 77.5 × 35 × 19.3
(30½ × 13¾ × 7⅝)
The Museum of Modern Art, New York. Gift of the Artist 1971
S 27; D 471
Illustrated on p.58

It is not known for sure when this sheet-metal construction was made, but the crude technique and rough edges, and the inclusion of a section of stovepipe to form the sound-hole, confirm that it was one of the metal constructions Picasso made before the First World War using only his hands and the simplest tools. William Rubin believes it belongs to the winter of 1912–13 (*Picasso and Braque: Pioneering Cubism*, New York 1989, p.269). But it could date from the spring of 1914 when Picasso made several small still-life constructions in tin, including no.25. It is, at any rate, referred to at some length by Picasso's friend, André Salmon, in *La Jeune Sculpture française* (the text was written in 1914 but the book was not published until 1919). Salmon writes: 'I saw what no one else so far had seen when Pablo Picasso, forsaking painting for the moment, constructed this huge guitar in sheet metal in such a way that its blue-print could be sent to all the fools in the universe and they could remake it just as well as he could himself. I saw Picasso's studio – a studio more haunting than the laboratory of Faust, a studio which, some would say, contains no work of art in the accepted sense, a studio furnished with objects of the newest kind' (pp.102–3).

The sheet-metal 'Guitar' is a fairly close replica of Picasso's first construction – a cardboard maquette, almost certainly made in October 1912, which can be seen hanging on the wall of Picasso's studio on the boulevard Raspail in photographs taken in November–December 1912. (See Rubin 1989, pp.30–5. The paper maquette, and hence the sheet-metal sculpture, used to be dated spring 1912.) In the early part of the following year Picasso incorporated the maquette into a more elaborate still-life composition in paper and card, teaming it with a bottle. Together with three of his other relief constructions, it was published in this form by Apollinaire in *Les Soirées de Paris* on 15 November 1913 (see fig.24 on p.192), causing an immediate

scandal among the magazine's subscribers. Two years before his death Picasso donated both the sheet-metal 'Guitar' and the maquette to the Museum of Modern Art, New York.

20 Guitarist with Sheet Music 1913
Guitariste avec partition
Paper construction 22 × 10.5 (8⅝ × 4⅛)
Private Collection
S 31; D 582
Illustrated on p.61

Picasso gave this little construction to Gertrude Stein, who had the box made to protect it. They had been friends since the autumn of 1905 when Picasso began work on the famous portrait which is now in the Metropolitan Museum, New York. 'Guitarist with Sheet Music' was preceded by an extensive series of drawings of guitarists dating from the summer of 1912 to the spring of the following year. Some of them appear to be studies for Cubist constructions, and it is possible that the present paper construction was a try-out for a sculpture on a larger scale and in more permanent materials. Other closely related drawings occur in a contemporary sketchbook (Carnet 109, e.g. ff.4, 12r, 14, 31r, and 61r; MP 1865), one of them on a scrap of newspaper dated 7 May 1913 (f.77v). Picasso was in Céret almost continuously from mid-March to late June 1913, and is believed to have made the construction there. It is the only surviving construction of a figure that he realised during the Cubist period. The only other figurative construction was ephemeral, and was probably a joke: on a large unfinished canvas of a musician Picasso pinned arms cut out from newspaper, and suspended in front a real guitar. It is known only from period photographs, and was made in Paris early in 1913 – that is, before the present paper construction (s 28; see fig.16 on p.188).

21 Glass and Dice 1914
Verre et dé
Painted wood 23.5 × 21.6 × 7
(9¼ × 8½ × 2¾)
Private Collection
S 43; D 747
Illustrated on p.64

Made in Paris in the spring of 1914, this construction has lost the paper fringe which was originally tacked to the edge of the table. Although the shelf or table-top on which the

glass and dice are standing projects beyond the rectangular backboard, the construction asserts its identity as a *tableau-objet*, midway between painting and sculpture in the round. Other contemporary painted reliefs were actually constructed within picture frames.

22 Still Life 1914
Nature morte
Painted wood with upholstery fringe
25.4 × 45.7 × 9.2 (10 × 18 × 3⅝)
Tate Gallery. Purchased 1969
S 47; D 746
Illustrated on p.63

This relief was made in Paris in the spring of 1914, probably shortly before the free-standing 'Glass of Absinthe' (nos.23–4). In iconography it is a plebeian and updated version of the still lifes of food and wine by Chardin and the Dutch seventeenth-century painters, and in style and technique it offers an ironic alternative to their mouthwatering illusionism. Picasso parted with very few of his Cubist constructions during his lifetime. This was an exception: he gave it to his close friend, the Surrealist poet Paul Eluard, and it was exhibited in the *Exposition Surréaliste d'Objets* in Paris at the Galerie Charles Ratton in May 1936. In 1938 Eluard sold it to Roland Penrose, the leader of the English Surrealist group and Picasso's future biographer.

23 Glass of Absinthe 1914
Verre d'absinthe
Sand-covered bronze and silver-plated spoon 21.5 × 16.5 × 6.5 (8½ × 6½ × 2½)
Musée National d'Art Moderne, Centre Georges Pompidou, Paris. Donation Louise et Michel Leiris 1984
S 36a; D 753
Illustrated on p.65

24 Glass of Absinthe 1914
Verre d'absinthe
Painted bronze and silver-plated spoon
22 × 16.5 × 5 (8⅝ × 6½ × 2)
The Berggruen Collection on loan to the National Gallery, London
S 36c; D 755
Illustrated on p.65

The 'Glass of Absinthe' series is contemporary with many small-scale paintings, *papiers collés* and wood and tin constructions of glasses executed in Paris in the spring of

1914. Daniel-Henry Kahnweiler, who was a great admirer of Picasso's sculpture, had six bronze casts made from the wax original. It thus became the first of Picasso's Cubist sculptures to be cast in bronze since Vollard began editing the 1909 'Head of a Woman (Fernande)' (no.6). Each cast was decorated differently by Picasso and equipped with a silver-plated, perforated absinthe spoon and a simulated sugar lump in bronze. This was the first time he had included a complete found object in a sculpture – a practice that proved to be the cornerstone of his method at key moments in his later career. As he said to Spies: 'I was interested in the relationship of the real spoon to the modelled glass – in their mutual impact' (Werner Spies, *Picasso Sculpture: With a Complete Catalogue*, London 1972, p.50). Five of the six casts were auctioned as one lot in the sale of Kahnweiler's sequestered stock held at the Hôtel Drouot in Paris on 13–14 June 1921 (lot 139). Kahnweiler acquired the unique sand-covered version for himself.

Absinthe was considered a particularly dangerous drink and was banned in France at various times. Although Picasso himself told Spies (ibid.) that this was never his intention, many critics believe that the glass doubles as the head of a man or woman in a hat, and it has also been suggested that Picasso was deliberately evoking the disorienting effect of drunkenness. Whether or not this is so, he did go on to explore the theme of the 'merry toper' in a number of drawings and paintings when he was in Avignon during the summer of 1914.

25 Bottle of Bass, Glass and Newspaper 1914
Bouteille de Bass, verre et journal
Painted tin, sand, wire and paper
20.7 × 14 × 8.5 (8⅜ × 5½ × 3⅝)
Musée Picasso, Paris
S 53; D 751
Illustrated on p.66

This was made in Paris in the spring of 1914 out of a single tin can which had contained dried milk. Bass Pale Ale was a popular drink in France, and Picasso reproduces the famous trademark of a red triangle fairly accurately.

26 Violin 1915
Violon
Painted sheet iron and wire
100 × 63 × 18
(39⅜ × 24¾ × 7⅛)
Musée Picasso, Paris
S 55; D 835
Illustrated on p.69

This has often been dated 1914, but most scholars now believe it was made in Paris the following year because of its stylistic similarities with the strong colour and bold geometric patterns of paintings of that period. Like 'Glass of Absinthe' (nos.23–4) it works both as object and (masked) head, the diamond pattern evoking the costume of Harlequin.

PAINTINGS AND COLLAGES

27 Musical Score and Guitar 1912
Feuille de musique et guitare
Papier collé and pins on cardboard
42.5 × 48 (16¾ × 18⅞)
Musée National d'Art Moderne, Centre Georges Pompidou, Paris. Legs de M. Georges Salles 1967
D 520; Z II**.416
Illustrated on p.59

It is possible that this is the very first of Picasso's *papiers collés* and that he produced it at the time he was working on the folded cardboard construction 'Guitar' (see no.19). The cut-out papers are loosely pasted onto the blue paper background and the rectangle at the centre of the guitar is pinned on, so that one is acutely aware of the work as an assembly of isolated component parts manipulated very physically into a still life.

28 Glass, Guitar and Bottle 1913
Verre, guitare, bouteille
Oil, papier collé, gesso and pencil on canvas 65.4 × 53.6 (25¾ × 21⅛)
The Museum of Modern Art, New York. The Sidney and Harriet Janis Collection 1967
D 570; Z II**.419
Illustrated on p.60

This is one of the most dense and impacted of Picasso's collages or multi-media works; the assembly of various media and techniques partially destroys the barriers between painting and sculpture itself. The guitar looks as it were folded outwards from the pictorial surface and is in effect a surrogate construc-

tion. The bottle is rendered by a negative shape which nevertheless moves to the foreground of the composition.

29 Violin, Glass and Bottle 1913
Violon au café
Oil on canvas 81 × 54 (31⅞ × 21¼)
A. Rosengart
D 571; z II**.438 *bis*
Illustrated on p.60

One of the greatest of all Picasso's early Synthetic Cubist still lifes this painting must have been executed more or less contemporaneously with the preceding collage. However, while the elaboration of the collage gives it the density and weight of a highly pondered painting, here the variety of paint surface and texture reflect the influence of collage procedures back onto painting itself: some of the painted white areas mimic the blankness of untouched paper, some of the paint is applied thickly and gives the impression almost of very low relief, other areas are cursorily and scrubbily coloured, while the wood-graining mimics the illusionistic wallpapers once so common in French cafés.

30 Head of a Girl 1913
Tête de jeune fille
Oil on canvas 55 × 38 (21⅝ × 15)
Musée National d'Art Moderne, Centre Georges Pompidou, Paris. Donation de M. Henri Laugier 1963
D 590; z II**.426
Illustrated on p.59

When Picasso adopted a Synthetic Cubist method of work, building up his images and subjects out of abstract pictorial elements, he became increasingly interested in the interchangeability of these elements and subsequently also fascinated by the interchangeability of imagery. The configurations that build up this head echo very closely those of the first 'Guitar' construction executed some months earlier (no.19). One senses that after a few initial compositional elements had been laid down they could just as easily have been turned into a musical instrument as into a head.

31 Wineglass with Slice of Lemon *c.*1914
Verre avec tranche de citron
Oil on canvas 20.5 × 18.5 (8⅛ × 7¼)
Royal Museum of Fine Arts, Copenhagen
D 655; z II**.494
Illustrated on p.64

The circular shape of this small but witty and engaging work helps to illustrate the Cubists' concept of the *tableau-objet*, the idea that a painting could be seen as a object that did not necessarily have to be hung on a wall, but could be moved around from place to place. The artists felt that each individual *tableau-objet* could be viewed as an independent, self-contained world.

32 Woman with a Mandolin 1914
Femme à la mandoline
Oil, sand and charcoal on canvas
115.5 × 47.5 (45½ × 18⅝)
The Museum of Modern Art, New York. Gift of David Rockefeller 1975
D 646; z II**.448
Illustrated on p.61

One of the freest and most fanciful of all Picasso's Synthetic Cubist figure pieces, this painting also reflects more directly than any other of his strictly two-dimensional works what might be described as the more 'floating' *papiers collés*, works in which the additive paper elements have been simply pinned or lightly affixed to their support in one or two places. The striped sleeves of the musician in particular recall the flopping newspaper arms of the 'Construction with Guitar Player' assembled by Picasso in his studio in the boulevard Raspail in Paris in 1913 – the largest of all Picasso's Cubist figure constructions – and subsequently destroyed (see fig.16 on p.188). To this extent it is a pictorial counterpart also to the little 'Guitarist with Sheet Music' of 1913 (no.20), given by Picasso to Gertrude Stein, and his only surviving figure construction of the period. The Russian script reads, in a typically fragmented Cubist way, as 'Grand Concert'. Picasso's contacts with Russia were still strong: his work was discussed in the Russian press and he had two important Russian patrons. The picture first belonged to Gertrude Stein (who used herself to send Picasso American comic strips).

33 Bottle of Bass, Wineglass, Packet of Tobacco, Calling Card 1914
Bouteille de Bass, verre, paquet de tabac, carte de visite
Papiers collés and pencil on paper
24 × 30.5 (9½ × 12)
Musée National d'Art Moderne, Centre Georges Pompidou, Paris. Donation de Louise et Michel Leiris 1984
D 660; z II**.456
Illustrated on p.64

During the course of 1914 Picasso produced a large number of small, exquisite *papiers collés* of still-life objects. In many of them the attention is focused on a single wine glass or goblet, and these, together with the small oil paintings on the same subject, can be regarded as the pictorial counterparts of the six sculptural versions of the celebrated 'Glass of Absinthe' (nos.23–4). Significantly enough, here the bottle and cigarette package appear to have been unfolded and flattened but the goblet remains solid and almost demands to be picked up. The visiting card is of the dealer André Level.

34 Wineglass and Dice 1914
Verre et Dé
Papier collé, graphite and gouache on paper 23.5 × 14.5 (9¼ × 5¾)
The Berggruen Collection on loan to the National Gallery, London
D 689; z II**.501
Illustrated on p.64

This witty and endearing little picture is one of a whole series of carefree studies in which Picasso focuses his attention on a single wineglass or goblet. To this extent it is another counterpart to the sculpted 'Glass of Absinthe' (nos.23–4). Here the bowl of the glass is represented by a fragment of newspaper left straight along its upper edge but shaded below to indicate roundness. The overlapping piece of *papier collé* is cut out from cheap flecked or spattered wallpaper that creates an effect of effervescence. But despite the tactile qualities of the elements of *papier collé* the most solid part of the picture is the stem of the goblet: we clench it with our eyes.

35 Playing Cards, Packet of Tobacco, Bottle and Glass 1914
Cartes à jouer, paquet de tabac, bouteille, verre
Oil and sand on board laid down on panel 36.8 × 49.8 (14½ × 18⅝)
The Berggruen Collection on loan to the National Gallery, London
D 777; Z II**.517
Illustrated on p.66

Picasso's still lifes executed at Avignon in the summer of 1914 tend to be light-hearted and decorative; and Alfred Barr coined the term 'rococo Cubism' to characterise them. This particular work, however, is solemn and weighty, despite the use of decorative and stippled areas. It is also more markedly sculptural in feeling than other pictures of the series. It is in many respects the counterpart of the painted tin relief 'Bottle of Bass, Glass and Newspaper' (no.25), executed in Paris just before Picasso's departure for the South. One can envisage dismantling or cutting out the painting's component forms, bending and twisting them, and then reassembling them into a three-dimensional structure. But whereas the tin relief is fragile, even insub stantial, the painting is heavy and dense.

36 Glass, Newspaper and Bottle 1914
Verre, journal, bouteille
Oil and sand on canvas 36.2 × 61.3 (14¼ × 24⅛)
Private Collection, USA
D 803; Z II**.531
Illustrated on p.62

This sombre still life is the direct counterpart of the Tate Gallery's important relief sculpture 'Still Life' (no.22) although the relief omits the bottle which in the sculpture would have introduced too pronounced a vertical. The painting may immediately precede the sculpture although the interchange between sculpture and painting was by now so fluid that it is impossible to be categorical about chronological sequences.

37 Woman with a Guitar 1915
Femme à la guitare
Oil on canvas 186 × 75 (73¾ × 29½)
Gregory Callimanopulos, New York
D 843; Z II**.547
Illustrated on p.67

This is one of the least well known of a series of monumental single figure pieces of 1915–16, of which the 'Harlequin' in the Museum of Modern art in New York is the most famous. In these canvases Picasso explored the compositional implications of *papier collé* in a new, structural or architec-tonic way. This painting is the most tactile or physical of them all in that it evokes very strongly sensations of pleating, bending and folding; one senses that the figure could be recreated in three dimensions out of tin and cardboard; and to this extent the work has a strong affinity with the painted sheet-metal 'Violin' also of 1915 (no.26). The surface of the canvas is rough and impacted and it is possible that it may have been reworked by Picasso in 1916–17.

38 Table, Guitar and Bottle 1919
Table, guitare et bouteille
Oil on canvas 127 × 74.9 (50 × 29½)
Smith College Museum of Art, Northampton, Massachusetts. Purchased, Sarah J. Mather Fund 1932
Z III.437
Illustrated on p.68

Although this is a very flat painting it, too, has a lot in common with the metal 'Violin' of 1915 (no.26). Both are monumental and hieratic images and they even share a common colour range. The striations which occur at intervals across the painting's surface, and which serve to differentiate and define planes in depth, have been achieved by pressing corrugated cardboard into the wet paint surface; Picasso then went back into the painting and redefined some of the striations in black. Later on Picasso was to use similar devices in his sculpture, pressing corrugated paper and other textural matter into wet clay or plaster.

3 The Sculptor's Studio

SCULPTURES

39 Guitar and Table in Front of a Window 1919
Guitare et table devant une fenêtre
Paper construction 16.4 × 15 × 10 (6½ × 5⅞ × 4)
Private Collection
S 61c
Illustrated on p.78

In the summer of 1919 Picasso and his wife Olga holidayed in Saint-Raphaël on the Riviera, returning in late October to Paris, where this paper construction was made. In Saint-Raphaël Picasso had painted a series of twenty-four exquisite gouaches and water-colours on the Matissean theme of the still life on a table before an open window (e.g. no.60). This diminutive construction, and another of the same date in painted card-board (S 61b), is derived from them. Prepara-tory drawings (e.g. MP 860, 861) make it clear that Picasso's intention was to reverse normal expectations about both mass and recession by presenting space in terms of solid forms, and solid forms in terms of voids. Thus the guitar is presented as an absence, as are the curtains looped in front of the window. On the other hand, the sea and sky beyond are represented by the arched and projecting cut-out of paper mounted on legs. The distinctly theatrical presentation of the construction is not fortuitous: before going to the Riviera Picasso had stayed in London for three months while he designed the curtain, sets and costumes for the ballet Le Tricorne (The Three-Cornered Hat), which was premiered on 22 July at the Alhambra Theatre.

40 Head 1928
Tête
Painted brass and iron 18 × 11 × 7.5 (7⅛ × 4⅜ × 3)
Musée Picasso, Paris
S 66A
Illustrated on p.82

This was probably the first welded metal sculpture Picasso made with Julio González in the latter's workshop on the rue de Médéah in Paris. Their active collaboration began in October 1928, after Picasso's return from his summer holidays in Dinard, and when a variant of the present sculpture was reproduced by Christian Zervos in *Cahiers d'Art* in 1929 (no.1, p.11) it was dated October

1928. The design of 'Head' is derived from the preparatory drawings (e.g. MP 1026) made in February 1928 for the great canvas 'Painter and Model' (Museum of Modern Art, New York). In these drawings it represents the painter himself, but by 20 March, in a sketchbook drawing (MP 1990–108), Picasso was envisaging the figure as a large free-standing sculpture mounted on a half-sphere, so that it somewhat resembles a floating buoy – an indication that it was one of his many abortive projects for the monument to Apollinaire. In all these studies, as in the sculpture itself, the single frontal head can also be read as two profile heads locked in a kiss.

Three versions of this small sculpture were made in 1928, each one painted slightly differently. One of the others belonged to Gertrude Stein. The sculpture was never realised on a larger scale.

41 Figure ?1931
Iron wire and wooden cotton reel
32 × 9.5 × 6 (12⅝ × 3¾ × 2⅜)
Marina Picasso. Courtesy Galerie Jan Krugier, Geneva
S 83
Illustrated on p.96

This was photographed by Brassaï in Picasso's rue La Boétie apartment in 1932. Like the other twisted wire 'Figures' of the same type (S 84, 85), it is usually dated 1931. It may, however, have been made earlier when Picasso was working closely with González on the wire constructions or the iron version of 'Woman in a Garden' (see no.83), as a form of a relaxation from the arduous work in the forge or as a playful riposte to González's meticulous craftsmanship. Christian Zervos describes Picasso 'playing' with wire on just such an earlier occasion: 'Picasso picked up a bit of wire which was lying around and started to twist it, while keeping on talking. Without depicting anything precisely, within a couple of minutes the wire had received the imprint of his special sensibility. Only Picasso could have twisted the wire in this particular way' ('Picasso à Dinard', *Cahiers d'Art*, no.4, 1929, p.5).

42 Figure 1935
Painted wood, string and wire, with a clay and wood base 58 × 20 × 11 (22⅞ × 7⅞ × 4⅜)
Private Collection
S 164
Illustrated on p.99

Maya, Picasso's daughter by Marie-Thérèse Walter, was born on 5 September 1935. This sculpture, which is faintly reminiscent of the Hopi Indian kachina dolls much admired in Surrealist circles, is one of several painted wooden figures made around the time of her birth. Picasso actually clothed two of the others with scraps of material so that they closely resemble traditional peg-dolls (S 160, 161).

43 Woman Seated in an Armchair 1940
Femme assise dans un fauteuil
Oil, card and wood on a cardboard box
15.5 × 11.5 (6⅛ × 4½)
The Berggruen Collection on loan to the National Gallery, London
S 184
Illustrated on p.81

This is one of four similar relief constructions made in Royan in early February 1940. It is dated 3 February, and although he kept all the others for himself (MP 184–6), Picasso gave this one to his friend Paul Eluard. He used an empty Gitanes cigarette box as the base for the construction, and the wooden strut of the chair is probably a paintbrush handle. The paradoxical treatment of the woman, who is both voluptuously seductive but, with her skull-head, also a sinister emblem of death, is highly characteristic of Picasso's work during the war, especially during the months he spent in Royan between September 1939 and late August 1940 with his companion Dora Maar.

44 The Venus of Gas 1945
La Vénus du gaz
Iron (burner and pipe from a gas stove)
25 × 9 × 4 (9⅞ × 3½ × 1⅝)
Private Collection
S 302A
Illustrated on p.97

This is one of Picasso's few genuine 'ready-mades' – a found object which he has not altered. According to Françoise Gilot, 'in a certain type of prewar gas stove there was one burner, different from the others, that looked as though it should have been a

Picasso sculpture of a woman' (*Life with Picasso*, Harmondsworth 1966, p.311). This was the burner which Picasso christened 'The Venus of Gas' in recognition of its affinity with prehistoric fertility idols, such as the Venus of Lespugue (of which he owned two plaster casts). The find probably occurred in early to mid January 1945, for on 17 January Picasso made careful drawings of the burner, standing upright and viewed from different positions, alongside drawings of flames burning in a grate. On 22 January he devoted another page from the same notebook to various drawings of a standing nude woman, in one of which she bears a distinct resemblance to the Venus of Lespugue. (Carnet x, ff.10, 11; Succession of the Artist.) During the winter of 1944–5 Picasso was at work on 'The Charnel House' (Museum of Modern Art, New York), his response to accounts of the Nazi concentration camps. The bodies piled in the foreground of the painting are directly connected by outline and configuration with his many contemporary drawings of logs burning in a grate (including those in Carnet x mentioned above, and ff.9, 12 and 13, 18 and 25 January 1945). 'The Venus of Gas' is thus surely connected through symbolism to 'The Charnel House', which is dedicated to the victims of the gas chambers.

45 Woman 1948
Femme
Bronze 18 × 14 × 7 (7⅛ × 5½ × 2¾)
Sammlung Ludwig
S 334.II
Illustrated on p.83

This is one of two bronze casts (made in the Godard foundry) from a baked red clay original. The terracotta was made in Vallauris, the pottery town of the Midi, where Picasso had been seriously engaged in making ceramics since August 1947. Like 'The Venus of Gas' (no.44), 'Woman' is one of several sculptures of pregnant figures dating from 1945-50 which are Picasso's equivalent to prehistoric fertility goddesses: in a photograph taken by Robert Picault in Vallauris in 1950 she looks like a gigantic cult-figure and presides over a group of diminutive acolytes. The theme of pregnancy had a personal meaning for Picasso at this time: his two children by Françoise Gilot were born in 1947 and 1949.

46 Woman with Clasped Hands 1950
Femme aux mains jointes
Ceramic 29 × 7 × 7 (11⅜ × 2¾ × 2¾)
Private Collection
Illustrated on p.98

The base of this figure, which was inspired by Françoise Gilot, was a small vase or bottle with a narrow neck thrown by a potter in the Madoura factory. While the clay was still malleable, Picasso worked it swiftly forming the head, arms and breasts with added lumps and rolls of clay. Still unpainted, the figure was photographed by Robert Picault in Vallauris in September 1950 (fig.53 on p.226). In painting the figure, Picasso treated the surface as if it were a canvas, emphatically defining and simultaneously flattening the forms with the boldly contrasted darks and lights. Small female figures like this one, frequently draped and sometimes kneeling or crouching, are referred to as Picasso's tanagras because of their relationship to the delightfully informal moulded pottery figurines which have survived in quantities from the Hellenistic period.

47 The Glass 1951
Le Verre
Bronze 23 × 12 × 22 (9 × 4¾ × 8⅝)
Private Collection
S 346.II
Illustrated on p.97

The original sculpture was assembled from the shoulder blade of a sheep and various bits of metal, including a curtain-pole ring, a bolt, and large and small nails, and was mounted on the base of a cardboard chocolate box filled with plaster. It may be seen as a reprise and development of the idea first explored in 'Glass of Absinthe' (nos.23–4). This is one of two bronze casts made by Valsuani in 1953.

48 Woman Reading 1951–2
Femme lisant
Painted bronze 15.5 × 35.5 × 13
(6⅛ × 14 × 5⅛)
Musée National d'Art Moderne, Centre Georges Pompidou, Paris. Donation Louise et Michel Leiris 1984
S 462.II
Illustrated on p.98

The original sculpture, which is in the Musée Picasso in Paris, was assembled from wood, nails, screws, other metal items and plaster, and is generally dated 1951. It was inspired by seeing Françoise Gilot reclining and

absorbed in a book – a subject which Picasso treated in various contemporary paintings (e.g. Succession of the Artist, inv.13238, oil dated 11 May 1952). Three bronze casts were made by Valsuani in May 1952, and Picasso then painted each of them differently. A painted bronze was exhibited for the first time by the Galerie Leiris in Paris in May 1953, and dated 1952 in the catalogue.

49 Palette 1952
Ceramic 40 × 35.5 (15¾ × 14)
Private Collection
Illustrated on p.95

This is dated 19 September 1952 on the back. It was created by taking an imprint in a slab of fresh clay from a piece of corrugated steel (which is conserved in the Estate). The clay was then roughly cut to shape. The blobs of colour were formed out of very soft, almost liquid clay. The corrugated surface, which alludes to the graining of an artist's wooden palette but also resembles corrugated cardboard, is a throw-back to the simulated textures and materials of the collages and *papiers collés* of the Cubist era, and to the textured surfaces of plaster sculptures like 'Woman Leaning on her Elbow' 1933 (no.100).

WORKS ON PAPER

50 Standing Nudes and Study of a Foot 1908
Nus debout et étude de pied
Ink and watercolour on paper 30 × 21.6
(11¾ × 8½)
Musée Picasso, Paris
Z XXVI.354
Illustrated on p.72

Executed in the summer of 1908, this is one of many contemporary drawings which resemble studies for, or of, wood carvings of standing figures. In its self-conscious savagery it reflects Picasso's intense interest in tribal masks and statues in 1907–8 as well as his actual experience of carving pieces like 'Figure' (no.4). Ironically, it was done on the back of an article on Rodin.

51 Standing Nude Seen from the Back
1908
Nu debout de dos
Gouache and pencil on paper 63 × 48
(24¾ × 18⅞)
Private Collection
Z XXVI.359
Illustrated on p.73

Although not a study for a sculpture Picasso ever made, this drawing is strikingly sculptural in conception, and there is, in fact, a contemporary drawing which is like a study of the front of the same nude figure (Z XXVI.353). In many significant respects – pose, three-quarter length view, bulkiness, sectioning of parts, rough-hewn appearance – this drawing relates closely to the unfinished oak figure of a woman which was Picasso's most ambitious carving to date (no.4). It tends to support the 1908 dating we suggest for that sculpture.

52 Head of a Man 1909
Tête d'homme
Brush and ink on paper 63 × 48
(24¾ × 18⅞)
The Metropolitan Museum of Art, New York. Alfred Stieglitz Collection 1949
Not in Zervos
Illustrated on p.74

This drawing relates most closely to bust-length paintings of men Picasso made during his sojourn in Horta de Ebro in the summer of 1909 (e.g. D 296, 297). But in the force and rigour of the faceting over the lower part of the face, it anticipates 'Head of a Woman (Fernande)', Picasso's first Cubist sculpture (no.6).

53 Still Life: The Cruet Set 1911
Nature morte: L'Huilier
Ink on paper 31.4 × 24.4 (12⅜ × 9⅝)
The Metropolitan Museum of Art, New York. Alfred Stieglitz Collection 1949
Not in Zervos
Illustrated on p.76

This drawing depicts the same cruet, seen from the same angle, as a small oil painting which Daix says is inscribed on the back January 1911 (D 370). Although not a study for a construction, it anticipates the studies of musicians and musical instruments Picasso made a year or so later which were the necessary prelude to the creation of his first paper and cardboard constructions in the autumn and winter of 1912. Picasso treats the

cruet like a high relief, and he investigates its interior spaces and the complex play of light and shade created by its struts and platforms in much the same way as he does later in the sheet-metal 'Guitar' (no.19).

54 Violin 1912
Violon
Charcoal on paper 57.8 × 45.7
(22¾ × 18)
Private Collection
Z VI.1128
Illustrated on p.76

This drawing probably dates from the spring of 1912. The instrument is shown hanging against the studio wall, which is how Picasso displayed both the musical instruments he owned and the Cubist relief constructions he later made. The violin was the subject of one of Picasso's earliest paper, cardboard and string constructions (fig.23 on p.192). This kind of analytical drawing was a necessary stage in the process of simplification and rationalisation that led to their execution in the autumn and winter of 1912–13.

55 Head of a Man 1912
Tête d'homme
Pencil on paper 64 × 49 (25¼ × 19¼)
Musée d'Art Moderne de la Communauté Urbaine de Lille, Villeneuve d'Ascq. Donation Geneviève et Jean Masurel
Z II*.328
Illustrated on p.75

In late June 1912 Picasso rented a villa in Sorgues, near Avignon, for the whole summer. This drawing was executed there. In October, after his return to Paris, he made his first construction – the paper maquette for the sheet-metal 'Guitar' (no.19). This drawing, although more complex and ambiguous in form, anticipates in a striking manner the structure of 'Guitar'. Moreover, inspired perhaps by the African masks he owned, Picasso treats the man's head like a relief hanging on the wall.

56 Woman with a Guitar 1912
Femme jouant de la guitare
Ink on paper 31 × 20 (12¼ × 7⅞)
Private Collection
Z XXVIII.151
Illustrated on p.77

William Rubin places this drawing in the summer of 1912 (*Picasso and Braque: Pioneering Cubism*, Museum of Modern Art, New York 1989, p.243). It was at this period that Picasso made numerous drawings which appear to be studies for complex free-standing constructions of musicians. In the event, his first constructions made a few months later are much simpler in both form and iconography, and are wall reliefs, rather than sculptures in the round (no.19). Nevertheless, they were assembled in much the same way, and from similar component parts, as the figure here. Moreover, the drawing does anticipate the one figurative construction that survives from the Cubist period – the small paper relief of a female guitarist he gave to Gertrude Stein (no.20).

57 Various Studies: Guitars 1913
Feuille d'études: guitares
Ink and pencil on paper 35.7 × 22.6
(14 × 8⅞)
Musée Picasso, Paris
Z XXVIII.282
Illustrated on p.77

William Rubin believes this sheet of studies belongs to the spring of 1913 when Picasso was in Céret (*Picasso and Braque: Pioneering Cubism*, Museum of Modern Art, New York 1989, p.268). The studies could be for such works as 'Guitar and Bottle of Bass', spring–autumn 1913 (D 630), for *papiers collés* or mixed media works similar in type to nos.27–9, or for contemporary paintings that imitate the effects of collage – Picasso's work in all media is very closely interconnected at this stage. In his desire to destroy the barrier between painting and sculpture, and to forge a construction technique adaptable to both, Picasso also sometimes experimented with inserting his paper constructions into collage-pictures, which he assembled directly on the studio wall, and the guitar projecting forcefully from the background in the central drawing looks very like one of the early paper constructions of a guitar with a similar stepped neck (s 29).

58 Three Heads 1913
Trois têtes
Ink on paper 35.8 × 23.3 (14⅛ × 9⅛)
Private Collection
Z XXVIII.283
Illustrated on p.77

These drawings relate directly to the paper construction of a female guitarist Picasso made in Céret in the spring of 1913 (no.20). However, the top hats on the two lower heads establish a further link with contemporary paintings and drawings of a male guitarist (e.g. D 616).

59 Woman in an Armchair 1916 or 1917
Femme dans un fauteuil
Pencil with charcoal on paper 34.5 × 32.6
(13⅝ × 12⅞)
Musée Picasso, Paris
Z XXIX.455
Illustrated on p.80

The date of this drawing is given as 1916–17 in the Musée Picasso catalogue, but it has previously been published as 1918 and by Zervos as 1919. Picasso made no sculpture in the latter years of the war, unless one counts the Managers' costumes and the masks for the ballet *Parade* (1917). The drawing does, however, have formal links with two painted sheet-metal Cubist constructions of musical instruments made about a decade apart – 'Violin' 1915 (no.26) and 'Guitar' 1924 (fig.4 on p.23). Moreover, it anticipates in a striking manner the cut and folded sheet-metal sculptures copied from Picasso's paper maquettes in the early 1960s, in particular 'Woman in a Hat' (no.145). This comparison serves to remind us how much Picasso's last sculptures still owed to the formal and technical language of Cubism.

60 Still Life in Front of an Open Window at Saint-Raphaël 1919
Nature morte devant une fenêtre ouverte à Saint-Raphaël
Gouache and graphite on paper 35.5 × 25
(14 × 9⅞)
The Berggruen Collection on loan to the National Gallery, London
Z III.396
Illustrated on p.79

This is one of the series of gouaches Picasso painted while he was holidaying in the summer of 1919 at Saint-Raphaël. Although he reminds us at every point that the spatial illusionism is pure hoax, that illusion is so

compelling that the still life on the table reads exactly like a free-standing, pop-out construction, and, with its crisp contours and folds, and its wafer-thin cut-away forms, has all the insubstantiality of the toy theatre-like paper models he made on his return to Paris in October (no.39). The gouache is obviously a sophisticated gloss on Picasso's prewar Cubist constructions and *papiers collés*, but it also anticipates the fastidious perspectival schemes of the open-work wire constructions he made with González in 1928 (nos.74–5).

61 **Still Life in Front of an Open Window at Saint-Raphaël** 1919
Nature morte devant une fenêtre ouverte à Saint-Raphaël
Gouache, graphite and watercolour on paper 31 × 49 (12¼ × 19¼)
Musée Picasso, Paris
Not in Zervos
Illustrated on p.78

This fascinating sheet of drawings was made in the summer of 1919 when Picasso was holidaying at Saint-Raphaël, and relates directly to one of the finest and most finished of all the gouaches he painted there (no.60) and to the small paper construction of a still life before an open window (no.39). Several of the peripheral drawings on the sheet appear to be studies for a construction of a guitar, and Picasso did in fact make a construction of a guitar and a *compotier* out of pieces of cut and interlinked cardboard on his return to Paris in October (s 61D). The drawing of the artist's hand, casually introduced, is a perhaps unconscious sign of his desire literally to make a still life, rather than to depict one.

62 **Three Nudes by the Sea** 1921
Trois femmes nues au bord de la mer
Pastel on paper 24.2 × 30.1 (9½ × 11⅞)
Graphische Sammlung Staatsgalerie Stuttgart
Z IV.280
Illustrated on p.88

This is inscribed 4 May 1921 on the back. It was executed at the height of Picasso's neo-classical phase, and at a time when he was designing regularly for Diaghilev's *Ballets Russes* but hardly making any sculpture (Spies catalogues no sculpture at all between 1921 and 1924). Picasso's neo-classical drawings and paintings were, however, so conscious of their heritage in the long tradition of classical sculpture, from the Greco-Roman period to

the latest products of Maillol, that they seem to be in competition with it: it would be hard to imagine anything more like an updated classical relief than this pastel. These works of the early 1920s became the springboard for Picasso's radical overhaul of the classical tradition in the plaster sculptures he made at Boisgeloup a decade later.

63 **Bathers (Study for a Monument)** 1928
Baigneuses (projet pour un monument)
Ink and wash on paper 30.2 × 22 (11⅞ × 8⅝)
Musée Picasso, Paris
Z VII.199
Illustrated on p.89

This is inscribed at the top left corner 8 July 1928. The drawing was executed in Paris and is on a page torn from Carnet 021 (formerly collection Marina Picasso). From inscriptions on the front and back covers, we know Picasso used this sketchbook in Paris between 18 June and 8 July 1928 – that is, shortly before he left for Dinard. Many of the drawings in it are projects for sculptures, and this one in particular relates very closely to the drawings that fill the first ten pages of Carnet 1044 (no.64). It was reproduced in Christian Zervos's 'Projets de Picasso pour un monument' in *Cahiers d'Art* in 1929 (no.8 9, p.341). The monument referred to is the monument to Apollinaire, which Picasso had been commissioned to design back in 1920, but on which he only began seriously to concentrate in 1927–8 (see nos.73–6, 83).

64 **Sketchbook 1044** 1928
Carnet 1044
Ink and pencil on paper: page size 96.5 × 78.7 (38 × 31)
Marina Picasso. Courtesy Galerie Jan Krugier, Geneva
Ten pages exhibited: ff.1, 4, 6, 8, 10, 18, 20, 45, 58, 60
Some pages in z VII: nos.188, 190, 192, 194, 200–8, 424
Complete sketchbook (including front cover) illustrated on pp.84–7

This sketchbook contains fifty-nine pages of drawings, an inscribed cover and two further pages with inscriptions. The inscriptions establish that Picasso began using the notebook in Dinard, where he was staying at the Villa Les Roches, on 27 July 1928, and that he also used it back in Paris, at his apartment at 23 rue La Boëtie, between 11

and 17 November 1928. Many of the individual pages of drawings also carry precise dates.

The great importance of this remarkable notebook is two-fold. In the first place, there are many drawings directly related to the series of small-scale paintings of schematised bathers playing on the beach which Picasso actually executed in Dinard, or to metal sculptures, including nos.74–6, which he made in Paris on his return, or in 1929–30, with the help of Julio González. (Some of the drawings were reproduced by Christian Zervos as 'Projets de Picasso pour un monument' in *Cahiers d'Art*, 1929, no.8–9.) In the second place, there are many pages of highly wrought, volumetric drawings of stacked and balanced bone- and stone-like forms, which are like projects for monumental multi-part sculptures – sculptures which Picasso never actually made, but which reflect his current obsession with inventing new forms and techniques for sculpture.

The fact that so many of the drawings are inscribed with dates also means that we are able to chart a 'progression' in Picasso's creative thinking during the period he spent at Dinard. Thus, broadly speaking, the notebook tells us that he was preoccupied with sculptural projects of one kind or another from 27 July to 3 August. From around 6 August until the end of the month, his attention seems mainly to have been devoted to painting – with an interruption on 12 August when he filled four further pages with drawings for the wire constructions (nos.74–5). When he used the sketchbook again in Paris in mid-November, he was concerned once more with sculpture. This pattern fits with his personal circumstances. When he went to Dinard for the family summer holiday with his wife and small son – but with his young lover, Marie-Thérèse Walter, installed conveniently close by in a children's holiday camp – Picasso was obviously thinking about the commission for the monument to Apollinaire: he had executed the plaster 'Metamorphosis' (no.73) before leaving, and he had already been in contact with González about the project. But in Dinard he had no access to sculptural materials, still less, of course, to a metal workshop, so he was forced to 'make sculptures in his head' and to paint pictures which realised some of the fantasies he had for multi-part sculptures arranged in ensembles along the promenade La Croisette at Cannes. Back in Paris in the autumn, he could devote himself to making sculpture and

to devising a totally new kind of monument which would be light, linear and open, not weighty and massive: in October, for instance, we know that he was working with González (see the essay by Marilyn McCully in this catalogue). A further point of interest about this notebook is that some of the flattest and most rigorously linear drawings of bathers made in August are like premonitions of the cut sheet-metal sculptures of the early 1960s (e.g. no.143).

65 Head of a Woman 1931
Tête de femme
Ink and wash on paper 33 × 25.5
(13 × 10)
Musée Picasso, Paris
Not in Zervos
Illustrated on p.94

This is inscribed in the bottom right corner Juan-les-Pins, 11 August 1931. It is a particularly fascinating case of Picasso working out precisely how he will, or might, make a sculpture, and it shows how intrigued he was by the possibility of making modelled, multi-part sculptures. In Juan-les-Pins he did not have a sculpture studio or materials, so drawing became a crucial means of remaining in touch with the activity that was currently his main obsession.

The first sketch at the top left corner of the sheet shows the head in schematic form with each component part numbered I to V. The five sections are then laid out as separate details. In the group of drawings on the right Picasso reintroduces modelling, and explores the spaces between the parts and the partly hidden section II. The main drawing imagines the realised sculpture strongly lit, as it would have appeared in the Boisgeloup studio where he often worked at night by the light of a lamp. In the event, Picasso never made a sculpture exactly like this, although the drawing relates specifically to three of the great plaster heads of Marie-Thérèse Walter he sculpted in June 1931 (nos.77, 79 and 'Bust of a Woman', s III).

66 The Studio 1933
L'Atelier
Pencil on paper 26.2 × 34.3 (10⅜ × 13½)
Musée Picasso, Paris
Z VIII.92
Illustrated on p.90

This drawing is inscribed in the bottom right corner 22 February 1933, but probably not in the artist's hand. Picasso contrasts the arts of painting and sculpture in schematic and witty fashion, dividing the drawing down the middle and allocating one half of the studio space to each: the painting on the easel is purely linear and as flat as the palette hanging on the wall behind, while the sculpture mounted on the table is heavily modelled. The irony is that the 'sculpture' was never actually made, but is a 'copy' of the bather in a painting Picasso had executed just two days earlier (no.98).

67 An Anatomy: Seated Woman 1933
Une Anatomie: femme assise
Pencil on paper 20 × 27 (7⅞ × 10⅝)
Musée Picasso, Paris
Z VIII.93
Illustrated on p.91

Dated 28 February 1933, but probably not in the artist's hand, this drawing was done at the same time that Picasso was making his celebrated series of drawings entitled 'An Anatomy', some of which were published in May in the first issue of the Surrealist periodical *Minotaure*. The same issue, which had a cover designed by Picasso, also carried André Breton's seminal essay on his sculpture, 'Picasso dans son élément', and over forty of Brassaï's photographs of the sculptures and studio at Boisgeloup. The difference between this drawing and the others in the series is that there is only one figure – instead of three – on the page, and she is seated on a chair, not standing on the ground. The 'Anatomy' drawings are probably the most self-consciously fantastic that Picasso ever made, and represent his most overt (albeit tongue-in-cheek) response to Surrealism, and to the challenge of creating Surrealist sculpture. They take to an extreme the idea of modelled sculptures assembled from various separate parts – an idea which, inevitably, was realised much more easily on the drawing-board than in the studio. But although the 'Anatomy' drawings seem to be absurd, Jarryesque fantasies, Picasso did go quite a significant way towards realising their formal and technical

implications later when, for instance, he made flamboyant use of found objects in 1935 (e.g. s 165), again during the Second World War (e.g. 'The Woman in a Long Dress', no.104), and then in Vallauris in 1949–53 (e.g. 'Pregnant Woman', no.106 and 'Little Girl Skipping', no.119). The sculpture which is closest of all to the 'Anatomy' drawings is, however, 'Man' (no.138), which, like some of them, equates the human figure with furniture.

68 The Vollard Suite: The Sculptor's Studio 1933
La Suite Vollard: L'Atelier du sculpteur
Etchings on copper
Musée Picasso, Paris
Illustrated on p.100–3 (six exhibited)

i) **Sculptor, Seated Model and Sculpted Head** 23 March 1933
Sculpteur, modèle accroupi et tête sculptée
Second State 26.9 × 19.4 (10⅝ × 7⅝)
G II.308

ii) **Sculptor with Two Sculpted Heads** 26 March 1933
Sculpteur et deux têtes sculptées
First State 26.7 × 19.4 (10½ × 7⅝)
G II.310

iii) **Sculptor at Rest with a Sculpture of Horses and a Bull** 31 March 1933
Le Repos du sculpteur devant des chevaux et un taureau
First State 19.4 × 26.7 (7⅝ × 10½)
G II.319

iv) **Sculptor at Rest with a Sculpture of a Centaur and a Woman** 31 March 1933
Le Repos du sculpteur devant un centaure et une femme
First State 19.4 × 26.8 (7⅝ × 10½)
G II.320

v) **Sculptor at Rest and Surrealist Sculpture** 31 March 1933
Le Repos du sculpteur et la sculpture surréaliste
First State 19.3 × 26.7 (7⅝ × 10½)
G II.322

vi) **Model and Large Sculpture Seen from the Back** 4 May 1933
Modèle et grande sculpture de dos
Fourth State 26.8 × 19.3 (10½ × 7⅝)
G II.345

The famous 'Vollard Suite' is an album of one hundred etchings created by Picasso between 1930 and 1937. It is generally classified into the following sections: twenty-seven separate sheets dealing with various themes; 'Battle of

Love' (five sheets); 'The Sculptor's Studio' (forty-six sheets); 'Rembrandt' (four sheets); 'The Minotaur' and 'The Blind Minotaur' (fifteen sheets); and finally three portraits of Ambroise Vollard made in 1937. The six etchings exhibited here all come from 'The Sculptor's Studio'. Forty of the forty-six plates in this 'chapter' were executed in a great burst of energy between mid-March and 5 May 1933, and the remaining six between January and March 1934: on some days Picasso made as many as four plates, and the sequence as a whole has been likened to a diary. The classical sculptor with his beautiful model is, of course, a thin disguise for Picasso himself and Marie-Thérèse Walter, and several of the sculpted heads that they contemplate with rapt attention are directly derived from the heads of Marie-Thérèse that Picasso had modelled at Boisgeloup in 1931. By contrast, the complex sculpted groups of horses and bulls or centaurs and women (as in iii and iv) find no echo whatsoever in Picasso's own sculpture.

Picasso made the great majority of the plates in the 'Vollard Suite' in 1933–4. But it is not clear exactly when or how Vollard commissioned the album from Picasso. According to Brigitte Baer, they probably came to an agreement that the copper plates go to Vollard as 'payment' for a Renoir and a Cézanne which Picasso had bought from him (a bill for the two pictures, dated 19 February 1934, has been discovered). Trial printing of the existing copper plates, by the master-printer Roger Lacourière, began in 1936, and it seems that it was only at this stage that Vollard began seriously to think of gathering them into one or two albums. Printing of the entire set was complete by 1939, the year in which Vollard died in a car accident. During the war the greater part of the edition of the 'Vollard Suite' was bought by the dealer Georges Petiet. The first sets were offered for sale in 1950 (see Bernard Geiser and Brigitte Baer, *Picasso peintre-graveur*, vol.I, Berne 1990, p.324).

69 **Two Figures** 1933
Deux figures
Pencil on paper 34 × 47.5 (13⅜ × 18¾)
Musée Picasso, Paris
Z VIII.95
Illustrated on p.92

This is inscribed at the top right corner Boisgeloup 12 April 1933. Not connected with any realised sculpture, it nonetheless creates a very similar effect to that of the plaster reliefs of Marie-Thérèse Walter's profile head which Picasso modelled in the autumn of 1933 (s 138–41). The reliefs share with the drawing a similar strength of contrast between the bumps and the hollows and a quasi-automatic freedom and intricacy of line. In the drawing itself Picasso contrasts an essentially pictorial with an essentially sculptural treatment of the same motif – something he had often done in separate Boisgeloup paintings, which tend to veer between extremes of decorative flatness and sculptural massiness.

70 **Bathers** 1933
Baigneurs
Ink and pencil on paper 22.9 × 28.9 (9 × 11⅜)
Private Collection
Z VIII.127
Illustrated on p.93

This is inscribed Boisgeloup 18 April 1933 in the bottom right corner. It belongs to a series of drawings of a couple making love on the beach executed between 18 and 22 April (z VIII.100–11, 114). All of them are savagely erotic, but most are drawn in a pure, fine outline which is the absolute antithesis of the heavy modelling employed in this one. In his sculpture Picasso always avoided narrative, and thus subjects like this: indeed, until the 1950s there are not even any groups in his sculptural oeuvre, and then only a few. But the drawing does share characteristics with the more loosely composed, fluently linear sculptures made at Boisgeloup, such as a 'Reclining Bather' of 1931 (s 109) and the profile heads of 1933 discussed under no.69.

71 **Composition** 1933
Pastel and charcoal on paper 34 × 51 (13⅜ × 20⅛)
Christine Ruiz-Picasso
Z VIII.148
Illustrated on p.94

This drawing is inscribed 19 November 1933, the day on which Picasso made another savagely hilarious pastel of a grotesque body-head which fuses male and female genitalia (MP 1116). Picasso did not attempt to make a sculpture like this in the 1930s. But in 1948–9, liberated by the experience of turning a gas burner into 'The Venus of Gas' (no.44), he did make a series of atavistic fertility goddesses (including no.45), which are slightly reminiscent of these two drawings. In another respect this drawing tells much about Picasso's aspirations as a sculptor: it gives the compelling impression that this is an ancient lidded stone tomb – at the very least the size of a man.

72 **Various Studies: Head of a Woman** 1936
Feuille d'études: tête de femme
Ink on paper 26 × 34 (10¼ × 13⅜)
Musée Picasso, Paris
Z VIII.283
Illustrated on p.91

The drawing is inscribed 16 April 1936. It was executed in Juan-les-Pins where Picasso was staying with Marie-Thérèse Walter and their six-month-old daughter, Maya. The framed drawing for a painting in the top left corner is annotated with details of colours. The grotesque heads, which seem to have sprung from this drawing, are numbered 1 to xv, and demonstrate the extraordinary fertility of Picasso's imagination when he allowed it free rein, as he frequently did when sketching. Fantasies for sculptures which he did not realise at the time, they not only relate back to some of the heads Marie-Thérèse inspired in 1931 (e.g. no.79), but look forward to the 'fertility goddesses' of the late 1940s, which were executed around the time of the birth of his two children by Françoise Gilot (e.g. no.106).

4 Classicism and Metamorphosis

SCULPTURES

73 Metamorphosis I 1928
Métamorphose I
Bronze 22.8 × 18.3 × 11 (9 × 7¼ × 4⅜)
Musée Picasso, Paris
s 67.II
Illustrated on p.123

Sketchbook drawings relating to this sculpture date back to the spring and summer of 1927 and are connected with the flowering of Picasso's love affair with Marie-Thérèse Walter (see Carnet 061, especially ff.17, 18 and 37; the sketchbook was in use between December 1926 and May 1927). As Peter Read establishes in his essay in this catalogue, the drawings for 'Metamorphosis' were among those Picasso proposed as possible designs for the monument he had been commissioned to sculpt for the tomb of Guillaume Apollinaire in the Père Lachaise cemetery in Paris. But when he showed them to members of the committee overseeing the commission in November or December 1927, they were rejected as potentially obscene. Picasso went ahead anyway and modelled the sculpture early in 1928, and illustrations of the original plaster were published on several occasions later that year, including André Level's monograph on Picasso, where it was captioned 'Composition', and dated 1928 (pls.58–9).

'Metamorphosis' exists in two variant forms. In the second version – reproduced here is the first – the facial features on one side are more marked and more emphatically sexualised. Both versions survive in their original plasters, and one bronze cast was made of each.

74 Figure: Project for a Monument to Guillaume Apollinaire 1928/c.1962
Figure: Projet pour un monument à Guillaume Apollinaire
Wire 95 (37⅜) high
Private Collection
s 69A
Illustrated on p.107

This is a later enlargement of a wire construction about sixty centimetres high (s 69) which was made in October 1928, to Picasso's specifications, by Julio González in the latter's metal-working studio in the rue de Médéah in Paris. In August 1928 Picasso made drawings for it and other similar constructions in a notebook he used during his summer holidays in Dinard (no.64), and they served as blueprints for González (see pp.200–1 above for full details). González appears to have made four wire constructions in all (s 68–71): they can be seen in photographs Brassaï took in 1932 in Picasso's apartment on the rue La Boëtie. One of them has since disappeared, but the other three are preserved in the Musée Picasso in Paris.

The four wire constructions of 1928 were projects for the memorial to Apollinaire, but were rejected by the commissioning committee to whom they must have seemed like the absolute antithesis of all that would be proper in a monument. According to Tériade, who saw them in November 1928, Picasso hoped that one day they would be built on a larger scale using iron rods or some other resistant material ('Une visite à Picasso', *L'Intransigeant*, 27 Nov. 1928, p.6). The present enlargement went some way towards realising that wish, although exactly when it was made or in what circumstances have not been fully established: Picasso certainly supervised the work, however, and kept the sculpture in Mougins. The artist's son, Claude, believes it was made in the early 1960s, and according to Roland Penrose, when he first approached Picasso in 1963 to ask him to design a twenty-metre monument for the new Civic Center in Chicago, the artist initially 'proposed that they should make an enlargement of the wire "space" sculpture of 1928' (*Picasso: His Life and Work*, Harmondsworth 1971, p.455). In the event a quite different design was used for Chicago (s 643), but Picasso may have made the suggestion because more modest enlargements of the wire constructions already existed. (See also no.75.)

75 Figure: Project for a Monument to Guillaume Apollinaire 1928/c.1962
Figure: Projet pour un monument à Guillaume Apollinaire
Painted steel rods 198 × 159.4 × 72.3 (78 × 62⅞ × 29½)
The Museum of Modern Art, New York. Gift of the Artist, 1979
s 68B
Illustrated on p.106

Like no.74, this is a later enlargement, but on a grander scale, of one of the wire constructions (s 68; Musée Picasso, Paris) made in October 1928 by Julio González to Picasso's specifications. The original construction was proposed as a maquette for the monument to Apollinaire, but was rejected by the commissioning body. There is also an intermediate enlargement (s 68A), just under one metre high, which was presumably made at the same period as no.74.

According to documents in the Musée Picasso archive, Picasso supervised the making of the present two-metre enlargement, which was constructed from a steel disc for the head and steel rods of three different thicknesses. There is some uncertainty about the precise date of manufacture, but the Museum of Modern Art catalogues it as 1962. Picasso, who kept it in the sculpture studio at Mougins, gave it to the museum in 1972, with the intention that it be used as the maquette for a four-metre enlargement in CorTen steel of the same construction (s 68c). The four-metre version was made in 1972 in New York. Picasso not only authorised it, but chose the materials, asserting that four metres was the height he had originally wanted the monument to be. As with Carl Nesjar's enlargements in concrete of other works, Picasso only ever saw photographs of the new sculpture, which was set up in the museum's sculpture garden.

76 Head of a Man 1930
Tête d'homme
Iron, brass and bronze 83.5 × 40.5 × 36 (32⅞ × 16 × 14⅛)
Musée Picasso, Paris
s 80
Illustrated on p.112

This sculpture was made in the summer or autumn of 1930 by Picasso and Julio González in the latter's metal-working studio in the rue de Médéah in Paris. There are many surviving drawings relating to it, two of which are inscribed Boisgeloup 20 July 1930 (Carnet 020, ff.45r, 46; MP 1990–109), and another 19 October 1930 (Succession of the Artist, inv.3405). (See Peter Read's essay in this catalogue for a full discussion. He believes that parts of the head were beaten and welded by González, but other parts by Picasso himself.) To judge by these drawings, Picasso originally intended to mount the metal head on the aggressively sexualised body of a quasi-mythological, god-like figure, but was undecided about what form exactly the body should take. Indeed, when the sculpture as we know it was first reproduced, it was captioned 'Detail of a monument' (Eugenio d'Ors, *Pablo Picasso*, Paris 1930 (date of printing 15 December), pl.48). Although no body was ever made,

'Head of a Man' was, clearly, another of Picasso's abortive projects for the monument to Apollinaire. In this context it is significant that, with its megaphone mouth, it is somewhat reminiscent of the costume Picasso designed in 1917 for the American Manager in Diaghilev's production of the Satie–Cocteau ballet *Parade*. Apollinaire was closely associated with *Parade* in Picasso's mind because he had written an introduction to the programme for the first performance.

77 Head of a Woman 1931
Tête de femme
Bronze 86 × 32 × 48.5 (33⅞ × 12½ × 19)
Städelsches Kunstinstitut, Frankfurt am Main. Eigentum des Städelschen Museums-Vereins e. V
S 132.11b
Illustrated on p.118

This is a cast of one of the works Picasso made in plaster (rather than clay) in Boisgeloup soon after he had installed sculpture studios there in the spring of 1931. He must have completed the original plaster by 13 June 1931 as it is shown mounted on a sculptor's stand in a dated drawing of the studio (Carnet 068, f.81; Succession of the Artist). A couple of drawings done in Juan-les-Pins that August (including no.65), appear to conflate this 'Head' with the multi-part 'Head of a Woman' (no.79). We are perhaps entitled to see that sculpture as a logical development of the implicit separation of the parts of the woman's head in the present work.

Apart from the original plaster, there is also a surviving plaster cast – the *plâtre de travail* (both are in the Succession of the Artist). In 1937 a cement cast was made for exhibition in the Spanish Republican Pavilion at the International Exhibition in Paris, where Picasso showed five sculptures in all as well as the Guernica mural. (The cement is now in the Musée d'Antibes.) During the Occupation, Picasso had the sculpture cast once in bronze. In 1973 two further bronze casts were made at the Valsuani foundry: this is one of them.

78 Bust of a Woman (Marie-Thérèse) 1931
Buste de femme (Marie-Thérèse)
Plaster 78 × 46 × 48 (30¾ × 18⅛ × 18⅞)
Private Collection
S. 131.1a
Illustrated on p.117

This is the original plaster of the most imposing and serene of the statues of Marie-Thérèse Walter. It belongs to the same moment as no.77, and is shown next to it on a sculptor's stand in Picasso's drawing of the studio at Boisgeloup dated 13 June 1931 (Carnet 068, f.81). Picasso clearly recognised the work as a masterpiece for it appears in a painting executed on 7 December, which depicts a bearded sculptor in his studio contemplating a very similar bust of a woman which has been mounted on a plinth (i.e. 'The Sculptor', MP 135). The painting was executed in Paris as a memory-image – a reflection on the meaning of his most recent works as well as a homage to the woman who inspired them: clearly Picasso was taking stock, and perhaps wondering about the way forward for his next sculptures.

Apart from the original plaster modelled by Picasso, a plaster cast of this sculpture also survives (Succession of the Artist). Two further casts were made – one in cement for exhibition in the Spanish Republican Pavilion at the International Exhibition in Paris in 1937, and one in bronze during the Occupation. Both are in the Musée Picasso, Paris.

79 Head of a Woman 1931
Tête de femme
Bronze 71.5 × 41 × 33 (28⅛ × 16⅛ × 13)
Musée Picasso, Paris. En dépôt au Musée National d'Art Moderne, Centre Georges Pompidou
S 110.11
Illustrated on p.120

Thanks to a series of drawings in a sketchbook Picasso used in Boisgeloup, we know he had arrived at the definitive design for this sculpture by 28 June 1931 (Carnet 068, f.90; Succession of the Artist), having started to develop the idea for it at least two weeks earlier (ibid., ff.73 and 86–8; drawings dated 12–14 June 1931). The penultimate sheet of drawings, dated 26–7 June 1931 (ibid., f.89), is particularly interesting because it suggests that Picasso had a more complex scheme in mind, which he presumably abandoned as unworkable. The latter sheet gives several views of a multi-part sculpture of a half-length reclining woman, who leans her head on her right arm, and whose left arm (which

is detached and treated like a giant sausage) curves round and encloses her two perfectly spherical breasts. The phallic connotations of the work in this form are even more pronounced than in the definitive sculpture. But the drawings are also important because they draw attention to the fact that the bone-like 'neck' of the sculpture should also be read as an arm supporting a pensive head.

Picasso's sketches later the same summer (e.g. MP 1058, 'Reclining Bather', 13 August 1931) reveal that he continued to be fascinated by the idea of a sculpture that combined modelling in the round with fragmentation and construction. A drawing dated 6 October 1931 shows a multi-part full-length reclining figure whose head is based on the present sculpture (Succession of the Artist, inv.3425), and the plaster of his 'Reclining Bather' (*circa* September 1931; S 109.1) is actually in separate parts which slot together on the low plinth. Usually, however, practical considerations meant that he had to be satisfied with painting, rather than making, such sculptures, and 'Head of a Woman' remains his most daring and thorough-going experiment in this genre. Picasso must have modelled the sculpture in plaster shortly before he went on his summer holidays to Juan-les-Pins, and this, the unique bronze cast, was made in the Robecchi foundry some years later – when exactly is uncertain. (The original plaster also belongs to the Musée Picasso, Paris.)

80 Head of a Woman in Profile (Marie-Thérèse) 1931
Tête de femme de profil (Marie-Thérèse)
Plaster 69 × 60 × 10 (27⅛ × 23⅝ × 4)
Marina Picasso. Courtesy Galerie Jan Krugier, Geneva
S 130.1
Illustrated on p.115

This is Picasso's original plaster. A much more naturalistic and classical portrait of Marie-Thérèse Walter than 'Head of a Woman' (no.77), it is somewhat reminiscent of the style of Roman coins, and was done either shortly after, or more probably shortly before, Picasso's summer holidays in Juan-les-Pins. A drawing made in Boisgeloup, which was certainly done from the sculpture – it reproduces the irregular shape of the background – is dated 6 September 1931 (Carnet 068, f.93; Succession of the Artist). A single bronze cast was made, probably during the Occupation.

which may represent a sculptor's tripod or stand, stabilises the composition and reinforces the painting's monumentality.

92 Head: Study for a Monument 1929
Tête: Projet pour un monument
Oil on wood 73 × 59.7 (28¾ × 23½)
*The Baltimore Museum of Art. The Dexter
M. Ferry, Jr. Trustee Corporation Fund 1966*
Z VII. 273
Illustrated on p.121

The painting is inscribed 1929 on the back, and drawings for, or possibly of, it are dated 13 June 1929 (Carnet 018, ff.55–6; MP 1875). At this period Picasso was working closely with Julio González on his various projects for a monument to Apollinaire, and this painting, like a series of others more or less contemporary with it, is evidently a surrogate sculpture. Picasso's composition suggests a scale so vast and a position so dominant that the great phallic head is on a level with the clouds: he had to wait over thirty years to see his sculpture attain a comparable monumentality with the execution of a twenty-metre high 'Head' in CorTen steel for the Chicago Civic Center (S 653). Of the sculptures which Picasso actually realised at the time, the Baltimore painting is perhaps closest of all to 'Head of a Woman' 1931 (no.79).

93 Study for a Sculpture 1932
Etude pour une sculpture
Charcoal on canvas 92 × 73 (36¼ × 28¾)
Beyeler Collection, Basel
Not in Zervos
Illustrated on p.121

Instead of being a study for a sculpture, this powerful drawing on canvas seems, rather, to provide us with a variant of the heads of Marie-Thérèse Walter Picasso modelled in plaster at Boisgeloup in 1931. It is also closely related to a drawing of a woman's head in profile which is dated 5 December 1931 (MP 1067). Having worked intensively in his newly installed sculpture studio in 1931, Picasso gave more of his time to painting and printmaking in 1932–3. But the obsession with sculpture as such did not diminish, for now many of his paintings, his most finished drawings and his prints turned on the theme of the sculptor's studio, incorporated busts in still-life compositions, or as closely as possible imitated the surface effects of plaster in oil paint. Thus this head on its square plinth is actually even closer to a sculpted

head pictured in the still-life 'Plaster Head and Bowl of Fruit' (dated 29 January 1933; Fogg Art Museum) than to any sculpture Picasso actually made.

94 Figures by the Sea 1932
Figures au bord de la mer
Oil and charcoal on canvas 130 × 97
(51¼ × 38⅛)
Private Collection
Not in Zervos
Illustrated on p.111

This is dated 2 January 1932 on the back. Picasso's ambition to make sculpture of colossal scale celebrating the erotic principle was rarely more explicit than in this extraordinary picture of two heads locked in a kiss and bestriding a small Mediterranean house. Sketches in a notebook Picasso used in Paris in June 1928 reveal that the idea for a sculpture of the kiss was already some four years old (Carnet 021, especially ff.2–6 and 34–6): the welded metal 'Head' of October 1928 (no.40) was a first attempt to realise it. Needless to say the astonishing scheme Picasso toyed with in this painting remained a fantasy.

95 Still Life: Bust, Bowl and Palette 1932
Nature morte: Buste, coupe et palette
Oil on canvas 130.5 × 97.5 (51⅜ × 38⅜)
Musée Picasso, Paris
Not in Zervos
Illustrated on p.119

This is dated 3 March 1932 on the stretcher. Here, as in many paintings, drawings and prints of the Marie-Thérèse period, Picasso reflects on the relationship in his work between painting (symbolised by the palette) and sculpture (symbolised by the bust). The style of the painting as a whole seems intended to dramatise the oppositions between pictorial flatness and sculptural mass in the oppositions between pure line and bold areas of colour on the one hand and gradations of light and dark on the other. The sculpted head is a synoptic reference to the earlier series of plaster heads inspired by Marie-Thérèse (including no.81). The same head, raised on a tall plinth and sometimes garlanded with vines, is an object of veneration in several of the etchings in the 'Vollard Suite' (no.68).

96 Reclining Nude 1932
Femme nue couchée
Oil on canvas 130 × 161 (51⅛ × 63⅜)
Private Collection
Z VII.331
Illustrated on p.123

From an inscription on the back we know that this was painted at Boisgeloup on 2 April 1932. Another canvas of the same size with a similar composition was painted two days later, but has an indoor, harem-like setting and is richly coloured and highly decorative (MP 142). The canvas exhibited here is, by contrast, extremely austere, and is like a painting of a stone or plaster sculpture. Picasso was fascinated by the intrinsic differences between the two art forms that he was practising at Boisgeloup, and would often use painting, drawing and printmaking in order to meditate upon those differences. These two pictures were surely conceived of as a pair – the one being about sculpture, the other about painting. The 'sculpture' in our painting is related to the loose-limbed 'Reclining Bather' on a low plinth, which Picasso had modelled in plaster in 1931 (S 109), but she is both more pneumatic and more gravity-defying.

97 Games and Rescue on the Beach 1932
Jeu de plage et sauvetage
Oil on canvas 97.5 × 130 (38⅜ × 51¼)
Private Collection
Z VIII.64
Illustrated on p.126

This painting is one of a series on the same theme executed in November 1932. It is connected with Picasso's memories of Marie-Thérèse Walter, who was a powerful swimmer, and her girlfriends playing by the seaside, and with some real or imagined near-fatal incident. Although at first sight the painting is the absolute antithesis of the sculptural, in fact it relates specifically to a group of small-scale sculptures of bathers running on the shore and, in one case, playing ball which Picasso modelled in 1931–32 (nos.82, 84–5 and S 113–14). To a remarkable degree, moreover, it anticipates much later sculptures which are notable for their flatness and their razor-sharp silhouettes – in particular his group of 1956, 'The Bathers' (fig.11 on p.34), which was assembled from planks of wood, batons and stretchers, and also the painted sheet-metal sculptures of the early 1960s (nos.143–4).

98 Seated Nude 1933
Nu assis
Oil on canvas 130 × 97 (51¼ × 38¼)
Kunstsammlung Nordrhein-Westfalen,
Düsseldorf
z VIII.91
Illustrated on p.125

This is dated 20 February 1933 on the stretcher. While it refers back to the sculptures Picasso modelled in Boisgeloup in 1931, especially to 'Bather' (no.82), it also anticipates 'Woman with a Vase' (no.99), his one truly monumental sculpture of a female nude to survive from this period. Even more explicitly than that work, the nude in this painting calls to mind the bunched and bulging forms of prehistoric fertility figures, such as the Venuses of Lespugue and Willendorf. That she is indeed a surrogate sculpture is suggested by the drawing Picasso made two days after completing the canvas in which she is depicted mounted on a table and contrasted with a painting of a reclining nude ('The Studio', no.66). The rather rough, grainy modelling of the body in the painting imitates the surface effects Picasso particularly sought in plaster.

5 Death and Transformation

SCULPTURES

99 The Woman with a Vase 1933
La Femme au vase
Bronze 219 × 122 × 110
(86¼ × 48 × 43¼)
Museo del Prado, Madrid
s 135.II
Illustrated on p.130

Along with other recent works, the original plaster of 'The Woman with a Vase' was photographed at Boisgeloup by Bernès-Marouteau in the winter of 1934. When the photograph was published in a special issue of *Cahiers d'Art* devoted to Picasso's work of 1930–5 (vol.10, no.7–10, 1935), the sculpture was dated 1933 (it is dated summer 1933 in the Spies catalogue). However, the work seems to be anticipated by several drawings dating from April 1929 depicting a female bather of very similar shape and form but with her arms raised above her head (Carnet 018, f.26; MP 1875) and by the full-length female nude in the background of the contemporary oil, no.91.

With its great scale, this fertility goddess was one of Picasso's most truly monumental sculptures to date, and was a natural choice for public exhibition in 1937 at the International Exhibition in Paris. Along with three other large-scale sculptures by Picasso (including nos.77–8) it was cast in cement to prevent any possible damage, and was exhibited in front of the south side of the Spanish Republican Pavilion. In this position, 'The Woman with a Vase' was close to the Polish Pavilion and was the cause of much irritation to the Polish commissioner, who repeatedly requested its removal on the grounds that it might be assumed to be the work of a Polish sculptor (see Catherine Blanton Freedberg, *The Spanish Pavilion at the Paris World's Fair*, 2 vols., New York 1986, pp.317–23). The cement cast appears to have been lost or destroyed, and there is no record of it in the succession of the artist. Two bronze casts were made right at the end of Picasso's life in the Valsuani foundry. It was his wish that one should go to the Prado to be reunited with the 'Guernica' mural which he had painted in 1937 for the Spanish Republican Pavilion. Ten days after his death his widow had the other cast set up over his grave in the garden of the Château de Vauvenargues. Presumably in obedience to

Picasso's wishes, the plaster was then destroyed. (Information from Brigitte Baer and Brigitte Léal.)

100 Woman Leaning on her Elbow 1933
Femme accoudée
Bronze 62.2 × 42.5 × 28.9
(24½ × 16¾ × 11⅜)
Musée Picasso, Paris
s 153.II
Illustrated on p.132

This is the only bronze cast from the original plaster, which Picasso modelled in his sculpture studios in Boisgeloup. Bernès-Marouteau photographed the plaster there in the winter of 1934, and when the photograph was reproduced in *Cahiers d'Art* twelve months later, in a special number devoted to Picasso's work in 1930–5, the sculpture was dated 1933. This was the year in which Picasso first tried out a new technique which involved taking impressions from various commonplace materials or objects in the wet plaster. In 'Woman Leaning on her Elbow' the principal materials he used were wood and crumpled corrugated paper. Although the style and technique of the work is extremely unconventional, the pose is a direct quotation from classical and neo-classical statues of figures supported against tree-trunks or columns.

101 The Orator 1933 or 1934
L'Orateur
Plaster 183 × 66 × 27 (72 × 26 × 10⅝)
Private Collection
s 181.I
Illustrated on p.132

This is the original plaster which Picasso modelled in Boisgeloup, using impressions of thick corrugated paper to form the folds of the drapery and of chicken wire for the torso, and a rough wooden stick to support the head, which was modelled over a disc. The drapery is reinforced at the back by a mass of plaster which is invisible from the front. The work has recently been restored and the stone base is a new addition. The single bronze cast, which was made before the outbreak of the war, is in the Musée Picasso, Paris. For many years the bronze did not have a stone base either, and there are snapshots showing it outdoors with the stake driven directly into the ground. Lionel Prejger has confirmed that he supplied the stone base for

the bronze in the 1950s (see the interview with Prejger in this catalogue, p.252).

'The Orator' has always hitherto been dated 1937, but it must have been modelled in 1933 or 1934 because it is just visible behind the plaster of 'The Woman with a Vase' (no.99) in an unpublished photograph taken by Bernès-Marouteau in the Boisgeloup sculpture studio in the winter of 1934. (This photograph is preserved in the MP Archive. Another photograph taken on the same occasion confirms that the closely related 'Head' (s 217), which Spies also dates 1937, was modelled in 1933 or 1934.)

The sculpture as we know it does not appear to have a specific political meaning, but instead seems to be a daring reinterpretation of the standard classical subject of the orator exhorting his audience. Nevertheless, in 1936–7 Picasso used the figure in several specifically political drawings which reflect his response to the dramatic events of the period. Thus he appears in the background of a drawing Picasso made on 13 June 1936, known as 'The 14th of July' (MP 1167), which depicts a crowd rioting in front of the burning Bastille. Then on 19 April 1937 Picasso made two sheets of sketches, one of them on the front page of the newspaper *Paris-soir* (MP 1190 and 1177), which include a figure derived directly from 'The Orator', except that he is brandishing a hammer and sickle in his raised left fist. These drawings are connected with Picasso's original idea for the mural he had been commissioned to paint for the Spanish Republican Pavilion at the Paris International Exhibition of 1937: at this stage he envisaged a painting on the theme of the artist and model. The bombing of Guernica on 26 April led, of course, to a radical revision of these plans, although the fallen and fragmented plaster figure in the foreground of the mural is surely related at some level to 'The Orator'.

102 **Death's Head** ?1941
Tête de mort
Bronze 25 × 21 × 32 (9⅞ × 8¼ × 12⅝)
Mr and Mrs Rafael Lopez Cambil
s 219.II
Illustrated on p.136

This is one of two casts made during the Occupation from the plaster original. It was one of the five sculptures included in the special retrospective devoted to Picasso's work in the Liberation Salon, October–November 1944.

'Death's Head' has been dated 1943 in the recent scholarly literature, and has often been seen as the tragic counterpart to the more optimistic 'The Man with a Sheep', which was definitely modelled in 1943 (no.105). However, it may date from as much as two years earlier. Pierre Malo, in an account of his visit to the rue des Grands-Augustins in early August 1941, describes going into the bathroom, where Picasso had installed a makeshift sculpture studio, and seeing 'a mocking death's head in the place of the sponge-bowl' ('Picasseries et Picasso', *Comoedia*, 30 August 1941, p.6). While it is true that Malo could be referring to any one of the five small death's heads (which Spies also dates 1943; s.212–16), this seems unlikely given their tiny scale and their considerable abstraction. The bronze cast of 'Death's Head' was certainly in existence by May 1943 when Françoise Gilot saw it lying on the floor of the rue des Grands-Augustins apartment (see Françoise Gilot and Carlton Lake, *Life with Picasso*, Harmondsworth 1966, p.15).

Unfortunately, drawings and paintings in which skulls appear are of little help in settling the question of the date of this magnificent sculpture: there are literally dozens of them dating from the outbreak of the war. Moreover, works like the oil 'Skull and Pitcher' (z XIII.89) and the related sketchbook drawing (Carnet 201, f.34), which look particularly like the sculpture, are dated 15 and 19 August 1943 and are, therefore, definitely later than it.

103 **Bull's Head** 1942
Tête de taureau
Bronze 42 × 41 × 15 (16½ × 16⅛ × 5⅞)
Private Collection
s 240.II
Illustrated on p.134

'Bull's Head' has often been published as a work of 1943, which may be the date of the present bronze cast. However, the original assemblage, which Picasso soldered roughly together himself and which is now in the Musée Picasso in Paris, was in existence by April 1942, when it was published with the title 'Objet (1942)' on the cover of *La Conquête du Monde par L'Image*, Paris. According to the artist's son, Claude Ruiz-Picasso, Picasso regarded the bronze cast as the true sculpture. When the inventory of his estate was being drawn up following his death, the original saddle and handlebars were discovered, but in separate rooms, the object having come apart at some point. They were fixed back together in 1984 using the bronze as a guide. There is a second bronze cast of both sections, which had not, however, been assembled at the time of the inventory.

'Bull's Head' was one of the five sculptures Picasso included in the special retrospective devoted to his work in the Liberation Salon, which opened in Paris in October 1944. He was clearly very attached to it and often described how he had found the bicycle parts by chance and 'seen' them immediately as a bull's head, adding that, ideally, one day a cyclist would find his assemblage in a tip and 'see' it as a saddle and handlebars: in that way there would be a 'double metamorphosis'.

Picasso's account of his discovery of the bicycle parts varied quite considerably in the telling. On one occasion, late in life, he said that he saw them when he was on the way to a funeral and, having thought about them during the service, picked them up on the way home (Robert Otero, *Forever Picasso: An Intimate Look at his Last Years*, New York 1974, pp.91–2). If this story is true, the funeral could have been that of Picasso's great friend, the sculptor Julio González, who died on 27 March 1942 (Picasso was a principal mourner at the funeral). Even if it is not strictly true, it is quite likely that 'Bull's Head' was closely associated for Picasso with González, for he painted three still lifes of a steer's skull in early April 1942 (including no.112) in homage to González. It would have been a fitting memorial for a Spaniard, and for the man who taught him to weld metal and helped him make his metal sculptures in 1928–31.

104 **The Woman in a Long Dress** 1943
La Femme en robe longue
Bronze 161.3 × 54.6 × 45.7
(63½ × 21½ × 18)
Estate of Mark Goodson, New York
s 238.II
Illustrated on p.133

In September 1943 Picasso told Brassaï, who was systematically photographing his sculptures in the rue des Grands-Augustins studio, how he had made this sculpture (see Brassaï's *Conversations avec Picasso*, Paris 1964, pp.75–6). He had found the belle époque dressmaker's wooden dummy in the flea market in Paris, and was greatly struck by its 'marvellously sculpted' form. To complete the figure, he roughly modelled the right arm himself, but the left arm was made with a wooden arm – said to have come from Easter Island – which was a present from Pierre

Loëb, an important dealer in tribal art. The head was one Picasso modelled in 1942 (s 238A), creating the high-necked fluted collar by pressing corrugated paper into the plaster. Although it seems more likely that the head pre-existed the idea of making this assemblage, it is possible that he modelled the head to go with the dummy. Picasso later told Werner Spies that he had asked Paul Eluard to procure some shoes so that he could add them to the sculpture. Eluard returned with a pair of his mother's shoes, but Picasso never used them (Werner Spies, *Picasso Sculpture: With a Complete Catalogue*, London 1972, p.269 n.114). Brigitte Baer believes that the work is a secret memorial 'portrait' of the artist's mother, who died suddenly in January 1939 (see her essay in *Picasso im Zweiten Weltkrieg*, exh. cat., Museum Ludwig, Cologne 1988, pp.49–79).

The whole assemblage was cast in bronze during the Occupation, probably soon after it was made, and became something of a favourite with Picasso. According to Harriet and Sidney Janis (*Picasso. The Recent Years, 1939–1946*, New York 1946, caption to pl.130), he referred to the sculpture affectionately as 'La Belle Ferronnière' – a joking allusion to the famous painting in the Louvre attributed to Leonardo da Vinci. On one occasion, 13 December 1946, when Brassaï was once again photographing the sculptures, he found Picasso in a state of high excitement. He had dressed the bronze woman in an artist's white overall, equipped her with a palette and brushes and set her up in front of a huge canvas in a malicious parody of the traditional *artiste peintre* (Brassaï, op. cit., pp.298–9: see fig.1 on p.14). A second bronze cast of the various parts of the sculpture exists, but had not been assembled at the time of the posthumous inventory of the artist's collection. Extra casts of the head were also made, and in 1952 Picasso painted one of them in a palette of greys and blacks (MP 325).

105 **The Man with a Sheep** 1943
L'Homme au mouton
Bronze 222.5 × 78 × 78
(87½ × 30¾ × 30¾)
Philadelphia Museum of Art. Gift of R. Sturgis and Marion B.F. Ingersoll
S 280.II
Illustrated on p.131

The original of this, Picasso's most celebrated monumental sculpture, was modelled in clay in his studio in the rue des Grands-Augustins

in February or March 1943. Having taken delivery of a large quantity of clay, Picasso worked extremely fast, completing it in one or two days (accounts vary slightly). The iron armature was not substantial enough, and at one point the statue began to collapse and had to be steadied with ropes. The lamb later fell out of the man's arms and had to be wired back into position. According to the account given by Brassaï, Picasso was aided by Paul Eluard, who happened to be in the studio the day Picasso began work on the sculpture, and also by his chauffeur, Marcel (Brassaï, *Conversations avec Picasso*, Paris 1964, p.226). Picasso had apparently intended to work further on the legs of the figure, but because the clay statue was so unstable he decided to have a plaster cast made as soon as possible without making any revisions.

Between 1948 and 1950 three bronze casts were made in the Valsuani foundry, one of which Picasso donated to the town of Vallauris. Initially, the Vallauris bronze was displayed in the chapel, but it was moved to the market square and inaugurated there in August 1950. Picasso himself felt that its impact was thereby diminished, and regretted the change. He kept the plaster cast, which was made in interlocking sections (*à la romaine*), and one of the bronzes until his death, always regarding the sculpture as one of his greatest works.

Picasso was able to execute the clay model at such speed partly because he was not attempting to achieve a fine, polished finish, but largely because he had been planning the statue for many months. The idea for the image originated in an etching dated 14 July 1942 showing a man carrying flowers, and the first preparatory drawings were made later in the same month. Many dozens followed, Picasso's conception of the figure altering quite significantly (thus, in the earlier drawings, the man is much younger). The classical sources and the symbolism of the sculpture have been much discussed by scholars, and it has been interpreted as offering a Christian message of hope and renewal during the dark days of the Occupation. However, Picasso himself resisted any specifically religious reading: 'There's nothing religious about it at all. The man might just as well be carrying a pig, instead of a lamb. There's no symbolism in it. It's merely beautiful … In *The Man with a Sheep* I have expressed a human feeling, a feeling that exists now as it has always existed' (quoted in *Musée Picasso: Catalogue sommaire des collections*, vol.1, Paris 1985, p.145).

106 **Pregnant Woman** 1949
Femme enceinte
Bronze 130 × 37 × 11.5
(51¼ × 14½ × 4½)
Musée Picasso, Paris
S 347.II
Illustrated on p.140

This is one of two bronze casts (made in the Valsuani foundry) from an assemblage of plaster and a long iron rod. It was probably one of the first sculptures Picasso made in the studio in the rue du Fournas, Vallauris, which he acquired in the late spring of 1949, and it was preceded by a smaller sculpture of similar design, known as 'Small Pregnant Woman' 1948 (s 335). While commemorating the birth in April 1949 of Paloma, Picasso's daughter by Françoise Gilot, it is obviously a symbolic work with strong overtones of a tribal fetish.

An undated crayon drawing shows the figure as we know it, but here it is the front part of an animal of sorts (Succession of the Artist, inv.6361). The creature recalls Picasso's post-war representations of centaurs (including a terracotta sculpture made in 1948 (s 336A)), but, with its powerful back legs, shorter front legs, and its scut, looks distinctly like a hare.

107 **Head of a Woman with a Bow** c.1950
Grande tête sculptée au noeud
Ceramic 37 × 24 × 30
(14¼ × 9½ × 11¾)
Mr and Mrs Rafael Lopez Cambil
Illustrated on p.143

This monumental head was formed from a large wheel-turned clay shape ordered specially from the potter. While it was still malleable, Picasso moulded the clay into the form of the head, incised details such as the mouth, and then painted over the surface, scraping the paint here and there just as if he were working on canvas. It is one of several large, boldly painted pottery heads, and can be seen on the floor of the storeroom in Vallauris where he kept his ceramics in a photograph taken by Robert Doisneau in September 1952.

Geneviève Laporte, who was having an affair with Picasso at the time, Dominique Eluard had recently bought a Panhard Dyna, and its form 'evoked this image for Picasso' (*Sunshine at Midnight*, London 1975, p.42).

Picasso had always had a special fondness for monkeys, keeping one as a pet before the First World War. He was very pleased with this sculpture, referring to it affectionately as 'the ancestor' (André Verdet, *Entretiens: Notes et écrits sur la peinture: Braque, Léger, Matisse, Picasso*, Paris 1978, p.160). The sculpture was cast by Valsuani in an edition of six numbered bronzes, and first exhibited in Rome in May 1953.

121 **The Crane** 1951–2
 La Grue
 Painted bronze 75 × 29 × 43
 (29½ × 11⅜ × 16⅞)
 The Berggruen Collection on loan to the National Gallery, London
 s 461.11c
 Illustrated on p.155

The original sculpture, which is in the Musée Picasso in Paris, is an amalgam of various found objects and plaster. Françoise Gilot says that 'it was finding the shovel which formed the tail feathers that gave [Picasso] the idea of making the sculpture of a crane' (*Life with Picasso*, Harmondsworth 1966, p.308). For the neck Picasso used a length of twisted wicker, and for the feet two damaged forks, which he strengthened with wire. The head is a *tour de force* – a tap fitting combined with screw nuts and a bent spike. The original sculpture is visible, finished, in a photograph taken by Robert Picault almost certainly in 1951 (MP Fonds Picault, photo no.464). An edition of four bronze casts – six were originally envisaged – was made by Valsuani, and Picasso then painted each one with a different combination of bars and stripes. Two of the casts were made in 1952 and were exhibited simultaneously in Rome and Paris in May 1953. The other casts date from 1954.

In French 'grue' is slang for 'woman of easy virtue'. We can be sure that Picasso thought of his crane in anthropomorphic terms because in May 1953 he made a delightfully witty series of ink drawings of Parisians walking along a busy pavement in the Latin Quarter or gossiping and flirting in cafés, and on the back of one of them he made a rapid sketch of his 'Crane' (MP 1413r, 1413v; see also Succession of the Artist, inv.5167, 5273–5, 5189, 5192: several of these

drawings are dated 14 May 1953). The gait of men, women and bird is identical, and one of the walkers who appears in many of the drawings is a tall young girl with a ponytail tripping along in trousers and high heels.

122 **Little Owl** 1951–2
 Petite Chouette
 Painted bronze 26 × 18.7 × 14.6
 (10¼ × 7⅜ × 5¾)
 Hirshhorn Museum and Sculpture Garden, Smithsonian Institution, Washington. Gift of Joseph H. Hirshhorn, 1966
 s 475.11
 Illustrated on p.154

The original assemblage, which is in the Musée Picasso in Paris, was created out of the iron blade of a hoe, a pair of pliers, nails, screws and plaster. Exactly when Picasso made it is not certain, although the MP catalogue dates it 1951. Two bronze casts were made by Valsuani in 1952 and were then painted by Picasso. This cast on show here was exhibited for the first time at the Galerie Leiris in May 1953, and was there dated 1952.

123 **Little Owl** 1951–2
 Petite Chouette
 Plaster, screws, nails and metal objects
 33.5 × 22.5 × 19 (13¼ × 8⅞ × 7½)
 Marina Picasso. Courtesy Jan Krugier Gallery, New York
 s 477.1
 Illustrated on p.154

This is the original assemblage. The owl's body has been built up over a tin bowl using plaster to set in place the various nails and screws from which its beak, eyes, feathers and legs are formed. It was probably made at much the same time as no.122. Two bronze casts were made by Valsuani. Picasso painted one and left the other unpainted.

124 **Still Life: Pitcher and Figs** 1951–2
 Nature morte: Broc et figues
 Plaster, wood and iron 32 × 48.5 × 21.5
 (12⅝ × 19⅛ × 8½)
 Marina Picasso. Courtesy Jan Krugier Gallery, New York
 s 460.1
 Illustrated on p.158

This is the original plaster. As on many previous occasions, Picasso impressed corrugated paper into the wet plaster to give the jug a contrasting texture and surface and

to create complex light effects. He then mounted the jug and the naturalistically rendered figs onto a rough section of floorboarding. There is no firm evidence for the date of the plaster: the classic, Chardinesque still-life subject of a jug and fruit was one Picasso had treated in painting in the past, but never before in sculpture. But it certainly belongs to the same moment as the other table-top still-life sculptures of bouquets of flowers he made at Vallauris (e.g. s 413, s 468), and as his great *memento mori* still-life, 'Goat's Skull and Bottle' (no.125). In 1953 the Valsuani foundry made two bronze casts of 'Pitcher and Figs'. Picasso painted each one slightly differently in a dramatic palette of greys and blacks. The version now in the Morton G. Neumann Family Collection, Chicago, was first exhibited at the Galerie Leiris in Paris in May 1953, and dated 1952 in the catalogue. A third bronze was cast later but was never painted.

125 **Goat's Skull and Bottle** 1951–3
 Crâne de chèvre, bouteille et bougie
 Painted bronze 78.8 × 95.3 × 54.5
 (31 × 37⅝ × 21½)
 The Museum of Modern Art, New York. Mrs Simon Guggenheim Fund, 1956
 s 410.11b
 Illustrated on p.153

In the original sculpture Picasso created the goat's skull (or, rather, head) out of plaster, into which he had impressed corrugated cardboard, and a set of bicycle handlebars he found in a dump; the eyes were made with screws, and the bristles between the horns with dozens of small nails set into plaster. The bottle was made with curved terracotta tiles, and the rays of light emanating from the candle with long carpenter's nails. Small lumps of plaster on the back of the tile-bottle evoke dripped candle grease.

We do not know for sure the exact date of the original. However, Picasso made a number of drawings of goats' and rams' skulls/heads in October 1951 (including MP 1406), and on 21 December 1951 he made a wash sketch which appears to be done from the sculpture itself as it reproduces the composition exactly and clearly shows the tiles from which the bottle is made (Succession of the Artist, inv.6354). In March–April 1952 he painted a series of four oils with the same iconography – no.133 is the last and is dated 16 April 1952. According to Françoise Gilot, the paintings came first and it was she who suggested to Picasso that he explore the

same image in sculpture (*Life with Picasso*, Harmondsworth 1966, p.310). However, the drawing mentioned above suggests that in this instance her memory was at fault, and that the paintings derived from the sculpture.

Thanks to a fascinating sequence of dated photographs taken by Robert Doisneau in Picasso's studios in Vallauris, we know that at least one of the two bronze casts was returned from the Valsuani foundry in September 1952. Doisneau recorded its arrival by car (brought by Picasso's son Paulo and his nephew Javier Vilato), the unpacking, and then Picasso's careful – and delighted – inspection of it, in the company of Edouard Pignon (MP Archive. Doisneau photos nos.30826–42). The casting of this sculpture presented special problems because each of the carpenter's nails had to have a separate mould. Picasso had painted both casts in a sombre grisaille palette in time for simultaneous exhibition in Paris and Rome in May 1953. (The present version was shown in the Salon de Mai in Paris and the other version, which is now in the Musée Picasso in Paris, went to his retrospective at the Galleria Nazionale d'Arte Moderna in Rome, where it was dated 1951–2 in the catalogue.)

126 Bird Breaking Out of an Egg *c.*1953
Oiseau sortant d'un oeuf
Ceramic 43 × 33 × 25.5 (17 × 13 × 10)
Mr and Mrs Rafael Lopez Cambil
Illustrated on p.157

The bird was shaped from a slab of drying clay and highlighted in black paint. The egg was formed from a sphere made for Picasso by a potter, which Picasso then cracked open. The work was one of several ceramics which Picasso originally intended as light fixtures, and a lamp was supposed to be inserted inside the egg.

127 White Owl 1953
Hibou blanc
Ceramic 34 × 33 × 24 (13⅜ × 13 × 9½)
Private Collection
S 403.III
Illustrated on p.154

This is dated 21 February 1953. It is one of a number of individually painted ceramic owls which were cast from an original modelled in plaster. There was also an edition of six bronzes cast in the Godard foundry. A variant of this peaceable owl is the screeching 'Angry Owl' poised for the attack (s 404), which was also issued in an edition of bronzes. The subject had a particular appeal for Picasso who, in 1946, had rescued and cared for an owl which had fallen from the beams when he was painting in the Château Grimaldi in Antibes (see the interview with Lionel Prejger in this catalogue, p.241). Owls in one guise or another were the subject not only of several assembled sculptures (nos.122–3) and the various series of ceramics, but also of several paintings, such as 'Owl in an Interior' 1946 (Musée Picasso, Paris).

128 Dove 1953
Colombe
Ceramic 15 × 21 × 13 (5⅞ × 8¼ × 5⅛)
Musée d'Art Moderne, Céret
Illustrated on p.156

This dove, which is dated 14 October 1953, was created by rapidly manipulating a freshly made clay vase or bottle with a tapering neck. While the surface was still soft Picasso cut into it here and there to form tufts of feathers in relief, and, before firing, marked out the salient details of eyes, beak, wings and so on with rapid strokes of paint. It is one of an extensive series of pigeons and doves made in a similar manner or from quickly twisted and folded sheets of fresh clay, and Picasso like to draw attention to the paradox that in order to give these birds life he had to wring their necks. He gave this particular dove to the museum in Céret where he stayed during the Cubist period before the First World War. Picasso's father, José Ruiz Blasco, had been noted locally in Corunna for his life-like and sentimental paintings of pigeons, and as a young boy Picasso had drawn pigeons in emulation. In later life he often kept birds as pets and they sometimes feature in his paintings. His best-known image in this genre is, however, the lithograph of a dove which was chosen for the poster of the Peace Congress held in Paris in April 1949.

129 Fish on a Sheet of Newspaper *c.*1957
Poisson sur une feuille de journal
Ceramic 39 × 32 (15⅜ × 12⅝)
Private Collection
Illustrated on p.157

The sheet of newspaper was formed by pressing a slab of wet clay against the negative typesetting matrix of *Le Patriote*, the local Communist paper which was printed virtually next door to the Madoura factory in Vallauris. (On the reverse of the work is the trace of a previous attempt.) A black wash of paint was applied to simulate newsprint and the sheet of clay was 'crumpled' by hand. The fish was carved out of another slab of wet clay, incised to indicate eyes, scales, etc., and painted. The work is undated, but may be dated *c.*1957 on analogy with other ceramics which celebrate freshly caught fish and simple meals, such as the extensive series of relief-decorated plates Picasso made at the period. Picasso admired the work of the great sixteenth-century French potter Bernard Palissy, famed for his dishes intricately decorated in relief with naturalistic plants, fruit, birds, lizards, etc. Although infinitely simpler and humbler, works like the present piece are in the tradition of the famous and much imitated Palissy wares.

130 Arm 1959
Bras vertical
Bronze 58 (22⅞) high
Moderna Museet Stockholm
S 555.II
Illustrated on p.159

This is one of eight bronze casts made in 1961 in the Valsuani foundry. The plaster original is dated 15 March 1959 (Succession of the Artist) . Throughout his life Picasso made a great number of drawings of hands – both his own and those of others. In 1937 he made various plaster casts of both his hands (S 220.A–C, 221, 224), and he made several sculptures of hands at other moments in his career. 'Arm' is, however, by far his most magisterial statement of the theme, and is surely a symbolic self-portrait. His friend and biographer, Jaime Sabartés, says that Picasso often quoted the maxim of his own father, 'in the hand one sees the hand' (i.e. the hand is an infallible indicator of personality, and representations of hands reveal the calibre of the hand that made them) (Jaime Sabartés, *Picasso: Documents iconographiques*, Geneva 1954, caption to pl.123).

PAINTINGS

131 Cat and Bird 1939
Chat à l'oiseau
Oil on canvas 97 × 130 (38 × 50¾)
Mrs Victor W. Ganz
z IX.297
Illustrated on p.147

This painting was executed in April 1939, probably at around the same time as the less monumental version which is dated 22 April and is in the Musée Picasso. Picasso kept cats from time to time throughout his life, but he always preferred feral street cats to the pampered domestic variety, and was fascinated by their promiscuity and ferocity. He made two well-known sculptures of cats during the Occupation, and this painting relates closely to the first, the pregnant and predatory cat he modelled in 1941 (no.116). However, the treatment of the animal – silhouetted like a cardboard cut-out against the plain background, its body described with scissor-sharp contours and stepped folds rather than gradated shading – bears little relation to his usual modelling technique and anticipates instead the cut and folded sheet-metal sculptures he created from 1954 onwards.

132 Cock and Wicker Basket 1950
Coq et panier d'osier
Oil on wood 116 × 89 (45¾ × 35)
Marina Picasso. Courtesy Galerie Jan Krugier, Geneva
z xv.154
Illustrated on p.150

This is dated 12 January 1950 on the back. The broken wicker basket which appears to menace the cock may well be the very one which Picasso found in a field near his studio in Vallauris and used to form the rib-cage of 'The Goat' (no.118). The great care with which he investigates its intricate structure reflects a long-standing fascination with weaving, knitting, canework and basketry – seen especially in his paintings of women in the late 1930s – but also recapitulates his experiments with complex open-work sculpture in welded or twisted wire in 1928-31 (nos.41, 74–5). In Boisgeloup in the early 1930s Picasso had made at least three sculptures of poultry (s 134, 154, 155). The preening movement of the fowl in the painting especially recalls that of 'The Cock' (no.86).

133 Goat's Skull, Bottle and Candle 1952
Crâne de chèvre, bouteille et bougie
Oil on canvas 89.2 × 116.2 (35 × 45⅝)
Tate Gallery. Purchased 1957
z xv.198
Illustrated on p.152

This is dated 16 April 1952 on the back of the canvas, and is the latest of a series of four paintings on the same theme (z xv.199–201). The two bronze still lifes with the same composition, which Picasso painted in a similar *grisaille* palette (no.125), almost certainly precede the paintings and are especially close to the Tate painting. Thus the intricate web of lines in the painting, which connects the two objects on the table to each other and to the background, finds an equivalent in the bronzes in the patterns of light and shadow painted over the surfaces, in the corrugations in the goat's skull and in the indentations in the plinth.

7 Cutting and Folding the Figure

SCULPTURES

134 Françoise Gilot 1950
Painted tile 100 × 21 × 10
(39⅜ × 8¼ × 4)
Private Collection
Illustrated on p.172

Françoise Gilot, who was present when Picasso first began to make and decorate ceramics in Vallauris in 1946, was intimately associated in his mind with his work as a sculptor-potter, and many of his ceramics (such as the contemporary tanagra no.46) are at some level a tribute to her. This, however, is unequivocally a portrait and is dated 8 September 1950 on the back. It is one of a series of figures painted relatively naturalistically in slip on *gazelles* – the curved props, resembling elongated Roman roof tiles, which are used inside the potter's kiln to aid ventilation. A *gazelle* formed the main section of the body of 'The Woman with a Key' a few years later (no.109).

135 Woman Carrying a Child 1953
Femme portant un enfant
Painted wood and section of palm leaf
173 × 54 × 35 (68⅛ × 21¼ × 13¾)
Private Collection
s 478
Illustrated on p.163

Since 1935, when he made a number of painted wooden 'dolls' (e.g. no.42) around the time of the birth of his first daughter, Maya, Picasso had not used wood as a material for sculpture, except as a component in an assemblage. In 1953, however, he constructed three tall painted wooden figures of women, as well as a whole series of wooden dolls for Paloma, his daughter by Françoise Gilot (s 478–87). His sculpture was about to enter a new phase, and wood became a favourite medium in the later 1950s.

'Woman Carrying a Child' is the largest and most complex of these new wooden constructions, and was surely inspired by the sight of Françoise carrying Paloma, who was four years old at the time. There is a certain poignancy here, for in 1953 Picasso's relationship with Françoise finally broke down and that September she settled in Paris with her children.

136 Head of a Woman 1957
Tête de femme
Painted sheet iron 87 × 27.5 × 45
(34¼ × 10⅞ × 17¾)
Musée Picasso, Paris
s 495.2
Illustrated on p.164

The many preparatory drawings for this sculpture, which are dated 13 June 1957 (e.g. MP 1516), reveal that Picasso initially conceived the head as a skull. The sculpture must have been executed in sheet iron very soon after the design was finalised because it is visible in a photograph taken by André Gomes in La Californie in July 1957 (MP ph. 1071). The paper maquette survives (Succession of the Artist, inv.6544), and the Musée Picasso possesses a related, contemporary three-piece cardboard model, 'Bust of a Woman' (s 496) of less austere design. A sequence of photographs by David Douglas Duncan suggests that Picasso worked from this sculpture when making certain contemporary paintings, in particular 'Head' (z xvii.347: Duncan, *Viva Picasso: A Centennial Celebration 1881–1981*, New York 1980, p.22).

On 8 April 1967 Picasso gave his written agreement for the enlargement of 'Head of a Woman' as a monument for the lido at the port of Le Barcarès, on the coast of Languedoc and Roussillon – and with its rudder-like or sail-like 'wing' at the back, the sculpture does indeed have a faintly nautical air. The monument, envisaged as 'a signal to attract the attention of tourists', was to have been about forty metres high, and would have been made in concrete by Carl Nesjar. Nesjar made a maquette in aluminium in 1968, but the project came to nothing. (Information, documents, etc. in the MP Archive.)

137 Head of a Woman 1957
Tête de femme
Painted sheet iron 77 × 35 × 25.7
(30¼ × 13¾ × 10⅛)
Private Collection
s 492
Illustrated on p.173

The four-part cardboard maquette for this sculpture is preserved in the Musée Picasso (s 640). Photographs taken by David Douglas Duncan in the summer of 1957 show Picasso painting the metal sculpture, which was inspired by Jacqueline Roque (*The Private World of Pablo Picasso*, New York 1958, pp.146–7). Also visible in other photographs taken at the same time, but already finished, is the closely related wooden 'Head of a

Woman' (MP 350; s 493). Picasso dreamed of enlarging these sculptures to an immense scale, and used the wooden 'Head of a Woman' in a mocked-up scenario in which it towers above holiday-makers (represented by diminutive cut-outs) sunbathing on the beach at Cannes (Duncan, ibid., pp.142–5; see p.161). This dream was at least partially realised when Carl Nesjar made huge replicas in sand-blasted concrete (e.g. s 593A, s 651).

138 Man 1958
Homme
Wood and nails 117 × 76 × 25
(46⅛ × 29⅞ × 9⅞)
Mr and Mrs Rafael Lopez Cambil
s 538
Illustrated on p.162

In mid-November 1954 Picasso made a series of drawings of easels which strikingly anticipate the form of this sculpture (Carnet 1073, ff.1r, 7, 8r, 9r; MP 1883). Contemporary with them is an oil entitled 'The Easel' and dated 18 November (Succession of the Artist, inv.13297). All these works have a strong figurative presence, so that 'Man' takes the ideas implicit in them to their logical conclusion. Although more monumental in its impact, 'Man' is also related closely in its technique, imagery and absolute frontality to 'The Bathers', the six-part ensemble rapidly put together from scrap wood in 1956 – especially to the two figures which are partly assembled from stretchers, 'The Man with Clasped Hands' and 'The Fountain-Man' (fig.11 on p.34) .

139 Head 1958
Tête
Open wood box, nails, buttons, painted plaster and painted synthetic resin mounted on overturned ceramic dish 50.5 × 22.2 × 20.3 (19⅞ × 8¾ × 8)
The Museum of Modern Art, New York. Gift of Jacqueline Picasso in honour of the Museum's continuous commitment to Pablo Picasso's art, 1984
s 539.1
Illustrated on p.162

A drawing done of the sculpture is inscribed 'wood … 10 June 1958' (Carnet 1175, f.32v; Succession of the Artist). The principal element is a simple wooden crate, and Picasso appears to have used parts of the lid to form the nose and mouth. A bronze cast, made in the Valsuani foundry, is in the Musée Picasso.

140 Standing Nude 1960 or 1961
Femme nue debout
Painted sheet iron 42 × 30 × 21
(16½ × 11¾ × 8¼)
Private Collection
s 581.2
Illustrated on p.171

This is usually dated 1961, but the folding of the woman's arms and legs is so similar to that of the male 'Bather' (no.155) that both sculptures are likely to have been made at much the same time – i.e. at the end of 1960. At any rate, 'Standing Nude' is visible, finished and already painted white, in a photograph taken by André Gomes in La Californie at Easter 1961 (MP ph.1121).

141 Standing Woman 1961
Femme debout
Painted sheet iron 42 × 19 × 9
(16⅝ × 7½ × 4⅜)
Private Collection, Switzerland
s 580.2c
Illustrated on p.170

This is another of the sheet-metal sculptures made in Lionel Prejger's factory in Vallauris from Picasso's cut and folded paper maquettes. The original one-piece maquette survives (Succession of the Artist, inv.6719) and is dated 7 January 1961. It was used to make two identical sheet-metal sculptures, distinguishable from each other only by adjustments to the bending of the arms, etc. Neither of them was painted.

142 Woman and Child 1961
Femme et enfant
Painted sheet iron 43 × 17.6 × 21
(16⅞ × 6⅞ × 8¼)
Private Collection
s 601.2
Illustrated on p.170

Picasso apparently used the same maquette (Succession of the Artist, inv.6720) for the woman as for 'Standing Woman' (s 580.2b), which is a variant of no.141. However, he bent the paper arms very differently in order to give support to the child, which was cut out from another piece of paper. The present sheet-metal sculpture was then made in Lionel Prejger's factory and given a coat of white paint. According to Prejger, the 'Standing Woman' series (s 580.2a–d) came first and the decision to create a maternity came later (see the interview with Prejger in the present catalogue). The sculpture almost certainly dates from the first weeks of 1961.

143 Woman with a Tray and a Bowl 1961
Femme au plateau et à la sébile
Painted sheet iron 115 × 62 × 34
(45¼ × 24⅜ × 13⅜)
Private Collection
s 598.2a
Illustrated on p.169

The paper maquette for the body of the woman is dated 2 February 1961 (Succession of the Artist, inv.6731). Lionel Prejger has confirmed that the same maquette was also used for the variant sculpture, 'Woman with a Child', which is in the Musée Picasso (s 599). Still unpainted, 'Woman with a Tray and a Bowl' is visible in a photograph taken by André Gomes in La Californie at Easter 1961 (MP Archive).

144 Woman with Outstretched Arms
1961
Femme aux bras écartés
Painted iron and metal sheeting
178.8 × 156.5 × 72.7
(70⅜ × 61⅝ × 28⅝)
The Museum of Fine Arts, Houston. Gift of the Esther Florence Whinery Goodrich Foundation
s 597
Illustrated on p.167

There were three identifiable phases in the creation of this sculpture. Picasso began by making the paper maquette (undated), measuring 36.5 by 37 cm, which is now in the Musée Picasso (s 594.1). Three same-size sheet-iron replicas of this maquette were then made in Lionel Prejger's factory in Vallauris, and Picasso painted each one differently in black and white. Finally, he instructed Prejger to make two enlargements, reproducing exactly the decoration of one of these small metal sculptures (s 594.2a). The present work is one of those enlargements, the other being in the Musée Picasso. Prejger has confirmed that the pieces of grille used to give texture to the black areas of these enlargements were forged into place in his factory, but in accordance with Picasso's instructions (see the interview with Prejger in this catalogue, pp.245–6).

The exact moment in 1961 when the work was made is uncertain, but a very similar figure of a female bather, moving forward with outstretched arms and flowing hair, appears in a drawing dated 3 June (z xx.9). Quite possibly the sculpture was made around this time, and certainly before Prejger decided to move to Paris in the early autumn.

There is, at any rate, a postscript to the story: in 1962 Picasso's dealer, Daniel-Henry Kahnweiler, commissioned Carl Nesjar to make a five-and-a-half metre high copy of 'Woman with Outstretched Arms' in concrete for the garden of his country property at Saint-Hilaire, Chalo-Saint-Mars, Essonne. Nesjar used the Houston sheet-iron sculpture (which was then owned by Kahnweiler's Galerie Louise Leiris) as his model, completing his giant concrete version on 21 October 1962.

145 Woman in a Hat 1961–3
Femme au chapeau
Painted sheet iron 126 × 73 × 41
(59⅝ × 28¾ × 16⅛)
Beyeler Collection, Basel
s 626.2a
Illustrated on p.177

Four identical sheet-metal versions of this sculpture were made in Lionel Prejger's factory early in 1961 using the same maquette. Preparatory drawings for the sculpture are dated 3 January 1961 (z xxix.410–11, 414–16), and a series of very closely related paintings was executed in late January – early February (e.g. z xxix.422). At least one of the sheet-metal sculptures, still unpainted and revealing all the marks of its manufacture, had been delivered to La Californie by Easter 1961, when it was photographed by André Gomes (MP ph.1128). The sculpture exhibited here was the only one which Picasso painted in polychrome, and, according to Spies, the colour was not added until 1963 when he was living in Mougins.

146 Jacqueline with a Green Ribbon
1962
Jacqueline au ruban vert
Sheet iron with oil paint and crayon
50.7 × 39 × 28 (20 × 15⅜ × 11)
Courtesy Jan Krugier Gallery, New York
s 629.2
Illustrated on p.173

Jacqueline Roque, who is portrayed here, married Picasso in March 1961. Picasso's paper maquette (Succession of the Artist, inv.6793) is dated 7 December 1962. It was copied in the Tritub factory in Vallauris, after Prejger's departure, by the skilled metal-worker Tiola, who, as on many previous occasions, used solder to 'draw' the eyes, mouth, ear, hair, etc.

147 Bust of a Woman 1964
Buste de femme
Painted sheet iron 48 × 34 × 30
(19 × 13⅜ × 11¾)
Christine Ruiz-Picasso
s 632.2
Illustrated on p.174

The cardboard maquette for this sculpture is dated 16 January 1964 (Succession of the Artist, inv.6546). It is the last of Picasso's original projects for sculpture, and once it had been transferred into sheet metal he painted it. All the sculptures realised after this date were enlargements executed by others using earlier maquettes, and Picasso himself did not work directly on them.

PAINTINGS

148 Two Women on the Beach 1956
Deux femmes sur la plage
Oil on canvas 195 × 260 (76¾ × 102⅜)
Musée National d'Art Moderne, Centre Georges Pompidou, Paris. Donation de Mme Paul Cuttoli 1963
z xvii.36
Illustrated on p.168

This is dated 16 February 1956 on the back, but, according to Zervos, was completed only on 26 March (a rough drawing of the composition, dated 13 March 1956, is in the Succession of the Artist, inv.6076). The heavy, blocky forms of the two women suggest roughly hewn stone, but, ironically, Picasso's contemporary sculpture, whether it was made from planks and batons of wood or cut and folded sheet metal (e.g. nos.135–8), was the antithesis of massive. There is nevertheless an obvious relationship to the sheet-metal sculptures in the clarity and firmness of the women's silhouettes against the background and the impression that the limbs are hinged and folded rather than modelled.

149 Composition: Two Women 1958
Composition: Deux femmes
Oil on canvas 194.5 × 260.5
(76⅝ × 102⅝)
Museo de Arte Contemporaneo Sofia Imber, Caracas
z xviii.82
Illustrated on p.166

This is dated 18 April 1958 and shares the majestic dimensions of other great paintings of nudes Picasso executed in the late 1950s –

a period when he was also much preoccupied with ways and means of at last realising his sculptures on a truly monumental scale for an outdoor setting. Picasso's long collaboration with the Norwegian sculptor, Carl Nesjar, had started in 1957, and the figure on the right of this painting seems to anticipate 'Woman with Outstretched Arms' of 1961 (no.144), the largest of the sheet-iron sculptures made for him in Lionel Prejger's factory, and one of the sculptures Nesjar recreated in sandblasted concrete on a giant scale.

150 **Seated Nude** 1959
Nu accroupi
Oil on canvas 146 × 114 (57½ × 44⅞)
Private Collection, Switzerland
z XVIII.488
Illustrated on p.165

According to Zervos, this painting was begun on 21 March but not completed until 24 June 1959. Presented as a compact cubic block, the figure may be intended to remind us of Maillol's celebrated neo-classical sculpture of a seated nude, 'The Mediterranean' 1905 – a work which is, however, much chaster and much less forthright. In terms of Picasso's own sculpture, 'Seated Nude' has points of contact with the sheet-metal sculptures of the early 1960s (such as no.145), especially in its paradoxical treatment of mass and depth and its scissor-sharp silhouette. However, it is surely also related to his plans to create a sculptural ensemble of naked figures seated and reclining outdoors – plans which dated back at least to 1958, but which were finally realised in his recasting of Manet's 'Le Déjeuner sur l'herbe' (nos.156–64).

151 **Seated Woman** 1962
Femme assise
Oil on canvas 146 × 116 (57½ × 45⅝)
Private Collection
z XXIII.91
Illustrated on p.176

According to Zervos this was begun on 9 November 1962 and completed on 6 December. Conceptually and stylistically it is very closely related to the contemporary sheet-iron heads of Jacqueline Picasso, especially to 'Head of a Woman' (s 631) and 'Jacqueline with a Green Ribbon' (no.146). (The paper maquettes for these works – dated 9 November and 7 December respectively – are, indeed, exactly contemporary with the

painting.) Despite differences in mood – the late sculptures are generally more playful – Picasso's sculpture and painting were never closer than at this period, and very soon he would cease to make sculpture altogether.

152 **Large Profile** 1963
Grand Profil
Oil on canvas 130 × 97 (51¼ × 38¼)
Kunstsammlung Nordrhein-Westfalen, Düsseldorf
z XXIII.117
Illustrated on p.175

This is dated 6 January 1963 on the back. The shifting viewpoints and changing patterns of light and shade evoked in the painting may be compared with the complex and ambiguous spatial effects of Picasso's recent sheet-iron heads of Jacqueline. The firmness of the painting's contours and the suggestions of manual folding and bending (for instance in the areas of brow and cheek) are particularly reminiscent of the paper maquettes for these late sculptures. On the other hand, once they had been rendered in metal, Picasso would sometimes roughly colour the surfaces of the sculptures with paint or wax crayon in imitation of the scumbled, expressive handling of his contemporary paintings. The sheet-iron heads of Jacqueline do not, however, attempt to match paintings like 'Large Profile' in hieratic grandeur or psychological penetration. In that respect this painting may be compared, rather, with the great plaster heads of Marie-Thérèse Walter that Picasso had modelled over thirty years before.

153 **Woman with a Coif** 1971
Femme à la coiffe
Oil on canvas 81 × 65 (31⅞ × 25⅝)
Private Collection, Switzerland
z XXXIII.80
Illustrated on p.174

This is dated 30 June 1971. Although painted some years after Picasso had completely ceased to make sculpture, it is very reminiscent of the late painted sheet-metal heads of Jacqueline, especially of the last of them, 'Bust of a Woman' 1964 (no.147). Picasso lived surrounded by his sculpture, and its seems likely that the painting, executed when he was ninety years old, was inspired by contact with his earlier work rather than by his wife herself.

8 New Arcadias

SCULPTURES

154 **Seated Bather** 1958
Baigneuse assise
Painted wood 62 × 49.3 (24½ × 19⅜)
Private Collection
s 547
Illustrated on p.180

This is dated 17 May 1958 on the back, and coincides with a series of drawings dated 10–19 May which appear to be projects for outdoor sculptures of seated and reclining nude figures (z XVIII.162–82). It thus anticipates the folded and cut-out cardboard maquettes Picasso made in August 1962 as part of his extended series of reinterpretations of Manet's 'Le Déjeuner sur l'herbe' (see nos.156–64).

155 **Bather** 1960
Baigneur
Cardboard 50 × 19 × 15
(19¾ × 7½ × 6)
Galerie 27, Paris
s 582.1
Illustrated on p.180

This maquette, which is dated 29 November 1960, was copied in sheet metal in Lionel Prejger's factory in Vallauris and was one of the very earliest sculptures to result from their collaboration. To make the maquette, Picasso appears to have stapled together two pieces of cardboard, one of which obviously came from a reinforced envelope and is postmarked 'Cannes, 25–7–60'. Originally a separate cardboard cut-out representing the shoulder-blades, back and buttocks was attached to the back of the figure with a paper-clip. Picasso gave the bather swimming trunks, facial details, nipples and a navel once he had been transferred into metal (Succession of the Artist).

156 **Le Déjeuner sur l'Herbe: Seated Woman** 1962
Le Déjeuner sur l'herbe: Femme assise
Pencil on cardboard 34.5 × 25
(13⅝ × 9⅞)
Musée Picasso, Paris
s 652b (1)
Illustrated on p.182

157 **Le Déjeuner sur l'herbe: Bather** 1962
Le Déjeuner sur l'herbe: Femme au bain
Pencil on cardboard 29 × 21.5
(11⅜ × 8½)
Musée Picasso, Paris
s 652c (1)
Illustrated on p.186

158 **Le Déjeuner sur l'herbe: Seated Man
Leaning on his Elbow** 1962
Le Déjeuner sur l'herbe: Homme assis
accoudé
Pencil on cardboard 28 × 37.5
(11 × 14¾)
Musée Picasso, Paris
s 652a (1)
Illustrated on p.186

159 **Le Déjeuner sur l'herbe: Seated Man
Leaning on his Elbow** 1962
Le Déjeuner sur l'herbe: Homme assis
accoudé
Pencil on cardboard 25 × 32
(9⅞ × 12⅝)
Musée Picasso, Paris
s 652d (1)
Illustrated on p.182

160 **Le Déjeuner sur l'herbe: Seated Man
Leaning on his Elbow** 1962
Le Déjeuner sur l'herbe: Homme assis
accoudé
Pencil and crayon on cardboard
(2 pieces) 21.5 × 27 (8½ × 10⅝)
Musée Picasso, Paris
Not in Spies
Illustrated on p.182

161 **Le Déjeuner sur l'herbe: Seated Man
Leaning on his Elbow** 1962
Le Déjeuner sur l'herbe: Homme assis
accoudé
Pencil and crayon on cardboard
21.5 × 26 (8½ × 10¼)
Musée Picasso, Paris
Not in Spies
Illustrated on p.184

162 **Le Déjeuner sur l'herbe: Seated Man
Leaning on his Elbow** 1962
Le Déjeuner sur l'herbe: Homme assis
accoudé
Pencil on cardboard 21.5 × 25.5
(8½ × 10)
Musée Picasso, Paris
Not in Spies
Illustrated on p.184

163 **Le Déjeuner sur l'herbe: Standing
Man** 1962
Le Déjeuner sur l'herbe: Homme
debout
Pencil and crayon on folded cardboard
36.5 × 27.5 (14⅜ × 10⅞)
Musée Picasso, Paris
Not in Spies
Illustrated on p.186

164 **Le Déjeuner sur l'herbe: Seated Man
Leaning on his Elbow** 1962
Le Déjeuner sur l'herbe: Homme assis
accoudé
Pencil on cardboard 24.5 × 33 (9⅝ × 13)
Musée Picasso, Paris
Not in Spies
Illustrated on p.184

These are nine of a total of eighteen card-
board maquettes which Picasso made
between 26 and 31 August 1962, and which
are all preserved in the Musée Picasso in
Paris. All but one of them are dated on the
reverse. Four of the maquettes (nos.156–9) –
slightly modified by the addition of drawing
on the back – were used as the models for
the monumental enlargements executed in
concrete in 1965 for the Moderna Museet in
Stockholm.

The cut and folded maquettes are a
transposition into sculptural terms of the four
figures of Manet's 'Le Déjeuner sur l'herbe'
1862 (Musée d'Orsay). Picasso, who had been
fascinated by Manet's work since the time of
his first visit to Paris in 1900, had been
preoccupied intermittently with this famous
masterpiece at least since June 1954, when he
made a number of relatively direct drawings
from it in a notebook (Carnet 1058, ff.2–5;
MP 1882). In August 1959 he began in earnest
on an extended series of variations on the
theme and composition of Manet's painting.
When the series, which he had worked on in
several intense bouts of activity, eventually
came to an end in July 1962 it numbered
some twenty-seven paintings and 140
drawings, plus a few linocuts (see nos.165–8).

The eighteen cardboard maquettes made
in late August 1962 are generally regarded as
a coda to these paintings and drawings.
However, in May 1958 Picasso had already
made a number of drawings of male and
female nudes, which are related to his later
transpositions of Manet's painting, and they
strongly suggest that he was planning to
execute some folded and cut-out figures in
either wood or sheet metal (z xviii.162–82).
Some of the drawings indicate an outdoor
setting, as if he envisaged setting the figures
up in a park. 'Seated Bather' (no.154) appears
to be the only realised sculpture to result
from this campaign. In other words, the idea
of a sculptural ensemble on an Arcadian
theme and loosely related to Manet's
'Déjeuner sur l'herbe', appears to date back
at least to May 1958. But like many of
Picasso's projects for monumental sculptures,
it did not immediately come to anything.

When the chance to realise his idea on a
monumental scale did come Picasso seized
it enthusiastically. According to records
preserved in the MP Archive, Carl Nesjar,
who had been collaborating with Picasso on
enlargements in concrete of his works for
several years already, first approached him in
October 1962 on behalf of Pontus Hulten,
the then Director of the Moderna Museet in
Stockholm, with a commission for a monu-
mental sculpture on an unspecified theme.
Nothing appears to have been decided at this
stage, but it is worth noting that at this
meeting Picasso and Nesjar discussed the
execution of engraved concrete murals for
Douglas Cooper's Château de Castille, and
that two of the drawings selected for Nesjar
to copy were from the 'Déjeuner sur l'herbe'
series. In January 1964, following further
meetings with Picasso, Nesjar wrote to
Hulten sending him photographs of the
'Déjeuner sur l'herbe' maquettes and
explaining that Picasso was proposing them
for the Moderna Museet, and wanted the
sculptural ensemble to be set up among trees
in a park. Negotiations proceeded, and on 7
July 1964 Picasso gave his final approval to
Nesjar's designs and the proposed outdoor
installation. In the spring of 1965 Nesjar
began work on the enlargements in Larvik in
Norway, finishing them that November. The
concrete figures, each of which is three to
four metres high, were transported to
Stockholm and installed in the garden of the
Moderna Museet the following year.

PAINTINGS

165 Le Déjeuner sur l'herbe, after Manet
1960
Le Déjeuner sur l'herbe, d'après Manet
Oil on canvas 130 × 195 (51¼ × 76¾)
Private Collection, Switzerland
z XIX.203
Illustrated on p.187

166 Le Déjeuner sur l'herbe, after Manet
1961
Le Déjeuner sur l'herbe, d'après Manet
Oil on canvas 114 × 146 (44⅞ × 57½)
Staatsgalerie Stuttgart
z xx.88
Illustrated on p.181

167 Le Déjeuner sur l'herbe, after Manet
1961
Le Déjeuner sur l'herbe, d'après Manet
Oil on canvas 89 × 116 (35 × 45⅝)
Picasso Collection of the City of Lucerne.
Rosengart Donation
z xx.91
Illustrated on p.183

168 Le Déjeuner sur l'herbe, after Manet
1961
Le Déjeuner sur l'herbe, d'après Manet
Oil on canvas 130 × 97 (51⅛ × 38¼)
Louisiana Museum of Modern Art,
Humlebaek
z xx.113
Illustrated on p.185

These four paintings belong to the extensive series of painted and drawn variations on Manet's celebrated masterpiece of 1862. The first is dated 29 February 1960, the second 10 July 1961, the third 16 July 1961, and the fourth 30 July 1961. Picasso began the series at the Château de Vauvenargues in August 1959. The final versions date from July 1962, and were executed at Mas Notre-Dame-de-Vie in Mougins. In August 1962 Picasso cut out the paper maquettes (nos.156–64) which later served as the models for giant concrete enlargements made by Carl Nesjar for the garden of the Moderna Museet in Stockholm.

The earliest of the paintings on display predates the spate of sheet-iron sculptures that resulted from Picasso's collaboration with Lionel Prejger between November 1960 and the summer of 1961. But in its figure style and flat lighting effects it seems particularly relevant to the simplified cut and folded paper maquettes Picasso gave to Prejger for transfer into metal (see, for instance, 'The Bather' no.155 and 'Woman with Outstretched Arms' no.144). The three later pictures executed in July 1961 were made in the wake of this intense sculptural activity. Although they are much more atmospheric, and in that sense more painterly, they seem to reflect the experience of making the maquettes, which were often very complex and sometimes involved not just ingenious cutting and folding, but overlaps of several separate cut-out planes and cutting away sections of the paper to form positive and negative spaces, strong contrasts of light and shade and intricately varied viewpoints (compare, for instance, 'Woman in a Hat' (no.145) with the seated bather on the left of the painting in Lucerne, no.167).

Index of Exhibited Works

Lenders

The Baltimore Museum of Art 2, 92

The Berggruen Collection on loan to the National Gallery, London 24, 34, 35, 43, 60, 121

Mrs Edwin Bergman 111

Beyeler Collection, Basel 93, 145

Museum of Fine Arts, Boston 8

Pinacoteca di Brera, Milan 112

Gregory Callimanopulos, New York 37

Museo de Arte Contemporaneo Sofia Imber, Caracas 149

Musée d'Art Moderne, Céret 128

Art Institute of Chicago 16

Royal Museum of Fine Arts, Copenhagen 31

Kunstsammlung Nordrhein-Westfalen, Düsseldorf 98, 152

Städelsches Kunstinstitut, Frankfurt am Main 77

Galerie 27, Paris 155

Mrs Victor W. Ganz 131

Estate of Mark Goodson, New York 104

Klaus Hegewisch, Hamburg 7

Hermitage Museum, St Petersburg 13, 14

Hirshhorn Museum and Sculpture Garden, Smithsonian Institution, Washington 122

The Museum of Fine Arts, Houston 144

Jan Krugier Gallery, New York 146

The Envoy and Latner Family Collection 5

Mr and Mrs Rafael Lopez Cambil 84, 102, 107, 108, 119, 126, 138

Louisiana Museum of Modern Art, Humlebaek 168

Picasso Collection of the City of Lucerne 167

Sammlung Ludwig 45

Museo del Prado, Madrid 99

Museo Nacional Centro de Arte Reina Sofia, Madrid 110, 114

Marx Collection on permanent loan to the Nationalgalerie, Berlin 113

The Metropolitan Museum of Art, New York 52, 53

The Museum of Modern Art, New York 9, 19, 28, 32, 75, 88, 125, 139

Art Gallery of Ontario, Toronto 6

Musée d'Art Moderne de la Ville de Paris 1

Musée National d'Art Moderne, Centre Georges Pompidou, Paris 18, 23, 27, 30, 33, 48, 148

Philadelphia Museum of Art 105

Marina Picasso 41, 64, 80, 123, 124, 132

Musée Picasso, Paris 4, 15, 25, 26, 40, 50, 57, 59, 61, 63, 65, 66, 67, 68, 69, 72, 73, 76, 79, 82, 85, 87, 90, 95, 100, 106, 118, 136, 156, 157, 158, 159, 160, 161, 162, 163, 164

Národní Galerie, Prague 10

Private Collections 3, 11, 12, 17, 20, 21, 36, 39, 42, 44, 46, 47, 49, 51, 54, 56, 58, 70, 74, 78, 81, 83, 89, 91, 94, 96, 97, 101, 103, 109, 115, 116, 117, 120, 127, 129, 134, 135, 137, 140, 141, 142, 143, 150, 151, 153, 154, 165

A. Rosengart 29

Christine Ruiz-Picasso 71, 147

Smith College Museum of Art, Northampton, Massachusetts 38

Moderna Museet Stockholm 130

Graphische Sammlung Staatsgalerie Stuttgart 62

Staatsgalerie Stuttgart 166

Tate Gallery 22, 86, 133

Musée d'Art Moderne de la Communauté Urbaine de Lille, Villeneuve d'Ascq 55

Photographic Credits

P.A. Allsten; Thomas Ammann Fine Art; Arphot; C. Bahier; Baltimore Museum of Art; Museu Picasso, Barcelona; Claire Batigne; Eric Baudoin; Galerie Beyeler; Museum of Fine Arts, Boston; Studio Brady; Chester Brummel; Gelett Burgess; Museo de Arte Contemporaneo Sofia Imber, Caracas; Luca Carrà; Musée d'Art Moderne, Céret; The Art Institute of Chicago; Color Gruppen; Royal Museum of Fine Arts, Copenhagen; David Douglas Duncan; Kunstsammlung Nordrhein-Westfalen, Düsseldorf; Ursula Edelmann; Ali Elai; Vladimir Fyman; Städelsches Kunstinstitut, Frankfurt am Main; Béatrice Hatala; Hirshhorn Museum; The Museum of Fine Arts, Houston; Imageart Antibes; Bill Jacobson; Bob Kolbrener; André Koti; Galerie Jan Krugier; National Gallery, London; Louisiana Museum of Modern Art; Picasso Collection of the City of Lucerne; Museum Ludwig, Cologne; Robert E. Mates; Metropolitan Museum of Art, New York; P. Migeat; Staatsgalerie Moderner Kunst, Munich; Carl Nesjar; Museum of Modern Art, New York; Gadi Oz; Pace Gallery; Ellen Page Wilson; Bibliothèque Centrale du Musée National d'Histoire Naturelle, Paris; Musée de l'Homme, Paris; Musée National d'Art Moderne, Centre Georges Pompidou, Paris; Photothèque des Musées de la Ville de Paris; Service Photographique de la Réunion des Musées Nationaux, Paris; Hans Petersen; Philadelphia Museum of Art; Eric Pollitzer; Museo del Prado, Madrid; Národní Galerie, Prague; Edward Quinn; Museo Nacional Centro de Arte Reina Sofia, Madrid; Smith College Museum of Art, Northampton; Sparte; Werner Spies; Lee Stalsworth; State Hermitage Museum, St Petersburg; Statens Konstmuseer, Stockholm; Staatsgalerie Stuttgart; Tate Gallery; Art Gallery of Ontario, Toronto; Malcom Varon; Musée d'Art Moderne de la Communauté Urbaine de Lille, Villeneuve d'Ascq; Sean Weaver; John Webb; Rolf Williman; Kunsthaus Zürich

All photographs from the Musée Picasso, Paris © RMN

The publishers have made every effort to trace all the relevant copyright holders and apologise for any omissions that may have been made.

Ways of Giving to the Tate Gallery

The Tate Gallery attracts funds from the private sector to support its programme of activities in London, Liverpool and St Ives. Support is raised from the business community, individuals, trusts and foundations, and includes sponsorships, donations, bequests and gifts of works of art. The Tate Gallery is recognised as a charity under Inland Revenue reference number x780551.

Trustees
Dennis Stevenson CBE (Chairman)
The Countess of Airlie CVO
The Hon. Mrs Janet de Botton
David Gordon
Christopher Le Brun
Sir Richard Carew Pole
Michael Craig-Martin
Richard Deacon
Bamber Gascoigne
Paula Ridley
David Verey

Donations

There are a variety of ways through which you can make a donation to the Tate Gallery.

Donations All donations, however small, will be gratefully received and acknowledged by the Tate Gallery.

Covenants A Deed of Covenant, which must be taken out for a minimum of four years, will enable the Tate Gallery to claim back tax on your charitable donation. For example, a covenant for £100 per annum will allow the Gallery to claim a further £33 at present tax rates.

Gift-Aid For individuals and companies wishing to make donations of £250 and above, Gift-Aid allows the gallery to claim back tax on your charitable donation. In addition, if you are a higher rate taxpayer you will be able to claim tax relief on the donation. A Gift-Aid form and explanatory leaflet can be sent to you if you require further information.

Bequests You may wish to remember the Tate Gallery in your will or make a specific donation In Memoriam. A bequest may take the form of either a specific cash sum, a residual proportion of your estate or a specific item of property, such as a work of art. Certain tax advantages can be obtained by making a legacy in favour of the Tate Gallery. Please check with the Tate Gallery when you draw up your will that it is able to accept your bequest.

American Fund for the Tate Gallery The American Fund was formed in 1986 to facilitate gifts of works of art, donations and bequests to the Tate Gallery from the United States residents. It receives full tax exempt status from the IRS.

Individual Membership Programmes

FRIENDS OF THE TATE GALLERY

Share in the life of the Gallery and contribute towards the purchase of important works of art for the Tate.

Privileges include free unlimited entry with a guest to exhibitions; *tate: the art magazine*; private views, events and art courses; 'Late at the Tate' evening openings; exclusive Friends Room. Annual rates range from £22 to £30.

Tate Friends St Ives offers a local events programme and full membership of the Friends of the Tate Gallery.

FELLOWS

The Fellows support the acquisition of works of art for the British and Modern Collections of the Tate Gallery. Privileges include invitations to Tate Gallery receptions, curatorial talks and behind-the-scene tours, complimentary catalogues and full membership of the Friends. Annual membership ranges from £100 to £500.

The Friends of the Tate Gallery are supported by Tate & Lyle PLC.

Further details on the Friends and Fellows in London and St Ives may be obtained from:

Friends of the Tate Gallery
Tate Gallery
Millbank
London SW1P 4RG

Tel: 071-887 8752

PATRONS OF THE TATE GALLERY

The Patrons of British Art support British painting and sculpture from the Elizabethan period through to the early twentieth century in the Tate Gallery's collection. They encourage knowledge and awareness of British art by providing an opportunity to study Britain's cultural heritage.

The Patrons of New Art support contemporary art in the Tate Gallery's collection. They promote a lively and informed interest in contemporary art and are associated with the Turner Prize, one of the most prestigious awards for the visual arts.

Annual membership of the Patrons ranges from £350 to £750, and funds the purchase of works of art for the Tate Gallery's collection.

Privileges for both groups include invitations to Tate Gallery receptions, an opportunity to sit on the Patrons' acquisitions committees, special events including visits to private and corporate collections and complimentary catalogues of Tate Gallery exhibitions.

Further details on the Patrons may be obtained from:

The Development Office
Tate Gallery
Millbank
London SW1P 4RG

Tel: 071-887 8743

Corporate Membership Programme

Membership of the Tate Gallery's Corporate Membership Programme offers companies outstanding value-for-money and provides opportunities for every employee to enjoy a closer knowledge of the Gallery, its collection and exhibitions.

Membership benefits are specifically geared to business needs and include private views for company employees, free and discount admission to exhibitions, discount in the Gallery shop, out-of-hours Gallery visits, behind-the-scenes tours, exclusive use of the Gallery for corporate entertainment, invitations to VIP events, copies of Gallery literature and acknowledgement in Gallery publications.

TATE GALLERY CORPORATE MEMBERS

Partners
ADT Group PLC
The British Petroleum Company plc
Glaxo Holdings p.l.c.
Manpower PLC
Unilever

Associates
Brunswick Public Relations
BUPA
Drivers Jonas

Global Asset Management
Herbert Smith
Lazard Brothers & Co Ltd
Linklaters & Paines
Refco Overseas Ltd
Salomon Brothers
Schroders plc
S.G. Warburg Group
THORN EMI

Corporate sponsorship

The Tate Gallery works closely with sponsors to ensure that their business interests are well served, and has a reputation for developing imaginative fund-raising initiatives. Sponsorships can range from a few thousand pounds to considerable investment in long-term programmes; small businesses as well as multi-national corporations have benefited from the high profile and prestige of Tate Gallery sponsorship.

Opportunities available at Tate Gallery London, Liverpool and St Ives include exhibitions (some also tour the UK), education, conservation and research programmes, audience development, visitor access to the Collection and special events. Sponsorship benefits include national and regional publicity, targeted marketing to niche audiences, exclusive corporate entertainment, employee benefits and acknowledgment in Tate Gallery publications.

TATE GALLERY LONDON: PRINCIPAL CORPORATE SPONSORS (alphabetical order)

Barclays Bank PLC
 1991, *Constable*
The British Land Company PLC
 1993, *Ben Nicholson*★
The British Petroleum Company plc
 1990–4, *New Displays*
Channel 4 Television
 1991–3, The Turner Prize
Daimler-Benz AG
 1991, *Max Ernst*
Ernst & Young
 1994, *Picasso: Sculptor/Painter*★
Pearson plc
 1992–5, Elizabethan Curator Post
Reed Elsevier
 1994, *Whistler*
Tate & Lyle PLC
 1991–5, Friends Relaunch Marketing Programme
Volkswagen
 1991–4, The Turner Scholarships

[293]

TATE GALLERY LONDON:
CORPORATE SPONSORS
(alphabetical order)

AFAA, Association Française d'Action
Artistique, Ministère de Affaires
Etrangères, The Cultural Service of the
French Embassy, London
 1993, *Paris Post War: Art and
 Existentialism 1945–55*
Agfa Graphic Systems Group
 1992, *Turner: The Fifth Decade**
Beck's
 1992, *Otto Dix*
Blackwall Green Ltd
 1991, International Conference on
 the Packing and Transportation of
 Paintings
 1994, Frames Conservation
Borghi Transporti Spedizioni SPA
 1991, International Conference on
 the Packing and Transportation of
 Paintings
James Bourlets & Sons
 1991, International Conference on
 the Packing and Transportation of
 Paintings
Clifton Nurseries
 1991–4, Christmas Tree (in kind)
D'Art Kunstspedition GmbH
 1991, International Conference on
 the Packing and Transportation of
 Paintings
Digital Equipment Co Ltd
 1991–2, *From Turner's Studio*
 1993, Library and Archive
 Computerisation
Alfred Dunhill Limited
 1993, *Sir Edward Burne-Jones:
 Watercolours and Drawings*
Gander and White Shipping Ltd
 1991, International Conference on
 the Packing and Transportation of
 Paintings
Gerlach Art Packers & Shippers
 1991, International Conference on
 the Packing and Transportation of
 Paintings
The German Government
 1992, *Otto Dix*
Harsch Transports
 1991, International Conference on
 the Packing and Transportation of
 Paintings
Hasenkamp Internationle Transporte
 1991, International Conference on
 the Packing and Transportation of
 Paintings
The Independent
 1992, *Otto Dix* (in kind)
 1993, *Paris Post War: Art and
 Existentialism 1945–55*
KPMG Management Consulting
 1991, *Anthony Caro: Sculpture towards
 Architecture**
Kunsttrans Antiquitaten
 1991, International Conference on
 the Packing and Transportation of
 Paintings
Lloyd's of London
 1991, Friends Room
Martinspeed Ltd
 1991, International Conference on
 the Packing and Transportation of
 Paintings
Masterpiece International Ltd
 1991, International Conference on
 the Packing and Transportation of
 Paintings

Mat Securitas Express AG
 1991, International Conference on
 the Packing and Transportation of
 Paintings
Mobel Transport AG
 1991, International Conference on
 the Packing and Transportation of
 Paintings
Momart plc
 1991, International Conference on
 the Packing and Transportation of
 Paintings
Nuclear Electric plc
 1993, *Turner: The Final Years*
Propileo Transport
 1991, International Conference on
 the Packing and Transportation of
 Paintings
Rees Martin Art Service
 1991, International Conference on
 the Packing and Transportation of
 Paintings
SRU Limited
 1992, *Richard Hamilton**
Sun Life Assurance Society plc
 1993, *Robert Vernon's Gift*
THORN EMI
 1993 *Turner's Painting Techniques*
TSB Group plc
 1992, *Turner and Byron*
 1992–5, *William Blake* display series
Wingate & Johnston Ltd
 1991, International Conference on
 the Packing and Transportation of
 Paintings

TATE GALLERY LIVERPOOL:
CORPORATE SPONSORS
(alphabetical order)

AIB Bank
 1991, *Strongholds*
American Airlines
 1993, *David Hockney*
Beck's
 1993, *Robert Gober*
British Alcan Aluminium plc
 1991, *Dynamism*
 1991, *Giacometti*
Canadian High Commission, London and
Government of Canada
 1993, *Elective Affinities*
Cultural Relations Committee,
Departments of Foreign Affairs, Ireland
 1991, *Strongholds*
English Estates
 1991, Mobile Art Programme
Ibstock Building Products Ltd
 1993, *Antony Gormley*
Korean Air
 1992, *Working with Nature* (in kind)
The Littlewoods Organisation plc
 1992–5, *New Realities*
Merseyside Development Corporation
 1992, *Myth-Making*
 1992, *Stanley Spencer*
Momart plc
 1991–4, The Momart Fellowship
NSK Bearings Europe Ltd
 1991, *A Cabinet of Signs: Contemporary
 Art from Post-Modern Japan*
Ryanair
 1991, *Strongholds* (in kind)
Samsung Electronics
 1992, *Working With Nature*
Volkswagen
 1991, Mobile Art Programme (in kind)

TATE GALLERY ST IVES:
CORPORATE SPONSORS

First Class Pullman, InterCity*
 1993–4, Annual Displays
South Western Electricity plc (SWEB)*
 1993–4, Education Programme

*denotes a sponsorship in the arts,
recognised by an award under the Gov-
ernment's Business Sponsorship Incentive
Scheme, administered by the Association
for Business Sponsorship of the Arts.

Tate Gallery Founding Benefactors
(date order)

Sir Henry Tate
Sir Joseph Duveen
Lord Duveen
The Clore Foundation

Tate Gallery Principal Benefactors
(alphabetical order)

American Fund for the Tate Gallery
Calouste Gulbenkian Foundation
Friends of the Tate Gallery
The Henry Moore Foundation
National Art Collections Fund
National Heritage Memorial Fund
The Nomura Securities Co., Ltd
Patrons of New Art
Dr Mortimer and Theresa Sackler
 Foundation
St Ives Tate Action Group
The Wolfson Foundation and Family
 Charitable Trust

Tate Gallery Benefactors
(alphabetical order)

The Baring Foundation
Bernard Sunley Charitable Foundation
Gilbert and Janet de Botton
Mr Edwin C. Cohen
The Eleanor Rathbone Charitable Trust
Esmee Fairbairn Charitable Trust
Foundation for Sport and the Arts
GEC Plessey Telecommunications
The Getty Grant Program
Granada Group plc
John and Olivia Hughes
The John S. Cohen Foundation
The John Ellerman Foundation
John Lewis Partnership
The Leverhulme Trust
Museums and Galleries Improvement
 Fund
Ocean Group plc (P.H. Holt Trust)
Patrons of British Art
Peter Moores Foundation
The Pilgrim Trust
Mr John Ritblat
The Sainsbury Family Charitable Trusts
Save & Prosper Educational Trust
SRU Limited
Weinberg Foundation

Tate Gallery Donors
(alphabetical order)

LONDON

Professor Abbott
The Andy Warhol Foundation for the
 Visual Arts, Inc
Lord Attenborough
BAA plc
Friends of Nancy Balfour OBE
Balmuir Holdings
The Hon. Robin Baring
Nancy Bateman Charitable Trust
Mr Tom Bendhem
Mr Alexander Bernstein
Michael and Marcia Blakenham
Miss Mary Boone
Card Aid
Carlsberg Brewery
Mr Vincent Carrozza
Cazenove & Co
Charlotte Bonham Carter Charitable
 Trust
Christie, Manson & Woods Ltd
The Claire Hunter Charitable Trust
The Clothworkers Foundation
Mrs Elisabeth Collins
Mr R.N. Collins
Giles and Sonia Coode-Adams
Mrs Dagny Corcoran
C.T. Bowring (Charitable Trust) Ltd
Cognac Courvoisier
Mr Edwin Cox
Anthony d'Offay Gallery
Mr and Mrs Kenneth Dayton
Mr Damon and The Hon. Mrs de Laszlo
Madame Gustava de Rothschild
Baroness Liliane de Rothschild
Deutsche Bank AG
Miss W.A. Donner
Mr Paul Dupee
Mrs Maurice Dwek
Elephant Trust
Eli Broad Family Foundation
Elizabeth Arden Ltd
European Arts Festival
Evelyn, Lady Downshire's Trust Fund
Roberto Fainello Art Advisers Ltd
The Flow Foundation
First Boston Corporation
Miss Kate Ganz
Mr Henry Geldzahler
Mr and Mrs David Gilmour
The German Government
Goethe Institut
Sir Nicholas and Lady Goodison
 Charitable Settlement
Mr William Govett
Mr and Mrs Richard Grogan
Gytha Trust
Mr and Mrs Rupert Hambro
Miriam and Peter Haas Foundation
The Hon. Lady Hastings
The Hedley Foundation
Mr Rupert Heseltine
Horace W. Goldsmith Foundation
Mr Robert Horton
Hurry Armour Trust
Idlewild Trust
The Italian Government
Sir Anthony and Lady Jacobs
Mrs Gabrielle Keiller
Knapping Fund

Mr and Mrs Richard Knight
Mr and Mrs Jan Krugier
The Leche Trust
Robert Lehman Foundation, Inc
The Helena and Kenneth Levy Bequest
Mr and Mrs Gilbert Lloyd
Mr and Mrs Lawrence Lowenthal
Mail on Sunday
Mr Alexander Marchessini
The Mayor Gallery
Midland Bank Artscard
Mr and Mrs Robert Mnuchin
The Monument Trust
Mr Peter Nahum
Mr and Mrs Philip Niarchos
Dr Andreas Papadakis
Mr William Pegrum
Philips Fine Art Auctioneers
Old Possum's Practical Trust
The Hon. Mrs Olga Polizzi
Paul Nash Trust
Peter Samuel Charitable Trust
Mr Jean Pigozzi
Reed International P.L.C.
Richard Green Fine Paintings
Mrs Jill Ritblat
Rothschild Bank AG
Mrs Jean Sainsbury
The Hon. Simon Sainsbury
Sebastian de Ferranti Trust
Schroder Charity Trust
Ms Dasha Shenkman
Mr A. Speelman
Mr and Mrs Bernhard Starkmann
The Swan Trust
Sir Adrian and Lady Judith Swire
Time-Life International Ltd
The 29th May 1961 Charitable Trust
Mr Barry and The Hon. Mrs Townsley
The Triangle Trust
U.K. Charity Lotteries Ltd
Mrs Anne Uribe-Mosquera
Visiting Arts
Mr and Mrs Leslie Waddington
Waley-Cohen Charitable Trust
Mr Mark Weiss
Weltkunst Foundation
Mrs Alexandra WIlliams
Nina and Graham Williams
Willis Faber plc
Mr Andrew Wilton
Thomas and Odette Worrell
The Worshipful Company of Goldsmiths
The Worshipful Company of Grocers
Mrs Jayne Wrightsman

and those donors who wish to remain
anonymous

LIVERPOOL (alphabetical order)

The Baring Foundation
David and Ruth Behrend Trust
Ivor Braka Ltd
The British Council
British Telecom plc
Calouste Gulbenkian Foundation
Mr and Mrs Henry Cotton
English Estates
European Arts Festival
Goethe Institut, Manchester
Mrs Sue Hammerson OBE
Mr John Heyman
Liverpool Council for Voluntary Services

Merseyside Development Corporation
Momart plc
The Henry Moore Foundation
Ocean Group plc (P.H. Holt Trust)
Eleanor Rathbone Charitable Trust
Tate Gallery Liverpool Supporters
Bernard Sunley Charitable Foundation
Unilever
Visiting Arts

and those donors who wish to remain
anonymous

ST IVES (alphabetical order)

Donors to the Appeal coordinated by
the Steering Group for the Tate Gallery St
Ives and the St Ives Action Group.

Viscount Amory Charitable Trust
Barbinder Trust
Barclays Bank PLC
The Baring Foundation
BICC Group
Patricia, Lady Boyd and Viscount Boyd
British Telecom plc
Cable and Wireless plc
Carlton Communications
Mr Francis Carnwath
Christie, Manson & Woods Ltd
Mr Peter Cocks
John S. Cohen Foundation
Miss Jean Cooper
D'Oyly Carte Charitable Trust
David Messum Fine Paintings
Dewhurst House
Dixons Group plc
Mr Alan Driscoll
The John Ellerman Foundation
English China Clays Group
Esmee Fairbairn Charitable Trust
Foundation for Sport and the Arts
J. Paul Getty Jr Charitable Trust
Gimpel Fils
Grand Metropolitan Trust
Ms Judith Hodgson
Sir Geoffrey and Lady Holland
Mr and Mrs Philip Hughes
Mr Bernard Jacobson
Mr John Kilby
Lloyds Bank plc
Lord Leverhulme's Trust
The Manifold Trust
The Mayor Gallery
Marlborough Fine Art
Mercury Asset Management plc
Meyer International plc
The Henry Moore Foundation
National Westminster Bank plc
New Art Centre
Pall European Limited
The Pilgrim Trust
The Joseph Rank (1942) Charitable Trust
Mr Roy Ray
The Rayne Foundation
Royal Bank of Scotland
The Sainsbury Family Charitable Trusts
Mr Nicholas Serota
Mr Roger Slack
Trustees of the Carew Pole Family Trust
Trustees of H.E.W. Spurr Deceased
South West British Gas
South West Water plc

South Western Electricity plc
Sun Alliance Group
Television South West
The TSB Foundation for England and
 Wales
Unilever
Mrs Angela Verren Taunt
Weinberg Foundation
Wembley plc
Western Morning News, West Briton,
 Cornish Guardian and The Cornish-
 man
Westlake & Co
Mr and Mrs Derek White
Mr and Mrs Graham Williams
Wingate Charitable Trust
The Worshipful Company of
 Fishmongers
The Worshipful Company of Mercers
Mrs Monica Wynter

and those donors who wish to remain
anonymous